AROUND
LINGFIELD
AT WAR

AROUND LINGFIELD AT WAR

WARTIME EXPERIENCES IN SOUTH-EAST ENGLAND
1939 – 1945

JANET BATESON

AMBERLEY

*Dedicated to the memory of my beloved daughter
Stephanie Helen Church: for whom the sun keeps shining.*

Also to those who have sacrificed their youth to war.

First published 2010

Amberley Publishing plc
Cirencester Road, Chalford,
Stroud, Gloucestershire, GL6 8PE

www.amberley-books.com

British Library Cataloguing in Publication Data.
A catalogue record for this book is available from the British Library.

ISBN 978-1-4456-0208-0

Typeset in 10pt on 12pt Sabon.
Typesetting and Origination by FONTHILLDESIGN.
Printed in the UK.

CONTENTS

Foreword

This account is of a rural community's response to a national emergency, the Second World War. The community is centred on the parish of Lingfield in south-east Surrey, close to the border with Sussex to the south and Kent to the east. The Sussex town of East Grinstead is three and a half miles to the south and is the nearest market town, centre of employment and a magnet for entertainment. For centuries the surrounding villagers have travelled back and forth for their work, rest and play, irrespective of the geographical and political boundaries that invisibly separate them from their neighbours.

The Second World War brought great social changes to the community. The absence of a 1941 census precludes the count of the population but it is clearly evident that more people came into this community in the war than left to join the civil defence and armed forces. The total number of souls in Lingfield, Dormans Land, Felcourt and Baldwins Hill according to the 1931 census was 5,314. As hundreds of men and women left the area for wartime service, hundreds of Canadian soldiers came in to the area. Five schools with teachers and helpers arrived on 1 and 2 September 1939; they were evacuees from south London. One thousand enemy aliens were imprisoned on Lingfield Racecourse in 1940. In 1941, prisoners of war were held on the racecourse, which was then known as 'Lingfield Cage'. The area also became host to refugees from Nazi-occupied Europe. One house provided peace and security for orphaned children of the London Blitz. The same house, at the end of the war, provided a safe haven for children rescued from the Nazi concentration camps.

Seventy years on, the war generation is gradually disappearing and it is important that their story of events is recorded for future generations. That is particularly true of the survivors of the Jewish Holocaust; there

are a growing number of people who for their own needs and political purposes are anxious to rewrite history by denying the holocaust. Child survivors of the Nazi death camps came to Lingfield in 1945, orphaned children who had witnessed the horrors of life and death in Theresienstadt and Auschwitz. One of the survivors now visits Lingfield Notre Dame School annually to speak of the horrors of her infant years to children who are currently studying the Second World War as part of the curriculum. Although liberation came in 1945, the successive traumas of losing her entire family, her own imprisonment and subsequent misguided attempts to help her to forget, have all fuelled her mission to teach the present generation of children about the events of the Nazi terror.

Several personal memories are included here; good and bad memories recorded by evacuees and refugees (not all householders welcomed 'the intruders'). One veteran soldier recorded his memories of battles in France, North Africa, Sicily and Belgium; he continues to be haunted by his wartime experiences, reliving the horrors again and again through nightmares.

Stories of individual bravery are here recounted as an inspiration for others. Agents of the Special Operations Executive risked their lives in enemy-held territory; Ides Floor was one such agent. Countless unknown individuals were prepared to risk their lives in secret underground locations on the Home Front; the identity of most of them remains a mystery. There are accounts of the deaths of local heroes – lost at sea, shot down from the sky or killed in a distant land.

Traces of military defences survive in the Surrey and Sussex landscape. At least one hundred pillboxes remain in the eastern section of the General Head-quarters (GHQ) 'Stop Line', between Burstow and the Kent border. Built in 1940/41, the Stop Line ran from Reading through Hampshire and Surrey to Kent following in part a line south of the North Downs, it was intended to delay the progress of armoured columns in an expected German invasion. The Council for British Archaeology completed a record of the twentieth-century militarised landscape in 2002. The database of the C.B.A. 'Defence of Britain Project' is now freely accessible via the internet. The C.B.A. obtained a lot of photographic evidence, including an anti-tank ditch and other defences in the GHQ Stop Line, from Luftwaffe Archives dated 1940. It is a chilling thought that in 1940 German Intelligence knew precise details of our home defences.

Acknowledgements

I could not have written this book without the help and goodwill of many people. I would particularly like to thank Eric Ellis for his memories of fear, bravery, horror, death and survival; the common experience of soldiers in wartime. Bishop Mark Green wrote an inspirational account of his experiences as a young priest during the D-Day landings in Normandy. He published the account with a collection of his writings in 2005, four years before his death at the age of ninety-two. I spoke with Bishop Mark shortly after the publication of *Before I Go*; at that time I was beginning my own research on the Second World War. He was then living at the College of St Barnabas, a home for retired clergy in Dormansland. When I asked whether I could use passages from his work in my own publication he replied, 'Yes gladly, I hope I will live long enough to see the book published.' Regrettably he did not.

Bill Coombes gave me many hours of his time and pages of information about his work in the fire brigade, and the sacrifices made by his close friends. Many local people have given me their unstinted support by recounting memories and lending photographs which have been reproduced in the book; particularly Bob and Jean Drew, Ian Gibbs, Brenda and Philip Huggill, Doris Jenner, John Jones, Garry Steer and Ralph Williams. I thank them all for the hours of their time, and their patience with my endless questions. I also thank Mrs Mary Alkherson, Bob Blackford, Jim and Shirley Landles, and Denis Leman for allowing the use of their own material and memories. The photographs and some of the details of Hobbs Barracks have been reproduced by permission of Felbridge and District Local History Group. Additional photographic material was kindly donated to the RH7 History Group by Jim Fry, a former resident of Dormansland. The illustrations on pages 17, 43, 179,

180, 181 and 261, and the photographs on pages 21, 31, 32, 33, 42, 83, 177, 178, 194, 197, 199 and 222 are reproduced with the kind permission of the Management Committee of the Hayward Memorial Local History Centre, Lingfield.

I am grateful for the help of Jo and Dick Osborne of Crowhurst, and Mary Chauncy of East Grinstead, who have enthusiastically helped my research on the Women's Land Army and the Surrey War Agricultural Committee. Ted Hook has also contributed his memories of wartime Crowhurst and working with 'Cock Robin' at Church Farm, Crowhurst.

Several wartime evacuees have recorded their experiences including the late Violet Kinnibrugh and Betty Snow. Violet and Betty came as evacuees from south London to Ford Manor, Dormansland, with their own young children and the Kintore Way Nursery School. Charles Bird, founder and ringleader of the Brockley Old Scholars Association and editor of the *Brockenian* has encouraged my research and provided photographs of the boys in their billet at Ranworth, Dormans Park. The Brockley 'boys' have been an inspiration to me; I have enjoyed hours of amusement, listening to and reading accounts of life as an evacuee in Lingfield between 1939 and 1944. My thanks go particularly to Peter Douglas, Derick Johnson, Dave Mitchell, Geoff Post, Bob Pucknell, Doug Ryall and Jack Ryde for the many happy hours of storytelling and to John 'Eddie' Parsons for his account of Sgt Alan Fuller. Sheila Clark, daughter of the Brockley Headmaster, has also contributed amusing stories of Ranworth and the owners. I am grateful to several of the Brockley girls, especially Irene Caton and Patricia Leadley for their memories of evacuation to Oxted. The annual reunion of the Brockley Old Scholars Association (boys and girls) takes place at the Lingfield Victoria Memorial Institute in October and is a must on my calendar; I am proud of my honorary membership of the association.

John Withall, a former ranger at Wakehurst Place, first led me to the underground zero station built by the Royal Canadian Engineers in the grounds of Wakehurst Place and provided additional material of the 1st Canadian Corps billeted in the main house. John has an infectious curiosity for wartime heroism that I have also succumbed to. I am grateful to Sir William Davies for permission to use the photograph of his aunt, Miss Beatrice Temple, the courageous Senior Commander of the ATS Special Duties Section. It was her duty to select the ATS telephone operators for the zero station at Wakehurst Place.

Bob Marchant, Hon. Curator of Queen Victoria Hospital Museum, and secretary of the world famous Guinea Pig Club, has patiently guided me through the 'temporary' wooden buildings that once housed Mr Archibald McIndoe's famous Burns Unit (Ward III is now the 'Spitfire Restaurant').

Photographs of the Queen Victoria Hospital and personalities of the Second World War are used with the kind permission of the Hospital Museum. Michael Harding has provided much of my material on Mr Alfred Wagg, a supporter and benefactor of the Queen Victoria Hospital and many other charitable groups locally and elsewhere.

I have collected stories from several Canadian war brides and thank especially Joan Reichardt, Margaret Houghton, Margaret Eaton, Kay Garside and Eunice Partington for their stories of love and marriage with Canadian soldiers. Sixty years after the war, the brides have written via the internet and 'snail mail', to tell of courting in the blackout, and their long journeys to a new life on the other side of the Atlantic Ocean.

I have a special memory of an afternoon I spent with the late Commander Robert Philpott who recorded his memories of the war and life at sea for the RH7 Memory Bank. One tape of his memories was almost complete when Bob was suddenly brought back to the present by the ringing of the Sanctus Bell at the nearby College of St Barnabas. 'Ah!' he exclaimed, 'the Sanctus Bell, time for a G and T, do you take ice and lemon?' In the fullness of time we returned to 1941!

Laurie Chester at St George's RAF Chapel, Biggin Hill, has given me valuable assistance in my search for lost airmen of the Second World War. Mrs H. Keane of the Air Historical Branch of the Ministry of Defence at RAF Northolt has also provided material on RAF casualties. Hilda Hook (formerly Hilda Godsmark) has given me her memories of life in the WAAF from 1942 to 1949.

The late L. A. (Len) Griffith encouraged my Second World War research and gave me extracts of his extensive notes on the bombing of the Whitehall Cinema and town centre of East Grinstead. Dorothy Hatswell has happily given me permission to use an extract from her own research on the 1943 bombing of East Grinstead.

I thank Mrs Christiane (Minou) Wellesley-Wesley for the detailed biographical notes of her father, Major Ides Floor 1905-76, a brave and truly remarkable man, a senior agent of the Special Operations Executive.

I am indebted to the children of Weir Courtney, especially Zdenka Husserl, Joanna Millan (formerly Bela Rosenthal), and Jackie Young (formerly Jona Spiegel). Their accounts and the experiences of other survivors of the Holocaust must be preserved as witness accounts for future generations.

The Lingfield librarians, Jane Rayner and Sue Sharp, have patiently supported my project by tracing rare books. I thank the staff of Surrey History Centre for all their help. The photograph on page 151 has been reproduced by permission of Surrey History Centre. The photographs on pages 38 and 235 are reproduced by the kind permission of the trustees of Imperial War Museum, London.

My sister, Sheila Mileham, read early drafts of the text and made many helpful suggestions on the way forward. Peter Francis has spent very many hours pouring over the book and identifying blunders, thus saving my embarrassment. I am grateful to both of them for all their editorial skills.

Finally, I owe a great debt of gratitude to my husband, John, for his patience and support during the gestation period of this book. All my family and friends have had faith in my ability to complete the project. To them all I give my love and my thanks.

Introduction

Throughout the 1930s, there was escalating tension across Europe and the rest of the World. On 30 January 1933, President Hindenburg announced Hitler's appointment as Chancellor of Germany. The following year, the Austrian Chancellor, Engelbert Dollfuss, was assassinated by Austrian Nazis on 25 July. In August 1934, President Hindenburg died and Adolf Hitler assumed the powers of a Dictator, having combined the offices of President and Chancellor.

On 2 October 1935, Italian forces invaded Abyssinia and the British fleet sailed to the Mediterranean – but no further. In 1936, the Rhineland was remilitarised, contrary to the Treaty of Versailles of 1919, Italian troops occupied Addis Ababa, Civil War broke out in Spain, and Japan signed an anti-communist agreement with Nazi Germany. Japan concluded a similar agreement with Italy in 1937 then went to war with China. By the end of 1937, Japan had captured Shanghai, Beijing and Nanjing. In February 1938, Austria was annexed by Germany and a year later Bohemia and Moravia were proclaimed a German Protectorate. Despite the Munich Agreement between Chamberlain, Daladier, Hitler and Mussolini, on 29 September 1938, war seemed inevitable.

The British government committed £100,000 to planning Air Raid Precautions in 1935, at the same time local authorities were alerted to organise Civil Defence at a neighbourhood level. Government and military planners fully expected that in the event of war the British civilian population would be at risk from aerial gas attacks. The production of various types of gas masks continued after the end of the First World War. By 3 September 1939, there were ample stocks of gas masks to equip the entire civilian population.

In the 1930s and 40s, the wireless set brought the world into the parlour. At five minutes past 3 p.m. on Christmas Day, 1932, King George V made the first royal Christmas broadcast. Every day the vast majority of British people listened to BBC news broadcasts, such as the arrival of the Olympic torch bearer in Berlin, in 1936 ('a fair young man in white shorts, beautifully made, a very fine sight as an athlete'). Edward VIII's Abdication speech was broadcast on 11 December 1936. News bulletins of the Munich Crisis in September 1938 culminated in Neville Chamberlain's speech on 'Peace in our time'. One year later, the nation heard the Prime Minister's announcement that we were 'at war with Germany', the choir of St John's Blindley Heath listened via a loudspeaker set up by the vicar, the Revd Pinney. Throughout the war, families listened to the latest news from the battlefields in Europe, the Far East and North Africa. Listeners heard of the loss of Allied and enemy shipping in the Atlantic, the Pacific and the Baltic seas. They heard on the wireless and saw with their own eyes the battles in the air between the RAF and the Luftwaffe.

News travelled very much faster than in any previous war, so much so that there was a deliberate blackout of many news items as it became clear that signals were also accessible to the enemy. The British Broadcasting Corporation was used by the government to raise public morale as well as to inform on the progress of the war. A forces network broadcast to serving troops abroad. The BBC also broadcast personal messages to agents in Europe. The Germans thought there was a complex code to be broken but in fact they were simple coded messages to individual groups announcing or postponing parachute drops of agents and arms. One agent in France, code-named Cesar, arranged to receive news of the birth in England of his son or daughter. The message read, 'Clement ressemble a son grandpere' (or 'grandmere', depending on the sex of the infant). On 5 May 1943, the news of his daughter's birth was broadcast by the BBC on the very day of her birth.

The Second World War brought an enormous death toll and devastating destruction to mainland Britain. Men and women left home to join the armed forces knowing that their families were in the front line of an expected invasion of Britain by Nazi stormtroopers; the real threat of occupation as suffered by families in Czechoslovakia, Poland, Belgium, Holland and France. The war brought in a standard rate of Income Tax at 7s 6d in £1, rationing, identity cards, gas masks, the Utility kite mark, Anderson shelters, barrage balloons, Nissen huts, pillboxes, Doodle-bugs, 'Make do and Mend' and 'Yes, we have no bananas'. It also brought a shared experience of death and bereavement, which cut across social barriers.

CHAPTER 1

A Time for War:
Air Raid Precautions

Several years before the war, the government began issuing directives to intelligence personnel on dealing with wide spread panic in the event of heavy bombing. The policy was based on experiences of the First World War and information gathered from European countries where civilians organised their own evacuation from vulnerable areas, causing major disruption to essential services. There was to be at least one withdrawal exit from each town as a safety valve for evacuees. Road blocks were to be erected across all other roads, to ensure the free flow of troops and emergency services.

In April 1937, the government launched the Air Raid Precautions Service (ARP) to give advice to householders on how best to prepare for air raids in the event of war. At the same time parish councils in the rural district of Godstone set up committees to consider national and local government proposals and appoint ARP officers (Chief Wardens) to oversee recruitment and training of neighbourhood volunteers. Brigadier H. S. Mosley DSO, the ARP organiser for Godstone Rural District Council, advised on appropriate numbers of ARP Wardens for each area.

The first ARP recruitment meeting in Dormansland was held at Little Farindons, Mutton Hill, on 26 April 1938. The meeting was called by the Chief Warden, Captain William St. Clair and was the first of several meetings held at his home. The Chief Warden's second meeting a month later was postponed as the local Women's Institute choir was competing at the Lewes Festival!

At eight o'clock on Friday 14 October 1938, the Lingfield Victoria Memorial Institute was packed for the first of a series of weekly lectures there on air raid precautions. The meetings included practical help on fitting a respirator, or gas mask. Several types and sizes of respirators

had been issued to the public, including Mickey Mouse masks for young children and special masks for babies in which the baby was completely enclosed in a sealed unit. Other subjects included first aid training, blackout demonstrations, making sand-bag defences to restrict blast damage and the provision of water and sand buckets as a fire precaution.

Outdoor exercises were held at the weekends during the winter months and evenings throughout the summer. Teams considered the defence of local public buildings and advice on protecting homes against aerial attack. Demonstrations were given by the local fire brigade, the St John's Ambulance Brigade and the Red Cross, the police and military personnel. Detailed plans were made for the treatment of war casualties, the evacuation of homes, and the erection of barriers and exclusion zones. Nearly one hundred local volunteers took part in the first exercise with medical support units in January 1939.

The late Bill Coombes wrote of one bombing exercise in Lingfield village. The local ARP officers had alerted the police and Redhill aerodrome to make the appropriate preparations but the villagers were somewhat sceptical when a twin-engined plane flew overhead and dropped a few bags of flour to simulate the bombs. Central Lingfield was covered in white flour; no-one was quite sure what they should have learned from the exercise.

The annual report of the Lingfield District Fire Brigade 1936-37, included a section on Air Raid Precautions:

> The Home Office has directed all Local Authorities to prepare schemes for safeguarding the civil population against attacks from the air. Close attention is being given by the Committee to all the preparations – particularly those closely affecting Fire Brigades – to minimise the consequences of such an attack, which to be effective must be made before the emergency occurs. Our Chief Officer has already attended a short course of training at the Surrey C.C. Anti-Gas School at Artington, near Guildford.

Despite the various preparations for war, life continued as normally as possible. Arthur Hayward, a well known local historian who, with Stanley Hazell, had published *A History of Lingfield* in 1933, divided his time between his home at the Guest House, adjacent to Lingfield Church, and his business as an architect in London. He noted in his diary in October 1938 that he attended a 'Machine Gun Dinner, had a very jolly evening'. Hayward had served with the 8th Reserve Bn, Machine Gun Corps in the First World War. The war service caused his deafness thereafter.

In January 1939, Mr Bruce-Roberts, Chief ARP Warden for Lingfield, District Councillor and neighbourhood dentist, posted notices asking for volunteers for national service.

NATIONAL

SERVICE

HAVE YOU OFFERED YOURS?

If you need advice as to the most suitable form of

NATIONAL SERVICE

in which to enrol, you should apply to—

A . W. BRUCE - ROBERTS Esq.

HARRIESVILLE

TEL.
LINGFIELD .37. LINGFIELD

CIVIL DEFENCE IS THE BUSINESS OF THE CITIZEN

(2569) Wt.47848/64481 Dd/5171 625 BPL 3/39 51/9249

The call to enrole for National Service.

The Prime Minister had introduced the campaign for national service in a broadcast from the BBC on the night of 23 January 1939:

> It is a scheme to make us ready for war. That does not mean that I think war is coming. You know that I have done, and shall continue to do, all I can to preserve peace ...

The next day 18 million copies of a buff-coloured *National Service Handbook* were distributed nationally to householders cataloguing the ways in which people could serve the nation if they chose. Activities were grouped under headings; 'Mainly for Younger Men (Auxiliary Fire Service, Territorial Army, etc.)'; 'Mainly for Older Men (Air Raid Wardens, Ambulance Drivers, Police War Reserve, etc.)'; and 'Opportunities for Women (Air Raid Wardens, Auxiliary Fire Service, Civil Air Guard, etc.).'

Special Constabulary or Police War Reserve

A Home Office letter was sent to the Chief Constable of Surrey at Guildford, Major G. Nicholson MC, on 25 August 1938, stamped:

> MOST SECRET. These instructions should not be opened except on receipt of the code telegram: EMPOL SEAME ACKNOWLEDGE MONEMPOL.

Instructions in the event of a war emergency requiring action to be taken for the protection of the civilian population against air raids.

A series of 'Government Absolute Authority Telegrams' were received by the Chief Constable in 1939:

> As from August 24 1939 the Observer Corps were in readiness.
> "Most Urgent" 25 Aug 39: Prepare to act as indicated Snuffbox London (see action 1 Sept. below)

Several orders were issued to put in action on 1 September 1939:

> Call out First Police Reserve [5 per cent of Police Force] and Police War Reserve. All to be sworn in.
> Take action to extinguish beacons – Civil Aviation, Air Ministry
> Aircraft seizure order – unofficial and foreign aircraft, Private Licenses withdrawn.
> Prohibit all sirens and hooters except for Air Raid warnings

The Government wish to be informed of the progress of evacuation – Controllers to send a special report at 18.00 hours, mention should be made of mothers and children.

Enforce lighting restrictions.

Emergency Fire Brigade Precautions. Call out Auxiliary Fire Brigade.

Operation Snuffbox London. Port of London Authority must not allow any unofficial personnel into the Docks. Chief Police Officer has military aid at his disposal to keep out any refugees.

Additional responsibilities were added to the load of every county police force in the Second World War. They were required to enforce the wartime blackout, report air raids and any damage to public and private property, to assist the rescue services during and after bombing raids, report crashed Allied and enemy planes, check on enemy aliens in the country, and to pursue army deserters, in addition to their peacetime duties of keeping the peace, pursuing criminals and making sure that the traffic flowed freely. The Special Constabulary, or Police War Reserve, was an essential support organisation. All Reservists or Special Constables had full-time

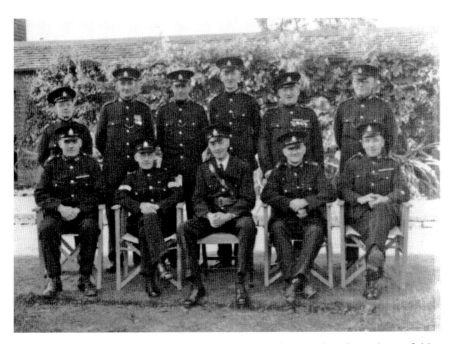

Lingfield Special Constabulary, 1941/42, at The Garth, Newchapel Road, Lingfield. From left to right, back row: -?-, John Taplin, John Banks, Jim Laker, Maurice (?) Dombrick, Sir (Arthur) Wilfred Moon Bt. Seated: Charlie Bracey, Sergeant Fiveash, Inspector Camden, Gordon Jenner, Joe Taylor. (*Courtesy of Miss Doris Jenner*)

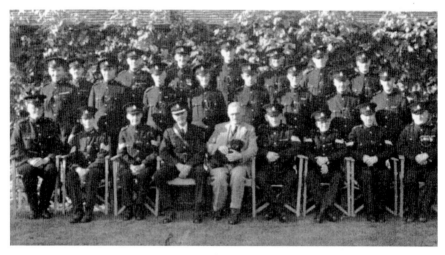

Lingfield Special Constabulary, 1941/42 at The Garth, Newchapel Road. (*Courtesy of Miss Doris Jenner*)

occupations and gave their free time to assist the County Constabulary. The general concern about imminent invasion in 1941 led to the transfer of many Special Constables to the coast to augment the coastal police forces in a full time capacity.

The County Constabulary was required to make monthly situation reports to the Home Office on public behaviour and public attitudes to the war, particularly noting evidence of subversive activity. Policemen often observed behaviour and listened to conversations in public houses, noting attitudes towards evacuees, lighting restrictions and food controls, and increases in drunkenness and crime. Surrey, South-East Area, reported 1 January 1941:

> Public morale remains good and encouragement seems to have derived from the success of our forces in Egypt. General comment on the recent enemy bombing and resultant fires in London, is one of bitterness and the hope that Berlin will suffer in a like manner.
>
> There appears to be expectancy among the public that Hitler will be making a move soon, either on the Continent or by an invasion of this country, but on the latter there is every confidence.

Police Report, 29 March 1941:

> The proposed conscription of women for war work has been generally accepted as necessary with certain reservations. There would be objections if married women with children were called upon ... The life of a child evacuee living apart from its parents is often not too happy.

There are a lot of young women of all classes with no ties who appear to have nothing to do and no interest in life beyond wearing trousers, painting finger nails and lips, and smoking, who could and should be conscripted in order to make some use of their lives.

Air Raid Precaution (ARP) Wardens

Air Raid Wardens were local men and women with a good knowledge of the geography of the area and of the people who lived there. Chief Wardens were appointed from councillors representing local parishes. Mr A. W. Bruce-Roberts was appointed Chief Warden in Lingfield and Captain W. F. St. Clair the Chief Warden in Dormansland, both were members of the Rural District Council Fire Protection and ARP Committee. Horne Parish Council decided that the RDC proposals were inadequate for their scattered parish and decided to appoint three area wardens, instead of one as recommended by the RDC; one to cover the church area, a second warden to cover Newchapel and Branford, and a third for Domewood and Snow Hill.

Wardens were issued with a battledress uniform, a steel helmet and a whistle to summon attention. Every warden was assigned to a particular Warden Post, identified by a number allocated by the Rural District Council and known to every police officer in the area. Each Warden Post was equipped with anti-gas suits, gloves, eye shields, curtains and rubber boots. They also had torches, two hand rattles, one hand bell, a first-aid box and a stirrup pump. The torches were modified with hoods to restrict

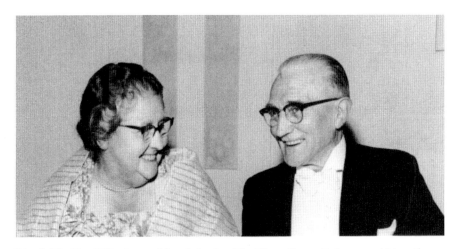

Lingfield's Head Warden and local dentist Cllr Albert Bruce-Roberts and his wife.

the amount of light visible from an aircraft and to concentrate the light in a small area. The stirrup pump could produce either a spray or a jet of water; the spray was intended for use against incendiary bombs, to prevent the scatter of molten magnesium.

Patrolling wardens enforced the blackout restrictions which came into force on 1 September 1939. All public buildings, including churches, factories and meeting halls were included in the general ban on light at night. Windows and doors were masked to make them invisible from the air. When a building was evacuated during an air raid, or closed at the end of the day, 'the last one out – put out the light'. It was every householder's duty to cover their windows and doors before sunset with heavy blackout curtains, cardboard or paint. The maximum fine for showing lights after nightfall was £100 and three months imprisonment.

Wardens maintained air-raid sirens and located and reported unexploded bombs. Possibly up to one in ten of all bombs dropped on Britain in the Second World War failed to explode on impact. Wardens arranged the evacuation of the immediate area and maintained a security guard around the site until the arrival of a Bomb Disposal Squad. After May 1940, they were supported in that task by the Home Guard.

Wardens were to be informed whenever houses were vacated for any period. Vital time could be lost trying to locate buried victims from a building which had been left empty for a day or a night. Inquisitive wardens were not always met with a sympathetic greeting! An Englishman's home is his castle after all.

Other duties included locating and reporting crashed aircraft and parachute landings. They also noted any strange visitors to the area. Every incident or change from the norm meant an incident report, copies of which were required by the police and Military Authorities.

Information notices on air-raid precautions were issued to all householders giving the name and address of the nearest warden and the Wardens Post, and the address of the nearest First Aid Post. Other information included:

What to do in case of Injury: specifically Wounded and Gas contaminated casualties.

 Gas Masks: Learn how to put them on, to take them off and how to store properly.

 Lighting Restrictions: Remember that a light at the back of the house is just as visible from the air as one at the front.

 Air Raid Warning signals: Warbling or intermittent sound on siren; Wardens whistle; Rattles warning of GAS; continuous sound of All Clear; Hand bell ringing All Clear.

Fire Precautions: Be ready to deal with an Incendiary Bomb. Clear all lumber from your attic.

NOW. Provide two buckets filled with water and, if possible, a stirrup pump. If you have no stirrup hand pump, have two buckets of sand or dry earth and a shovel with a long handle near the top of the house.

Have a reserve supply of water in buckets. Leave used water in the bath.

ON NO ACCOUNT THROW WATER ON THE BOMB OR AN EXPLOSION MAY RESULT.

Air-Raid Shelters

Air-raid shelters were erected in private gardens throughout the country. Godstone District Council gave advice on the sizes and types available, and instructions on choosing a site and methods of construction. Several garden shelters remain today, half-buried or completely hidden in undergrowth.

Public air-raid shelters were built on recreation fields. An underground shelter was built in Jenners Field Lingfield, the stair access, covered with turf, created a mound in the grass that was invisible from the air. Underground were two long tunnels lined with wooden benches. Public shelters were also erected close to Star Field and the New Star in Lingfield, the recreation ground in Dormansland and at Haxted Mill for the use of the congregation of the Haxted Mission Church.

Several buildings had designated areas considered to be strong enough to withstand bomb blast, including a corridor in Lingfield School which was used whenever children were unable to get to the shelters before enemy aircraft arrived overhead. The church vestry, porch room and boiler room at St John's Dormansland were considered to be 'very poor shelters but as nothing better was available, children from the nearby village school should be taken to the rooms in the Church during air-raids'.

Air-raid shelter, partially hidden in a Lingfield garden. Built by a local builder in 1940, the date-stone is visible on an internal wall.

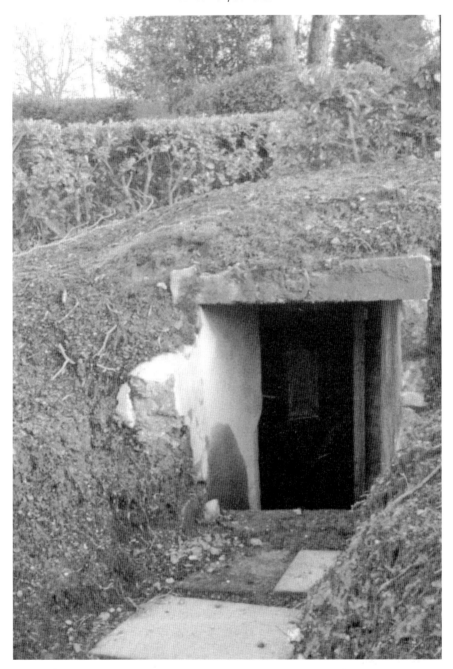

Underground air-raid shelter in a Felcourt garden. A lucky horseshoe remains over the entrance. Steps lead down to a room fitted with a three-bed bunk unit. Two pipes bring fresh air from the surface.

The Fire Service

There was no cohesive organisation of fire services in Godstone Rural District before the Second World War. The District Council provided a fire brigade for Oxted and Limpsfield only. The Parish Councils of Tandridge and Godstone each operated a parish brigade. Lingfield parish was served by a voluntary brigade that also served Horne. Tatsfield and Crowhurst had no brigade or formal arrangements, although Lingfield Brigade answered calls in Crowhurst. Teams of volunteers operated 'Fire Posts', or Sub-Stations at Blindley Heath, Baldwins Hill and Dormansland.

The first fire station in Lingfield, partly built from old railway sleepers, stood just inside Star Field. It was replaced in 1911/12 by a new substantial brick station in Church Road, built by Mr Frederick Palmer of Crowhurst Place, Surrey (later Sir Frederick Palmer). The new station was dedicated to the memory of his younger son, Frederick Charles Llewelyn Palmer. The Lingfield District Fire Brigade was controlled by a committee of local men and women, including the trustees of the Llewelyn Palmer Memorial Trust, and supported by public subscription. A Civil Engineer by profession, Frederick Palmer was Chief Engineer of the Port of London Authority between 1909 and 1913 and a past president of the Institution of Civil Engineers. He was created Knight Commander of St Michael and St George in 1930. As trustee, Sir Frederick was a committee member of Lingfield District Fire Brigade until his death in 1934 when his widow, Lady Florence Palmer, represented the interests of the Memorial Trust.

The Lingfield District Fire Brigade also ran the Sub-Station at Dormansland which was sited in the Twitten off the village High Street. Dormansland Fire Station was a wooden hut with a wooden bell tower six feet above the roof of the hut. An annual rent of £1 was paid by the Trust for the use of the Sub-Station. It was equipped with a hand cart and axes. Sisters Dilys and Gladys Laker were members of the voluntary fire service attached to Dormansland Sub-Station throughout the years of the war.

The Fire Brigade Committee wanted to retain the auxiliary status of the brigade but the RDC decided to keep control of the whole organisation making a charge against the rates. They planned to provide and equip three fire brigades for the district: Oxted, Godstone and Lingfield, and to take over the personnel of existing brigades if they were willing to accept service under the Council. To that end the chairman, engineer and deputy clerk of the Fire Brigade Committee met the Captain and members of the Lingfield Brigade on 10 January 1939. At that meeting it was decided that the Lingfield Station was 'barely large enough for the existing engine [a Stanley Morris engine] it being only 20 ft in length whereas the appliance which the Council were called upon to place at the station was 22ft 6ins'.

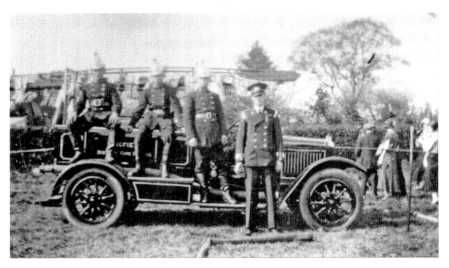

The Lingfield and District Fire Brigade, shortly before the war. Left to right:
Raymond Head, William (Bill) Coombes, Arthur Bulmer, George Martin (Chief
Officer). (*Bill Coombes*)

Godstone Rural District Council took over the Lingfield Fire Brigade on
29 January 1939 under the powers conferred on them by the Fire Brigade
Act of 1938.

The Lingfield team comprised George Martin (Chief Officer), William
Potter (2nd Off.), Engineers Edward Kenward and Hillier Wallis, and the
Firemen Leslie Boorer, Thomas Boorer, William Boorer, Arthur Bulmer,
William Coombes, Harry Giles, Alan Head, Raymond Head, George
Parry, Henry Reynolds, Harry Seal and Cliff Tanner, they all 'signified their
willingness to accept service under the Council'.

Emergency planning for war required every Fire Authority to form
an Auxiliary Fire Service (AFS) under the direction of the local chief fire
officer. The role of the AFS was to prepare for the eventuality of war and
for dealing with fires that would follow an air raid. On the outbreak of
war, Godstone RDC agreed to reduce the number of duty hours of all
regular Firemen to eight hours per day and arranged for volunteers of
the newly formed Auxiliary Fire Service, and ARP volunteers, to do out
of hours duty at the station. Units of trained volunteers were seen as a
vital addition to the force, often acting as emergency telephone operators.
Arthur Hayward was a volunteer night duty officer, sleeping in the near-
by undertakers' office until woken by an alarm call from the telephone
exchange.

Before the war, fire crews were alerted by a fire bell in a turret above the
fire station roof, but the bell remained silent throughout the war. Similarly,

church bells remained silent; they could only be rung to warn of imminent invasion, for example large numbers of paratroops dropping from the sky! The duty officer was responsible for operating the air-raid siren erected on a post at the corner of Church Road, adjacent to the butcher's shop. At 11.25 a.m. on the day war was declared Duty Officer, Fireman Bill Coombes received a call from Miss Lambert, Senior Telephonist at Lingfield Telephone Exchange informing him of 'Air Raid Warning Red' (top priority warning). The siren was heard in Lingfield, as in every other town and village throughout Britain but it was a false alarm.

Godstone Rural District Council offered to buy the Llewelyn Palmer Memorial Fire Station and all of the equipment, lock, stock and barrel for the sum of £550 but the offer was rejected; the trustees wanted £750 for the sale. The Council replied that they could provide a new station in Lingfield, complete with equipment and accommodation for one or more trailer pumps at a cost of approximately £300. They withdrew their offer to buy the existing station and instead erected a new, much larger, wooden building in Saxby Lane in 1940. Doug Ryall, an evacuee from Brockley, was billeted nearby at Saxby's Cottage. He noted the new fire station in his diary in June 1940, 'and air raid syren (sic) on a pole'. New fire-fighting equipment was provided by the Council and the Stanley Morris machine (in the photograph above) was sold to the smaller unit at Forest Row.

In 1940, several villagers were hoping that the British Legion would open a Soldier's Club in the redundant Llewelyn Palmer Memorial Fire Station. Instead the Home Guard took over the building later that year.

Major cities throughout Britain opened additional fire stations in large vacant buildings. Many school buildings, left empty after the children had been evacuated to the countryside, were requisitioned for use by the Auxiliary Fire Service. The London AFS also acquired redundant lorries, vans and taxis which were equipped with pumps and hoses. When the German Blitz on England began many Surrey and Kent Auxiliary Firemen were drafted to London to help fight the enormous fires, including Fireman Bill Coombes who was transferred to Kingston.

All the separate locally-controlled fire brigades were amalgamated in August 1941 to become part of the National Fire Service.

The Emergency Hospital Scheme

Preliminary planning for the requisition of suitable accommodation for the care and treatment of casualties of war began in 1938. The following year the Ministry of Health introduced the Emergency Hospital Scheme after consultation with local government authorities and hospital

representatives. Hospitals in cities and towns considered at greatest risk from enemy attack were classified as Casualty Hospitals. Every bed was primarily for the use of civilian, military or Local Defence Volunteer casualties. In the event of a full scale emergency routine operations and minor injuries were to be diverted elsewhere.

Specialist treatment centres were identified for the care of burned civilian casualties and airmen outside the areas of high population. Queen Victoria Cottage Hospital in East Grinstead was one such specialist treatment centre (Government Code no. 7224).

Mr Archibald McIndoe, a New Zealander, was one of four specialist surgeons who were assigned by the government to deal with military casualties. Mass civilian casualties of German bomber attacks were predicted in 1938. Four centres were set up: Basingstoke, St Albans, Roehampton and East Grinstead. Archibald McIndoe was assigned to the East Grinstead Cottage Hospital and the Royal Air Force. McIndoe arrived at the hospital in 1939 and very soon installed his own dedicated nursing and anaesthesia teams. A series of 'temporary' wooden buildings were erected adjacent to the community hospital to accommodate an additional eighty (facial) casualties, the team of medical staff and necessary support facilities. The hospital was thereby increased from a 42-bed cottage hospital to a 122-bed principal hospital unit, within a very short time. Two hutted wards, numbered III and IV, were sited at the centre of the new hutted complex of temporary buildings. The two wards were contiguous; rooms for the two Sisters and their nursing staff were all that separated the two long wards. The two wards were jointly known as 'Ward III' by staff and patients.

Maternity hospitals or maternity wards in general hospitals would not be expected to receive casualties while maternity work was being continued. But once an emergency had developed a hospital in the danger area would not feel able to admit new maternity cases other than those of a difficult labour. Under the Emergency Hospital Scheme expectant mothers living in Greater London, and within one month of confinement, could be taken out of London to a safe environment for the benefit of mother and baby. In 1940, Old Surrey Hall was requisitioned and became an Emergency Maternity Hospital, initially under the supervision of Matron, Miss E. Braine-Hartnell, SRN, SCM. The owner of Old Surrey Hall, Lt-Col. Ian Anderson and his family, moved out of the Hall and into the barn in the outer courtyard.

Parties of twenty to thirty expectant mothers from south London arrived at the house where they would remain until their confinement. They travelled with a midwife who was equipped to deal with any emergency on the journey. Mothers usually stayed at the Hall for about six weeks

before returning home, or transferring to a billet in the reception area with the new baby and any other children. The Emergency Maternity Hospital continued at Old Surrey Hall until the Doodle-bug threat to the south-east area in 1944. Expectant mothers from the London area were then taken in parties all the way to Wales for their confinement.

During the First World War, in 1917, a temporary home for thirty men suffering from the effects of neurasthenia (shellshock) had been erected at Lingfield Epileptic Colony; the project was initiated by the British Red Cross Society. The facilities included homes and workshops for the ex-servicemen. Although several of the First World War veterans in the Red Cross Unit had died before 1938, it was expected that similar military casualties would result from another war; the Unit was alerted to prepare for further admissions. In addition, government and local medical authorities decreed that in the event of war the Colony's Griffith Home and the Main Hall should be converted into an Emergency Hospital (Government Code 9714). One hundred and sixty-five beds, bedding and cases of drugs were supplied. But, despite all the preparations, the Emergency Hospital provision at the Colony was never used. The Colony had its own ARP organisation throughout the war.

Voluntary Aid Detachments

In 1914, The British Red Cross Society and The Ambulance Brigade of the Order of St John had joined forces to provide emergency help; the Voluntary Aid Detachment was formed and continued to serve the country throughout the First World War. The organisations reverted to their separate status in 1919.

In 1939, the two organisations once more came together while preserving their individual identities. The urgent need for first aid personnel prompted a Government ARP Circular which recognised the standard certificates of the St John Ambulance Association, the British Red Cross Society and the St Andrew's Ambulance Association. The Voluntary Aid Detachments supplemented existing agencies, aiding the sick and wounded of the three services at home and overseas, prisoners of war in enemy hands, and civilians injured by enemy action at home.

Many of the volunteers were trained nurses or nursing auxiliaries who had left full time employment to look after their families but offered their services to the VAD Auxiliary Reserve after war broke out. VAD nurses worked in hospitals and convalescent homes, nurseries, ambulance units, first aid posts and rest stations as part of the Civil Nursing Reserve. On the battlefields, VAD personnel were employed as stretcher bearers, ambulance

drivers, cooks, clerical assistants, dental assistants, pharmacists, dispensers, laboratory assistants, masseuses and radiographers. Wherever there was a need, there was a representative of VAD.

Auxiliary hospitals and homes for wounded servicemen were set up in buildings ranging from town halls and vacant schools (after the evacuation of the children) to large private houses. Over 3,000 auxiliary hospitals were set up during the war, staffed by a Commandant in charge of the hospital, and a Matron who directed the work of the local VAD staff. Medical assistance was provided by local doctors. The patients were usually the less seriously wounded casualties and convalescents. The Red Cross also ran an Emergency Aid Scheme for disabled servicemen and their dependants.

One Red Cross department dealt with wounded and missing people, tracing relatives and informing the next of kin of the whereabouts of a loved one. Volunteers with appropriate expertise gave help or advice on marital and financial problems, liaising with the POW Department of the War Office. Their services extended to the dead. By arrangement with the Luftwaffe an exchange of photographs of graves was maintained. Pictures of those of German airmen buried in cemeteries in Britain were dispatched to Germany in exchange for similar pictures of graves of British pilots in Germany. The German Army and Navy did not cooperate in the scheme but the Wounded and Missing Department of the International Red Cross

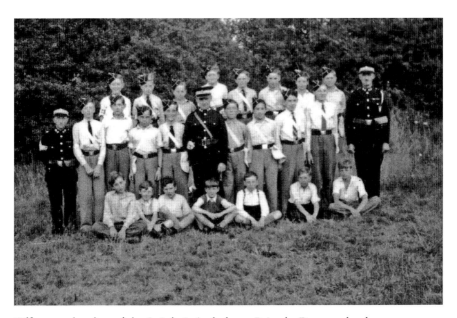

Officers and cadets of the St John's Ambulance Brigade, Dormansland *c*. 1942. Officers left to right: Mr Huggett, Mr Grainger, Mr Tom Walls.

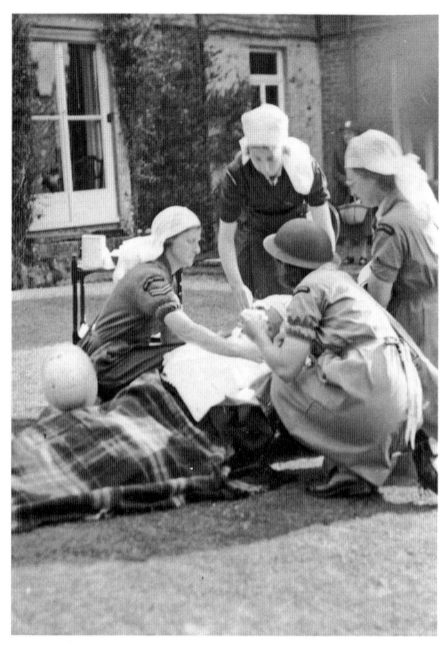

The Civil Nursing Reserve (a voluntary organisation of trained nurses, assistants and auxiliaries) give a demonstration of First Aid in the garden of Beacon Cottage. Left to right: Miss Jean Hadden, Vera Walls, (another) Miss Hadden, Mrs Charlton. The CNR supplemented hospital nursing staff, manned First Aid Posts and aided District Nurses. Most nurses were members of the Red Cross or St John's Ambulance Brigade.

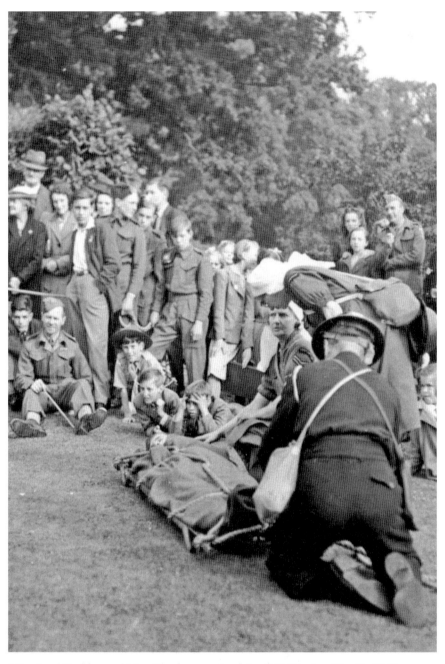

Miss Jean Hadden and Mrs Charlton, assisted by ARP Warden, Neville Wallis.
Members of the Home Guard are among the spectators, including Mr Vine,
Headmaster of Dormansland School.

sent a large number of photographs of German soldiers and sailors to Germany.

Many VAD personnel were engaged in packing and despatching food parcels, medical supplies, educational books and recreational materials to prisoners of war worldwide.

All this work was funded by the Duke of Gloucester's Red Cross and St John Appeal which successfully raised over £54 million before 1946. A lot of that money was raised through the penny-a-week Fund. Various town and village organisations collected their own penny-a-week fund; workers agreed voluntary deduction at source from their wages and volunteers made house to house collections.

First Aid demonstrations were given by local officers of The British Red Cross Society, under Commandant Mrs Watt, and The Ambulance Brigade of the Order of St John under Superintendant Allday.

Identity Cards and Rationing

On National Registration Day, 29 September 1939, every householder had to fill in a form giving details of everyone in their house. The government issued an identity card and ration book to every citizen. The ration book contained coupons that had to be cut out, cancelled by pen, or signed by the shopkeeper, every time rationed goods were bought. Rich or poor everyone had the same entitlement. No rationed goods could be bought without surrendering coupons from the ration book.

Motor vehicle fuel (petrol) was the first item to be rationed starting in late 1939. Private cars that were not used for essential services were locked in the garage for the duration of the war. Business at Drew's Garage in Lingfield High Street suffered as petrol was only sold from a central depot elsewhere and was for essential purposes. Vehicle parts for repairs were also in short supply. Bob Drew remembers that the family business struggled to survive but was supported by local farmers and trades people who required general repairs to equipment. Bob left school in 1940 at the age of fourteen and joined his father's business. One of his tasks was to recharge wireless accumulator batteries. There were usually about fifty batteries on charge at any one time, twenty-four hours a day. The garage price to recharge a battery was 4*d*.

Some old cars were abandoned at 'Brook's Dump', Lingfield. Bob Blackford remembers playing in Brook's Dump, on the corner of Bakers Lane and Station Road.

> We used to sit in the cars and think we were going somewhere. Where we lived, at Railway Cottage, we had a nice large garden and several sheds,

so my father let me have the first shed and we used to go over to the
dump ... to take the seats out of the back of the cars over there. We used
to take two or three and put them in the shed and they'd make nice seats.
One of the pubs at Dormansland, the Old House at Home, nearly all the
seats in their pub were car seats from Brook's Dump.

Britain introduced rationing of butter, sugar, bacon and ham on 8 January
1940. By the middle of 1940, all meat as well as eggs, cheese, jam, tea,
margarine and milk were rationed. Clothing was rationed from June 1941,
due to the shortage of raw materials. Clothing factories and workers were
diverted to producing weapons, ammunition and aircraft for the war.

One person's Weekly Food Allowance:
Lard or butter 4 oz (113 g)
Sugar 12 oz (340 g)
Bacon 4 oz (113 g)
Eggs 2
Meat 6 oz (170 g)
Tea 2 oz (57 g)

Un-rationed foods and home grown fruit and vegetables were used to
eke out the rations. The onset of winter brought food shortages and high
prices, a long queue meant a new delivery of some precious commodity.
Enterprising housewives spent hours of their time bottling fruit in season
and making jams and pickles to store for the winter months. Enterprising
husbands supplemented family rations with the occasional wild rabbit,
pheasant or pigeon. Bananas, oranges, peaches and other imported fruit
and vegetables disappeared from the shops for the period of the war.
Flower gardens were turned over to vegetable plots, lawns were dug up
to plant potatoes and onions, and odd little corners were converted to
chicken runs to provide fresh eggs. Parklands were turned into allotments
and everyone was encouraged to 'Dig for Victory'.

The Ministry of Food produced an endless stream of leaflets and
advertisements in the newspapers on the many ways to use powdered eggs
and tasty ways to cook un-tasty foods, spam was particularly versatile.

The introduction of clothes rationing in June 1941 also saw the
introduction of 'make do and mend'. As cloth was in short supply,
trousers were made without turn-ups, skirts without pleats, tops without
embroidery, and pockets and buttons were kept to a minimum. The
Kite mark was the sign of Utility fashion. Old clothes were recycled as
something new, old jumpers were unravelled and the wool reused to make
socks, gloves, or scarves. Silk stockings disappeared as silk was diverted to

the production of parachutes, the ever resourceful women dyed their legs and drew a fake line down the back with eyebrow pencil to resemble the seam of a stocking.

Women's Land Army (WLA) and the Surrey War Agricultural Committee

The first Women's Land Army had been formed in the First World War but was disbanded in 1919. With the threat of war looming the second Women's Land Army was formed on 1 June 1939 to remedy the national shortfall of around 50,000 agricultural workers. Between the wars, Britain had become increasingly reliant on imported food as agricultural workers moved to higher paid industrial labour in the cities. In an effort to keep the labour on the land, Godstone RDC reserved part of their housing stock for agricultural workers. The scheme was administered by an Agricultural Workers Sub-Committee of the RDC.

County War Agricultural Committees were formed on 3 September 1939. Committee members were unpaid landowners, farmers and nurserymen; district sub-committees included representatives of the farm workers and one woman representing the WLA. Farmers could get free expert advice from the County War Agricultural Committee or County 'War Ag' as they became known. Various grants and subsidy schemes were made available to farmers for the purchase of farm machinery and an incentive payment of £3 per acre was given to convert meadow land for growing essential crops. Fertilisers and animal feed were available on credit, although rationed. The county committee had the power to direct what was grown, to take possession of land and terminate tenancies if necessary to control food production. They regularly inspected farm properties and organised mobile groups of farm workers to assist or take over inefficient farms.

The Defence of the Realm Act enabled local authorities to commandeer unoccupied land for wartime allotments. A great ploughing-up campaign led to the take over of building sites, public parks and recreation grounds by the County 'War Ag'.

The first two groups of the WLA were trained before war broke out in September 1939, but recruitment had slowed down by August 1940 when only 7,000 women had joined. Food shortages caused by the success of Hitler's U-boats prompted a huge drive to recruit more women to work on the land. Government adverts showed glamorous images of smiling young women in sunlit fields but failed to attract sufficient recruits. In fact, the work was physically hard and the young women often worked in isolated communities. They looked after animals, ploughed fields, dug up potatoes,

harvested crops, killed rats and dug and hoed for 48 hours a week in the winter and 50 hours a week in the summer. Cows had to be milked twice a day, every day, and pigs had to be fed and cleaned out all through the year in all weathers. For city girls it was a complete change to their life, many were sent to live in run down cottages without running water, electricity or gas. They were paid £1 8s 6d (£1.42 ½ p) per week.

Several former WLA girls have said that the hardest thing they had to deal with was antagonism from the men who remained on the farms and who objected to the intrusion of the women. Agricultural work was a reserved occupation according to government legislation and thereby exempt from conscription. The remaining men on the farms were experienced hands who scorned the inexperienced women in uniform dress.

In general, men were opposed to women's working clothes. Uniform breeches and trousers were issued to women working in factories and on the land. A style of dress born out of practical necessity for war work was seen by men as vulgar and more importantly a threat to their own masculinity. Only movie stars such as Marlene Dietrich and Katherine Hepburn wore trousers, their own wives, daughters and girl friends did not wear trousers!

The WLA uniform was a green jumper over a long or short sleeved white 'Aertex' shirt, brown corduroy jodhpur-style breeches or brown dungarees, brown felt brimmed hat, brown shoes with steel tips, wellington boots and a khaki great coat. Aertex fabric was developed in the late nineteenth century, made of loose weave cotton; it had insulating qualities and was used for uniform issue to the British troops in the Second World War.

A continuing shortage of recruits led to the government directive to conscript women to work on the land, rather than join the Women's Army, Navy or Air Force. Young male conscripts were also sent to work on farms rather than take their first choice of military service. In some cases they too were subjected to scorn and humiliation from experienced farm hands.

Many people referred to the WLA as 'Land Girls' but officially 'Land Girls' were directly employed by farmers and not conscripted into the Women's Land Army. Thousands of men and women volunteered to do paid work on farms during their summer holidays to help bring in the harvest. The official minimum age of WLA recruits was seventeen years, volunteers of sixteen years or younger often became 'Land Girls'.

Training courses were held in agricultural colleges throughout the country. Limpsfield Lodge at the entrance to Titsey Place was a training centre for south-east Surrey WLA. Practical skills were learned on the surrounding farmland of Pitch-font Farm under the watchful eye of Miss Dann and her assistant Dolly. Miss Dann lived in a caravan on the farm site, within call but out of sight of the girls thereby keeping her privacy!

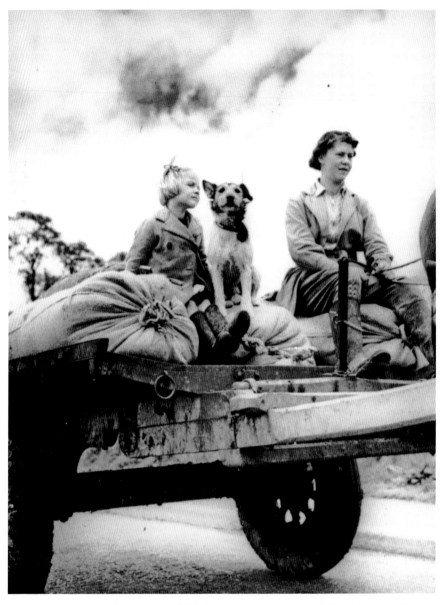

'Carrying grain on a farm in Lingfield, Surrey 1941.' (*Imperial War Museum, Image Ref. D 4741, Wartime Kitchen and Garden album*)

Josephine (Jo) Steel qualified as a WLA Dairy Girl at Limpsfield Lodge in 1945. It was there that Jo met Dick Osborne who made regular visits to Limpsfield Lodge during the course of his work.

As a young fifteen-year-old boy Dick Osborne left school in Coulsdon to work on a local farm in 1939. He had joined the Air Training Corps and had hoped that eventually he would join the Royal Air Force. When he became eligible for conscription in 1942 he became indefinitely exempt from military service and was drafted to work at Crossways Farm at Gatton, a seven mile bicycle ride from his home in Coulsdon. There he learned to drive a large American built earth-moving machine, powered by diesel fuel. Eventually Dick and the machine worked all over east Surrey to the Kent border. Over time the diesel fuel caused a contact dermatitis which brought an end to Dick's driving work. He moved to Tanhouse Farm, Four Elms, near Edenbridge in 1945 where he continued to work until he and Jo were married in June 1948.

In December 1941, the government passed the National Service Act, all single women between 20 and 30 years of age were called up for war work in one of the armed forces, or for work in a factory or on the land. The age range was later broadened to 19-43 years and included married women but not pregnant mothers or mothers with young children. Sixteen-year-old Mary Curd helped as a volunteer at her local Toc H canteen in Reading in 1939. Mary had wanted to join the Royal Air Force on conscription but was drafted to the WLA in April 1942 at the age of nineteen. By 1942, there was an acute shortage of labour in the factories and on the land.

Mary with fifty-one other girls worked on a large allotment managed by Suttons Seeds of Reading, growing vegetables and tomatoes. The girls continued working while bombs were dropping and air fights continued in the sky above. They spent all day every day bent over the fields planting potatoes and other crops. During wet weather they worked inside the greenhouses, tying up tomatoes. In spring, the field had to be ploughed and planted, in the summer the plants were hoed and weeded, in autumn the crops were harvested and the potatoes bagged up, and in winter they spent their time packaging seeds for sale. The girls had to heave large sacks of potatoes. The remaining men on the staff were expected to teach the girls to lift the sacks without causing damage to their spines but as most were antagonistic to the WLA girls few girls were taught the technique of lifting sacks of potatoes.

The girls formed firm and lasting friendships. Mary was one of a 'gang of six' whose friendship has continued for more than sixty years. As her mother was incapacitated she was allowed to live at home. She had to cycle over four miles to and from her home each day, in her own words she 'was

fortunate as she could still look after her sick mother'. Most girls lived in hostels or on farms or and were bussed in each day by the War Ag.

Mary spent her leisure hours knitting clothing items for the RAF Comforts Committee. Her brother was serving in the RAF at the time. Mary like many other knitters took her knitting to the cinema. Men and women knitted socks, gloves, mittens, scarves, pullovers and balaclava helmets for servicemen and servicewomen in each of the forces. Special forms were printed in knitting pattern books to obtain free knitting coupons. The *Illustrated London News* published a photograph of Princess Elizabeth knitting garments for the Royal Navy.

The Toc H Movement took its name from Talbot House in Poperinge, a large house once owned by a wealthy brewer which was damaged by German shelling early in the First World War. The owner offered the empty house for rent to the British Army for 150 Francs a month on condition the house was to be made weatherproof. The large house was named Talbot House in memory of Lieutenant Gilbert W. L. Talbot, aged 23, who was killed at Hooge in the Ypres Salient on 30 July 1915. That year the house opened its doors to welcome British soldiers to a new club. It became a rare place where soldiers could meet and relax regardless of rank. A notice was hung by the front door bearing the message: 'Abandon rank, all ye

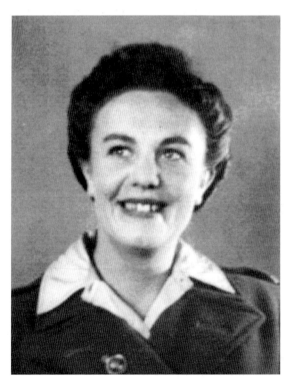

Miss E. Mary Curd, Women's Land Army 1942-46 (now Mrs Mary Chauncy of East Grinstead).

who enter here'. The men were encouraged to mingle and make friends, ignoring the normal rules of rank or status. The name Talbot House soon became known to the soldiers of the Ypres Salient in a shortened form of 'TOC H'. TOC was the British Army signaller's code for 'T'. In 1929, Lord Wakefield of Hythe bought the house for £9,200 and donated it to the Talbot House Association.

Women's Voluntary Service (WVS)

The Women's Voluntary Service was formed in 1938 by Stella Isaacs, the Dowager Lady Reading, at the Home Secretary's request. Originally called Women's Voluntary Service for Air Raid Precautions, it became in 1939 the Women's Voluntary Service for Civil Defence. A national appeal for members in 1939 received a popular and immediate response.

A Lingfield based organisation was mooted in April 1939, and was recruited largely from members of the various local Women's Institutes. On 3 May 1939, Miss Hilda Dunstan informed Lingfield WI members that 238 offers of voluntary service had been received from the surrounding villages. The president of Lingfield WI, Mrs Yvonne de Clermont of St Piers Cottage, became the chairman of the newly formed Lingfield WVS. Rural District Councillors Mrs M. Eden and Miss Edith Nelson, who were also members of the Lingfield WI, agreed to serve on the committee. The Dormansland WI mandated five of their members to the newly formed committee of the WVS.

The Garden Room (now Barn Cottage) became WVS Headquarters in Lingfield. The building was owned by Arthur Hayward who lived in the old Guest House and offered the use of the building for the duration of the war. The Garden Room became known as the 'Ventilation Room' where householders and evacuees (or more likely their parents) could air their grievances. Miss Dunstan and Miss Nelson took overall responsibility for the welfare of the evacuees.

The primary task of the WVS was the running of the Evacuation Scheme and before the arrival of the evacuees from London in September 1939 they had set up a card index file of all vacant accommodation in the villages surrounding Lingfield. The task required great tact, commitment and a vast investment of time from members. Mrs Block, who lived in the medieval house of Old Felcourt, was physically attractive and had a particularly persuasive manner. She encouraged the owners of several large houses in the area to open their houses to evacuees. Her arguments were difficult to resist! Every spare room in every house in Lingfield, Blindley Heath, Felcourt, Dormansland and Dormans Park was potentially a billet

The Garden Room *c.* 1900 (the garden under construction). The newly restored Guest House in the background is now the home of Lingfield Library. (*Hayward Collections*)

for a teacher, a pupil, or a parent of an evacuee from south London, three large houses accommodated whole schools.

The magazine *Illustrated* published an article of 'Lingfield at War' in November 1940. The article paints a rosy picture of an ideal reception area, where all grievances were easily aired and inappropriate billets quickly changed. Former evacuees remember a different scene, where grievances were more often kept quiet. For every one zealous parent successfully negotiating billet changes there were three or four absent parents unaware that their children were unhappy living with their new foster parents.

The Women's Institute (WI)

The Women's Institute movement began at Stoney Creek in Canada in 1897. The first British WI meeting took place on 16 September 1915 at Llanfairpwll, North Wales. The organisation was set up to revitalise rural communities and to encourage women to become more involved in producing food during the Great War. Branches in south-east Surrey were set up in the years following the First World War; a Dormansland

branch was founded in 1919 and Lingfield and Blindley Heath branches in 1921.

Miss Rowe came to speak to the Dormansland WI in October 1939 on the 'Central Hospital Supply Services for the Working Classes'. A sub-committee decided to hold a work day each Thursday in the Parish Room from 11 a.m. to 4 p.m., to make garments for the service. This was in addition to their sewing and knitting parties who had completed 400 garments in one year for the Personal Service League. The League, patronised by HM Queen Mary, was founded in 1934 to mobilise supplies of clothing to the unemployed in distressed areas. When the wartime Blitz began the Headquarters in Lowndes Square, London, was inundated with requests from the heavily bombed areas for clothing and blankets. A Knitting Club was started in April 1938, at Burstow Hall to which members of all local WI branches were invited.

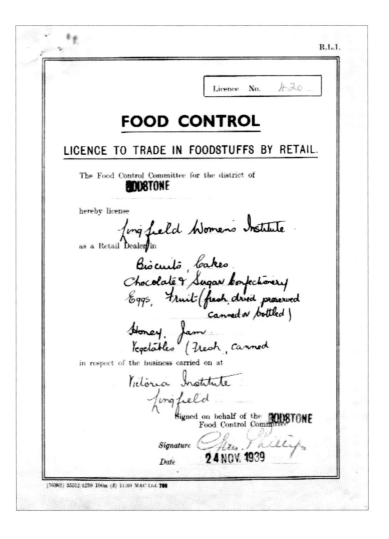

Licence to sell foodstuffs.

Members were encouraged 'to cultivate their gardens to the utmost'. A Collection of Seeds was started in support of the 'Dig for Victory' scheme, packets of tomato seeds were sold for *6d* each. The WVS and WI ran the Lingfield Central School Canteen. The Headmaster, Cecil Paine, allowed members full use of the school kitchen where they made 1,887 pounds of jam and bottled 200 pounds of fruit in the first year of the war.

Lingfield WI had held weekly markets selling food and homemade goods for several years before the outbreak of war, but local authority controls on the sales of food were introduced in 1939. The WI successfully applied to Godstone Food Control Committee for license to trade. The licence gave authority to trade from the Victoria Institute as a retail dealer in biscuits, cakes, chocolate, sugar confectionery, eggs, fruit (fresh, dried, canned or bottled), honey, jam and fresh or canned vegetables. They also erected a weekly stall outside the Cage Cafe during weeks when members had a surplus of perishable fruits and vegetables.

In October 1939, Lingfield members organised a welcome reception at the Cage Cafe for teachers and parents of evacuees, and on Friday 20 December a Christmas Social was held from 6 p.m. to 11 p.m. in the Victoria Institute. The programme included games and riddles, community songs and carols. Tea was at 8 p.m., followed by Christmas tree distribution of presents with gifts for each soldier present. From 9-11 p.m. there was dancing, every WI member was encouraged to bring a soldier as a guest, but soldiers could bring their own partner.

Members set up a Sewing Party and a Knitting Party to make garments for evacuees and service personnel; the knitting party made socks, scarves, helmets and pullovers. Knitted squares were also made into blankets and sent to The Personal Service League.

A Soldier's Club for the many Canadian and Irish soldiers was more difficult to arrange, members spent almost a year searching for suitable accommodation. The first plan was to use the redundant Llewelyn Palmer Fire Station but the premises were taken over by the newly formed Home Guard in 1940. Mr Green, the Brockley School headmaster was very willing to allow the use of the Old Star building, out of school hours, but after close inspection the WI Secretary considered the accommodation was quite unsuitable for the purpose. The next plan was to use the large wooden hut in the orchard at the end of Camden Road. Finally in January 1941, Jupps Hall, a building at the rear of Jupp's drug store in Plaistow Street, was secured by the WI as a recreation club and canteen for members of HM Forces. 'The number of men who have used the club [in the first year] has been ample proof of how badly it was needed. The gratitude shown by them at all times has been quite out of proportion to the very little we have been able to do for them.' Jupp's Hall was also used by ARP

Wardens for rest between night patrols, and was a popular venue for other village groups.

As the war continued, the various WI branches responded to each new request for help. Toys were made for children in the London air-raid shelters. Toys were also sent to a children's home at Caterham and to a local wartime nursery which was set up in the summer of 1941 at the home of Sir Benjamin Drage at Weir Courtney. Members also made handkerchiefs from old sheets for the local hospitals and the nursery at Weir Courtney. Several members of Dormansland WI were recruited as volunteer helpers at the Weir Courtney Nursery, which was part of a scheme organised by Anna Freud to help all children who suffered as the result of war conditions, irrespective of nationality, race or religion. Most were orphans, some were from the blitzed area of the East End of London.

A book collection service was started for local hospitals and for the Soldiers Club. Lingfield WI recruited volunteers for a Bicycle Messenger Service to be on standby if needed in a national emergency. Whist Drives were held to raise money for Warship Week and for the local Spitfire Fund; members saved their 'ship' half-pennies for the Merchant Navy, and contributed pennies to the Red Cross 'Penny-a-Week Fund'.

The Drill Hall

In September 1939, the Drill Hall in Racecourse Road, Dormansland, became an anti-aircraft post manned by the 27th Anti-Aircraft Brigade, Lingfield, and part of 6th Anti-Aircraft Division, Home Counties Area, Eastern Command. The 27th A-A Brigade had been raised at Kenley on 15 December 1935. In 1939, the Drill Hall was also the local headquarters of 4th Battalion (C Company) Territorial Army (Queen's Royal Regt). The former owner of the site, which included the nearby Lingfield and Dormansland Miniature Rifle Club, was Mr Philip de Clermont. He was president of the Rifle Club and thirty-five local gentry were vice-presidents, most were retired military officers. Many young village boys were members of the club and had become proficient riflemen before enlisting, or were conscripted to military service.

CHAPTER 2

Refugees and Evacuees

Refugee Children

After the German Nazi party's rise to power in 1933, many German-Jewish families made plans to flee the country. The majority of the German people had elected Chancellor Hitler and thereby opened the door to his policies of racial purity. The Nazi regime introduced strict controls over emigration, limiting the number and type of possessions and restricting amounts of money that could be taken out of the country. As the restrictions were tightened in the mid 1930s, so the fleeing Jews restricted their luggage to a minimum. They arrived at their destination with few items other than a change of clothes and sufficient funds for the journey.

After the Kristallnacht Pogrom of November 1938, when thousands of synagogues, Jewish businesses, schools and homes were damaged or destroyed, conditions deteriorated dramatically for Jewish families. Many made the hard decision to send their children away to safety. The 'Kindertransport' or Refugee Children Movement began evacuating children from Germany, Austria, Poland and Czechoslovakia. The first Kindertransport arrived at Harwich on 2 December 1938. British Jews contributed funds to support those that fled to Britain.

The Kindertransport movement was responsible for bringing a total of 9,354 children to Britain between 1 December 1938 and 30 August 1939. Their ages ranged from two months to sixteen years, not all were of the Jewish faith; 7,482 were Jews, 1,123 were Christian and 749 were described as Un-denominational. The refugee children were eventually placed in British foster homes, hostels, and farms, dispersed throughout England, Wales, Scotland and Northern Ireland.

In December 1938, an urgent plea was received at the headquarters of the Children's Movement of the Central Council for Jewish Refugees in Russell Square (CMCCJR):

> There are 600 children in Prague and elsewhere in Czechoslovakia who urgently require emigration to England; 300 were originally from Germany and Austria, and 300 Sudetans and 'No Man's Land'. Please stress seriousness of position to Council for German Jewry.
>
> Signed: Mrs Schmolka, Mrs Steiner and Martin Blake.

The organising genius of the 'Kindertransport' in Czechoslovakia was Nicholas Winton, a London stockbroker. Winton was a friend of Martin Blake, one of the authors of the urgent plea for help. Blake was a British Embassy official, based in Prague, and already involved in helping people in the refugee camps in Czechoslovakia. Nicholas Winton went to Prague in December 1938, and immediately became involved with the project to rescue as many children as possible from the camps and send them to England.

He made a scrapbook of his work entitled 'Saving the Children', a copy is held by the Wiener Library in London. Winton noted his frustration with the various authorities and the urgent need to cut through bureaucratic red tape. 'There were endless questions about how to get to England, as though it only needed a magic carpet ... if anything should blow up, God help the Refugees.'

The Barbican Mission to the Jews in London organised the first party of children to leave Prague on 12 January 1939, Winton and Blake having organised the transport. Winton described the scene to his mother:

> The entire company was taken out in several buses to the airport ... After much trouble posing as a journalist, I was actually able to accompany the children onto the field and into the plane. This of course the parents were not allowed to do, but the final adieus, being made at a distance of some 50 yards, were all the more pathetic. I did not see one of the children crying, they were far too excited.

The children flew from Prague to Croydon Airport.

By March 1939, Winton had established his own organization, 'The British Committee for Refugees from Czechoslovakia, Children's Section.' The committee consisted of himself, his mother, who lived in Hindhead, Surrey, his secretary and a few volunteers. British friends wrote to Nicholas Winton's employers pleading that Mr Winton be allowed to remain in Czechoslovakia as 'he has drawn all the different organisations together in a most amazing way and brought order into the chaos'.

Winton's first hurdle was arranging permits for the children through the Home Office. The Home Office required guarantors for maintenance, education and training until the age of eighteen. Appeals were published in the British newspapers for potential sponsors for the scheme and foster families to take the children. Any who were unable to undertake that liability were encouraged to send donations so that a fund could be raised sufficient to bring over batches of children.

None of the children had passports. In view of the urgency, the British Home Office finally approved a substitute card showing a photograph and brief particulars of name, age, parents and place of origin. The Children's Movement guaranteed that the children should not become a public charge and that they should be re-emigrated before they reached the age of eighteen, or when their training in this country was complete. Winton prepared case sheets of about 5,000 children, each with a photograph and complete data. His office in Prague selected from those 5,000 a list of 250 desperately urgent cases. In all, some 796 children were rescued; they travelled by train from Prague, crossed into the Netherlands and Belgium, and then continued their journey to Britain by ship where they boarded another train for London. The first train left Prague on 14 March 1939 carrying just 20 children. The train transports were particularly busy in July. A total of five trains carried 646 children to safety during July 1939. The last contingent of 130 children left Prague Station on 1 September 1939; they arrived five days later at Liverpool Street Station to a reception of press photographers and journalists.

All emigration from Europe stopped at the outbreak of war. Several transports of children were unable to leave for England, notably a large transport of 180 children from Prague. The fate of those children is unknown.

Erica and Horst Tichauer, fourteen and eleven years old respectively, were rescued from Czechoslovakia by the Kindertransport organisation in May 1939. They eventually arrived in Lingfield and attended the Central School. A photograph of Horst was included in an article published by *Illustrated*, 30 November 1940. According to the reporter, Horst Tichauer found a happy refuge in Lingfield, free from persecution and his burnt-out home in Czechoslovakia. Horst believed that his father was being held as a prisoner in a large concentration camp. The children eventually settled in the U.S.A. They learned later that both parents were transported to Auschwitz where they were killed in the gas chambers.

The *East Grinstead Observer* and *East Sussex Courier* published two significant reports on 3 February 1939. The first report concerned a meeting of the East Grinstead branch of the International Friendship League, at the Parish Hall. The I.F.L. was founded by Noel Ede at Peacehaven, Sussex,

in 1931. Their aim was to provide friendship, understanding and service for all nationalities following the conflict in the First World War. The East Grinstead branch meeting was addressed by Doctor Otto Wagner who emphasised at the outset that he would not be able to deal with the Jewish question.

Dr Wagner gave a brief history of Germany and said that after the Great War, Germany was denied the right to live as a great nation; Herr Hitler had given her new hope. The German population numbered about seventy-nine million and was too big for the German territory, unemployment had reached seven million. Germany wanted a fair share of world resources and the return of her colonies. Herr Hitler had made proposals and suggestions for drastic disarmament, but they were rejected by the governments of France and Britain, forcing Germany to re-arm. Dr Wagner said that his country wanted nothing more than peace and that adjustment can be achieved by negotiation and peaceful means. Herr Hitler and Mr Churchill had recently signed a declaration to that effect.

The second significant report in the local newspaper concerned the arrival, at Old Surrey Hall, of twelve Jewish refugee boys, some recently released from Nazi concentration camps. East Grinstead Council had 'decided that even if we do go to war with Germany, we will do our best to help those affected by Hitler's harsh new laws, especially the Jewish'. The Council planned to take 150 young Jewish men to be trained in agriculture.

Mr Ian Anderson pledged his support for the scheme and had offered his large estate on the boundary of East Grinstead and Dormansland (Old Surrey Hall) to the Council for German Jewry. All the young men were expected to arrive by May 1939. They were to be housed on the estate and learn about agriculture and how to look after farmlands and animals. Later, if it was still difficult for them to live in their own country, arrangements would be made for them to take up a living in Palestine or Australia.

The Council for German Jewry was a British Jewish organization established in 1936 to help German Jews leave Germany. The organisation was able to help almost 100,000 Jews leave Germany by the time the Second World War broke out, and financed several work-training programmes in Germany and other countries.

A Copthorne resident sheltered several Jewish refugee children, most were from Hampstead, London. The children, all boys, attended Primary School in Lingfield.

Without witness reports local reactions to the refugees must be speculative. Letters from a German Jewish schoolboy to his parents, sent from his new home in Horsham, have been published by Horsham

Museum. The letters testify to the attitudes of Horsham people towards
any German speaking children:

> ... the atmosphere against the Germans is very strong and it is best not to
> say a word of German on the street because the reactions are unpleasant,
> even when you are refugees ... In playtime some of the German and
> Austrian boys had to fight some of the English boys who called them
> blooming Nazis and swore at us. Though they called us Nazis it was not
> a bit of anti-Semitism in it.
> (Letters from a War Child: Ernest Dieter Ball's correspondence, 1939-41.
> Publication by Horsham Museum, 1999)

Several wealthy British parents chose to send or take their children to the
safety of the United States of America or Canada before the outbreak of
war. In early 1939, Southern Rhodesia and Canada offered to take under
sixteens and over sixties. Australia offered to take orphans.

By July 1939 a steady trickle of people had started to leave London and
other major cities voluntarily to find billets of their own, or to stay with
relatives in so called non-target areas. Some schools were already closed
and became registration centres for the official evacuation scheme.

In May 1940, the British Channel Islands were in immediate danger
from invasion by German forces. Machine-gun units had been garrisoned
on the islands nine months earlier but were withdrawn in June 1940 to
defend mainland Britain. The governor was withdrawn by the British
government on 21 June and the immediate evacuation of children and
their mothers began. About 20 per cent of the inhabitants of Jersey, 50 per
cent of those on Guernsey and almost all of the population of Alderney
were evacuated from the Islands to the British mainland ahead of the
German invasion. The Germans invaded the Channel Islands on 30 June
1940. One ten-year-old girl came with her mother to Lingfield ahead of the
German occupation of Jersey. Hilda and her daughter Joan came to live
in Newchapel Road, Lingfield. Joan was registered at Lingfield Primary
School on 1 July 1940. After one year at Lingfield School she had excelled
at her studies and was offered a special place at Oxted County School,
beginning the autumn term of 1941.

Operation Pied Piper

Operation Pied Piper was the government's code name for the mass
evacuation of children from cities to areas which they considered safe
from aerial attack, called Reception Areas (officially defined as 'Areas for

accommodating dispersed persons'). The mass evacuation of children and other vulnerable people ahead of an expected aerial bombardment also ensured that evacuees would not be caught up in a perceived collective panic to get away from major cities. A panic situation was regarded by government as inevitable, based on data gathered from the London dockyards in the First World War and the evidence of refugee movements in Europe ahead of Nazi occupation. The mass movement of refugees and their belongings after the declaration of war would clog the roads and hinder the movement of essential vehicles. Much of the public transport system in London was reserved for the evacuation process which was expected to take up to four days. Many banks and offices in London closed for the short period to keep the roads free for the evacuation.

The evacuation of vulnerable people was planned by the Anderson Committee and implemented by the Ministry of Health. Vulnerable people in the community were identified as schoolchildren and their teachers, younger children with mothers and guardians, and pregnant women nearing the time of their confinement. Evacuation was considered advisable but registration for the scheme was entirely voluntary. One month before war broke out less than 70 per cent of London schoolchildren had been registered for evacuation. Evacuation was not made compulsory and many parents chose not to send their children away, but to keep the family together whatever Herr Hitler might decide to send over. Billeting though was compulsory; anyone living in a Reception Area with suitable accommodation could be prosecuted and fined if they refused to take an evacuee into their home. In May 1938, the London County Council approved the principle of evacuating all L.C.C. Schools. Schoolchildren were evacuated in school parties under the care of teachers, the initial costs were paid by central government.

Parents who chose to keep their children at home were told they must not send them to school until further notice. Their children enjoyed the enforced holiday of several weeks. In some areas parents made their own arrangements for teaching their children at home until local authorities made alternative arrangements.

Lingfield was within a designated Reception Area. The WVS made all the billeting arrangements working from their headquarters in the Garden Room (later Barn Cottage) on the north side of Lingfield Church. The Garden Room was owned by Arthur Hayward who lived in the Old Guest House on the opposite side of the path. The Lingfield branch of the newly formed Women's Voluntary Service for Civil Defence had been accumulating data on the number of spare beds and spare rooms in every house in Lingfield, Dormansland and Blindley Heath. The completed survey was stored on a card index file and ready for use on 1 September 1939.

Germany invaded Poland on 1 September 1939. The same day a fleet of London buses brought children from two Nursery Schools in South London to two large houses, Ford Manor in Dormansland and The Grange in Felcourt. All the children were under five years old. In charge were the headteachers, other teaching staff and several voluntary helpers (mothers of some of the children). Mothers of children up to the age of five were allowed to accompany their children to the reception area. Several children came without their mothers.

Blackout restrictions enforced by local ARP Wardens also began on 1 September. As well as restrictions on lighted windows in houses, shops, factories and public buildings, the street lights were turned off and motor cars were not allowed to show headlamps. William Stanford an eighty-five-year old veteran of the Boer Wars was knocked down and killed in Newchapel Road, Lingfield. The driver of the vehicle, Gilbert Brooks a local motor engineer, said it was a foggy night and he had driven his car at just 10 mph with the offside wheels just over the white line. He had suddenly felt a bump and found Mr Stanford lying in the road.

Lingfield Parochial Church Council held a special meeting to revise the times of church services to conform to the new lighting restrictions. But it would be another year before blackout curtaining was obtained 'at wholesale price, thanks to Mrs Haworth' (Lingfield PCC Minutes, 1940). 'Mrs Haworth' was possibly Norah Haworth wife of Canon Harold Wilfred Haworth, Canon Emeritus of Chester Cathedral. Canon and Mrs Haworth moved to Cranford, Campden Road, Lingfield in 1939 when illness compelled the Canon to retire.

On Saturday 2 September, a fleet of Greenline buses arrived from Caterham with even more children from south London. The children of Brockley Central School had left London by train early that morning and travelled as far as Caterham, then transferred to the fleet of buses for the journey on to Lingfield. Younger children, from two Brockley Junior Schools arrived by bus the same day. The schools arrived with their teachers and several mother helpers. Every child had a bag of personal items, a regulation gas mask, and a label strung around their neck. The WVS were on hand to advise on billeting arrangements and the vicar, ARP Wardens and many other willing hands set about the tremendous task of ferrying all the evacuees to their new billets.

The Lingfield WI arranged a welcome tea for the parents and teachers a month after their arrival. The children were regarded with a certain amount of suspicion. Some local people were sure that the children would be dirty and infested with fleas, very few were. There were cases of children bed-wetting in the first few weeks which is not surprising; they were frightened, far from home and living with strangers, some of whom were unsympathetic

and some openly hostile to opening their homes to strangers. Happily there were good as well as bad experiences for the children and their mothers.

Five London schools from the Metropolitan Borough of Lewisham were evacuated to Lingfield, Dormansland and Blindley Heath by the London County Council in 1939:

1. Kintore Way Nursery School, Grange Road, S.E.1
2. Honor Oak Nursery School, Turnham Road, S.E.4
3. Turnham Road National School, London, W.4. Mixed Junior and Infant Departments
4. Mantle Road Junior School, Brockley S.E.4
5. The Boys of Brockley Central School (The girls of Brockley Central School and the Junior and Infant Departments went to Oxted and Limpsfield Chart respectively)

Every parent had been instructed by L.C.C. circular to pack essential clothing for the children:

BOYS	GIRLS
2 vests	2 vests
2 under pants	2 liberty bodices (if worn)
2 shirts	2 pairs of knickers
2 pyjamas or night shirts	2 nightdresses or pyjamas
2 pairs of socks	2 pairs of socks or stockings
1 pair of Wellingtons (if possible)	1 pair of Wellingtons (if possible)
1 warm coat and / or mackintosh (if not being worn)	1 warm coat and / or mackintosh
1 pair knickers or trousers	1 warm dress or tunic and jersey
1 pullover	1 cardigan
6 handkerchiefs	2 cotton frocks
1 toothbrush	6 handkerchiefs
1 face flannel	1 toothbrush
1 comb	1 face flannel
2 towels	1 comb
	2 towels

Gas mask
Identity Card
Ration book
Clothing and personal coupons

At the bottom of the list was added: 'You will wish to do everything possible to ensure that your child goes away with clean clothes, clean hair and a clean body.'

The Ministry of Health commissioned a Statistical Analysis of Conditions of School Children on arrival in Reception Areas, in September 1939. The results were the subject of central government debate. According to the table of results 1,546 children were evacuated from the London Borough of Lewisham, 4 per cent of those had head lice, 2 per cent had skin disease (impetigo) and 6 per cent were subject to bed-wetting. The averages across all South London Boroughs were 19 per cent with head lice, 5 per cent had skin disease and 13 per cent were bed-wetting.

Kintore Way Nursery School, Grange Road, London SE1

Head Teacher: Miss D. E. Day.

The newly built Kintore Way Nursery School in south-east London first opened to pupils on 1 March 1939. Parents complained on the first day that the sand pit could not be used because of the 'foul smell' caused by cats and dogs. Instructions were given to replace the sand and erect fencing around the sand pit; the sand pit was still out of bounds when war broke out.

On Friday 1 September 1939, sixty-five boys and girls aged between two to five, with staff and voluntary helpers (all mothers) gathered at the Nursery School. They had gathered at the school every other day that week as instructed, not knowing which day the evacuation would take place, if at all. Children, teachers and helpers all carried their gas masks and luggage and waited for the arrival of several double-decker buses to take them to an unknown destination. The buses arrived at 8.30 a.m. on the Friday morning and the excited children waved goodbye to emotional parents, friends and neighbours and set off on their journey to an unknown destination. In Croydon, they were held up for some time, some shoppers realising that the buses were filled with young evacuees brought sweets and other treats for the children.

The late Betty Snow was one of the mother helpers and recorded her memories of the journey from London to Dormansland:

> We eventually came to sheep and cows, the first time that some of the children had seen these animals. At last we came to that long drive which we discovered led to Ford Manor. Standing by the servants' entrance at the back of the house was Mr Nicholls, the butler; his silver hair shining in the sunlight for it was a beautiful day.

The children were looked after by the school staff while the rest of us set about putting up beds, sorting luggage, looking for our own quarters and finding our way around the house ...

Within a few days an outbreak of measles meant isolation for those infected so a separate building once used by menservants was prepared. Nurses and cots were provided by a local hospital and about 40 children spent their allotted time there.

A playground was provided on the golf course with old car tyres, sand pits and swings as well as the school's own equipment ...

Christmas came and went and some children were taken home since there had been no air raids ... later on the storm clouds gathered and we often watched battles going on in the sky. The servants' dining hall and the large dining hall were used as shelters when the sirens started, shutters had been made to cover the windows ...

The local people began to unbend a little when they realised we were not all crooks!

We learned that the Canadian Army were going to take over Ford Manor and we would have to move. We moved to our new quarters at Rede Hall, Burstow on 5 December 1940. [The day after an unexploded bomb had been removed from nearby Burstow churchyard.]

Honor Oak Nursery School, Turnham Road, London SE4

Head Teacher: Miss H. M. Edwards.

Honor Oak Nursery School was opened at Turnham Road, Brockley, on 13 February 1939. The school roll showed fifty-six children registered on the first day. After only three weeks 107 children were on the waiting list and two additional Nursery Assistants were engaged.

The School was evacuated to The Grange, Felcourt, Lingfield, on 1 September 1939. The Grange was then the home of William Guy Fossick. Ten months later the schoolchildren exchanged accommodation with Balham Nursery School who had been billeted at Birch Grove, Chelwood Gate, Horsted Keynes. Honor Oak Nursery School was in turn billeted with Mr M. Harold Macmillan, Conservative MP for Stockton-on-Tees, and Lady Dorothy Macmillan at Birch Grove in July 1940.

Balham Nursery School occupied The Grange for only a few months then returned to London. The Grange and estate was taken over by the War Office for British military occupation.

Turnham Road National School, W4

Head Teacher (Junior Mixed School): Mr L. R. Forward, 'The Little House', Lingfield.

Head Teacher (Infant School): Miss A. E. Shepherd, 'Tanglewood', Newchapel Road, Lingfield.

The schoolchildren had to share the premises of Lingfield Junior School with local children. When Lingfield School reopened for the new school term on 11 September 1939, the school worked in two shifts:

8.30 am to 12 noon for Lingfield Junior Mixed & Infants
12.20 pm to 4 pm Turnham Green Junior Mixed & Infants

Arrangements were quickly made to use the Mission Hall behind Lingfield Junior School to accommodate the Turnham Green children. The move to the Mission Hall allowed more teaching hours for both schools. Lingfield Junior School had also accepted nineteen other evacuees from vulnerable areas whose parents had made their own arrangements for their children.

Derick Johnson's memory:

I was seven at the outbreak of War. My home was at New Cross Gate where I lived with my mother, father and one brother who was six years older than me. I was at Monsoon Road Junior School near the Millwall football ground. It was obvious being close to the docks we were to be no. 1 danger area, so we were encouraged to evacuate. My brother was at Brockley Central School so I was transferred to Turnham Road Junior School, the Honor Oak Estate, which was to be evacuated to the same area as Brockley C.S.

I was put on a commandeered Green Line bus to go to Lingfield (although I didn't know that at the time). We had one stop to pick up our rations, i.e. a tin of Corned Beef, a bar of chocolate and a few other items which were to be handed over to our foster parents on arrival. I also had a gas mask in a case slung around my neck which none of us liked putting on because of the strong smell of rubber and the inevitable condensation.

The Vicar Mr Christofferson took my brother and me to Rostrevor, a house on Lingfield Common with a garden of four and a half acres. It was the home of Percy Napoleon Fielding and his wife Nettie; they ran a dry cleaning business from the premises. Percy had spent thirty five years as an engineer in the mines of Bengal and the inside of the house was very Indian in appearance. Summer and winter he would always have his siesta in the afternoons on the settee in the lounge with a mosquito net covering him from top to toe ... He seemed to visit the village once a week

dressed to kill and wielding a silver tipped cane. His object in visiting the village seemed to be to complain about the beer supplied by Sitford's "Its like bilge water" and getting his hair cut at Jeeves the barbers.

My school was a small wooden Mission Hut next to Lingfield Central School. Mr Forward [the Head-Teacher] was once a teacher at Brockley C.S. He had been a violinist with the London Symphony Orchestra at one time and held extended assemblies playing his violin to the accompaniment of a piano. The winter of 1939/1940 was very severe and there was a lot of snow, my walk to school of about 2 to 3 miles was very tiring. The house was very cold. Only one fire was lit in the living room, every other room was unheated, including the bedrooms.

I remember the joy of being in the country and fishing with an improvised bean stick, piece of string and bent pin by the tranquil waters of the River Eden.

My father had to have an operation and died in 1940 and it was then that I really missed not being at home. My mother received a widow's pension of 10/- [50p] she had to find work to support the family. My brother had to leave school to work in a munitions factory before later taking up an apprenticeship in the printing trade.

I sometimes managed to go home for a day or two when the raids on London eased a little. Every night we spent in bunk beds in the shelter at the bottom of the garden. I can remember looking out of the shelter at the bombers which were caught in the searchlights and the noise of many anti-aircraft guns firing at them.

Mantle Road Junior School, Deptford

At the end of the Summer Term in 1939, Dormansland Junior School had ninety-seven local children on the School Register. Twenty-four children left the school at the end of that term to join local Senior Schools. The remaining seventy-three scholars were joined on 11 September 1939 by another seventy-four new children on the first day of the new term, thus doubling the size of the school. Only two children were local, all the others were evacuees from south London. A few of the new intake had been privately evacuated and were staying with relatives or guardians in the village. The majority of the new pupils were from Mantle Road School, Deptford, and Turnham Road School. All were billeted in the village. After the acquisition of the Mission Hall, Turnham Road children were transferred to Lingfield to join their fellow pupils there.

Children, who were under school-age and living in an Evacuation Area, were given the opportunity to move to the same Reception Area as the

local school they would eventually join on reaching school age. The young children were accompanied by their mothers. All the billeting arrangements were made through the local authorities. One young evacuee, Francis Wallace, has recorded his memories as part of the BBC Second World War People's War project. Francis Wallace was two years old when he and his mother left London for Dormansland in September 1939. The hosts at their first billet would not allow them to stay in the house during the day time, whatever the weather. His mother Winifred had been a regular church attender in Brockley and tried to join the Dormansland Mother's Union at the Parish Room in Dormansland but was refused membership as she had not been confirmed in the Church of England. Winifred Wallace's sense of injustice at her reception by the people of Dormansland remained with her long after the war. The small family happily found a welcome in a new billet at The Homes of St Barnabas, Station Road, Dormansland. Mother and son returned to London in 1942 when Francis reached school age. The Mantle Road School had by that time returned to Deptford. Children had lessons in a temporary wooden classroom with a tarpaulin roof as the original building had been bombed!

Of the seventy-two evacuees who joined Dormansland School on 11 September 1939, forty had returned home before Christmas. Several more returned home over the next few months. Some London schools began reopening in November 1939 as evacuees drifted back. If their school building had been requisitioned for an essential service, children were able to go to any school within three miles of their home. Several schools had been taken over as bases for the Auxiliary Fire Service.

The Battle of Britain caused another evacuation of schoolchildren. At the beginning of the new school year, in September 1940, children from Bond Road School, Mitcham and several children from schools in the Croydon area were admitted to Lingfield and Dormansland Schools. Most of those children had returned home within six months.

Brockley Central (Boys) School

Head Teacher: Mr Charles H. Green B.Sc.

The Head Teacher's first residence in Lingfield was at Old Felcourt, the home of Mrs Block, one of the Billeting Officers. Old Felcourt became the temporary home of Mr and Mrs Green, their son and two pupils of Brockley Central School. The headmaster's daughter Sheila had been evacuated with her own school (the Mary Datchelor Girls School in Camberwell) to a farm at Great Chart, near Ashford. Sheila was soon brought to live with her parents at Felcourt and transferred to the County

Not used.

...relief is School tho

BROCKLEY CENTRAL SCHOOL FOR BOYS,
WALLBUTTON ROAD, S.E.4.

27th September, 1938,

Dear Parents,

Will you have your boy's luggage ready Wednesday morning, fully labelled. If you live more than 15 minutes walk from the school, **he must bring his case with him** on Wednesday morning.

EQUIPMENT (apart from clothes worn)

/Washing things - soap, towel. *Each* School Hymn book.
/Older clothes. / /Shirts. 3
no Gym. vest, shorts & plimsolls. /Pyjamas or (nightshirt.)
/6 stamped post cards. /Pullovers.
/Mackintosh, brush, comb. /Strong walking shoes.
/Socks or stockings. *no* Story or reading book.
/Card games. ~~Blanket, wrapped in water-~~
/Gas Mask. *not needed* ~~proof.~~

ALL TO BE PROPERLY MARKED

FOOD (for 1 or 2 days)

¼lb cooked meat. ¼lb chocolate.
2 hard boiled eggs. ¼lb raisins.
¼lb biscuits (wholemea 1) 12 prunes.
Butter (in container) Apples, oranges.
Knife, fork, spoon. Mug (unbreakable)

Yours sincerly,

CHARLES H. GREEN.

A letter sent by Headmaster Charles H. Green to parents regarding evacuation.
(*Doug Ryall*)

School in East Grinstead after announcing her intention to marry one of the farm-hands at Great Chart (she was thirteen at the time).

Brockley Central School (B.C.S.) prepared to evacuate in September 1938 at the time of the Munich crisis. Schoolchildren took home a letter to their parents on the evening of Tuesday 27 September 1938 warning of a possible evacuation of the school the next day. The evacuation was delayed pending news of Prime Minister Chamberlain's meeting with Daladier,

Hitler and Mussolini. The Munich Agreement, giving the Sudetenland to Germany, resulted in one more year of peace for Britain and one more year before the evacuation of schoolchildren. The list of essentials remained the same one year later. The list included stamped post cards to assure parents of their safe arrival at their distant billets, card games and story books as well as gas mask and the school hymn book.

When the actual Evacuation Day came, on 2 September 1939, the boys of Brockley Central School set off from Brockley Station for Lingfield, although they did not know that until their arrival in the village. At the same time Brockley Central School for Girls set off for Oxted.

The Headmaster of B.C.S. had a nervous twitch affecting his head, probably due to his service in the First World War. The schoolchildren called him 'Wag' but despite the nickname the boys had great affection and respect for the headmaster. The geography and science teacher, Mr Lewis or 'Lulu', had a nervous cough which the children mimicked. It was the gentle, harmless fun of schoolchildren at a particularly difficult time.

Doug Ryall wrote to his parents from his billet with Mrs Rose at 3 Jubilee Road (now Headland Way):

> This little village ... is reached by a train from Brockley Cross Station via Norwood Junction, East Croydon, Sandersted, Oxted and Hurst Green halt. When we came we landed out at Caterham, had food given to us at a nearby church, boarded a Greenline bus and rode through Godstone to Lingfield. John [Doug's younger brother] is staying ... next door to me. He is being well looked after but let the side down by messing himself through nervesness on Sunday ...
>
> The house is a modern house built in 1938/9 ... the garden is about 3 times the length of ours and is planted with vegitables, spuds, cabbages etc ...
>
> Some of our chaps have been billeted on 'lar-dedar' people and some are in very poor houses. Stan is at a farm whose proprietors are 6 middle-aged cranks, 4 unmarried, and whose clothes are green with age. All the same he says the grub is good and he doesn't mind.
>
> The local boys are propper country types, all scruffy, cap wearing, uncreased-trousered articles, one especially, he is 4'8" high, about 16 years old and smokes shag and boot leather in a foul smelling pipe.
>
> The Flirtatious ones of B.C.S. are V dissapointed because our girls were billeted with Askes School in Oxted and the few available in Lingfield are meagre and won't go round.

Philip Huggill and his younger brother Geoffrey were the only children left at the end of the selection process by local residents. They were eventually

taken by an elderly couple in Jubilee Road, Lingfield. Philip was twelve years old and Geoffrey nine. One day Geoffrey fell in the dirty waters at Lingfield Pond and was covered in dirty green algae. He was forced to take off his clothes in the shed before going into the house to clean up. The boys were too much for the elderly couple and a new billet was found for them in Newchapel Road. Again the boys were most unhappy and cruelly treated, they ran away to find their parents in south-east London. Philip wrapped up their clothes in coats as they had no suitcases. He can remember losing some of their belongings at Norwood Junction, 'hey boy you've lost your socks', a pair of shoes also dropped out of their precious bundles. The runaways eventually arrived home where they stayed for a time until their parents brought them back again, this time to live with Mr Robbins and his sister Mrs Sawyer on Hollow Lane. It was there that Philip got to know the attractive girl next door, Brenda, who eventually became his wife in 1952.

When Mr Robbins died in May 1940, Phil and Geoff moved from Hollow Lane to The Platt. The following year, their mother moved down from London to avoid the heavy bombing, their father joined the family soon afterwards. The Huggill family moved to No. 2, Cherry Cottages, The Platt, where Cherry Tree Cottage now stands. Gordon Jenner, the Lingfield Carrier, moved all their furniture down from London. The small bedroom in the lean-to at the back of the house was 'air conditioned' (daylight being clearly visible through holes in the brickwork). The family stayed at No. 2 Cherry Cottages until the 1950's when they were rehoused by the Council at New Farthingdale.

Dave Mitchell was approaching senior school level when the school was evacuated.

I was 14 when I was evacuated to Lingfield in September 1939. My first billet was in Campden Road, Lingfield, with a retired Major (ex Indian Army) his wife and unmarriageable daughter. The one bathroom (upstairs) was reserved for the ladies only. The Major insisted on a cold water plunge every morning in a zinc bath downstairs. The evacuees (Ken Burt and me) were not expected to bath. We evacuees had to eat all our meals in the kitchen, with the Major looking on. On the second day we set out for a walk and change of scenery when a window flew open, the daughter looked out and enquired why we were going out as it was Siesta time. The family always slept at Siesta time.

Sheila Green (now Sheila Clark) wrote of her parents' brief stay at Old Felcourt with Mr and Mrs Block before their move to Ranworth, a large house in Dormans Park:

Mrs Block ... was very charming, very generous, very beautiful and fun! ... When she and her husband dined in the various houses in the district, such were her charms and powers of persuasion that as like or not her hosts would wake up next day to find they had agreed to take in a couple of boys. One of these hosts, Captain Greenwood, proved to be more than usually susceptible, so that he found he had offered to turn over a whole flat ... he already had a houseful of paying guests, including wives of officers in the Tank Corps which were stationed in the Park ... my mother swiftly enlisted a gang of volunteers to clean up the flat, a semi-basement ... previously inhabited by a variety of animals including two monkeys ... the end room was always known as 'the monkey room' ...

Captain Greenwood's wife [Mary Elizabeth] was deaf and dumb ... she was passionately fond of animals. As well as the monkeys ... there was a donkey, an alarming flock of hissing geese, chickens, bantams, guinea-fowl and two horrible smelly goats who ate everything in sight including the washing off the line ... There were cats all over the place, domestic cats, wild cats, cats having kittens in your bed, and several dogs including a couple of neurotic spaniels ... and an enormous mastiff who had the run of the house and slobbered disgustingly. He had a cloth attached to his collar and anyone passing was supposed to mop him up a bit. He finally departed with the Tank Corps as their mascot.

When the bombing of London started the great-hearted Captain Greenwood instructed my father to bring down as many boys as he could round up ... the farm cottage was opened up and one of the lodges, while the rest were accommodated in one of the cellars which had been the old dairy ... Beryl Newell slept in the cupboard (being small enough to fit).

The Greenwoods had purchased Ranworth from Sir Frank William Madge in 1938. The domestic staff was mainly a mix of German Jewish refugees. One of the schoolboys, Peter Douglas, particularly remembers the very attractive dark haired maid Leila and another refugee who taught the boys card tricks. However, in June 1940, all the refugees were interned as 'aliens'.

Peter Douglas and John (Buddy) Hughan had the good fortune to be based in Ranworth's Wine Cellar:

I moved into the Wine Cellar with a bunch of boys ... We had about four feet wide cubby holes created by brick walls with slate shelves every three feet or so. Your bed on the floor went into the cubby hole about three feet. The levels above were filled with vintage wines. Over my head I had about seventy bottles of 1928 port ... unfortunately the bottles were all covered with a thick layer of dust, it would have been difficult to remove

one without being detected. As luck would have it one section was filled with an old bird cage, which when removed revealed several bottles ... of Peach and Apricot Brandy, without a speck of dust. We also found a large bottle of chutney preserve and one of those big cube shaped tins of ice cream cones, still very crisp ... for a number of days we had a late night snack of chutney filled cornets washed down with brandy liqueurs, albeit in china mugs ... [inevitably they were discovered] it was decided that probably the bombing was less of a risk than alcohol, so we were moved upstairs.

There was also a very sad side to the Wine Cellar. Buddy Hughan, who slept next to me, was told by one of the helpers that his mother had been killed in an air raid. She was in a tram outside the Bricklayers Arms on the Old Kent Road.

Buddy Hughan was reputed to be the only pupil to have driven a bren-gun carrier, the property of the Princess Patricia's Canadian Light Infantry. When caught he said he only meant to borrow it. He left school in 1945, stowed away to Canada, was deported back to the UK, joined the Canadian Army and served in the Army of Occupation in Germany. He then went on to study architecture at the University of Manitoba in Winnipeg.

Gradually the whole of Ranworth and the South Lodge were taken over by the school, the Greenwoods moved out to The Shooting Box, at Shovelstrode although they continued to show a keen interest in the children at Ranworth. Any boys unhappily billeted in Lingfield were taken to Ranworth as too were some mothers of Brockley boys who came as voluntary helpers. A few Brockley girls went to live at Ranworth, several were sisters of boys at Ranworth; the girls occupied the master bedroom and dressing room, and also had use of the en suite bathroom. One of their teachers occupied the next suite of rooms to keep order!

One of the teachers, 'Stoker', had been a Stoker in the Royal Navy during the First World War and used his naval experience to keep Ranworth's boats ship-shape. The large Ranworth Lake covered more than six acres and had a boat house and four small islands. Stoker taught the boys to row using paddles made in woodwork class by Sixth Form boys. The lake was usually out of bounds for the boys unless they were accompanied by Stoker. Unfortunately, the lake was drained when it was realised that it could be used as a navigational aid for enemy aircraft. Captain Greenwood was soon ordered by the War Office to drain the lake and the fish were sold to Macfisheries for fish-cakes.

The Headmaster tried to exercise as much control and authority as possible but the surrounding gardens and woodlands were difficult to oversee. Some areas of the woodland were made out of bounds to prevent accidents. Several

trees which were considered safe to climb were marked with a cross. By the next morning some bright spark(s?) had put crosses on every tree in that area. The boys were given gardening duties, producing vegetables for the kitchen and table as most of Ranworth's gardening staff was then serving in the forces. The schoolchildren were also involved with growing vegetables on an allotment created behind the New Star Inn in Lingfield.

In March 1940, Brockley pupils dug an ARP shelter trench, near to the Twitten, alongside the New Star Inn. The project was organised by Mr Harrison, one of the masters. Unfortunately, one pupil, Ken Newell, pierced the electrical joint for the feed to the Inn. The project was abandoned and the cellars of the Inn had to be shored up. The cellars were used as the school air-raid shelter as they were close to the school classrooms in the Old Star building on the opposite side of the road. The rear hatch door to the cellar gave a peep-view of the patch of sky over the building, a good observation point for air battles above.

All the rooms in the Old Star Inn were used by Brockley Central School. Douglas Ryall wrote of sitting alone in the 'small attick at the top of the Star Inn' writing his history exam paper. One question concerned a subject

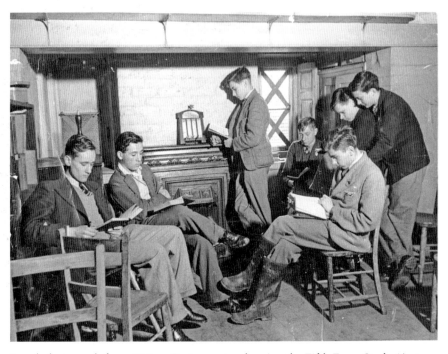

Posed photograph for a *Picture Post* reporter showing the Fifth Form Study (Anteroom to Wag's Office), The Old Star, Lingfield. Left to right: Ken Newell, Dave Mitchell, Ronnie Leach, Pat Welford, Bob Taylor (Wellington boots!), Pat Cole, John Horsnell.

The Old Star is on the right of picture. The diagonal tape across the glass windows was to reduce shattering in the event of bomb damage.

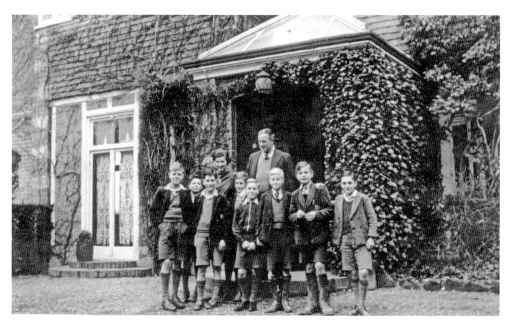

Captain Gilbert Greenwood and Mrs Mary Greenwood with a few Brockley Central Boys, at Ranworth *c.* 1941.

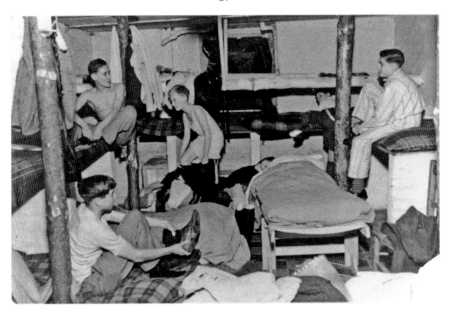

In the air-raid shelter at Ranworth, 1940. From left to right, top: Ken Newell, Alan Newell, Frank Jackson. Bottom row: Ron Leach, unidentified boy in bunk.

the school had not touched on: the serious food shortages in England after the French Wars and the Great War and the protective measures taken by England at those times. Doug cannot now remember whether or not he likened the situation to the food shortages and protective measures of the Second World War!

The single-storey building adjoining the main building of The Old Star was formerly the Jug and Bottle off-sales area, before being adapted for a classroom. 'Stoker' rode his bicycle to school every morning, on one morning a child suspended his bike from the ceiling in the Jug and Bottle. The culprit then had a stand-up fight with the teacher when he was discovered. The memory of that scene lives on. The form of punishment which inevitably followed has been forgotten!

All schools worked hard at keeping up their standards of education during the war. Mr Green was particularly concerned that music had been severely curtailed:

In spite of this [he wrote to the parents] we gave a concert and a Carol Service at Christmas and provided a Musical programme for the Lingfield Women's Institute. The choir has a splendid history behind it ... It is their privilege, once a week, to have the use of the Church for their practice. The atmosphere of this fine old building cannot but leave a mark not only on the Choir's singing but also on the boys' Lingfield memories.

EXHIBITION and OPEN DAY
of

LINGFIELD and B ROCKLEY CENTRAL SCHOOLS

and

EVENING INSTITUTE

JUNE 19th, 1940.

2.30 - 8 p.m.

--o--O--o--O--o--O--o--

This is a War-time Exhibition. Both schools have been working under difficulties during the past winter and the work shown represents the successful surmounting of a great number of obstacles.

Exhibitions and demonstrations of work open throughout the afternoon with Performances as follows:-

2.30 - 3.00	Display of Cultural Activities (Brockley) Victoria Memorial Institute.
2.30 - 4.00	Demonstration of Commercial Work (B) In Class Room.
2.45 - 3.15	Girls' P.T. display (Lingfield) On playground behind school.
3.30 - 4.00	Scene from Midsummer Nights Dream (L) On Lawn.
3.30 - 4.10	Scenes from Midsummer Nights Dream (B) On Lawn.
4.10 - 4.30	Country Dancing (L) On Playground.
6.00 - 6.30	Puppet Plays (L) In the School Hall.
6.30	Demonstration of Flying Models (B) On School Field.
7.00	Display by Women's "Keep Fit" Evening Class

- - - - - - -

Tea may be obtained from 4.30 to 6.00
in the Dining Hall at 6d. per person.

The WOMEN'S VOLUNTARY SERVICE will be in attendance to
answer questions about the canteen.

--O--O--O--O--

Programme for the exhibition and open day.

At the end of the first full school year of the war, Lingfield and Brockley Central Schools joined with the Victoria Evening Institute to produce an exhibition and open day to demonstrate their success under the difficult circumstances.

Outdoor activities included care of beehives, pigsties, chicken houses, rabbit hutches and the rebuilding of an old motor-car as a farm-car.

Midsummer was the haymaking season. Doug Ryall wrote home: 'the smell of the newly cut sweet hay and freshly tarred roads forms a good background to our supper of lemonade and pickled onions at Deacons, by lamplight. The lettuces have come up well. On my plot I've some large marrows and many beans. We have just made 16 lbs of plum and apple jam.'

After four and a half years with Brockley Central School in Lingfield, Bob Pucknell, Geoff Huggill and Michael Meachin achieved the Oxford School Certificate in 1944 and joined the Haberdashers' Aske's Boys' School which had been evacuated to Oxted and Limpsfield Chart. They travelled to Oxted each day on the train and then caught a bus to Limpsfield Chart. The split site must have caused an organisational headache as outdoor recreation was held on Master Park, Oxted. A rugby pitch was allowed on the park for the use of Haberdashers' Aske's.

Brockley Central (Girls School)

Brockley Central School for Girls were evacuated to Oxted on 2 September 1939. School lessons were held in various church halls in the area. The headmistress, Miss Copsey was billeted near to Oxted Railway Station as were members of her staff. The children were in private houses in the town and at Limpsfield.

Patricia Leadley (formerly Cowling) and her sister Vera joined Brockley Central School for Girls in Oxted in 1940. After a few happy months living with one maiden lady in the town they were moved to another billet.

They had a big house at the end of a long drive surrounded by quite big grounds. They had a putting green on the lawn, a private chapel, a chicken run, as well as a big kitchen garden. There was a cook, a gardener and a parlour maid – we had to have our meals in the kitchen with the servants. We were expected to help in the house. On Saturdays we had to do our own washing and ironing, clean all the shoes then clean all the brass stair rods. My sister and I had to wait at table if they entertained any guests. For doing all this we were given 1/- pocket money (5p). By this time the parlour maid had been called up to go into the Land Army.

My mother came to see us one day ... she was very upset and asked for us to be moved from there ... After several temporary billets we eventually moved to Mill Barn Cottage ... we were very happy there as we were treated like one of the family. Down the lane was a farm and we would go there every day to fetch the milk which was straight from the cow.

Our house in London was bombed and my parents lost all their belongings. My twin sisters had been sent to Devon with my grandmother and another sister came to be near us at Oxted but we did not live together. My maternal grandmother had been killed in an air raid and also an aunt, an uncle and a cousin (they were all in the same shelter). Another aunt survived and was badly injured, she spent the rest of her life in a wheelchair ... She had many operations over the years. Soon after this my mother and two brothers were evacuated to Yorkshire for the rest of the war, we didn't see them again until 1945.

National Federation of Women's Institutes – Report on the Evacuation Survey, 1942

In 1940, five thousand eight hundred Women's Institutes were issued with questionnaires about their experiences of evacuees. Only 29 per cent of those circulated replied. None of the institutes in the south-east area of Surrey replied, or if they did their replies have not been included in the report file at the London Metropolitan Archive.

The object of the survey was to provide local authorities with comments on the condition and habits of the evacuees whom WI members had received into their homes, and the reaction of country women to their town guests. The preamble stated that the survey was undertaken 'in a constructive spirit and not with a sense of grievance'.

> When evacuation took place our members did their best to make visitors comfortable and happy, and made great sacrifices to this end. It was a shock to them to find that many of the guests arrived in a condition and with modes of life or habits which were startlingly less civilised that those they had accepted for a lifetime.

Mothers of evacuees were criticised for their poor mother-craft and lack of cookery and needlework skills.

The report was poorly received by individual Borough Councils. Battersea and Deptford Councils reacted strongly to comments on bodily infestation and the prevalence of bed-wetting.

London County Council stoutly defended their evacuation policy. In their response L.C.C. stated that firstly the evacuation had taken place at the end of the summer holidays and the school authorities could not be held responsible for the state of the children's heads. Secondly, there were a number of reports of children going home for Christmas or the weekend and returning with dirty heads, this was beyond the control of the schools. Thirdly many children were infected by contact with others after their arrival in the Reception Area, implying that local children could have infected the evacuees. Lastly, on the issue of bed-wetting, it was widely recognised that the number of cases was unusually high due to the sudden shock of leaving home and to the new circumstances and surroundings.

The L.C.C. considered the WI Report to be statistically unsound. The general conclusions drawn about the upbringing of children in London homes were ill-founded and provocative. Nevertheless, though its value as a piece of research seemed negligible, the report was on the face of it a well-meant effort on the part of well-meaning people to make a contribution to social betterment in wartime. The Ministry of Health Report commissioned in September 1939, and considered by Parliament in 1940, was agreed to be a more reliable tool.

In recent years, Dr Martin Parson's research in other areas of the country has suggested that 15-18 per cent of evacuees were abused (University of Reading, Institute of Education, ResCEW). No evidence of abuse had been discovered in south-east Surrey but lack of evidence is not proof that abuse did not take place.

Notre Dame Convent School

Not all evacuees came from the Metropolitan Borough of Lewisham. The Roman Catholic Residential Boarding School of Notre Dame in Faversham, Kent, was evacuated to Lingfield in 1940. Three Sisters of the Notre Dame School travelled to Lingfield on 7 June 1940 to find accommodation for themselves and fourteen pupils of their school. Six of the Sisters had already been interned as 'aliens' and the remaining four Sisters had decided to bring the children away from the coast and the imminent danger of enemy invasion. One Sister remained in Faversham with the pupils while the three others found accommodation for them all in Lingfield.

Miss Wheeler of Welstrode, Saxbys Lane, offered to share her little cottage with the Sisters and children. Two weeks later, the fourth Sister arrived with the evacuees, fourteen children aged between five and eleven. Very soon the children were joined by local children, as day pupils. The

rapidly growing school became too large for the little cottage. Additional accommodation was found for the boy pupils with Mrs Last of Wisteria, Blenheim Road (now Bakers Lane).

By 1942, the school had grown to nearly seventy pupils and larger premises on a single site were considered necessary. Oakleigh House in Town Hill, Lingfield was bought and the school occupied the house for the next three years. All the time pupil numbers were growing.

Before the end of the war, Batnors Hall became vacant and was purchased by Notre Dame Convent School. Batnors Hall had been used during the war by officers of the Aliens Camp, then by officers of the Prisoner of War Camp on the Racecourse.

CHAPTER 3

The British Expeditionary Force and Operation Dynamo

In February 1939, the British government officially announced that, in the event of war an expeditionary force of 300,000 men would be sent to France. In April that year, the new Military Training Act required that all men between the ages of twenty and twenty-one had to register for six months military training.

The British Expeditionary Force (BEF), under the command of General Lord Gort, crossed the English Channel to reach France on 10 September 1939. The force included four regular infantry divisions and fifty light tanks.

In October 1939, the British government introduced conscription or compulsory military service. Conscription was by age and in October 1939 men aged between twenty and twenty-three were required to register to serve in one of the armed forces. They were allowed to choose between the Army, the Navy and the Air Force. As the war progressed the age range for conscription widened, all men aged between eighteen and forty-one who were not working in reserved occupations could be called to join the armed services if required.

Women were required in large numbers to take up work in factories and farming and in 1941 single women aged between twenty and thirty were conscripted to the war effort. They applied to join the Women's Land Army, the Auxiliary Territorial Service, the Women's Auxiliary Air Force, the Women's Royal Naval Service and the First Aid Nursing Yeomanry (FANY). Some women were recruited to the secret agencies and parachuted behind enemy lines.

Staffing at Lingfield Epileptic Colony became a problem as men received their call-up papers. Conscientious Objectors, men who for moral or religious reasons felt unable to take part in the war, were recruited to fill

the vacancies. According to Angus J. Mobsby, who wrote a history of the Colony, some conscientious objectors had a profound effect on the cultural side of Colony life with paintings and exhibitions, music and percussion bands.

Private Eric Ellis was a young man of twenty when Great Britain officially declared war on Germany, on 3 September 1939. That same day he went to Mitcham Road Barracks, Croydon, with his brother Bob to volunteer for Allied Service. He gave his name and his Lingfield address and was told to return home to wait for a recall for a medical examination. Eric has recorded many of his memories of that time:

> After a couple of weeks or so I was called up and told to report to Brighton where I had a medical, and after another couple of weeks, which would be about the end of September I went down to Chichester and then joined the 4th Battalion of the Royal Sussex Regiment at Thornford in Dorset.

After initial training in Dorset, Eric Ellis sailed to France in early April 1940 with the 4th Battalion Royal Sussex Regiment; part of the reinforcement of the BEF.

> At first we didn't do a lot, we were training of course and getting a bit fed up actually. About the end of April we went on a long route march, they said it was training. We marched about one hundred miles in a week, finishing about 6th or 7th May. It was hot that summer and we wanted a good rest. We had marched up to the Belgian border. We marched on another forty or fifty miles into Belgium and took up positions in the front line. [In May 1940 Hitler's armies had invaded first Holland then Belgium.]
>
> We were quite happy then, we thought it would be great fun, well, you don't know much about what it is like, until the shells started coming down. We soon changed our mind then and we started to get frightened … prior to doing it, you're frightened but once fighting starts and you're in the thick of it, all your fears leave you, you don't think about it. Then when things quieten down again and you're sitting down, then they start shelling you like blazes, then you're frightened again.
>
> We started to dig in and we dug big trenches in Belgium then, on the First World War system, big long trenches. Anyway we were there a few days until we more or less got blown out of it and the Germans attacked us. They were coming in one end of the trench and we hopped out the other.

Private Eric Ellis.

On 25 May, Boulogne was captured, the following day Calais fell. In the evening of May 26, the Admiralty signalled the start of 'Operation Dynamo', the evacuation of troops stranded on the beaches at Dunkirk.

After being driven back from several defensive positions by a German army with superior equipment, Eric's battalion was given the task of defending the railway and road crossing at Caistre. There they fought for several days until the patrols reported that the Germans were ready for a large attack with tanks. Having no tanks themselves to stop the German advance, the battalion was ordered to retreat to a hill, called Mont de Cat, a distance of about 6 miles.

We took up positions on the top of this hill and there was a great round pit, a big sand-pit or something, about two hundred yards across. It was very deep and we were right around the top. We got there in the early hours of the morning and then, at about dawn, we heard aircraft coming over and, good heavens, there were about twenty or thirty Stuka dive-bombers coming over; they dive-bombed us for about an hour.

We saw the enemy coming up the hill, their artillery firing on ours; we found out later that all our own artillery had been wiped out by the dive-bombers. We hadn't any support at all. Then we had the order to get out! The trouble was the pit – if we had run round it the Jerries would

probably have mown us down. So we thought we would go down into the pit and up the other side, but when we got down, we couldn't climb up the other side, it was a hell of a job. When we got there an order came through, "Every man for himself, make your way to the coast."

On 27 May, the Belgian army had capitulated on the order of King Leopold. British forces were to be withdrawn from Flanders.

Everyone scattered in all directions, three of us finished up together. After walking for several miles we hardly saw anyone else. We didn't know which way to go – had no idea! When we heard the enemy guns, they were on each side of us! Somehow we struggled on to about 10 miles from Dunkirk when we were really stuck. One of my mates said he would have a look – he went one way and we heard gun fire – we never saw him again. The two of us went the opposite way.

After a couple of hours walking we saw one or two British blokes. Along the way someone had said that they were taking us off the beach at Dunkirk so we spoke to them about Dunkirk and asked the way. They said "you can't go there, the Jerries are in Dunkirk, go along there to the beach." So we went on the beach at De Panne – or Le Panne as it was then.

We got there about five o'clock in the morning and we just waited for the little boats to pick us up. Only the little boats, little row boats, came in for us because the bigger boats were way out in deep water. We went into the water and hoped that we'd be picked up. Later in the afternoon the Germans had arrived with their artillery and started shelling the beaches. So we went out deeper in the water, up to our necks. I eventually got picked up at five o'clock the next morning. I came home on the Medway Queen [a Thames estuary paddle steamer] we got bombed all the way but survived it.

The *Medway Queen* holds the record number of crossings to Dunkirk in 1940, rescuing 7,000 men in seven trips. A total of 299 British warships and 420 other vessels took part in the evacuation of ten divisions of the British Expeditionary Force and remnants of the French army, from the beaches around Dunkirk. The armada was under constant enemy attack from heavy artillery and aircraft fire, many were sunk or disabled. Craft of almost every sort was launched from the English Channel coast to rescue the troops; including mine sweepers, tugboats, paddle steamers, trawlers and small fishing boats. An eye witness, onboard one of the boats described the scene, 'great plumes of smoke across the French coast line and the noise of artillery fire and the clacking of machine guns. As far as

eye could see were giant queues of men, in the sea, on the beaches and in the sand dunes'.

Wrecked and abandoned vehicles and equipment littered the beach of Dunkirk. Soldiers had escaped with the bare essentials for survival as they were driven into the sea. A total of 338,226 Allied troops were rescued from the advancing German army. Many, like Eric Ellis, had spent up to twenty-four hours on the beach, twelve hours of which were in the water. Operation Dynamo took ten days, from 26 May to 4 June 1940. The new Prime Minster, Winston Churchill who had taken office on 10 May, called the rescue a 'Miracle of Delivery'.

When the men arrived in England they were surprised by their welcome. People lined the route from the Port of Dover to the Railway Station, cheering and clapping the soldiers in a holiday atmosphere. As the train loads of men set out for the journey inland, people again lined the route cheering the dirty, beard-stubbled faces that peered out of the carriage windows, offering them food from their rations.

Then followed the chaotic logistics of reassembling the British Army from their temporary camp billets scattered across the country. Eric Ellis and other survivors from his unit were gradually assembled together at Copthorne Barracks, close to the centre of Shrewsbury where they were given a forty-eight hour leave pass. They had no kit and no money but had forty-eight hours to recover and contact relatives. The remnants of the regiment were then sent to Goole for regrouping and training. In Goole Eric met his future wife, Theresa Brodigan.

Private John Alfred Boorer of Lingfield also served with the 4th Battalion, Royal Sussex Regiment but was killed one month after arriving in France during the regiment's attempted defence of the railway and road crossing at Caistre, a small town in the department of Nord, 6 km north-east of Hazebrouck. He died on 28 May 1940 aged twenty-one and was buried in the small Communal Cemetery at Caistre.

2nd Lt John Wainwright Hopkins of New Place, Lingfield, a Barrister-at-Law, joined the B/O Battery, 1st Regiment of the Royal Horse Artillery (RHA) in June 1939. The regiment crossed to France in 1939 and was camped in Neville, south of St Valery and west of Amiens. At 9 p.m. on the 11 June 1940, Hopkins was instructed to take his Wagon Line personnel to wreck all the main line trucks; thus rendering them useless to the enemy. The Battery then moved on foot to St Valery where they were to embark at 1.30 a.m. the following morning as part of the strategic withdrawal of British and French troops. When the soldiers arrived at St Valery they were told that ships could not get into the port. The entire Battery took refuge in the gardens of a house where, in the early morning of the 12 June, they were captured by the Germans.

The following morning they were taken by lorry to a temporary camp on the outskirts of Rouen, where they stayed the night before setting off on the 180 km trek to the POW camp at Bethune. Hopkins and his men were first escorted by lorry, then as more prisoners joined the column they marched on foot; British and French officers and men, in a long column, 4-5 km long. The column had very little food on the journey and covered about 25 km a day.

During a halt for rest, 7 km north of St Pol, 2nd Lt Hopkins and 2nd Lt John Rae, escaped into some bushes. The column moved off but Hopkins and Rae stayed hidden in the bushes until dark. At 11 p.m. that night they marched westward towards the coast, guided only by the stars. They obtained food from a peasant who they found working in a field. Hopkins and Rae's report of the escape shows that they never had the slightest difficulty in getting food, nor came across any peasant who showed the slightest sign of wishing to betray them. They also obtained advice, maps and civilian clothes.

On 2 July, they reached the coast at Groffliers on the estuary of the River Authie where they hid in the sand dunes. They managed to make contact with the Concierge of a chateau nearby who supplied them with food while they made plans to find a suitable boat for their escape. Bad weather and adverse night tides set in on 5 July and lasted until 12 July when the two men decided to retire to a wood near a friendly farmer, 6 miles inland. Their escape was then made impossible by the arrival of large numbers of German artillery, who were billeted at the chateau at Groffliers. A party of Germans also arrived in the village of Lepine where the two men were sheltering so that the villagers could no longer provide them with food and shelter. As the tide would not be suitable for a night time escape before the 4/5 August they decided on 24 July to change their plans and make for Unoccupied France.

They marched eastward by night, along the north bank of the River Authie, then crossed the river at night to make for Long-sur-Somme. There they met a Captain Mills, 'M', who courageously offered to guide them over the River Somme and onwards to the south avoiding large towns.

The three men marched by day, crossing rivers by dams and locks, via Chateau Neuf and Chartres, continuing South until on the 19 August they reached Loches. 2nd Lt Rae found an Englishman who cashed him a cheque for 1,000 francs with which they were able to buy new clothes and rail tickets for Chateauroux, and then caught another train to Marseilles via Toulouse. They reached Marseilles on the evening of 20 August and spent the following ten days seeing a Consular and other authorities. Hopkins and Rae finally secured papers under the names of Emeric Nagy and Paul Benon, cousins, and embarked on a French troop ship bound for

Oran in Algeria where they arrived on 2 September. There they boarded a train for Casablanca, on the Atlantic coast of Morocco, where they were given British Emergency Certificates before embarking on a ship to Lisbon. They reached Lisbon on 17 September, and finally reached England by air from Lisbon on 19 September 1940. They were interviewed by M.I.9 the following day. (TNA Ref: WO 373/60)

Private Albert Strudwick and Private Thomas Strudwick lived in the family home in Station Road, Lingfield. The brothers joined the Queen's Own Royal West Kent Regiment. Both were taken as prisoners of war by the Germans during the regiment's withdrawal to Dunkirk. They were eventually taken to separate POW camps in Poland.

Many soldiers from the south-east corner of Surrey died during the evacuation from Dunkirk. Several were captured and held as prisoners of war by the Germans for the next five years.

CHAPTER 4

The Home Guard, Auxiliary Units and the Battle of Britain

After the emergency evacuation of the BEF from the beaches of Dunkirk a German invasion of Britain was expected any day. Arrangements for augmenting the home defences were already underway following the fall of Holland, Belgium and France. An organisation of Local Defence Volunteers (L.D.V.) backed up by the arrival in Britain of Canadian forces, were seen as Britain and the Commonwealth standing alone against the might of the German forces.

On 30 May 1940 Field Marshal Ironside, C-in-C Home Forces ordered the removal of signposts and street names to confuse an invading army. Local Highways Departments set about removing all signposts which were put in store until the end of the war. Village stores and post offices removed the village name from the shop-front and 'Lingfield Garage' became an anonymous garage on a village High Street. Ingenious military drivers, and others, managed to find their way by reading the local authority's names on manhole covers and addresses which were still posted up in most telephone kiosks.

Parish Invasion Committees were formed in all rural areas at the instigation of Herbert Morrison in May 1941. Committees took inventories of all horses, carts, hand-carts, trailers, wheelbarrows, crowbars, spades, shovels, picks, ladders, oil stoves and paraffin lamps. Inventories even included mattresses, blankets, rugs, sheets, pillows, hot water bottles, kettles and buckets, and any other item considered likely to be of use to the community if invasion and occupation occurred.

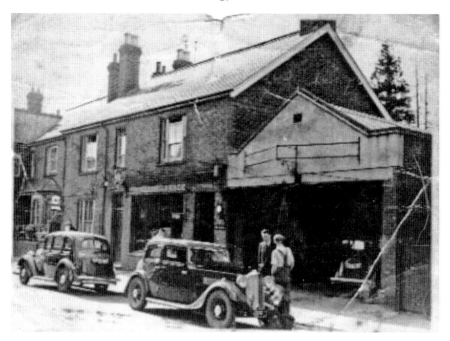

Lingfield Garage in 1940. Garage owner Ernest Drew talking to Frank Mill of Ford Manor Farm. The garage complied with government restrictions on signage by removing the name of the village from the forecourt sign. (*Bob Drew*)

Local Defence Volunteers (L.D.V.), Later Known as the Home Guard

Directly after the 9 p.m. news on 14 May 1940, the Secretary of State for War, Mr Anthony Eden, broadcast an appeal for men between the ages of seventeen and sixty-five to offer their services as Local Defence Volunteers. Within twenty-four hours of that broadcast almost a quarter of a million men had reported at local police stations to volunteer their free time service. Police stations throughout Britain were inundated and in some cases overwhelmed by the response of eager volunteers.

A debate was held in the House of Commons on 23 July 1940 where the Secretary of State for War read a statement on the organisation of the Local Defence Volunteers, which at the time was undergoing a name change to the Home Guard, apparently at the suggestion of Prime Minister Winston Churchill. Eden's statement to the Commons set out the object of the voluntary, unpaid, part-time force which was 'to augment the local defences of Great Britain by providing static defence of localities and protection of vulnerable points and by giving timely notice of enemy movements to superior military formations'. (*Hansard* Vol. 363)

The L.D.V. was under the operational control of the Commander-in-Chief Home Forces and a chain of Army Command and District Military Areas. Retired army officers were appointed as Area Commanders.

The oldest of the volunteers had seen service in the Boer War, several had served on the Indian Frontier and very many had served in the First World War and were experienced riflemen. The guns which were eventually distributed to the Home Guard were familiar weapons to First World War veterans. The Dad's Army image of the Home Guard although comically amusing is unfair to the veterans of the First World War and an injustice to their reputation. The younger volunteers had no military experience, but everyone had some specialist skill which could be put to good use. Almost every conceivable occupation was represented among members of the Home Guard.

By February 1941, developments in the war meant that compulsory Home Guard service was introduced with the aim of recruiting all able men for a younger and fitter defence force. Women were not able to enrol in the Home Guard before April 1943.

In south-east Surrey, the Home Guard units were part of south-eastern command, Dorking Sub-District (north Kent & Surrey District), Oxted Battalion: specifically the 9th Surrey (Oxted) Battalion. The battalion was divided into companies, which were subdivided into localised platoons. Usually in cities, platoons were formed of about 400 men but numbers were significantly less in rural areas.

A Company – Caterham (Godstone Road): Platoon Nos. 2, 3 & 4

B Company – Woldingham/Tatsfield: Platoon Nos. 7, 8 & 9

C Company – Caterham (Croydon Road): Platoon Nos. 28 & 29

D Company – Oxted, Godstone, South Godstone and Blindley Heath: Platoon Nos. 10, 11, 12 & 13

E Company – Limpsfield: Platoon Nos. 14, 15, 16, 17, 18 & 19

F Company – Lingfield, Felbridge, Dormansland and Felcourt: Platoon Nos. 20, 21, 22 & 23

G Company – Bletchingley, Poplar House: Platoon Nos. 24, 25, 26 & 27

The Administrative Headquarters of 9th Surrey (Oxted) Battalion was Old Surrey Hall, Dormansland, in the extreme south-east corner of Surrey. Old Surrey Hall was the home of the Battalion Commanding Officer, Lt-Col. Ian Anderson, MC. The Battle HQ was The Clayton Arms Hotel, Godstone. Second in Command (or 2 I/C) was Major A. B. Ogle OBE of Lullenden until March 1942, when Major R. V. Toynbee of Starborough Castle was appointed 2 I/C. The Adjutant was Captain G. C. Manton, New Cottage, Holtye Road.

The officers assumed overall responsibility for intelligence, ammunition, signals, liaison and the appointment of a medical officer. They were also given the responsibility of planning for bombing and petrol disruption at Redhill Aerodrome in the event of imminent enemy invasion. Redhill Aerodrome was a satellite for RAF Kenley in 1940 and a base for Canadian and Polish Squadrons.

D Company (Oxted, Godstone, South Godstone and Blindley Heath)

The Battle HQ: the Hare & Hounds, Godstone, Admin HQ: Station Rd West, Oxted.

D Company was sub-divided into four Platoons:

No. 10 Platoon: Station Road West, Oxted
No. 11 Platoon: St. Hubert's Stables, Eastbourne Road, South Godstone (area included Blindley Heath)
No. 12 Platoon: The Hare & Hounds, Godstone
No. 13 Platoon: Station Road West, Oxted

E Company (Limpsfield)

The company was subdivided into six platoons for the defence of Limpsfield Nodal Point; the strategically important road junction of the A25 with B269. Defenders were to restrict, delay or hamper the operations of enemy invaders until reserves and reinforcements could be brought up. Road blocks were constructed 250 yards to the east and west of the Nodal Point on the A25, and to the north and south of the Nodal Point on the B269. In 1941, the company was equipped with four Spigot Mortar guns. Mortar guns were designed as anti-tank and anti-personnel weapons and had a maximum range of 75 to 100 yards. The gun emplacements were set in a pit 3 foot 10 inches below the ground surface and concealed by undergrowth, the guns were set on a concrete pedestal or 'thimble' that had a central metal pivot, or 'spigot' mounting.

Each gun had a crew of three, including a Platoon Commander. Training in the use of Spigot Mortars was received at the No. 1 Home Guard Training School at Denbies, near Dorking. One criticism of the gun was that it had to be loaded from the front, in full view of the approaching enemy.

F Company, 9th Surrey (Oxted) Battalion Home Guard, outside 20 Platoons HQ, Lingfield. (*Hayward Collections*)

No. 14 Platoon: Battle HQ Rocks Hill (overlooking the western road block)

No. 15 Platoon: Battle HQ Pebble Hill Cottage (overlooking the eastern road block)

No. 16 Platoon: Battle HQ Lanterns, 14 Wolf's Row (overlooking the southern road block)

No. 17 Platoon: Battle HQ The Bull Inn (overlooking the northern road block)

No. 18 Platoon: Battle HQ The Bower (the corner of High St and A25, overlooking the Nodal Point)

No. 19 Platoon: Battle HQ Thornhill. (*The Spigot Mortar Platoon HQ*)

F Company (Lingfield): Company HQ
The Old Star Hotel, Lingfield

The first Company Commander was Major Ralph Toynbee of Starborough Castle. After Major Toynbee's appointment as 2 I/C to Lt-Col. Anderson in 1944, Major Ian B. M. Hamilton of Winns, Moor Lane, Dormansland, was promoted to F Company Commander and Captain L. G. Vine his 2 I/C.

Lt C. J. Druitt was given responsibility for Redhill Aerodrome. After the establishment of the Airfield at Horne, in 1944, Lt Druitt was given that additional responsibility.

Lt P. C. Hodge, the Company Weapon Training Officer
2nd Lt F. R. Jones, Company Information Officer

The Lingfield Company was sub-divided into four Platoons:

No. 20 Platoon: HQ The Old Star Hotel, Lingfield. O/C: Lt W. C. Lacey
No. 21 Platoon: HQ Kingates, Copthorne Road, Felbridge. O/C: Lt J. A. Thomas
No. 22 Platoon: HQ The School, Dormansland. O/C: Lt I. B. M. Hamilton
No. 23 Platoon: HQ Felwood, Felcourt. O/C: Lt A. W. Day

G Company (Bletchingley)

No. 24 Platoon – Poplar House, Bletchingley
No. 25 Platoon – Ditto
No. 26 Platoon – Scouts Hut, Midstreet, South Nutfield
No. 27 Platoon – Ditto

On 19 May, all Platoon Commanders issued the first item of uniform to all their men, a white armband with the letters L.D.V. in black (Local Defence Volunteer). By June 1940, all the platoons were settling into cohesive units, all pre-war sporting rivalries were put on hold; instead they developed company and platoon rivalries.

Fifty-four members of 'F Company' were trained soldiers, veterans of the Great War. Three had also served at the Indian Frontier in 1908 and one had been awarded the Indian General Service Medal, 1896. Corporal Hobday had served throughout the Great War, was awarded the Long Service Special Police Medal, was mentioned in Despatches and earned the Military Medal. Revd Frederick Baggallay was a Captain in the Army Chaplain's Department in the Great War. In 1940, he was made Corporal of No. 21 Platoon, Felbridge Home Guard. Lance Corporal Maurice Hudspith had served with the Royal Artillery in the First World War and first saw action in Salonika, in November 1915. Maurice Hudspith came to Lingfield as a teacher with Brockley Central School in 1939 and joined No. 23 Platoon, Felcourt Home Guard in 1940. Private W. Tinsey had served with the Royal West Surrey Regiment throughout the First World War and earned the Military Medal. Private W. T. Tester similarly had served in the First World War and was awarded the Long Service Special Police Medal and Bar.

The Felbridge Platoon was under the command of Captain Jack Thomas who had been a non-commissioned officer in the Royal Artillery, serving in

France during the First World War. He was awarded the Military Medal for running ammunition supplies to the front line under heavy enemy fire and had been mentioned in Despatches for rescuing a team of horses that had come under attack. The 2nd I/C of Felbridge Platoon was Lt Arnold Kelf, an explosives expert, who was responsible for attaching wiring devices to most of the bridges in the Felbridge area in case of a German invasion.

After the defeat of Dunkirk, there was an acute shortage of rifles and ammunition, most of the equipment had been left on the roads and beaches of France. As new equipment was produced it was allocated to the regular and conscripted troops. The Home Guard drill often involved using broom handles instead of guns. Some units had First World War bayonets strapped to the end of the broom handles for bayonet practice. Gradually anti-tank grenades and First World War rifles were issued during 1941, most of the rifles originated from the USA and Canada.

Uniforms and equipment were slowly acquired. By the end of June, most Home Guards were equipped with denim overalls, trousers, boots, leather gaiters, forage caps and a replacement khaki armband embroidered with 'L.D.V.' to show that they were military personnel not guerrilla fighters and were therefore protected by the Geneva Convention. A few rifles were available for men on duty which were kept at the post HQ with ten rounds of ammunition for each rifle. Eventually battledress, greatcoats and finally respirators were issued in sufficient numbers to equip all ranks. A few Thomson sub-machine guns (Tommy Guns) were issued to NCOs.

The Thomas sisters of Brook Nook in Furnace Wood had set up a riding school before the war and feared that their horses were threatened after war was declared. Riding was considered a luxury and food for the horses was scarce. Their father was the Officer Commanding the Home Guard Felbridge Platoon, Lt Jack A. Thomas, who enlisted all his daughters' horses as a means of transport for the Felbridge Home Guard, an action that ensured their food allocation and survival. As such, the Felbridge Home Guard was the only Home Guard unit to have 'pack horses' during the war!

Although drill and small arms training took place locally at the Drill Hall and at Hobbs Barracks, the main Home Guard Training School was at Denbies, near Dorking. Denbies was then a large nineteenth-century mansion house owned by Henry, 2nd Lord Ashcombe, and Lord Lieutenant of Surrey. The house became the training HQ of the Home Guard where recruits received professional instruction in operating Spigot Mortar Guns. Training in handling bombs and grenades took place at the nearby Bury Hill. A travelling wing of regular officers and three Warrant Officers instructed all Companies of the 9th Surrey (Oxted) Battalion in tactics and weapon training.

Field-craft training centres were established throughout England. At Burwash, a training centre taught bivouacking and camouflage, a field-craft centre was established at Bletchingley (at an overgrown golf course), and another at Shagbrook, Reigate Heath. The emphasis of training was drill, bayonet practice, rifle training, anti-aircraft action, field-craft, signalling (including radio transmitting and receiving) and first aid. Units were taught to make Molotov cocktails from glass bottles, petrol and a wick of cloth. Engineers among the ranks of the Home Guard devised homemade booby traps to delay advancing troops.

The Battle of Britain coincided with the arrival in the area of a brigade of the 1st Canadian Division. The Seaforth Highlanders of Canada were billeted in Limpsfield and instructed the local Home Guard on field warfare. Many of them were trappers and had developed the ability to cover the ground unseen and unheard. According to W. A. D. Englefield, the author of *Limpsfield Home Guard*, no Home Guard ever reached the same standard as the Canadian troops. The Rector of Burstow welcomed the arrival of 'the troops from overseas ... a splendid body of men ready to defend these shores, if Hitler ever did try to invade us'.

Being too young to join the services, Ken Housman joined the Home Guard and went on several manoeuvres with the Felbridge Home Guard around Felbridge. One manoeuvre in Lingfield involved Canadian soldiers pretending to be Germans. Felbridge Home Guards were caught in a hollow between the road and a barbed wire fence. Ken fired at the Canadian soldiers, having a banger at the end of the rifle to give a bang sound. The response was that the Canadians threw a thunder flash at him, which blew up at his feet. Captain Jack Thomas was captured and frog-marched off to the 'Headquarters'. When Ken caught up with him he was covered in flour as a Spitfire had been bombing the Headquarters with flour!

In Holland and Belgium, the Germans had dropped parachute troops behind the main defensive lines and it was expected that an invasion attempt on Britain would follow along the same lines. The primary object of the Home Guard was to offer stout resistance in every district and to meet any military emergency until trained troops could be brought up. They were expected to delay the movement of troops that had landed, to maintain communications by signals and runners and if necessary carry out rescue work, fire fighting, first aid, evacuation of refugees and the maintenance of food supplies.

Guarding Nodal Points of defence was a priority. All Nodal Points had been identified by police and local authorities and agreed by the Home Office in 1938. They were strategically important sites and included vulnerable road junctions. Nodal Points were identified at Limpsfield,

Godstone, Newchapel and East Grinstead. They were garrisoned normally by local Home Guards with the addition of any available troops stationed in the vicinity. One of the main duties of E Company at Limpsfield was the defence of the Nodal Point at the junction of the east-west A25 with the north-south B269. Platoon battle positions surrounded the intersection of the two roads. Similarly, 21 Platoon, F Company (Felbridge) defended the Nodal Point at the intersection of the north-south A22 and the east-west B2028.

The civil population living within the military perimeter of Nodal Points were required to stay put under invasion conditions, unless given instructions to go elsewhere. They were to be told what was expected of them and why – i.e. to prevent refugee problems being added to the dangers of invasion and to safeguard the people themselves from motor transport, armoured fighting vehicles, and troops landing from planes and gliders, or by parachute.

The War Office considered that the Home Guard should be trained to deal with enemy parachutists and tanks. They were to guard the Company Headquarters, the telephone exchange and the 'Stop Line' (a continuous

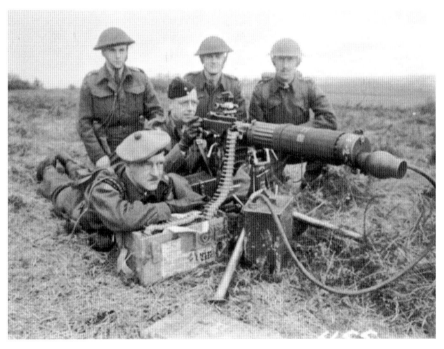

Officers of the Cameron Highlanders of Ottawa (M.G.) with a Vickers Heavy Machine Gun, 8 April 1942 (possibly Dry Hill, Dormansland). The Canadian Army had a leading role in training Home Guard Companies. (*Photographer: Capt. Frank Royal, PA – 145777, Library and Archives Canada*)

east-west line of anti-tank obstacles from the west of Horne to the Kent border at Haxted). Lingfield and Dormansland units were also expected to support the guard units at the Aliens Camp on Lingfield Racecourse.

The Home Guard gave armed support at the scene of all crashed aeroplanes; reported all aerial attacks to police HQ, including the number of exploded and un-exploded bombs, number of known casualties, the possibility of buried casualties and damage to property. They also maintained a guard at potential enemy targets. Fighting posts were manned each night from dusk to dawn by sentries with loaded rifles and fixed bayonets.

On 3 Sept 1940 Major Bull, the Officer Commanding B Company (Woldingham/Tatsfield), reported:

there was a heavy air battle over this district and a number of machines were brought down ... at 1 pm a Hurricane crashed on Fuller's farm, near his house [Halliloo Farm, Woldingham]. I arrived there about 1.15 and found, from info given to me by the police and my own enquiry [that] Fuller saw the machine crash, petrol was running from it, the pilot was pinned inside, Private Fuller personally with the help of two of his men tore open the cockpit and did all in his power to give first aid to the pilot and extricate him. He was unable to do so as the machine was resting on his legs. He felt his pulse and attended the pilot till he died, caused a telephone to be sent to the police and took charge until help arrived. He showed remarkable coolness and efficiency.

A week later (11th Sept) a stick of bombs fell on his farm. Fuller dashed out examined all the craters and put men in charge to prevent anyone going near them as he suspected delayed action bombs amongst them. Shortly after 250 or so Incendiary bombs fell on another farm of his, Warren Barn Farm, Private Fuller and his men went out in the heavy bombing which was taking place all around and dealt with the incendiaries. There was a heavy attack on at the time on a 'dummy aerodrome'.

The dummy aerodrome was at Farleigh Common, Warlingham, one of several constructed throughout the country to deceive enemy bombers. They were fully equipped with dummy aircraft and buildings. Private Charles Martin Fuller was later promoted to L/Cpl, Cpl, and finally Sergeant, in January 1942. In July 1942, at a Company Parade at Woldingham, Sgt Charles Martin Fuller, Halliloo Farm, Woldingham, was presented a certificate for Meritorious Service by Lt-Col. Ian Anderson, CO Oxted Home Guard Battalion on behalf of the C-in-C, Home Forces.

Nearly forty years later, in 1977, Charles Martin Fuller wrote an article about his two farms for the Bourne Society. Of the war years he wrote:

'we collected about 6 bombs, many incendiaries, one Hurricane fighter, one V-1 and parts of a V-2 and had one cow killed by a cannon shell. At the commencement of the war we had an extensive dairy business and the cows were fed on cheap imported foods which were mostly by-products of cereals and oil seeds. With the U-boat menace, supplies became short and we had to become self-supporting ... the family took over Warren Barn Farm.'

During the late afternoon of 7 September 1940, witnesses saw squadron after squadron of German planes flying high in the sky, moving slowly northwards, like clouds of gnats in the sunshine. The first heavy daylight raid on London had begun, night raids followed immediately, the Battle for Britain had started in earnest, and Hitler's paratroops were expected any day.

Major Bull reported an incident in October 1940 when 'a bomb was dropped on Limpsfield Rd. Warlingham, hitting a truck carrying Canadian soldiers, several of whom were killed, some blown to bits and others burned to death. Private Gordon T. Jell of Botley Hill Farm heard the bomb and rushed out of his house, found what had happened and sent his wife to telephone for the Police and ambulance and ran all the way under the bombing to Beach Farm and brought out the Home Guard who remained out all night giving what help they could.'

There was little that the average householder could do during an air raid, other than seek shelter. Leonard Sandall, the Lingfield dispenser and self-styled field naturalist and microscopist, wrote in his log book:

> dozens of planes in the sky overhead – a terrific din! Big guns and anti-aircraft guns making the devil's own row but I did not budge. I went on writing and looking at slides and turning out notes ... and so keep my mind and my pen occupied and away from the wretched and wicked war ... I only came down [the stairs] once when there was a dog-fight over my house and I was afraid that one of them would come down on to the roof and catch the house alight ... They swooped down on each other at roof height – gunning each other, then off they flew and I went upstairs to bed to finish my sleep and cuss them for all this foolery.

Local Platoons of the Home Guard made frequent night patrols looking for any signs of abnormal behaviour and checking open spaces which would make suitable targets for parachute landings. Manoeuvres were arranged with neighbouring platoons, one playing the enemy. On 27 April 1941, Lingfield F Company attacked Limpsfield Nodal Point from the south and quickly overran Limpsfield's defences. The Nodal Point was guarded on all sides by Limpsfield E Company. As a result of the defeat by Lingfield

Home Guard the garrison at Limpsfield was strengthened and gun sites for the Spigot Mortars were erected at strategic positions for the defence of the Nodal Point, each in the charge of a lieutenant.

In December 1941, company officers attended an address by the S.E. Army Commander, Lt-Gen. B. L. Montgomery at Reigate. Precisely on time the general arrived on stage where he stood perfectly still, except for some adjustments to his Sam Browne (officer's leather belt) and slowly waited for his audience to assume absolute silence. Without reference to any notes and against the background of an enormous map of the world the general surveyed the war situation in all parts. He then went on to explain his plan of defence for this country. The plan was to prevent the enemy establishing a beachhead, but, if the enemy succeeded, then to break up the main thrusts and launch a counter-attack.

The role of the Home Guard as he saw it was:

To hold defendable towns and villages.
To provide observation posts and scouting parties – to locate and report on the enemy and to supply information and guides for the Field Forces.

In 1942, the 9th Surrey (Oxted) Battalion Home Guard was strengthened by compulsory service recruits. In August of that year, reinforcements from the Women's Home Defence League joined the Limpsfield Platoon; four joined the Signals Section as general purpose signallers, and five others operated the telephone and became signal clerks.

By 1943, fears of a full-scale waterborne invasion were past but invasion by air was still considered a possibility. The Home Guard became the main home defence organisation as locally based units of British and Canadian forces were in training for the assault on the German held territories in Europe.

Auxiliary Units

The secret organisation known as the Auxiliary Units was formed in May 1940 under the guidance of Colonel Colin Gubbins, Head of the Special Operations Executive. Officially part of the Home Guard they wore the same uniform but operated independently of the Home Guard. A veil of secrecy surrounded the Auxiliary Units; even the close families of those involved were unaware of their involvement in anything other than Home Guard manoeuvres, a potential seedbed for troubled relationships. Husbands could be absent from home for weeks on training exercises whereas Jack next door was only ever away with the Home Guard for a

day or two at a time! Secrecy caused several problems for the command structure. One retired Brig-Gen., then officer in charge of the Home Guard in the Portsmouth area, insisted that Auxiliary Units in his area operated under the command of platoon commanders and 'are not to use their initiative'. The irate Gubbins wrote to Lt General Auchinleck, GOC Southern Command and in overall charge of the Home Guard to complain, 'their whole operation is vitiated if they merely act with the rest of the Home Guard ... I would be grateful if you could have that made clear to the Brigadier-General'.

Gubbins' headquarter staff comprised intelligence officers and specialist munitions experts who very quickly set up a network to recruit suitable civilians from all walks of life, but often farmers or gamekeepers, people who had an intimate knowledge of the terrain and could be trusted to operate in total secrecy. Once selected as a likely recruit a letter of introduction was sent from GHQ Home Forces to the relevant County Chief Constable. Local police made a thorough investigation into the recruit's background but were never told the purpose of the investigation or its outcome.

Patrols of six or seven men were selected for their personal qualities of courage, initiative and resource, who were prepared if necessary to work behind the enemy's lines sabotaging their lines of communication. The patrols were resistance cells, stationed around the coastal areas of England, Wales and Scotland in case of a German invasion. The coastal strip extended in key areas to a maximum of thirty miles from the sea, an area which included most of Kent and Sussex.

Before the war a secret department in the Foreign Office known as 'Section D' was working on the development of special weapons which could be useful to a guerrilla force. In the spring of 1939, Military Intelligence (Research) took over the coordinating role of weapon development and the organisation of guerrilla units. Colin McVean Gubbins, a member of the Military Intelligence (Research) Unit, (MI(R)), wrote three training manuals that were to become universally used by clandestine agents.

A sticky bomb was one of the new developments by MI(R), an armour piercing grenade covered with a tacky substance designed to adhere to tanks. Their other gadgetry included an RAF trouser button that could be turned into a compass to help airmen escape from POW camps.

Some of the men were trained to infiltrate invading forces. The patrols were equipped with fighting knives, one hand torch, one spare torch battery, one spare torch bulb, two hurricane lamps, mess tins, three tin openers, one chemical closet, one chemical Elsanol and four shell dressings. Personal packs for every individual contained one gallon jar of rum, two gallons of paraffin and 1 lb candles. Other equipment included one pair

rubber boots, water sterilisation sets, one wick-less oil stove, two shovels, a pick, one helve pick and one thermometer. Should an invasion occur units were expected to survive for a maximum two weeks. Those auxiliaries who survived this period would have reverted to their civilian occupations in the hope and anticipation of a successful British counter attack.

The main training base for GHQ Auxiliary Units was established by HQ Southern Command at Highworth, Wiltshire. Training of specialist units took place at several locations, Blandford, Coleshill Park and Salisbury, and a small school of instruction at Faringdon, Berkshire. Special equipment was provided including assault boats for reconnaissance and waterproof leather despatch cases for motorcyclists. Each officer was equipped with a pistol, magnetic pocket compass and binoculars.

Auxiliary Units received training in the martial arts. They learned how to kill silently, to blow up bridges and railways, to blow gearboxes and back axles and how to blow the tyres off aeroplanes with gun cotton. They were equipped with plastic explosive and fuses and learned about the various types of fuels which burned at different speeds.

Each patrol had an underground Operational Base capable of holding three men. The OBs were constructed either by Royal Engineers or by civilian contractors. The contractors and any curious locals, were told that these were to be emergency food stores. Situated usually in dense woodland, the bases were constructed of brick, concrete and pre-formed corrugated iron segments with waterproof seals. They were sunk into the ground and had concrete pipe access and escape tunnels. Entrances to the bases were made under hedgerows and trees and amidst undergrowth, clay pipes were hidden in the hedges and undergrowth to provide ventilation to the underground chambers. Ingenious methods were used to camouflage and operate the entrance trap doors. Rat poison was sometimes spread under the surrounding undergrowth to disguise the smell of humans in order to put dogs off the scent. Accommodation included wooden bunks, a water tank, a tilley lamp and a cooker. Explosives and ammunition were stored separately. Operational stores and rations were sufficient for fourteen days only – the anticipated useful life of the fighting patrols of the British Resistance. At no time during enemy occupation would they ever have returned to their homes or have tried to communicate with their families.

The identity of individual Auxiliary Unit personnel will probably remain secret. Individuals were sworn to secrecy at the time and most have remained silent over all the years. One record at The National Archive indicates that at least three personnel lived in the East Grinstead area and two lived in Sharpthorne. The locations of their concealed Operational Bases are unknown.

Special Duties Zero Station, Wakehurst Place

Unknown to the Auxiliary Unit Patrols, a completely separate Special Duties Section of the Auxiliary force established a wireless network across the south of England. Also housed in underground bases known as Zero Stations, they were secret radio stations for receiving and transmitting military intelligence in the event of a German invasion. One Zero Station was built by the Corps of Royal Canadian Engineers in the gardens of Wakehurst Place, north of Ardingly. The underground corrugated iron construction had three chambers and an escape tunnel.

Zero Stations were manned by specially trained women of the Auxiliary Territorial Service. The women were selected by the Senior Commander of ATS personnel, Beatrice Temple. Three ATS women were to live in each concealed underground hideout if the Germans landed in England. Their job was to receive news of invading troops from out-stations on the coast and relay the news to HQ. For their own and others safety they knew nothing of the organisation of the Auxiliary Unit Patrols. They were also trained in the art of spying and set up secret 'letter boxes' in hollow trees, bird's nests, drain pipes and other suitable hiding places in which they could hide information on enemy activity after an invasion. The letters would be collected by other unknown agents operating in the area.

All Zero Stations were built and equipped to the same pattern. The entrance to the underground Zero Station had a wooden hatch, concealed below undergrowth, the door release mechanism, once hidden in a nearby tree, long disappeared. Under the hatch was a small compartment lined with shelves, when a certain part of the shelving was pressed a wall would swing up to reveal the inner operating chamber, the radio station. Wireless sets were encased in a metal box and could withstand damp conditions. They were powered by large six-volt accumulator batteries and could operate on high frequency over a short distance of ten to twenty miles. Inside the chamber would have been three beds for the women operators, rations, batteries for the radio and an air purifying machine. The generator chamber was behind another sealed door at the rear of the operating chamber. The generator in this third chamber charged the accumulator batteries and provided lighting for the three chambers and ventilation for the air purifier. If the Germans had discovered the top compartment, the operators (members of the Special Duties Section of the ATS) were to destroy the codes and the equipment and escape via the generator chamber through an escape tunnel leading to the surface, the exit buried beneath undergrowth some distance away from the station.

Each Station had two transmitters and two receivers, one set in use every day during the existence of the radio network, the other for special

The now collapsed entrance to the wartime underground base built by the Corps of Royal Canadian Engineers.

One of the nearby trees with radio wires concealed in the grooves, once part of the wartime communication system. The radio aerial antenna, originally hidden high in the top of the tree, was erected by the Royal Canadian Corps of Signals.

transmissions concerning imminent invasion. The everyday broadcasting equipment was usually kept in a hut above ground, within 500 yards of the underground Zero Station.

In November 1941, Commander Beatrice Temple was appointed Senior Commander of ATS personnel and assigned to the Auxiliary Units. Beatrice Temple, was the niece of the then Archbishop of Canterbury, William Temple. She joined the ATS in 1938 and after officer training was appointed Company Commander attached to the Seaforth Highlanders, with the rank of Captain. Beatrice Temple was promoted to Major and Commander of the ATS units in 1941 and set about the task of selecting radio operators for the Zero Stations. Major Temple interviewed almost a hundred volunteers for the Special Duties Auxiliary Units in the fourth floor lounge of Harrods in Kensington, London. In interview twenty years later she explained 'the chairs were far enough apart so that we could carry on a conversation without being overheard. After the interviews, whether the women were acceptable or not, I always rewarded them with a free afternoon in which to shop.' The women were selected for having a clear voice and accents that could be easily understood in any part of the country, they had to be intelligent, even-tempered and completely self-reliant.

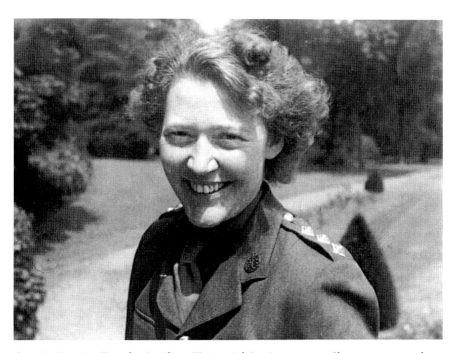

Captain Beatrice Temple, Auxiliary Territorial Service *c.* 1939. She was promoted to Major in 1941. (*Sir Michael Davies*)

The dangerous nature of the work was explained to the girls who were chosen for their self-reliance, initiative and clear voice, essential for transmitting military intelligence. The successful applicants were issued with an instruction warrant: to take a train from Liverpool Street Station, change at Marks Tey, Essex, and get out at Hundon in Suffolk. There they must make their way to the Rose and Crown public house where a car would come for them. Following voice tests at Special Duties Signals, Hundon, recruits began a period of detailed training at a secret location somewhere in Essex. The women were instructed in the maintenance of the small radio telephony sets, deciphering/enciphering codes, and the use of a rifle and pistol (although these were not issued to the officers). This was followed by a shortened Course at No. 1 ATS Officer Cadet Training Unit, Edinburgh and subsequent posting to Auxiliary Units with the rank 2nd Subaltern.

The ATS officers were allocated to Zero Stations in three-woman units and billeted nearby. The mansion house at Wakehurst Place would probably have been the billet for the ATS officers as the area was well hidden in the Sussex countryside with few other buildings in the vicinity. The house was also occupied by HQ Forward Planning, South East Command.

ATS watches were programmed to listen out for broadcasts by suspect agents. Any contact had to be reported immediately to the G2 Intelligence at the Area HQ. Their main task was to link up with a network of out-stations along the coast. Intelligence reports of an approaching invading force would be received by telephone link from specially trained civilian personnel based along the coast, who were equipped with hidden transmitters. The messages were received in code and passed on HQ Special Duties Signals. The only instructions ever committed to paper were changes to codes; the instructions were written on special digestible paper which had to be chewed and swallowed.

If anybody asked the ATS women what their work was, they merely answered 'Signals'. Their final reply to persistent questioners greatly superior in rank was: 'I'm not allowed to tell you, but I can give you the name of somebody who can'. The 'somebody' was usually the officer commanding the Resistance's signals HQ at Hendon. David Lampe the official historian of *Britain's Secret Resistance* reported that someone in ATS HQ at the War Office once asked Miss Temple, 'What exactly do your officers do? We hear that they sit in caves all day and knit'. Miss Temple smiled, 'That's what they do.'

The operators were required to keep on air as long as possible after the country had been invaded, even after the stations themselves had been overrun. Their orders were that all three would remain with the zero

transmittor until they heard the Germans actually breaking into the outer room. Only then could they smash the transmitter and escape through the emergency pipe. Describing the underground stations in an article for the *Lewes Evening Argus* in March 1968, Miss Beatrice Temple, then Mayor of Lewes, wrote of her own fear of claustrophobia, 'I should not have cared to crawl along them [the escape tunnels] however many Germans were after me.'

Out-stations were simply locations for hidden radio telephony sets sited in private houses, inns, garages, boat sheds, dug-outs, barns and other seemingly ordinary places. The carefully selected men and women who operated the out-stations could be doctors, office clerks, fishermen, housewives or retired military personnel. The civilian spotters had no uniform and could disappear into a crowd unnoticed.

Wakehurst Place became the Forward Planning HQ for South East Command in 1942. Headquarter staff of the Canadian Forces were based in the house from January 1942 until the Spring of 1943, initially under Brigadier Harold O. N. Brownfield, Commander Corps, Royal Artillery, 1st Canadian Corps.

In the build-up to D-Day, the headquarters of two of the four British Corps involved in Operation Overlord were in West Sussex. The 8th Corps used Wakehurst Place, Worth Priory and The Grove at Worth; the 30th

Wakehurst Place, Ardingly: Forward Headquarters of South East Command 1942-44.

Corps used Milton Mount College at Three Bridges. The Staffordshire Yeomanry, 27th Armoured Brigade, occupied Wakehurst Place between April and May 1944.

The Construction of GHQ Zones and Anti-Tank Stop Lines, June-August 1940

At the beginning of the war most attention was given to planning the construction of defensive road blocks in the south-west of the country, from Cornwall and Devon and extending to a line east of the Isle of Wight and north to the Salisbury Plain and eventually to Reading. With mounting tension and increasing threat of imminent invasion General Ironside put forward his plan for further anti-invasion measures which were agreed by the War Office in 1940. Defensive rings were constructed around aerodromes, cities and industrial plants throughout the country, and a further series of Stop Lines to contain and delay an advancing invasion force.

The line of pillboxes, remaining in the fields of south-east Surrey sixty-five years after the end of the Second World War, was built in 1940/41 as part of the extension to GHQ Stop Line running from Reading, through Hampshire and Surrey to Kent. The Surrey section follows in part a line south of the North Downs.

A series of continuous lines of anti-tank obstacles, consisting of wide, deep ditches or a series of irregularly shaped concrete blocks, foxholes and rolls of barbed wire were placed along a line of natural defences, mainly earthworks and rivers. Lines of pillboxes were constructed at irregular intervals, in places double lines of pillboxes were built to reinforce vulnerable points in the natural topography. The Stop Line was completed by local contract labour in a relatively short space of time. Stop lines were planned to confine and isolate an attack from any direction and to block or delay the progress of invading armoured columns until the arrival of local military units, thus setting them up for a counter-attack.

Various bridges and crossings were demolished, or defended by units of the Home Guard. Generally main road bridges were maintained and defended, while minor road bridges were demolished. Ray Bridge was demolished on the road between the main Eastbourne Road and the village of Lingfield. Canadian soldiers erected a wooden footbridge at the site of Ray Bridge, which could be easily destroyed in the event of invasion. The wooden bridge provided much relief for the villagers who needed to maintain economic links with neighbouring villages. Minor road bridges over railways were demolished, whereas railway bridges over roads were defended by the Home Guard.

The Chief Constables of Surrey, Hants, Bucks, Berks, Oxon, Dorset, Portsmouth and Southampton, and representatives of Aldershot Command, the XII and IV Corps, were ordered to attend the office of the Regional Commissioner for Civil Defence at the HQ in Reading on 22 July 1940 to discuss essential transport communication in their areas. The main item on the agenda was:

> Keeping essential roads clear – It was essential for Chief Constables to obtain supplies of direction signs, especially No Entry signs which would be useful in keeping evacuee traffic away from reserved roads. It was the Military responsibility to provide barriers ... the Police with their local knowledge should give all possible help ... panic evacuation plans made some time ago dealt with the panic movement of population consequent upon heavy bombing ... there should be at least one withdrawal exit from each town to act as a safety valve ... panic evacuation schemes had been prepared only as regards Portsmouth and Southampton.

Pillboxes

Several designs for pillboxes were approved by the War Office in 1940. All had walls of reinforced concrete 3 foot 6 inches thick, often with a brick facing (some were camouflaged with local materials). They were built by local construction companies to many different designs often disguised to look like barns and bridges, one pillbox overlooking White Bridge at Blindley Heath was disguised as a tea room, complete with a dummy chimney; notices on the outside advertised teas and snacks.

Access to the pillboxes was by one steel door, 4 feet high by 2 feet wide. Most were fitted with turnbull mountings for guns allowing a 60 degree arc of fire. Pillboxes aligned on the Stop Line were built at irregular intervals, some only a few feet from each other, others set up to 100 yards away from the nearest pillbox but always in range of the guns for defensive purposes. The most common types of pillbox in the south-east Stop Line were:

- **Rectangular** with 'loopholes', or gun apertures, on opposite walls offset from the centre so that they were not sited opposite to one another. Loopholes could be either on the short sides, long sides or on adjacent walls.
- **Pentagonal** with loopholes on two adjacent sides or on opposite sides.
- **Hexagonal** with one loophole to each outer face, the rear face having a doorway flanked by two loopholes.

- **Disappearing Concrete Pillbox.** The concrete roof was at ground level when not in use but rose 2 foot 6 inches above the ground when required for defence and surprise. The box was lifted by compressed air or a hand pump. Designed primarily for the static defence of aerodromes, they were sited in the middle of the aerodrome or unobstructed road. It could also be employed as a tank ambush if sited on the defender's side of a humped back bridge. The low command of the pillbox enabled fire to be directed on to the floor of a tank as it reached the crest of the hump back.

Pillboxes began springing up in hundreds, not always as planned. They were built by local construction companies and were often modified to suit a particular site; some did not meet the official criteria. Reports reached GHQ Home Forces that contractors had changed the sites of pillboxes after they have been fixed by reconnaissance and a directive was issued on the 15 July 1940:

> These changes have apparently been made either in error or with intention owing to difficulties in the site chosen. Changes of this nature cannot be allowed. Where they have occurred orders will be issued for the work to be demolished and rebuilt at the contractor's expense on the correct site.

An appendix was added, 31 July 1940: Protection against flame throwers:

> Definite information is not available but it appears that the Germans may possess portable flame throwers with a range of 30 to 40 yards with a flat trajectory. Larger patterns carried in vehicles may have a range of 150 yards. Somewhat fantastic claims regarding the heat of the jet are sometimes made but there is no scientific evidence to support the assertion that flame throwers are capable of burning holes in steel plates and destroying concrete. On the other had, the moral effect of this form of attack is great and protection is therefore necessary. It is probable that the method of attack would be for the flame thrower to be directed at a loophole from such an angle that the defender would be unable to fire at the attacker. Tests are taking place to design an appropriate shutter for the loopholes.

Tests also showed that a bullet striking the splayed side of a concrete loophole, usually disintegrated, and if the loophole was smooth, the fragments would be projected with considerable velocity into the pillbox.

Loopholes with smooth splayed sides, therefore, constituted a danger to the defence, and where they had been provided in pillboxes, were to be modified by cutting a series of steps about one and a half foot deep in the face of the concrete. This could be affected with a hammer and cold chisel or by means of a pneumatic hammer.

More design faults soon became apparent. Queries were raised on the suitability of mountings for machine gun or Bren-guns, mounting frames were cemented into the wall below the loopholes. It proved difficult getting a 2-pounder Mk. II anti-tank gun into action in an emplacement built to specification.

Finally on 12 March 1941 came a command from HQ:

Pillboxes have many disadvantages; they give a false sense of security to the garrison, make them static minded and prevent the full employment of the weapons. It is for this reason that it has been laid down that they are to be used only for Vickers and light automatics. Many pillboxes located at a distance from buildings, are very conspicuous and draw attention to what otherwise might be well concealed positions. No more pillboxes will therefore be built after the completion of existing contracts except in the case of aerodromes, military establishments and

Internal view of a pillbox, the position of the frames for the gun mountings is clearly visible in the walls below the stepped loopholes. The brick structure on the right is part of the central blast wall. The blast wall was intended to prevent grenades or small shells from killing all inside.

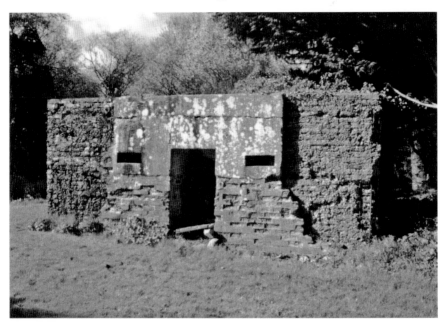

One of forty-four pillboxes that remain in the vicinity of Lingfield, 2009, a type twenty-four standard design pillbox an irregular hexagon. The entrance is in the longest and rear face on the north-east side, the doorway flanked by two loopholes. It has a central internal, freestanding blast wall aligned on the doorway.

those places where the nature of the country provides full facilities for concealment.

The main difficulty is to know when to put the crew into the pillbox and to communicate with them once they are in. Further, they can only be expected to remain inside for a limited period.

All those pillboxes which are in any way obvious should be evacuated as soon as alternative positions can be built. Such pillboxes should be retained as decoys. Instead of pillboxes, units will arrange to construct fire trenches of narrow type and solid revetment – concrete where necessary. The widest possible field of vision must be provided for every rifleman. Vickers and Lewis Machine Guns positions will be built to fit into the contours of the ground and must not stand up above the parapet.

The Battle of Britain

The battle began over the sea on 8 August 1940 and over land on 10 August. The first targets were the airfields of south and east England. RAF pilots took off to defend the airfields from attacks from the German Luftwaffe.

Lingfield Junior School Log Books show that air-raid warnings were sounded almost every day after 23 August 1940, some days there were several alerts and school attendance was affected. As the raids increased in severity, with frequent bombs and machine-gun fire, many children were kept at home. The Chief Warden regularly inspected the children's gas masks. On one occasion the children wore their gas masks for the whole of the first lesson (twenty-five minutes).

An incident which took place on 30 August 1940 caused excitement in Lingfield and the surrounding countryside. The sequence of events was published in *The Blitz Then and Now* (Vol. 3):

Pilot Officer John D. B. Greenwood flying a Hurricane of No. 253 Squadron, newly based at Kenley, shot down a Heinkel 111 which force-landed at Haxted Farm, Lingfield at 11.35 am. The aircraft had been on a bombing raid on Farnborough. Of the five man crew onboard, one was killed, 2 were captured wounded and 2 captured unhurt.

Memories of the event resemble a film farce made by J. Arthur Rank. Three schoolboys furiously pedalled towards the Haxted site, from different directions. Meanwhile bobbies on bicycles and Home Guards were pedalling towards the same site. Brockley schoolboy Dave Mitchell takes up the story:

Kenny Newell and I were ... guarding the rear hatch door leading to the cellar of the New Star Inn, the cellar doubled as the school Air Raid shelter ... we spotted a Heinkel III, only a few hundred feet above and nicely on fire. We sprang for the opening, hit the saddles of our waiting bikes and tore off after the Hun, which we could now see over the station and turning to port pursued by a Hurricane, then back towards Haxted Mill, then further round towards the brickworks and finally it came down in the fields of Crowhurst. Helped by the smoke trail we left the road and rode across the fields until we met a great score on the ground which we could follow through a smashed hedge and into another field where the wrecked aircraft lay.

 We arrived as the crew was climbing out and lifting a terribly injured comrade to the ground. Others were arriving from all quarters, farm workers, and a couple of Home Guards, Police, and eventually an Army field ambulance. We stood around helplessly while the man, who had lost his forehead, was laid in a truck. It rocketed across the field, stopped suddenly, and an orderly opened the back and shouted, no doubt with compassion, "he's dead".

Meanwhile another schoolboy, Dennis Leman was furiously cycling from Dormans Park:

> ... when a bomber came down just the other side of Lingfield, a Heinkel. I cycled over there and the crew were still sitting in the aircraft in the middle of the field. It made a pancake landing and I stood at the farm gate watching them and wondering what to do ... then these four blokes came out and eventually an army truck came along and took them away. I then climbed into the aircraft and had a good look around and tried to pinch a few souvenirs, it made life interesting.

David Gorringe, a Constable in the Police War Reserve, attended the crash site off the Haxted Road and accompanied one of the injured German airmen to Edenbridge Hospital.

All schoolchildren were continually warned of the consequences of souvenir hunting in the debris of crashed planes. The Rector of Burstow wrote in the church magazine, 'I am asked to draw my reader's attention to the fact that any fittings or parts of aeroplanes that may be found should at once be handed to the police or military. Anyone detaining them is liable to prosecution' (Revd A. Hackblock, September 1940). Mrs Green, wife of the Brockley Headmaster, discovered bits of aircraft under the beds at Ranworth while hunting out the source of an evil smell which turned out to be coming from the camouflage dope painted on the aircraft parts. The parts were consigned to the woods around Dormans Park, much to the frustration of the boys. 'Wag' the headmaster reprimanded Dave Mitchell and Kenny Newell for doing a bunk to Haxted in search of aircraft parts:

> We were torn off a monumental strip, reduced to the ranks and given a fair old caning, on top of the sobering scene we had witnessed. It left us 'considering our position' as they say. Made of sterner stuff (more likely obstinate to the end) we formed E.P.U., the Ex-Prefects Union.
>
> In time the kindly Wag found reasons to re-appoint us and we would proudly wear the little enamel badge again. But not for long. Whilst we would like to think that our services were vital to the school during the last few weeks of our attendance one must draw the conclusion that our final re-appointment as prefects was to enhance our leaving testimonials and for that, and so much more, thanks Wag, wherever you are.

According to Denis Leman:

> a dozen or more aircraft ... crashed within cycling distance of Dormans Park and I think I must have visited most of them. One in particular

was a Messerschmitt 109, a single-seater, which came down near the railway bridge in Tandridge Lane, by the pub [The Brickmakers' Arms]. On the right hand side there, it crashed into the field and had come down vertically from about 20,000 feet, completely burying itself into the ground and all you could see was just a hole on the surface and as far as I know that aircraft is still buried there. Quite a lot of the crews of these aircraft came down by parachute and I was always hoping that none of them would fall in our garden.

During the period of the Phoney War, between September 1939 and April 1940, several evacuees returned home, several came back to the relative calm of the Surrey countryside when the Battle for Britain began in 1940. Although the spectacle of aerial dogfights in the skies above Kent and Surrey became a daily entertainment for those below, the evacuees were also anxious about their parents and their homes in London. Some distraught children started bed-wetting. The daily fear for their parents' lives caused some to 'run away' to check up on their parents, others had frequent nightmares. Inevitably some of the children did lose a parent, or both parents in the Blitz, and the London homes of several were destroyed.

The Blitz of London

The term 'Blitz' was taken from the German 'Blitzkrieg', meaning 'lightning' war; first witnessed on 1 September 1939 when 1.25 million German troops with tanks swept into Poland. The London Blitz began in the late afternoon of Saturday 7 September 1940. On the first day, 430 citizens were killed and 1,600 were severely injured. Intensive high-explosive bombing of the dockland areas destroyed homes, schools, churches, shops, factories, warehouses, roads and railways as well as the docks. The area of bombing widened to cover the whole of central London, the intense bombing continued until 11 May 1941. The vibrating hum of engines and the rattle of machine-guns filled the air above the fields of Kent, Surrey and Sussex

On the night of 10/11 September 1940, there was heavy bombing of both London and Berlin. Daylight brought deterioration in the weather; there was little enemy action during the morning. The weather improved in the afternoon when German bomber formations were reported building up in the Pas-de-Calais shortly before 3 p.m., they were accompanied by about 200 fighter aircraft.

The bombers flew up the River Thames to London while the fighters pulled away to the south and formed up in circles over the Croydon area

to cover the withdrawal of the bombers but, it was later reported, had wasted too much fuel on the approach to the target and had to break off and return to base in France. The Heinkel bombers were left without protection. Sixty aircraft of No. 6 Squadron, Hurricanes and Spitfires fell upon the retreating bombers. (*The Blitz Then and Now*, Vol. 3)

One of the bombers, a Heinkel He III, was hit in one wing by anti-aircraft fire over London. The aircraft rapidly lost formation; both engines were then disabled in attacks by the RAF. Four of the five-man crew were seen to bale out as the crippled aircraft flew over Dormansland, its path being tracked by the Home Guard. The pilot, Oberleutnant W. Abendhausen baled out and was captured unhurt. Unteroffizier H. Hauswald baled out and was captured wounded. Two airmen baled out but were killed; the parachute of one remained caught on the wing of the aircraft, the other's parachute failed to open. The plane crashed and exploded at 3.45 p.m., at Hoopers Farm, Dormansland. The body of a fifth crewman was found in the wreckage.

The three dead German airmen were Feldwebil Heinrich Westphalen, age twenty-eight; Unteroffizier Bruno Herms, age twenty-three; and Gefreiter F. Zahle, age unknown. They were buried in Dormansland churchyard on 16 September, a dull wet day. The short graveside service was conducted by Revd E. A. Shattock.

The area *Police Day Book* record of the forty-eight hours between midnight on 27/28 September and midnight on 29/30 September shows that there were 172 alerts; reports of crashed and disabled aircraft and exploded and unexploded bombs. Extracts from the *Day Book* entries:

Parts of a German plane fell in field ... due south of Puttenden, 2 Machine Guns and other units have been called by Lingfield Police.

Spitfire has come down in flames in Felcourt District. Wardens investigating.

Hurricane down at Mrs Downs' Farm near Hobbs Barracks, Lingfield. No fire.

Unexploded bomb fell at Gibbs Brook Farm, Crowhurst, 20 yards south of road leading from Brickmakers Arms to Crowhurst and 40 yards from Railway.

Special Constable Hewson, K-11, speaking from Gaysland Farm, Tandridge Lane, "We have one oil bomb exploded here and believed about 6 unexploded bombs in the area. The oil bomb is extinguished, no damage".

From Wardens Post (no 49) at Blindley Heath. Four High Explosive bombs at Sunhill Farm, Blindley Heath, all unexploded. Further reported by Head Warden who received it from the Searchlight people at Sunhill Farm, one bomb is ¼ mile west and 3 ½ mile east of searchlight battery.

Mr Steer, Fire Chief, re. house next to Wheatsheaf Public House, Old Oxted, struck by incendiary bomb. The Canadians have broken open the door and the house contains furniture etc. Tenants are away.

Miss Close, The Wain House, Uvedale Road, "There are some parts of an aeroplane on my lawn."

Miss Dennis, Green Hedges, Westerham Rd., "We have some parts of an aeroplane in our garden."

Oil bomb fallen ¼ mile from Newchapel X roads. Some fire, soon extinguished. Telephone wires down. No casualties.

Line of incendiary bombs extending from Hedgecourt Wood over Hobbs Barracks to Wiremill Farm. Slight fires but no damage.

Oil bomb, Crowhurst Rd, Lingfield at Bungalow 'Brinkhaff' – damage: 2 garden sheds, glass from 1 window.

Old Surrey Hall, Dormansland. Eleven High explosive bombs all exploded, no fire, no damage, no roads blocked. All bombs on Old Surrey Hall Estate, Warden now investigating.

Head Warden of Crowhurst reported one crater believed made by magnetic mine, 60 ft across x 20 ft deep Church Farm, Crowhurst.

In late October 1940, a German bomb fell a few feet away from the ancient tower of Burstow Church and nearby rectory, but mercifully did not explode. The ARP Wardens evacuated the immediate area and reported the incident to the Bomb Disposal Unit. In his monthly address to the parishioners, the rector thanked 'everyone for their kindness and offers of help at having to leave our home so suddenly'. All November services were held in the Church Room in neighbouring Smallfield, including one wedding. Bomb Disposal teams were kept fully occupied elsewhere in November; rural Burstow was considered low priority. The congregation in the meantime were praying that the bomb would be undisturbed, while the wardens and Home Guard kept all local inhabitants, visitors and

inquisitive children well away from the site. The bomb was eventually defused and removed from the site on 4 December by a Bomb Disposal Unit comprised of seven men under the charge of a corporal. A collection for the men of the bomb disposal team was taken at the door of the church which amounted to thirty-five shillings; each man received their five shillings share on 21 December. Had the bomb exploded, the medieval church and nearby rectory (once the residence of John Flamsteed, the first Astronomer Royal), would have been destroyed.

Meanwhile, life went on despite the bombs and sirens. Rooftop firewatchers, tired from peering into the night sky, did their utmost to arrive on-time at work the following morning. ARP Wardens and Home Guards juggled the time between their essential work supporting the wartime economy and their equally essential Home Defence duties. Mr Dinsley who worked for Benn Brothers Press in Fleet Street left his farm at Edenbridge each morning but asked to leave early one November day, 'to make sure that a fire, caused by some bombs that he had left smouldering during the night, had been effectually disposed of'. Commuters continued their daily journey to and from London. Sometimes the rail lines were destroyed and diversions were in place but business continued even under the longest continuous air bombardment of the war. Occasionally premises had been bombed during the previous night and rubble and a gaping hole all that remained of a shop, office or factory. Signs were often posted on barriers to bomb sites with details of business relocation, or an address to contact for details. Milk and postal deliveries were delayed and train timetables were unreliable but everyone continued to do their best because 'Don't you know there's a war on.'

On 28 November, the tail unit of a low-flying Junkers 88 was severed by overhead power cables near Redhill. The aircraft plunged to earth at Blindley Heath and remained mainly intact. There were no bodies in the wreckage, no reports of German airmen baling out and no prisoners captured in the vicinity. Sometime after the war it was discovered that the plane developed engine trouble and the crew had baled out. The crewless Junkers flew on until it ran out of fuel over Blindley Heath!

Official Control of Public Notice Boards

The Southern Regional Commissioner issued the following notice on 1 September 1940:

> In countries which the enemy has invaded he has spread false orders, alarms and rumours and has thus caused panic and interference with defence operations.

One of the ruses which he has adopted is the posting of notices giving false information or orders. In the event of his invading this country, therefore, the display of notices will be controlled and I shall issue a direction accordingly at the appropriate moment.

When this direction has been issued, all notices must be ignored other than those which appear on notice-boards at the following places:-

Offices of Government Departments, Police Stations, Fire Stations, A.R.P. Depots and Posts, Municipal Buildings and Schools, Parish Halls, Public Halls, and Churches.

The Ministry of Information will, in addition to the above, use Newspaper Offices and Newsvendors shops for display of their bulletins.

If members of the public see notices posted at places other than these or if they are suspicious of any notice which they may see displayed they should at once report to the Police.

This does not apply to notices warning the public of danger at a particular place such as the sites of unexploded bombs, dangerous structures etc.

Every town and village in Surrey was instructed to submit to the police authorities' details of all public notice boards in their area. The notice boards were then agreed by the police and came under their control and the supervision of all local defence agencies.

Officially approved Public Notice Boards in the Lingfield area include: the Police Station, Saxbys Lane; Victoria Memorial Institute; Lingfield Parish Church; Lingfield Baptist Chapel, High St.; Lingfield Methodist Church, High St.; Top of Baldwins Hill opposite Prince of Wales P.H.; Baldwins Hill Parish Church; High Street, Dormansland; Dormansland Parish Church; Dormansland Baptist Chapel.

Crowhurst Notice boards: beside the door of St George's Church, Crowhurst; on the wall of the stable facing the main road at Church Farm, Crowhurst.

Horne Notice Boards: church porch; on buildings of Church Farm; Parochial School (hanging on fence); The Hall, Newchapel, fixed to front wall of building.

Godstone area: new Police Station at Tylers Green; the old Police Station; Godstone Club; Godstone Fire Station, High St; Lagham Road, Post Office House; Blindley Heath Sub-Station; The Garage; Blindley Heath; Felbridge Fire Station; ARP posts and depots; Senior Wardens post: there may be others in the knowledge of the Head Warden.

No 209

"*Achtung!*" "*Spittfeuer!*"

("Look out!" "Spitfire!") These words rang a death-knell in the ear-phones of many a Nazi Raider in the momentous Battle of Britain.

LINGFIELD SPITFIRE WEEK-END

July 19th and 20th, 1941

(Inaugurated by the Lingfield & District Spitfire Fund.)

Programme of Events

AT THE

Recreation Ground.

This Programme, Price 3d., admits you to the ground.

(Children under 14, Free.)

NOTE THE NUMBER—IT MAY BRING YOU A PRIZE.

Lingfield's week-end of events in aid of the local Spitfire Fund: the target was £5,000, the cost of a new Spitfire.

Spitfire Funds

Lord Beaverbrook began a campaign to encourage towns and villages to buy a Spitfire from 1940 onwards. During the Battle of Britain, many communities started their own Spitfire Fund and went to great lengths to raise the money required. By the end of the war well over 1,500 Spitfires are known to have carried presentation names but sadly most of the relevant official documentation was scrapped in the early post-war years and it is now almost impossible to trace every presentation Spitfire, unless some chance discovery of photographic evidence proves the existence of a specific named Spitfire. Not all small communities raised sufficient funds, the total cost of a new Spitfire was £5,000, and often the fund was passed over to the RAF Benevolent Fund.

The opening ceremony of Lingfield Spitfire Weekend began with Squadron Leader C. H. Grey DSO, inspecting a Guard of Honour supplied by the Air Training Corps commanded by Pilot Officer Cecil F. Paine, RAFVR Demonstrations were given by units of the fire service, the Red Cross and St John Ambulance, and the East Surrey Gas Company's Emergency Repair Squad. Musical entertainment was by the Lingfield Central School Choir, who also demonstrated country dancing, additional entertainment was given by the intriguingly named 'Lofty Ballet Girls'. A Spectacular finale on Saturday evening was the Mass Pumping by teams from all the local Fire Posts. Entrance to the Recreation Ground, at the end of Talbot Road, cost 3*d* (1¼ p).

A Sunday procession from Mount Pleasant Road to the Recreation Ground was led by The Drums and Fifes of the Training Battalion Irish Guards. A Drumhead Service was conducted by Revd D. Christopherson and Revd F. W. Baggallay at the close of events. A Drumhead Service is when the Drums are piled neatly and draped with appropriate colours (national or regimental flags) to create an altar; in the tradition of the battlefield.

CHAPTER 5

The Queen Victoria Cottage Hospital, East Grinstead

At the beginning of the war the 36-bed community hospital in East Grinstead was only three years old. The hospital was built on land given by Sir Robert Kindersley, President of the National Savings Committee and a director of the Bank of England. The hospital was opened on 8 January 1936, by Her Highness Princess Helena Victoria, granddaughter of Queen Victoria. The accommodation comprised three wards (for men, women and children), a small operating theatre, and an X-ray department.

In 1939, the Ministry of Health's Emergency Medical Service sought hospital accommodation for the many casualties expected in the event of war. The Queen Victoria Cottage Hospital was selected as being outside the main target areas for enemy bombing and with sufficient additional space for expansion to accommodate large numbers of casualties. The majority of emergency admissions were expected to be civilians injured by heavy bombing. Incendiary bombs would cause mutilation as well as death and specialist Maxillo-facial units were planned to treat burn victims. When the defence of Britain began in earnest it was the injured airmen who filled the new wards and tested the skills of the surgical teams. The cockpits of damaged aircraft were often filled with highly inflammable fumes from fuel tanks and in the words of a survivor these, 'cooked the aircrew'.

Mr Archibald McIndoe was one of four plastic surgeons selected by the Ministry of Health to set up the new Maxillo-facial Unit at Queen Victoria Cottage Hospital, East Grinstead. The thirty-nine-year-old McIndoe, a New Zealander by birth, arrived at the hospital on 4 September 1939. The new facility needed to be built as soon as possible and two local philanthropists set about raising the necessary building funds through their business contacts. Sir Robert Kindersley and Mr Alfred R. Wagg were both trustees of the Queen Victoria Hospital. As well

as his city interests Sir Robert Kindersley, the donor of the hospital land, was a major shareholder in the Canadian National Railway, the railway settlement of Kindersley in Saskatchewan was named after him. Mr Alfred Ralph Wagg JP, was chairman of the merchant bank Helbert, Wagg and Company, he was indefatigable in his fundraising efforts on behalf of the local community and elsewhere. The two men successfully persuaded the Canadian Government to supply a shipload of prefabricated cedar wood to build the new unit. Canadian cedar wood was specially selected for its natural anti-bacterial and anti-fungal properties as well as its durability.

Within a short space of time McIndoe's 80-bed burns unit, known as Wards III and IV, and all the additional accommodation and support facilities were built on the north side of the Community Hospital. The wooden buildings were planned as a temporary facility but seventy years later still have a use.

McIndoe immediately began to recruit his specialist team of dental surgeons, trainee surgeons, anaesthetists, nurses and orderlies. The anaesthetist, John 'the Giant Killer' Hunter became a special favourite of the patients; the last face they saw before an operation and the first they saw on regaining consciousness, Dr Hunter remained with his patient throughout. The nurses were invariably good looking as well as proficient, a tonic for the eyes of badly injured young men. Archibald McIndoe's skill as a plastic surgeon was matched by his ability to abolish unnecessary rules and regulations. He had a natural talent for putting his patients at ease while leaving no doubt in their minds about the long and tortuous journey back to a kind of normality. Most of his very young patients had suffered disfigurement which at one time would have assigned them to an institution for the rest of their lives. McIndoe gave them a will to survive as well as a useful life ahead. The unit became the focus of reconstructive surgery and made Archibald McIndoe and his team famous throughout the world.

McIndoe was instrumental in bringing about the eventual banning of the use of tannic acid in the first aid treatment of burns. His report to the Royal Society of Medicine in November 1940 advocated keeping wounds, clean, dry and intact, and the application of tulle gras or saline compresses before the casualty's arrival at a specialist burns unit. That, he had discovered, kept the wound site flexible for subsequent skin grafting procedures. Minimum treatment was to be given to the site of burn injuries and maximum attention given to stabilising the patient. Speed of transfer from the crash site to the emergency treatment centre was critical to the success of his treatment; any delay increased the risk of infection and compromised the surface of the wound for skin grafting procedure.

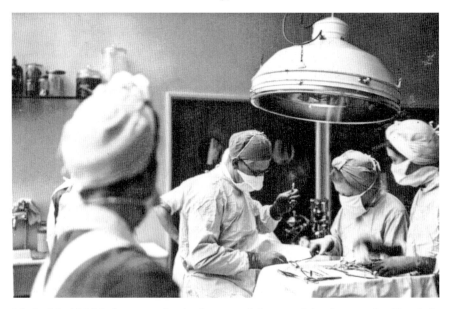

Mr Archibald McIndoe operating in the general theatre of the Community Hospital, early 1940. (*Queen Victoria Hospital Museum*)

The entrance to Ward III (now the Spitfire Restaurant).

A Christmas celebration around the piano, Mr McIndoe is sitting alongside the pianist – McIndoe was also an accomplished pianist.

In Wards III and IV, officers and other ranks were treated side by side under the care of McIndoe's team. Although two separate wards, each with a Ward Sister and nursing staff, they were linked by a connecting corridor and would always be known by the patients as one ward: Ward III. The isolation of the unit from the general wards of the community hospital minimised the risk of cross infection. Meals were served whenever the patient was hungry. Rehydration was critically important and to this end a barrel of beer was always kept in the wards as in many cases it was far more acceptable to take than water.

McIndoe's pioneering treatment involved regular immersion in warm saline solution in specially designed ebonite baths. Surgery could involve making eyelids using skin grafts from the arms, segments of scalp became eyebrows, ears were rebuilt, legs were temporarily sewn together to form a cross-flap to transfer tissue from a good leg to a bad leg, fingers were reconstructed to make hands usable. Some patients lost count of the number of operations they had undergone in the weeks and months of their treatment. Pedicle grafts in which a flap of skin is lifted from one part of the body, turned in on itself to form a tube, and attached to another part of the body to form new tissue, became a routine procedure for many burn victims. In the early years of the war, fighter pilots were the main casualties but as the war continued more bomber pilots, navigators, wireless operators, flight engineers, bomb-aimers and rear gunners occupied the beds in Ward III.

Rehabilitation to everyday life was considered a major part of the recovery process. Great efforts were made by hospital staff and local people to involve the airmen in everyday life. Long term burn patients were invited to weekends at The Hermitage, the East Grinstead home of Alfred Wagg and his sister Elsie. In the beautiful gardens of The Hermitage patients could enjoy freedom and privacy and play a game of croquet on the lawn. At meals they would meet other house guests from a whole variety of backgrounds. Other families with large gardens were persuaded to follow a similar policy and 'adopt' Guinea Pig members.

The Wagg family worked tirelessly on behalf of various charities. An old Etonian, Alfred Wagg was a founder member of the Manor Charitable Trust set up to fund a sports and social club in the deprived East End of London; the trust evolved from The Eton Mission at Hackney Wick. Alfred Wagg developed an area of land in Ashdown Forest (the Isle of Thorns) as a summer camp site for the boys and included a pavilion, playing field, open air swimming pool, novelty golf course, football and cricket pitches and wooden blocks of dormitories. His sister Elsie opened the garden of The Hermitage to raise funds for The Queens Institute of District Nursing, the first garden to be opened to provide pension support for district nurses and the beginning of the National Garden Scheme. Alfred Wagg was the main benefactor of the home built for retired district nurses at 14 Wellington Road, Brighton.

For the convalescent patients on Ward III there were frequent visits to local bars. The airmen became 'regulars' at the Rainbow Bar and Ballroom in the Whitehall in East Grinstead. The measure of successful reconstructive surgery was the ability to hold a pint of beer, the next improvement, to be able to deal playing cards. The airmen were uniquely permitted to wear the uniforms of serving airmen outside the hospital grounds, despite the fact that the majority would never again serve in the RAF.

Local people were well aware of the pioneering surgery taking place at the Cottage Hospital and were proud to help in the rehabilitation process, they knew that just one look of horror at a chance meeting could undo many months of confidence building.

Groups of airmen regularly swam in the pool at Old Surrey Hall and a games room was specially adapted for their use as an indoor lounge area. Many wrote their names on the oak pillars in the room. After the war, when the Anderson family sold Old Surrey Hall and moved to Wilderwick Farm, the oak pillars were moved with them.

Some patients received treatment at the hospital for a period of two to three years. At the end, and sometimes between treatments, patients were transferred to the convalescent facility at Dutton-Homestall, Ashurstwood.

The house was lent to the Q.V.H. by the Dewar family (the house later became Stoke Brunswick School). Marchwood Park in Hampshire was also used for Occupational Therapy.

The Guinea Pig Club

On 20 July 1941, some of the airmen were chatting in a newly erected hut at the hospital when one suggested forming a club, specifically a drinking club. Someone claimed 'The Guinea Pig Club' would be appropriate. After all, Guinea Pig animals were used for medical experimentation, as were the burned airmen. A committee was immediately formed. Mr McIndoe nicknamed 'The Maestro' or 'The Boss' became the honorary president of the Guinea Pig Club. The secretary was a pilot with badly burned fingers, which meant he was excused from writing letters; the treasurer was a member whose legs were badly burned and would prevent him from running away with the funds.

Most Guinea Pigs were aged between nineteen and twenty-five. There were three types of members:

(1) The Guinea Pigs: Second World War aircrew, members of the Allied Air Forces who had undergone at least two operations on burns or other crash injuries.
(2) Honorary Members: The Scientists (all members of the medical staff).
(3) Friends of the Guinea Pig Club: benefactors, otherwise known as The Royal Society for the Prevention of Cruelty to Guinea Pigs. Sir Robert Kindersley and Mr Alfred Wagg were included in this category.

In time the Guinea Pigs added a fourth category – The Guinea Pig and Bar – for those who went back to war and received more injuries requiring surgery.

New members were recruited early in their treatment. The brotherhood of Ward III poked fun at their personal tragedies and thereby retained their sanity. Experienced 'Guinea Pigs' who had already undergone reconstructive surgery could testify to the new light at the end of the long, long tunnel but they would not allow self pity. They developed a black humour to cope with the horror of pain and disfigurement. Ward III became 'The Sty', the anaesthetist 'the sandman', his equipment 'the gas works', 'singed', 'mashed' and 'cooked' were their injuries.

The Guinea Pig Anthem, sung to the tune of 'The Church's One
Foundation'

We are McIndoe's army,
We are his Guinea Pigs.
With dermatomes and pedicles,
Glass eyes, false teeth and wigs.
And when we get our discharge
We'll shout with all our might:
'Per ardua ad astra,'
We'd rather drink than fight.

John Hunter runs the gas works,
Ross Tilley wields a knife.
And if they are not careful
They'll have your flaming life.
So, Guinea Pigs, stand steady
For all your surgeon's calls;
And if their hands aren't steady
They'll whip off both your ears.

We've had some mad Australians,
Some French, some Czechs, some Poles.
We've even had some Yankees,
God bless their precious souls.
While as for the Canadians
Ah! That's a different thing.
They couldn't stand our accent
And built a separate Wing.

Albert Ross Tilley was born in Canada in 1904, the son of a doctor. He
studied plastic surgery with Canada's first plastic surgeon, Dr Fulton
Risdon, before the war. Dr Ross Tilley was a captain in the Royal Canadian
Army Medical Corps when war broke out but soon transferred to the
Royal Canadian Air Force Medical Branch, and by 1941 was principal
medical officer at overseas headquarters.

In 1942, Wing Commander Dr Ross Tilley joined Mr McIndoe's surgical
team at the Queen Victoria Hospital; the two men quickly formed an
excellent working relationship and mutual respect. They worked side by
side, pioneering and perfecting techniques for the restoration of natural
movement and function in mutilated hands and limbs, as well as creating

Above: Typical humour of the Guinea Pigs. (*The Guinea Pig Club*)

Right: Wing Commander Dr A. Ross Tilley (the 'Wing-co').

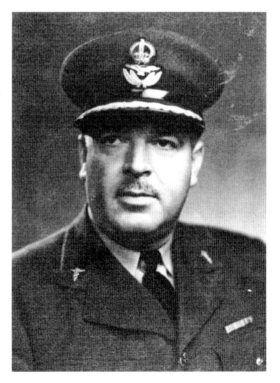

noses, eyebrows, lips and ears for young airmen who had been horribly mutilated by the effects of flash burns in burned out aircraft. Dr Tilley developed a specialty for reconstructing hands.

Canadian casualties were the second largest nationality group in the burns unit and as pressure on bed space became acute in 1942, Dr Tilley sought funding from the Canadian Government for additional facilities at the East Grinstead Hospital. Plans were approved and finalised for a fifty bed Canadian Wing. The Queen Victoria Cottage Hospital had far outgrown the concept of a small community hospital and it was decided to drop the word 'Cottage'.

Air Marshal Harold 'Gus' Edwards as Air Officer Commanding, Royal Canadian Air Force Overseas, laid the cornerstone of the RCAF Wing of the Queen Victoria Hospital. The wing was built by the Corps of Royal Canadian Engineers (RCE) and entirely funded by Canadians. The Canadian Wing was finally opened in July 1944. By then Dr Tilley, nicknamed 'Wing-co', although by that time he was a group captain, had a staff of more than fifty Canadian personnel; doctors, dentists, nurses, orderlies, cooks and clerks funded by the Canadian Government. Between them they created a little bit of Canada in Britain to help the recovery of the Canadian airmen, far away from home and family. The Canadian Wing also cared for any overflow from Ward III.

The hospital was supported by many local organisations; extra rations of food were collected by an army of volunteers. Miss Miller's shop in East Grinstead, became a collection point for fresh eggs and locally grown fruit and vegetables.

The Personal Story of William Foxley

I joined the Air Force at the age of nineteen at which time I had never been "kissed, kicked or cuddled", as I always like to tell my friends. On 16th March 1944 I was flying in a Wellington Bomber, as a navigator with five other crew, when there was a mechanical problem and the plane crashed; literally dropping out of the sky, hitting the ground and bursting into flames. I managed to exit the aircraft through the astrodome but returned when I heard my wireless operator screaming for help. He was trapped behind a table in the burning fuselage. Although I eventually managed to release him and get him out of the plane, he died of his injuries as did two other crew members. I was not aware of the extent of my own injuries immediately following the crash but do remember being led away because I could not see. My face and eyes had been so badly damaged by the fire.

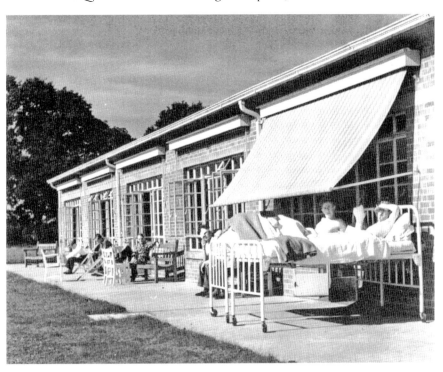

Sunbathing outside the Canadian Wing. (*Queen Victoria Hospital Museum*)

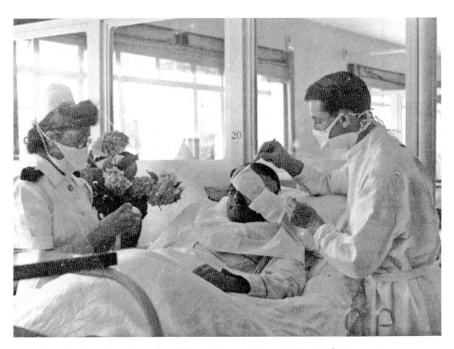

Changing the dressing, Canadian Wing. (*Queen Victoria Hospital Museum*)

I was also unaware for some months as I lay sedated in my hospital bed, that my fingers had been burned away when I tried to pull myself and my wireless operator out of the white hot plane. Archie [Archibald McIndoe] found me on one of his regular visits to RAF hospitals around the country looking for the worst burn victims. He brought me to East Grinstead for treatment and I spent a total of three years in hospital.

(Reprinted from *The Blond McIndoe Res. Foundation Newsletter,* with kind permission of Mr William Foxley)

CHAPTER 6

The Canadian Army

Canada declared war on Germany on 10 September 1939. The Canadian forces made a tremendous contribution to the defence of the UK, and the battle for Nazi occupied Europe. In 1941, well over 100,000 Canadian men and hundreds of Canadian women were billeted in Britain defending the Home Front. Canadian pilots, observers and air gunners fought the Luftwaffe or bombed Germany from British bases; they served in squadrons of the Royal Canadian Air Force and with the Royal Air Force. Canada's Navy was active in British waters and in the North Atlantic on convoy duty; bringing grain to Britain, and assisting in the protection of vital trade routes.

Soldiers of the Canadian Expeditionary Force sailed from Halifax, Nova Scotia, expecting to reinforce the British Expeditionary Force in France. But the defence of Britain became the priority after the emergency evacuation of the BEF from Dunkirk. Canadian forces in Britain grew into an army of two Corps. The majority of the Canadian land forces were aiding in the defence of Britain between 1940 and 1942. Five divisions of the Canadian Army were based throughout south-east England against an expected German invasion. Canada, like the United States of America, was also sending machines, weapons and food; vital aid after the loss of British equipment on the coastal areas of France.

The 1st Canadian Infantry Division, under the command of Major-General A. G. L. McNaughton, arrived at Greenock in December 1939 to a great Scottish reception with bands playing and people cheering. They were immediately moved south by train to Aldershot for training; more than half of the men were raw recruits. The Secretary of State for War reported to the War Cabinet on 21 February 1940 that 'the approximate strength of Canadian troops in this country is 690 officers and 15,200

other ranks'. By the end of February there were over 23,000 Canadian soldiers in the Aldershot area. Numbers continued to increase, month by month.

In May 1940, the Secretary of State reported that 'training continues to be hampered by a shortage of equipment and it has been necessary in some cases to send troops overseas incompletely equipped'. On 24 May 1940, units of the 1st Canadian Infantry Brigade and Canadian Horse Artillery were mobilised and landed in France but were ordered to return to England to assist in the defence of Britain. The massive loss of equipment in France during the retreat from Dunkirk left Britain vulnerable to imminent invasion by German forces. Brigadier J. H. Roberts MC, commander of the 1st Field Regiment, Royal Canadian Artillery, distinguished himself in France in June 1940 (at least in the eyes of the Canadian Army) by insisting on being allowed to withdraw his guns, in spite of orders to destroy them.

The defence of Britain then assumed paramount importance. The C-in-C Home Forces was appointed, the newly promoted Lt-Gen. A. G. L. McNaughton, CB, CMG, DSO. A new Corps, called The 7 Corps in GHQ Reserve, was formed in July 1940. The new Corps consisted of 1st Armoured Division, 1st Canadian Division, New Zealand Force and Selected Artillery Troops. The staff was selected from Canadian and British resources.

Headquarters and units were mobilized under the supervision of HQ Aldershot Command at 00.01 hours on 21 July 1940, at Beaumont Barracks, Aldershot. The New Corps HQ was at Headley Court, near Epsom. Merstham House and Ashridge House in Reigate were also taken over by senior officers of the Canadian Force. Vehicles were provided from Canadian sources.

In the summer of 1940, the Surrey countryside became host to the Canadian soldiers and their convoys of guns, tanks, trucks and motor cycles. Large houses were requisitioned and tented villages were erected in fields to provide accommodation for thousands of Canadian troops in three concentrated areas to the south and south-east of the Surrey Downs, including one large camp at Smallfield. Tents were seen as a temporary measure until the arrival of more substantial Nissen huts. Nissen huts were named after the Canadian engineer Lt-Col. Peter N. Nissen, who had designed them in the First World War. They were simple brick and tin structures with a concrete floor and a small coke stove for warmth.

Large houses in Godstone, Limpsfield, Oxted, Burstow, Horne, Blindley Heath, Lingfield, Dormansland and Dormans Park were requisitioned for the use of the Canadian 1st Division officer accommodation. Langsmead in Blindley Heath, the Dormans Park Hotel and nearby Badminton Hall in Dormans Park were all occupied by Canadian officers. Their vehicles were

parked under trees to hide them from any overhead Luftwaffe spotters. Canadian officers were also billeted at Starborough Castle, the home of Ralph Victor Toynbee who was to become 2 I/C of 9th Surrey (Oxted) Battalion Home Guard. Some houses were occupied by small specialist units such as medical units at Ford Manor, and a Field Hygiene unit at Morven House in Dormansland.

Princess Patricia's Canadian Light Infantry were billeted in Nissen huts erected at Norbryght, Tilburtstow Hill between September 1940 and June 1941. A short distance away from the camp was Lamb's Brickworks which was requisitioned for the use of the Royal Canadian Armoured Corps, as a depot for repairing tanks and storing general armaments. The Seaforth Highlanders of Canada were billeted in Limpsfield village in the summer of 1940 and remained in the area until the Italian Campaign, 1943-45.

On Christmas Eve 1940, the 7 Corps became The Canadian Corps. The 1st Armoured Division, 1st Army Tank Brigade, 53rd Light Anti Aircraft Regiment and British Non-Divisional units, previously allocated to 7 Corps, came under the command of The Canadian Corps on its formation. Barrack accommodation in Aldershot was completely full, and still additional troops continued to arrive in Britain. In the following eight months all British staff were gradually replaced by Canadian officers.

Langsmead, Blindley Heath: the house was occupied by Canadian officers during the war. At the end of the war the house was demolished. (*Hayward Collection*)

Brigadier Guy Granville Simonds and his family were allocated a building at Old Surrey Hall in 1940. Three years later Simonds, by then a Maj.-Gen., commanded the 1st Canadian Division in the assault on Sicily, as part of the General Montgomery's Eighth Army in July 1943. He was promoted to Lt-Gen. and appointed to command the 2nd Canadian Corps, then in England training for the invasion of Normandy.

Accommodation for the Canadian Corps became increasingly difficult as additional troops arrived in south-east England in 1941. They camped throughout the county of Surrey, and the Ashdown Forest area of Sussex. A General Staff Memo dated 6 February 1941 addressed the accommodation crisis: 'it is impossible to accommodate any more troops in Surrey and Sussex'. A Conference was held at the War Office on 8 February 1941 to discuss the crisis. The balance of Corps troops was then likely to arrive before commencement of the camping season but tented accommodation was nevertheless still a possibility for many.

A month later a memo from Gen. McNaughton suggested that if adequate accommodation could not be guaranteed he would cable Canada to defer the next despatch of troops, which would react adversely not only on Canadian Corps but also on public opinion in Canada. Brigadier Winfield (Director of Quartering at the War Office) agreed in March 1941 to authorise the issue of 4,000 Nissen huts from Lingfield and Cobham to ease the situation. At that time substantial buildings had been newly erected on Lingfield Prisoner of War Camp which freed Nissen hut accommodation for use elsewhere.

Five new camps in the Ashdown Forest were under contract to four civilian contractors in March 1942 but the contractors experienced great difficulty in obtaining labour, the sites included Pippingford and Chelwood Gate. The vast area of Ashdown Forest in Sussex was considered particularly at risk from invasion by German Paratroops.

The Isle of Thorns area of the Ashdown Forest had been purchased by Mr Alfred Wagg in 1933 on behalf of the Eton Manor Charitable Trust. The Trust was founded in 1924 by four old Etonians (Arthur Villiers, Gerald Wellesley, Alfred Wagg and Sir Edward Cadogan) to provide a charitable trust to run and support the Eton Manor Mission in Hackney Wick, London. The Isle of Thorns was purchased to provide summer camp facilities for disadvantaged children from the East-End of London. The site included blocks of wooden dormitories, cricket and football pitches, an open air swimming pool and a gymnasium. Three other large estates in the Ashdown Forest were purchased by Alfred Wagg, at Blacklands, Broadstone Warren and Hindleap. They were designated for the use of the Scouting Association, the Girl Guides and the Federation of Boys' Clubs but were commandeered for home defence during the war.

The swimming pool, the Isle of Thorns Camp, Chelwood Gate.
(*Mr Michael Harding*)

The Isle of Thorns Boys' Summer Camp was taken over by 3rd Battalion of the London Scottish Regiment; the newly formed 97th Heavy Anti-Aircraft Regiment RA, TA (The London Scottish). For the first two years of the war all three battalions of the London Scottish Regiment were engaged in training and defence duties and were in action throughout the Battle of Britain as part of the anti aircraft defences of London. When the 3rd Battalion left for Egypt in December 1942, the Isle of Thorns was used for billeting Canadian troops.

The Corps of Royal Canadian Engineers (RCE) built a concrete Radio Station near Duddleswell crossroads in the Ashdown Forest. The facility was equipped and maintained by the Royal Canadian Corps of Signals. The radio station is believed to have been used by the Foreign Office for broadcasting propaganda and information to resistance workers. In the early period of static defence of Britain, the RCE built beach obstacles, pillboxes, anti-tank ditches, and minefields. They also improved British roadways to facilitate the movement of military traffic and constructed military air bases. An airstrip was built in the Ashdown Forest as an emergency landing strip, adjacent to the Isle of Thorns at Chelwood. In 1944, the RCE built the Canadian wing of the Queen Victoria Hospital in East Grinstead.

In January 1942, Wakehurst Place in West Sussex became the Forward Planning HQ for South East Command. Headquarter staff of the 1st Canadian Corps were based in the house from January 1942 until the spring of 1943. All Canadian personnel left Wakehurst Place in 1943 for service with Allied forces in the invasion of Sicily and mainland Italy.

A plaque from the mess room of the Commander of Canadian Corps, Wakehurst Place, Sussex in 1942-43. A list of all the Mess officers is attached to the back of the plaque and includes: General Officer Commanding: Lt-Gen. H. D. G. Crerar CB, DSO, Jan. 1942; Brigadier General Staff: Brigadier G. G. Simonds CBE, Jan. 1942, Brigadier C. C. Maun DSO, July 1942; Deputy Assistant & General Staff: Brig. G. R. Turner CBM, CDCM, Jan. 1942, Brig. A. E. Walford MMED, Apr. 1942, Brig. J. F. A. Lister, Apr. 1943. (*John Withall, former ranger at Wakehurst Place*)

The Canadian Soldiers in the Community

The Blitz did much to break down barriers between the Canadians and their British hosts. The British press, true to form, played up any court cases involving Canadian soldiers. Offences were relatively minor such as drunkenness and petty theft of chickens, etc. Most of the bad publicity concerned the moral behaviour of Canadian soldiers and young British women. General McNaughton defended his Army's moral principles in a memo to the War Office: 'the problem is universal, as for illegitimate children it takes two people to produce an illegitimate child

and illegitimate children were being born before the arrival of Canadian troops.'

Denis Leman remembers the Canadians coming to Dormans Park:

> They were certainly a lively lot, broadly speaking they were very well behaved; they walked to the pub in Dormansland in the evening ['The Old House at Home'] and got drunk and came home singing their heads off ... The house behind the letterbox by the railway bridge on The Approach was a Church Army canteen for them. My mother used to go there two or three evenings a week as she was a member of the WVS and she would serve them with cups of tea and coffee and snacks. They converted the area from Shama to Brackenors into a shooting area, which was used by the Home Guard and me.

Another Lingfield schoolboy recalled:

> When the soldiers were all round here, we used to go down to where they had their campsites and mix in with them, and then we used to walk up to the Plough at Dormansland. Of course you weren't allowed in or anything like that, but we used to be after their cigarette cards, Sweet Caporal Cigarettes, because they used to have the aeroplanes on them of all the different aeroplanes ... then we used to go round and try and find pieces of shrapnel and bullet cases. It's surprising what you could find. And we used to collect some tin foil they used to drop, to mess up the radar. We used to try and collect the perspex sometimes, to try and make rings and different things out of it. [I made] a brass one from a Bofors shell. [Bofors anti-aircraft guns]

Life in Surrey was very different from life in Canada. Many of the Canadian servicemen were first generation Canadians, their parents had immigrated to Canada from Great Britain and northern Europe. Others were from the Rocky Mountain territories, from the vast grassland prairies, or from the Indian Reserves. Many Canadian French-speaking troops too arrived in England. All of them found that life in an English village was very different from their homeland. The Province of Ontario had 'beverage rooms' where only beer could be drunk, music and any other forms of entertainment were banned. It was illegal in Ontario to consume alcohol in public. No wonder then, the English 'pub' was a novel and very pleasant experience; a place to meet men and sometimes women, and to drink freely what they chose. Irate Englishmen and women wrote to the local newspapers about drunken and profane Canadians making their way back to their billets after an evening in the local pub. The blackout added to the mysteries of finding their way home.

The Crown in East Grinstead was a favourite pub for the Canadians and the Irish Guards, who were based at Hobbs Barracks. William (Bill) Foxley, a member of the Guinea Pig Club, remembers that The Crown was always good for a punch-up between the Canadians and the Irish Guards. One frequent cause for argument was that the Canadians had a little more money to spend.

Several wall murals were painted by Canadian soldiers on the walls of pubs and other halls used by them during the war. A mural of the arrival of Father Christmas was painted on the gymnasium wall at The Isle of Thorns Camp, Ashdown Forest.

Canadians also occupied the Parish Halls in East Grinstead and painted 'saucy murals on the kitchen wall' (M. J. Leppard). A mural of the Canadian Rockies decorated a wall of The Plough Inn at Dormansland until the late 1970s.

A flourishing black market in packaged foods, cigarettes, blankets and anything that was scarce existed between soldiers in the area and local opportunists. General McNaughton sent a strong letter to all Canadian units on 15 October 1940:

> the many complaints that are reaching me regarding drunkenness and disorderly behaviour, damage to private property, slovenliness in dress, misuse of mechanical transport, dangerous driving and loss of equipment, and the indications amounting almost to a certainty that

The gynasium where the wall mural was painted. (*Mr Michael Harding*)

there is a considerable traffic in petrol and, to a lesser extent, in blankets and other public property are evidence of a grave failure in the discharge of their duties on the part of officers, warrant officers and N.C.O.s.

It was not all friction between the English and Canadians, some soldiers were entertained in the homes of local people and Canadian soldiers made special arrangements to entertain children, especially at Christmas. Several soldiers lent a hand on local farms, particularly at harvest time. Mrs Bridget Toynbee of Starborough Castle befriended the wives of Canadian officers billeted in her home. She read a letter from her 'adopted' soldier's wife in Canada to the members of Dormansland Women's Institute in July 1940 and asked that twelve members write to other soldier's wives in Canada to foster links of friendship.

The Police Superintendant of Oxted Division, A. F. King reported on the behaviour of Canadian troops in the area on 4 June 1941:

As far as this division is concerned there is very little to complain of. The Canadians have been with us here for nearly 12 months; a number of them have married local girls, and a good many have found friends with whom they spend their off time and the great majority are welcome anywhere ... I have not had the trouble with them I anticipated when I first knew they were coming. There are a few who break out after pay day and get drunk. They sometimes cause trouble and commit a little damage, but it is nothing very serious, and they are generally 'squared up' by the better ones amongst them.

I'm also glad to say that there has been a very considerable improvement in the manner in which their trucks are now being driven. This was bad to begin with, but this has now been put right.

Two weeks later Superintendent King reported:

There are few black sheep who try to spoil things by getting drunk after pay parade and they do occasionally commit damage and make themselves unpleasant but the great majority are well behaved and try to curb the activities of those ... They found that people were a little insular at first but now both sides are learning to appreciate each other with the happiest of results. The Canadians here have never given the Civil Police any serious trouble and as long as things remain the same, I shall be glad for them to remain another 12 months.

Things did not 'remain the same' for long, his report of 2 July:

There have been one or two instances recently of immoral conduct between Canadians and the wives of English soldiers, with consequent trouble, and the breaking up of one home at least, but I do not know that one can attribute the whole of the blame to the soldiers ... the women must be equally guilty.

Chance encounters, local social events and dances ensured that Canadian servicemen met young women in cities, towns and villages all over the United Kingdom. Inevitably, many fell in love. Although some war brides describe whirlwind romances, others had known their Canadian fiancés for one, two, even three years before deciding to marry. In her book *Pardon my Parka* Canadian war bride, Joan Walker, wrote: 'Anyone can be a pioneer. All you need to do is to fall in love with a Canadian Major in the London blackout and find that he is every bit as attractive when you get him into the light.' The first marriage between a Canadian soldier and a British woman took place in Farnborough Church on 29 January 1940.

The first marriage between a Canadian soldier and a Dormansland woman took place in St John's Church, Dormansland on 19 October 1940. Between 1940 and 1945 nine Dormansland girls married Canadian Servicemen at St John's Church. One Canadian bride married her Canadian groom at Dormansland Church; a Captain of 1st Canadian Army in England, married a Nursing Sister of 4th Casualty Clearing Station, RCMAC, based at Ford Manor.

Nine Lingfield brides married Canadian servicemen at St Peter and St Paul's Church, Lingfield between 1 November 1942 and 18 March 1946 and six brides married Canadian servicemen at St John's Church, Blindley Heath, between August 1941 and November 1945.

With the arrival of the first draft of the Canadian Women's Army Corps in November 1942, British soldiers started to fall in love with Canadian girls, some of the relationships resulted in marriage. The vast majority of the marriages of Canadian personnel were between Canadian men and British women. A total of 44,886 Canadian service men married British girls between 1940 and 1946. Tension between the British and the Canadian soldiers arose over competition for girls and over pay; the basic pay of a Canadian private was more than double that of a British private. In an effort to reduce the differential, part of the allowance to Canadian personnel was withheld in a savings account for payment at the end of the war.

Kay Reed met her Canadian husband, Private F. M. (Fred) Garside at a dance in her hometown of Wimbledon. He was a farmer in Colfax, Saskatchewan before volunteering for war service in June 1940. On coming to England later that year Fred was stationed at Dorking. He moved to

Private Frederick (Fred) Myles Garside, 4th Canadian Casualty Clearing Station, Royal Canadian Army Medical Corps, based at Ford Manor in March 1943. (*Kay Garside*)

Ford Manor near Lingfield in March 1943 with his unit, the 4th Canadian Casualty Clearing Station. In February the next year, the unit was posted to Italy. Fred married Kathleen (Kay) Reed of Wimbledon on 29 Jan. 1944. Two weeks later he was posted to Italy with the 1st Canadian Research Laboratory (RCMAC) where he served until 1945.

Tiny, seventeen-year-old Joan Fisher met her tall red-haired Canadian soldier at a dance in December 1944. John Reichardt was the son of Dutch parents who had immigrated to Canada in 1925. New Years Day 1945 was not a public holiday but Joan took a day's leave to take John to Kew Gardens. The gardens did not look their best that winter's day and Joan managed to lose the way but her new boyfriend found the exit!

Margaret Dicks was sixteen when she met nineteen-year-old Sgt Arthur James Houghton in Leatherhead. Margaret was acting as chaperone for her friend who was waiting to meet her boyfriend on a seat in the local park. When the boyfriend arrived he was with another soldier friend, the tall and handsome Sgt Arthur Houghton. After a brief courtship Margaret and Arthur were separated when Arthur was sent with his regiment, the 7th Anti-tank Regiment, RCA, first to Africa, then Sicily, Italy, Belgium and Holland. Arthur finally returned to England in 1945. Meanwhile, Margaret volunteered to serve in the Auxiliary Territorial Service. Margaret and Arthur married on 1 September 1945, 'then almost immediately he was shipped back to Canada'.

Wartime romances were not the preserve of the Canadian soldiers. A former Grenadier Guardsman, Ben Cumming, recorded his memories of 1941-42 for the BBC2 War Memories project:

We were sent to where the aerodromes of the fighter planes operated from (viz: Biggin Hill and Henley) as the Battle of Britain raged on; the Germans had a ploy of following returning aircraft and shooting up the runway. An ingenious means of defence was sunken pillboxes which by the use of hydraulics rose from the ground and could be used to engage any incoming enemy. Eventually, the RAF formed their own Defence Regiment and we went off to the Home Counties, mainly Surrey, to resume battle training. One location was Lingfield in Surrey where we were billeted in what was formerly racing stables, which was an ideal billet on the grounds that one was able, when off duty, to slip in and out surreptitiously without being caught.

Having a drink in the local pub one evening, I met a girl named Jessica, and after a few more meetings we began a relationship. I soon found out that she was married to a soldier and I should have ended it, but as it was wartime, one's morals were not as good as they ought to have been, and we spent as much time together as we could. It was wonderful whilst it lasted, but it all came to an end one night when I was with Jessica at her home, and she cried out that her husband and his father were approaching the front door. It transpired that they had found out she was having an affair with a Guardsman and they intended to give me a good going over. I scarpered out the back way and got clear. A couple of days afterwards the Padre of the man's unit came to see me and accused me of breaking up the marriage, and I got reprimanded by the Adjutant and was transferred to the 5th Battalion, which was stationed in Yorkshire. A sad end to a romantic interlude.

The 1st Exercise Tiger

'Tiger' was the code name used for two military training exercises in the Second World War. The first was an eleven day exercise held in 1942 and involved British and Canadian land forces in the South Eastern Command Area, supported by squadrons of the RAF. The second was an eight day rehearsal of D-Day procedures for American land forces supported by the Royal Navy. It was held in 1944 off the coast of Devon at Slapton Sands and was a military disaster.

The first Exercise Tiger, under the Command of Lt-Gen. B. L. Montgomery, began on 20 May 1942 and lasted eleven days. Montgomery's objective

was to study certain aspects of mobile operations between two forces where opposing commanders have freedom of action and manoeuvre. He also wanted to study his new model organisation for armoured and infantry divisions.

The opening narrative began: 'Kent and Sussex are two neutral countries, not yet engaged in the present war. The frontier between them is the present inter-Corps boundary between 12 Corps and Canadian Corps. The country lying to the north of the present rear boundaries of Corps is a small state jealous of its independence. Its people are of fighting stock but avoid taking part in the quarrels between other states. But if their frontier is violated by armed forces of other countries they will immediately declare war on the invader. They can put into the field 2 divisions and these are kept ready for action. Their country is called Surrey, and is obviously to be avoided. The frontier between Kent and Sussex will be considered closed to all movement and traffic of the opposing forces as from 24.00 hours on 19 May. The employment of agents or fifth columnists in plain clothes is forbidden.' The Exercise was controlled from an HQ at Possingworth Park Hotel, Cross in Hand (O.S.973403).

The Kent Side had two Infantry Divisions and one Armoured Division on the new model organisation. The side was deliberately strong in armour, but weak in the air.

The Land Forces were the 12th Corps and No. 11 Armoured Divisions, total forces of about 60,000 troops and military transport.

The Air Forces, a total of four squadrons: Army Cooperation Command: 26 Squadron, West Malling (Kent) and 239 Squadron, Detling (Kent); Bomber Command: 13 Squadron, Manston (Blenheims); Fighter Command: No. 32 Squadron, Manston (N. Yorks.) a daytime fighter Squadron.

The Sussex Side consisted of Canadian Corps: three Infantry Divisions and one Army Tank Brigade; all on the old organisation. This side was deliberately weak in armour, but strong in the air. The Land Forces were the Canadian Corps: total forces of about 60,000 troops (no Armoured Division). The Air Forces, a total of eight squadrons:

Army Cooperation Command: 400 Squadron Gatwick, and 414 Squadron Croydon; Bomber Command: 114 Squadron and 226 Squadron (Bostons) both based at Odiham; Fighter Command: 1 Squadron to operate from Tangmere, 245 Squadron to operate from Tangmere returning each night to Middle Wallop, 43 Squadron to operate from Ford, 253 Squadron to operate from Shoreham.

Instructions were given that various forces would not take part in the exercise: Anti Aircraft Command; static troops and training establishments; the Home Guard; the RAF, other than Squadrons specifically detailed;

aerodromes; anti aircraft gun positions. The exercise was administered under war conditions, troops had only basic food rations, mobile canteens were forbidden to operate and troops were forbidden to purchase supplies of food or drink from civil sources. No military transport was allowed to be used for the carriage of infantry or other dismounted personnel. The infantry units marched over 150 miles during the course of the exercise, some infantry units had marched and fought over 250 miles of country when they got back to their normal locations eleven days later. When the operations ceased many soldiers had no soles to their boots.

In his final report Lt-Gen. Montgomery wrote that 'the powers of endurance of the troops were stretched to the limit'. He recognised the importance of Bicycle Companies and noted: 'In every battery there must be sufficient push bicycles to mount a company ... I am examining the bicycle situation. This exercise has clearly proved their value.' Montgomery directed that June was to be devoted to the training of the Home Guard. Home Guard Battalions had a fortnight's intensive training under the instruction of the Canadian Field Army. Subjects covered village fighting, house clearing, wood clearing, tank traps, stalking and silent crawling. The Canadian Corps were closely associated with the Home Guard; the men of the 9th Surrey (Oxted) Battalion had a high regard for the Canadian forces.

Troopers of the Ontario Regiment taking part in Exercise Tiger, East Grinstead May 1942 (on the 'Sussex Side'). (*Photographer: Lt C. E. Nye / Canada. Dept. of National Defence / Library and Archives Canada / PA-145777*)

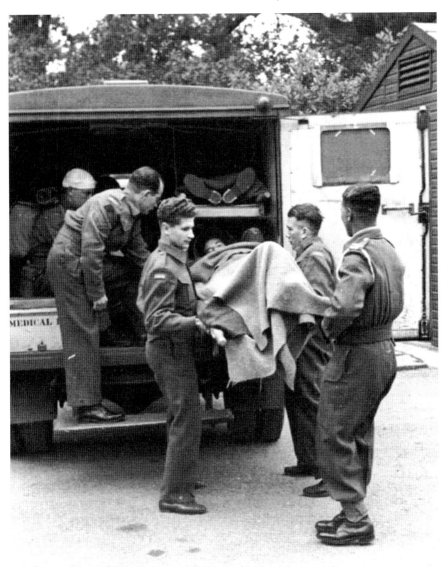

Personnel of a Casualty Clearing Station R.C.A. Medical Corps (Ford Manor,
Dormansland). Evacuating 'casualties' during training exercise with the Home
Guard, Lingfield, 16 June 1942. Ford Manor was acquired by the Canadian Army
in 1941. (*Photographer Lt C. E. Nye, PA – 151132. Dept. of National Defence /
Library and Archives Canada*)

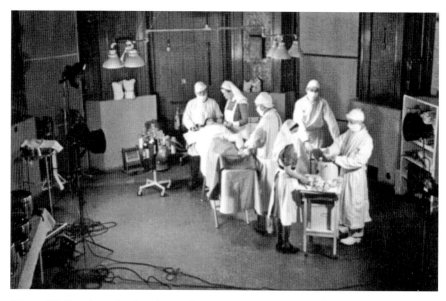

Private H. Roach, a simulated casualty, receives treatment in the operating theatre of No. 5 Casualty Clearing Station, Royal Canadian Army Medical Corps (RCMAC), Ford Manor, Dormansland, June 1942. Left to right: Major P. J. Maloney, Nursing Sister Evelyn Pepper, Private H. Munro, Major S. W. Houston, Private B. Grayson, Nursing Sister E. Galbraith. (*Photographer unknown. Dept. of National Defence / Library and Archives Canada / PA-151138*)

The same room at Ford Manor in 2009 now called 'Greathed Manor'.

Canadian Forces Graffiti on a pillar in the north cellar of Greathed Manor (formerly Ford Manor), listed in order:
RRR (Regina Rifle Regiment) (3)
South Saskatchewan Regt (1)
Royal Montreal Regt (3)
Royal 22nd Regt (2)
Toronto Scottish Regiment (1), (3)
Queen's Own Cameron Highlanders of Canada (1)
Seaforth Highlanders of Canada (2)
Essex Scottish Regiment (1)
Black Watch (Royal Highland Regt) of Canada (1)
Royal Canadian Regiment (2)
Le Regiment de Maisonneuve:
5 Field Regt Royal Canadian Artillery (2)
6 Field Regt Royal Canadian Artillery (2)
4 Field Regt Royal Canadian Artillery (2)
Royal Hamilton Light Infantry (1)
Royal Regiment of Canada (1)
Carleton and York Regiment (2)
PPCLI: Princess Patricia's Can. Light Infantry (2)
West Nova Scotia Regt (2)

48th Highlanders of Canada (2)
Lorne Scots Regiment (2)
P.L.D.G.: Princess Louise Dragoon Guards (2)
Canadian Forestry Corps (3)
 (1) Fought in Operation Jubilee, the raid on Dieppe, 19 August 1942
 (2) Fought in Italian Campaign 1943–45
 (3) Fought in Operation Overlord (D-Day Landing, Juno Beach)

More graffiti in the cellar of Ford Manor, including the signature of Private Harold Roach (simulated casualty in the photograph of the operating theatre, Ford Manor, June 1942). He was killed in Italy on 20 December 1943 in the Battle for Ortona.

No. 5 CCS: Casualty Clearing Station → GGS

GGS: Ground Gunnery School. A Canadian School of Gunnery was established in Seaford prior to the Normandy invasion, 1944.

The Canadian Army and the Dieppe Raid
August 1942

Smallfield Hospital, Broadridge Lane, had been built in 1939/40 for a maximum of 1,000 civilian air-raid casualties. It was taken over by the Canadian Army in 1940 to provide accommodation for injured Canadians. After the Dieppe raid of August 1942 there were 1,300 Canadian casualties receiving treatment at the hospital.

In May 1942, Prime Minister Churchill was under pressure from America and Russia to mount an attack on the coast of France to relieve pressure on the Eastern Front. On 20 May 1942, several Canadian Infantry Regiments were moved to the Isle of Wight, which was sealed off and a programme of rigorous training initiated. **Operation Rutter**, the code name for the raid on Dieppe, was set for 4 July. The Normandy Port of Dieppe was chosen as it was just 70 miles from Newhaven and according to intelligence reports not heavily defended. Aerial cover was to be provided by Fighter Command. The Canadian forces began boarding more than 200 vessels, mainly converted Channel ferries but manned by Royal Navy personnel. The ships were attacked by the Luftwaffe while they were waiting for good weather and favourable tides. Two large ships anchored off the Isle of Wight were hit and the element of surprise had been lost. Operation Rutter was cancelled on 8 July; troops were disembarked and were dispersed.

Plans for a new raid on Dieppe, code named **Operation Jubilee**, were complete by early August 1942. The force numbered 6,106 of whom the Canadian army provided 306 officers and 4,658 other ranks. The rest were made up of British Commandos, Americans, and official observers. The force was supported by Royal Navy personnel, 252 ships and landing craft. Aerial cover by RAF fighters and heavy bombers was changed in the final preparations when the heavy bombers were withdrawn in favour of a smoke screen camouflage.

The force sailed in fine weather from Portsmouth, Southampton, Cowes and the smaller Sussex harbours of Newhaven and Shoreham on 18 August 1942 to attack the French port of Dieppe, overrun the German batteries and then withdraw. The raid, called a 'reconnaissance in force' by the planners, was a military disaster in terms of casualties and equipment lost.

The German garrison at Dieppe was only 1,500 men but strong reserves of another 6,000 men and the 10th Panzer Division of tanks were within 60 miles. Before the force reached the beaches, it was spotted by a German naval convoy, and a sharp exchange of fire began. Few units from the landing force moved far beyond the beachhead as German resistance proved to be far stronger than anticipated.

Just before 03.00 hours on 19 August, when some 10 miles off Dieppe, the Royal Regiment of Canada embarked in LCAs (landing craft assault). They were picked up by searchlights and the invasion craft came under heavy fire. As the Canadians landed they were attacked by machine-gun fire. Those that managed to make some headway forward came up against a 12 foot high sea wall. The men were killed, wounded or captured. The second wave came in at 05.30 hours fortunately the smokescreen laid by the RAF afforded them some cover before a southerly wind blew the screen clear of the beach.

Eventually a complete withdrawal was ordered and the depleted convoy returned to England. Of the 2,210 who returned to Britain only 236 were unhurt and 200 of those were men who had not been landed. A total of 907 Canadians were killed in the raid, another 2,460 were wounded and 1,874 taken prisoner by the Germans. Those who died of their injuries in the UK were buried in the Canadian section of Brookwood Cemetery, near Woking.

In April 1942, Lt-Gen. H. D. G. Crerar was given permanent command of the 1st Canadian Corps. He wrote to the War Office on 21 Aug 1942, from the advanced HQ (at Wakehurst Place), about the serious loss of men in the Dieppe Raid: 'As a result of recent operations against the enemy the strength of 2nd Canadian Division has been considerably reduced'. In the meantime steps were being taken to bring 2nd Canadian Division rapidly up to strength. Reinforcements had arrived before 8 October 1942 (802 officers and 8,540 other ranks) followed a month later by another 411 officers and 4,739 other ranks.

The British Military Advisors to the Censorship took exception to a statement made on 19 April 1943 by the Canadian Prime Minister Mackenzie King to the effect that the Canadian Army in Britain numbered 190,000 men. The PM, speaking to the Canadian Club of Toronto, said that:

> the Canadian forces in Britain had grown into an army of two Corps with an appropriate proportion of armoured formations. While training under conditions as similar as possible to those of actual warfare that army had stood guard at the heart of the world's greatest citadel of freedom, constantly in readiness to repel the invader ...

The PM disclosed that in round numbers the total strength of the Canadian armed services was now over 700,000. Of which the army accounted for 435,000 (190,000 were in Britain) the air force totalled 200,000. 20,000 women were also in uniform. After the movement of the Canadian troops to North Africa, Sicily and the Italian mainland in 1943 only three Canadian divisions were left serving in England.

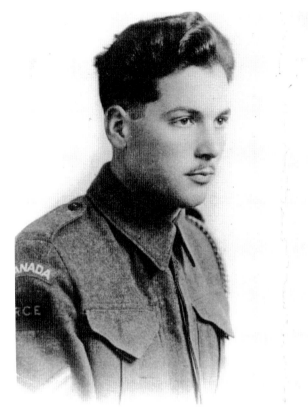

Sergeant Reginald Partington 9th Field Squadron, Royal Canadian Engineers, 4th Division, based at Chelwood Gate Camp in 1944. Sgt Partington was due to be married to Eunice Theed in August 1944 but the wedding was postponed on account of D-Day. (*Eunice Partington*)

The 22 March 1944 was an unusually fine, warm day. Arthur Hayward noted in his diary, 'The Canadian soldiers were showing a Montreal Newspaper man around the village of Lingfield'. Soon afterwards, all Allied troops in England moved towards the South Coast to prepare for the D-Day landings.

CHAPTER 7

Hobbs Barracks

Hobbs Barracks was built in 1938 on the west side of the A22 Eastbourne Road at Newchapel. Building of the wooden barrack accommodation began after the land was acquired by the War Department under Section 1 of the War Department Property Act 1938. The War Office eventually purchased the site from the owner in January 1940. Training companies of the Irish Guards occupied the barracks from autumn 1940 and formed the 3rd Battalion Irish Guards. Additional facilities included medical and dentistry units and a NAAFI. The Irish Guards shared Guard Company duties with other regiments at Lingfield Prisoner of War Camp from 1941 until the end of the war.

Hobbs Barracks was also a depot for the Royal Army Service Corps South Eastern Command and supplied all British forces based in South East Command area. They also supplied all the rations for the 'enemy aliens' held in Lingfield between 1939 and 1940, and the prisoners of war in Lingfield from 1941 to 1945. War Office records show that 1,000 reserve rations were drawn down from Hobbs Barracks at the end of September 1941 for an intake of 378 Italian Prisoners of War at the Racecourse Camp. In 1943, the depot facility was increased by the addition of a new bakery which was built on the opposite side of the Eastbourne Road and officially known as No. 1 Static Bakery. Ten large ovens were in continuous use supplying the increasing military commitments in the run up to the D-Day invasions, as well as the prisoners of war on Lingfield Racecourse.

Bob Blackford remembers fresh supplies of food for Hobbs Barracks arriving through Lingfield Railway Station:

[The Station] was very, very busy in the war because of Hobbs Barracks … food stuff, truck loads of food stuff came in, sacks of things and petrol. Petrol trains used to come in, and cans of petrol in cardboard cartons. I used to go round with the lorry driver … they used to have two trucks. They used to come up with the cab and take one [truck] off, go to the barracks while the other one was being loaded up ready … I used to like going to Hobbs Barracks. I used to sit on the battery box in the front with the two men … sometimes the other man used to sit in the back … and he used to milk the sugar bags. He used to get like a pencil and fill the little bags of sugar and a lot of other things … and to put them in this battery box … they used to check the lorry to make sure you hadn't got anything, but I used to be sitting on the box. They used to look in the back and just look in the front.

Very often you used to get something from the NAAFI. They used to give the driver a cup of tea because he delivered stuff to the NAAFI and I used to sit down with a great big pint of tea and a great big wedge of fruitcake. Lovely!

Recruits from regiments other than the Irish Guards received their basic training at Hobbs Barracks, as did all the local units of the Home Guard. The Commanding Officer, Lt-Col. Viscount Gough, authorised use of their training ground for all seven companies of the 9th Surrey (Oxted) Battalion Home Guard. The rifle range at Hobbs Barracks was also used by Felbridge and Felcourt Platoons of F Company. Lingfield and Dormansland Platoons used the rifle range at the Drill Hall on Racecourse Road.

Throughout 1941 and 1942, additional facilities were made available for training Home Guards. New training staff were appointed and new courses designed solely for the benefit of the 9th Surrey (Oxted) Battalion Home Guard. Limited numbers of officers and NCOs spent long weekends at the barracks. Those who took the course on infantry training under barrack conditions acquired a prestige of their own on their return to Home Guard HQ. A story of one Irish Guardsman's outburst to an unidentified Home Guard Captain was published by W. A. D. Englefield in his book, *Limpsfield Home Guard*:

So ineffective was [the Captain's order to fire] that shots were sprinkled all over the target. With unusual restraint the Sergeant repeated the Captain's fire order and quietly pointed out the errors. He then relieved his feelings with the following outburst: "If you had heard anyone else give that order you would have called him a bloody fool, Sir! Of course I can't call you a bloody fool, sir, but nobody but a bloody fool could have given that order!

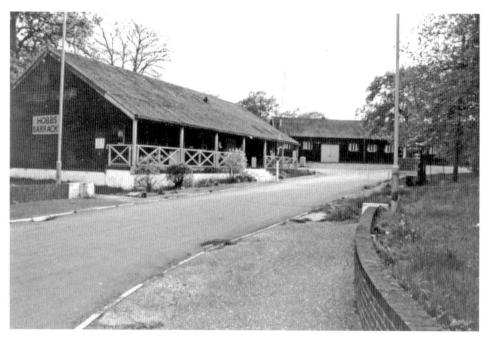

Hobbs Barracks.

The abandoned huts at Hobbs Barracks. (*Felbridge and District History Group*)

Private Theresa Brodigan, Auxiliary Territorial Service, 1944. Theresa was engaged to be married to Private Eric Ellis of 6th Battalion Durham Light Infantry, then serving with the 8th Army in Europe.

Eighty-nine women of the Auxiliary Territorial Service (ATS) were attached to the Royal Army Service Corps in 1944. Theresa Brodigan joined the ATS at Hobbs Barracks, she was then engaged to be married to Private Eric Ellis. Eric and Theresa met in 1940 in Theresa's home town of Goole where Eric was posted after the rescue of troops from Dunkirk. They corresponded through the months of training and Eric's posting to Egypt in 1942. Theresa moved to Lingfield to be near to Eric's home and family.

Theresa worked in the NAAFI canteen, the Navy, Army and Air Force Institutes unit at Hobbs Barracks. Soldiers bought extra comfort rations from the NAAFI when they were available, including chocolate, cigarettes, and miscellaneous allsorts.

The 3rd Battalion Irish Guards remained at Hobbs Barracks until the autumn of 1943 when they marched away on a very public diversionary move before joining the Guards Armoured Division in training for D-Day. In 2004, Theresa Ellis (formerly Brodigan) related the story of the day the battalions left Hobbs Barracks in 1943:

The Irish Guards set off from Hobbs Barracks preceded by the Fifes and Drums and marched along Newchapel Road towards Lingfield. Crowds of people watched as they marched by. When they arrived at Lingfield Station they boarded special trains for a secret destination. Villagers and friends cheered and waved them goodbye wishing them good luck

for whatever lay ahead. In fact the whole journey was a spoof to fool German Intelligence; when they arrived in Scotland they took cover and then set off on a circuitous route to the west coast where they turned south and made their way to the south coast of England. There they joined the Guards Armoured Division in training for D-Day.

The battalion became part of the 32nd Guards Brigade who in turn joined the Guards Armoured Division and landed in Normandy in June 1944. They fought throughout the campaign in north-west Europe. New recruits to the Irish Guards continued to receive their basic training at Hobbs Barracks until the end of the war.

The Enemy Aliens: 'At night the camp looks like Brighton front in peacetime'

After the Nazi's rise to power in 1933 many German-Jewish families made plans to flee Germany. Some crossed the border to France, or Holland, while some wealthier families fled overseas to Britain, or further away to Palestine or America. Jewish refugees in Britain were assisted by The Central British Fund for German Jewry which was founded by a group of Anglo-Jewish community leaders in the early months of 1933. It became part of the Council for German Jewry in 1936, and in 1939 changed its name again to the Central Council for Jewish Relief. The organisation grew to be part of an international network of aid agencies.

On their arrival in Britain the refugees had to register with the police as 'Aliens'. When war finally broke out in September 1939, their 'Alien' status changed immediately to 'Enemy Alien'.

In September 1939, tribunals were set up in towns and cities to decide which enemy aliens were to be interned and which were to be allowed to remain at liberty. The tribunals operated under the guidance of the Home Office, and usually under the chairmanship of a member of the legal profession. It was initially the intention of the British Home Office that only those enemy aliens who remained sympathetic to the war aims of their native countries should be interned. Refugees, most of whom were Jewish and had left Germany or Austria to escape Nazi persecution, were to be allowed to remain free. All Germans and Austrians over the age of sixteen were called before the special tribunals and were divided into one of three groups:

- 'A' – high security risks, numbering just under 600, who were immediately interned.
- 'B' – 'doubtful cases', numbering around 6,500, who were supervised and subject to restrictions.

- 'C' – 'no security risk', numbering around 64,000, who were left at liberty. More than 55,000 of this category were acknowledged to be refugees from Nazi oppression, the majority were Jewish.

The internment of foreign nationals was carried out in varying degrees by all belligerent powers in both World Wars. It was also the fate of those servicemen who found themselves in a neutral country. Internment of German nationals, who were considered to be potentially hostile and were therefore a high security risk, began immediately before the outbreak of war in September 1939. Some of those high risk aliens were imprisoned on Lingfield Racecourse, which had already been designated as a secure camp to hold either aliens or prisoners of war.

Batteries 265, 266, and 267 of East Surrey Anti Tank Regiment guarded the internment camp at Lingfield Racecourse during the winter of 1939/40. Guard duty was on a 'one night on/one night off, one hour on/4 hours off' basis. The weather during December and January was bitterly cold. The soldiers were billeted in barely heated Nissen huts on the racecourse, while the internees were quartered in the racecourse buildings. The internees were high risk category 'A', German civilians and merchant seamen who were confined in the Camp in 1939. Some were tough Nazis who had previously been sent to South Africa by Hitler to form a Nazi Bund and promote Nazi ideals there.

An attempt by German civilians interned in Lingfield Cage to tunnel their way to freedom was reported in the press. The escape was planned to take place in the winter of 1939/40. A fire which began in a living hut at the camp led to the discovery of the incomplete tunnel when camp guards of the East Surrey Anti Tank Regiment began an investigation to find out the cause of the fire. The tunnel started in the ablution-block where spoil was flushed away through the drains. The planned exit was near to a broken flood-light lamp, which would have provided the ideal patch of darkness. Those responsible were placed under guard.

The photograph below shows an armed sentry on duty between the two flood-lit barbed-wire fences which surrounded Lingfield Internment Camp. Powerful electric lights illuminated the whole of the camp although private houses in the neighbourhood were strictly blacked out. One local inhabitant was reported as saying, 'At night the camp looks like Brighton front in peacetime.'

Public attitudes to aliens in Britain began to change in the spring of 1940 as fears of an invasion increased. German forces had successfully overrun Denmark in April; in May the British government debated the disastrous failure of the Norwegian Campaign, the same month the Netherlands, Belgium and then France were invaded and the British Army was evacuated from the beaches of Dunkirk. An outbreak of spy fever and

Lingfield Cage.(*Copyright permission: Surrey History Centre and the Queen's Regimental Museum, ref: ESR/6/12/4*)

agitation against enemy aliens in the UK led to more and more Germans and Austrians being rounded up for police interrogation. When Italy declared war on Britain and France on 10 June, Italian immigrants were also classified aliens. There were at least 19,000 Italians in Britain in June 1940, and Churchill ordered that they all be rounded up. This was despite the fact that most of them had lived in Britain for decades.

A German invasion of England seemed a distinct possibility in 1940. Fears of subversive infiltration increased and all enemy aliens came to be regarded as a potential threat. The British government and people were fearful, some openly hostile, to the large numbers of German refugees. The government acted swiftly to remove a perceived threat to national security. In June 1940, any male 'Enemy Alien' over the age of 16, who was not employed on important war work, was detained by the police and interned in secure camps. Thousands of Germans, Austrians and Italians were sent to camps set up at racecourses and incomplete housing estates, such as Huyton outside Liverpool.

Jewish refugees who had fled from Nazi oppression were angry and hurt that after escaping the terror of Nazi xenophobia they were then imprisoned by the British. Furthermore they were interned with known Nazi sympathisers, who had been imprisoned several months earlier. The Racecourse Camps were intended as temporary holding camps for the aliens until arrangements were made for their transfer to a remote facility; either to the main Internment Camp on the Isle of Man, or deportation to the colonies and the dominions.

A Report on the Military and Internee Staff at Lingfield Internment Camp dated 18 December 1940 is held in The National Archives at Kew. In addition to the Camp Commandant and thirteen officers (including an Emigration Officer), there was a Guard Company of 150 soldiers.

Sixty internees were paid from canteen profits for specialist services such as translators and one camp doctor. Twelve of the internees were voluntarily employed as camp leaders, cleaning and billeting supervisors, clerks and a stenographer.

On arrival at the Camp, all internees were given a postcard to notify their next of kin of their whereabouts. One of those cards has been preserved at the Wiener Library in London, the card makes provision for the briefest of detail:

> Identification No...........................(a unique number allocated by
> the Police on registration)
>
> Date...............................
> Signature........................
>
> Camp address..

Internees were given four optional sentences; all unnecessary words were to be deleted:

> I am (not) well
> I have been admitted into Hospital (sick/for operation) and am going on well
> I am being transferred to another camp
> I have received your card dated................

At the foot of the card was a warning, should anything else be added the postcard would be destroyed.

Facilities in the camps were basic, internees suffered most from boredom. They organised their own educational and artistic projects, including lectures, concerts and camp newspapers. Among them were trained doctors, teachers and musicians, many had professional or skilled expertise that could be used to help, educate or entertain their captive audience. At first married women were not allowed into the camps to see their husbands, but by August 1940 visits were permitted.

Freddy Godshaw was an internee and recorded his memories in BBC/ Second World War People's War Project:

> A convoy of army lorries with out riders took us to Lingfield Racecourse, which had been hurriedly converted ... We were given paliasses, mattresses

stuffed with straw, to sleep on. Some put down mattresses on the grand stands while we were taken to the stables, which had been cleaned out. There must have been several hundred men in the camp at that time. I shall always remember a concert one evening where a young man played the Moonlight Sonata with all of us sitting in the grand stand with the full moon rising over the racecourse. Years later I found out that the young man was Franz Osborn who later became a world-renown pianist.

Chaim Raphael was a British civilian, appointed Chief Liaison Officer at Lingfield Racecourse in May/June 1940. He was born in Yorkshire, attended school in Portsmouth and then read Hebrew studies at Oxford. Knowing some German he understood the language well and had visited Germany before the war. His task at Lingfield Alien Internment Camp was to arrange emigration of aliens, mostly to the USA.

Some refugees had fled to Britain as a first stage of escape from their homeland; their eventual destination was the United States of America. Some had already started the process of applying for permission to enter America before leaving their homeland but had lost or had their papers taken away. A considerable number accepted Britain's offer of assisted emigration to the USA.

On his first day at Lingfield Chaim Raphael noted that the first detainees, who had arrived in 1939, were 'Hitler Germans'. The 'new' refugees were anti-Nazi and vociferously anti-Hitler. They considered that the fortified barbed wire, although appropriate for holding Nazi sympathisers, was entirely inappropriate for holding refugees. The refugees thought they were caught in a trap, waiting for the imminent invasion by German forces that would be welcomed and aided by the Hitler Germans already in the camp. They had access to newspapers and wireless and knew about the Blitz and the real danger of invasion. There were frequent air alerts over the camp.

Several internees had lost their identity papers; some were without any sort of papers. The United States of America set limits on the number of immigrants and required visas and guarantors. Only those with visas could apply for a job. Raphael devised a basic documentation form which gave the refugees an identity and recruited some refugees with administrative experience to help speed up the application process.

The applicants were then taken in small numbers by bus, with a soldier guard, to the American Embassy in Grosvenor Square to present themselves personally for American approval. A few applicants had wives interned in prison who were freed to accompany their husbands to America. The entire process was overseen by a committee operating from Bloomsbury House near the British Museum. Bloomsbury House informed the Embassy when a boat with fifty or so berths was ready to take them to the USA.

More than 7,000 internees were deported from Britain in 1940; the majority to Canada, some to Australia. The British liner *Arandora Star* left for Canada on 1 July 1940 carrying German, Austrian and Italian internees. The ship was torpedoed and sunk off the West Coast of Ireland by a German submarine. 800 passengers were drowned, 682 of those were internees. Others being taken to Australia on the liner *Dunera*, which sailed a week later, were subjected to humiliating treatment and terrible conditions on the two-month voyage. Some had their possessions stolen or thrown overboard by British military guards. Reports in the British press led to a massive switch in public opinion, to one of sympathy for the refugee aliens. Protests led to a change in internment policy, enemy aliens were thereafter held in Britain only.

The first releases of internees began in August 1940 and most had been released by the end of 1942. Many of those released from internment subsequently contributed to the war effort on the Home Front, or served with the British armed forces abroad. The high risk category 'A' enemy aliens were not released until late 1945, when they were repatriated.

Walter Elfer was a German citizen who moved to Italy sometime after 1933 but left Italy for Britain after the alliance between Fascist Italy and Nazi Germany in May 1939. Walter was imprisoned in Lingfield Aliens Camp as a category 'C' Enemy Alien. He was released to work at Piper's Nursery on Lingfield Common sometime in 1940. Walter continued to live in the village eventually marrying a local girl. The couple had three children but Walter died when their children were all very young. The children, boy and girl twins and another boy all live in Surrey. During their internment in the UK, Canada and Australia, category 'C' internees between the ages of 18 and 50 were actively encouraged to enlist in the Auxiliary Military Pioneer Corps, subject to medical fitness. At first they served in Alien Companies, but by 1942 when their loyalty was confirmed many were allowed to transfer to the Fighting Arms of all three services.

By September 1940, four thousand enemy aliens of German, Austrian, Italian and Czech nationality were in training for the Pioneer Corps.

Lingfield Racecourse continued to be a short-stay Internment camp throughout 1940. In December that year, the Vicar of Lingfield reported to the P.C.C. that 'Officers at the Internment Camp were arranging to provide a Recreation Hut for the use of soldiers of the Guard and would welcome gifts of furniture, such as small tables, chairs, games etc'.

The Imperial War Museum holds many personal accounts of aliens in wartime Britain, including the story of Kurt Tebrich, who was held at Lingfield Racecourse from June to October 1940. His two daughters have deposited several boxes of their father's wartime memorabilia at the Imperial War Museum, including his autobiographical notes and correspondence. The autobiography of Kurt Tebrich begins:

NOTICE TO BE EXHIBITED IN CAMPS

AUXILIARY MILITARY PIONEER CORPS

Male Germans and Austrians between the ages of 19 and 50 inclusive who were in Category "C" when interned are invited to apply for enlistment in the Auxiliary Military Pioneer Corps.

Those who have applied for enlistment before being interned may apply again, and when doing so should state when and where the previous application was made.

Enlistment will be for General Service in any part of the world and for so long as His Majesty may require their services in connection with the present emergency. If they are serving at the termination of the period of emergency they will be discharged as soon as their services can be dispensed with thereafter.

Applications for enlistment should be made in this Camp at _____

Date _____

M F -21214/200 Aug./1940

Pioneer Corps enlistment poster. (The National Archives *TNA ref: HO 213/174*)

I was born on September 14 1923, the only child to loving and moderately prosperous parents. My father, Martin, came from a large family who owned a well established draper's shop in a small town in Saxony. He took pride in his Jewish background, culture and tradition, even if he did not observe the religious aspect. Although originally apprenticed as a draper's assistant he later studied medicine and established a busy

general practice in the suburbs of Hamburg. Unlike my father, my mother Ruth came from a practicing Jewish background. She was 16 years younger than my father ... she was a lively, cheerful person, always singing, always busy. The family environment was cosmopolitan, liberal and fairly assimilated with Jewish and Gentile friends. All that changed in 1934. My father was deprived of his Kassenpraxis (Public Health Service permit) under the new Nuremburg anti-Jewish laws ...

At the age of fifteen, Kurt escaped with the Kindertransport organisation. His Aunt Margot, his father's sister, lived in Cowley, Oxford, with her husband and family. Kurt visited the family and was in regular correspondence with his Aunt Margot but was placed with a strict Jewish family in Scotland. Kurt was not very happy living with the new family who criticised his upbringing, while acknowledging that his father was 'a bookie academic, he did not teach him Jewish laws and Hebrew'.

On Kurt's sixteenth birthday in 1939 he had to present himself at the Aliens Tribunal where he was classified 'C' and freed of all restrictions. But on 12 May 1940 he was detained by a friendly police officer and taken to police HQ, from there he was taken to a Victorian building on the outskirts of Edinburgh:

the former lunatic asylum, now an internment camp. The entire male refugee population of Edinburgh is milling about, meeting friends ... [Two days later he was told] "at five, this afternoon you'll go to London and from there to Lingfield. Do you know where that is? It's in Surrey. It's nice there" said our Highland Corporal.

Coaches take us to Waverly Station. We are guarded by soldiers wearing steel helmets and with fixed bayonets who march us to our train through gaping but good natured crowds. The solders who patrol the gangway gradually mellow and exchange jokes. "You're not real Jerries, are you?" [Jerries – war slang for Germans] ... At Kings Cross we say farewell to our friends, the soldiers, who hand us over to another detachment, again with fixed bayonets and helmets.

They escort us to New Scotland Yard. The name conjures up visions of all the detective stories I have read. You can have a wash and pee ... Then we line up for a big breakfast of bacon, sausages, baked beans, toast, marmalade and gallons of tea. Aaron doesn't eat bacon and sausage! I offer him my toast and take his sausage and bacon ...

We are taken by coaches to another station and onto green trains this time. The journey is quite short. We get out at a small station. Where are we? Dunno someone must have pinched the station sign. See, screw holes on the board. Our new escort lines us up in threes and we march

in a straggly column up a warm country road. Trees are in blossom. We watch planes skimming about in the sky but on the ground it seems peacefully early summer ...

We arrive outside a double barred wire fence with a crude wooden and barbed wire gate in the middle ... The Sergeant disappears into a hut leaving us to the dubious welcome of his companion who glowers at us as if he had just seen something putrid and addresses us in a strong coarse Hamburg accent: "My name is Herr Ludke – Partei-Genosse Ludke. I am Deputy Senior Camp Leader. Here we have order. Here you'll obey. If you don't obey, you'll have it coming to you. Is that understood?" ...

Our accommodation is under the grandstand in a long room that must have been a bar with a long counter at the rear ... The other wall is all glass. We have low wooden cots and are given some coarse canvas sacks, called paliasses which we are told to fill with straw ... We meet other refugees some are Jewish or of mixed racial background, others are political, international sailors. Several of us attach ourselves to a young Catholic priest, nicknamed 'Pius' who escaped from Germany to Norway and then to Britain on a British destroyer ... A sense of solidarity compels me to demand kosher food. The food in the camp is good and plentiful but in answer to our demands we now get a large dollop of jam or a couple of sardines dished up with our cabbage!

On the whole we have little conflict with the German internees, many of whom are kindly disposed towards us but they cannot show that because there are always a number of dedicated Nazis, under the benevolent guidance of Party-member Ludke watching them.

One day we were moved to another part of the camp, to the stables at the back of the showers. We are delighted. Large open boxes with large barn doors, 6 of us share a box. The reason for the move is that Italy has entered the war and Italian internees have been moved into our earlier accommodation. Most of the Italians are connected with the catering trade. Soon the Germans are told to pack their bags to march to the station. Where are we going? – Not a clue mate – Isle of Man? Not the foggiest.

They were taken to Liverpool where they boarded a ship to take them across the Atlantic to an Internment Camp in Canada. There were three Internment Camps in Canada, all in remote places. Meanwhile, Kurt's Aunt was concerned about his whereabouts. She wrote a post card to Kurt's only known address in Edinburgh on 31 May 1940, it was redirected by the Post Office to: 'Mr Kurt Tebrich, No. 14411, Race-Course Alien Camp D, Lingfield, Surrey.' In December 1940, Aunt Margot wrote to Kurt in Canada to tell him that she had received a letter from his parents, via the Red Cross: 'Both parents are well and happy' she wrote.

Kurt eventually enlisted in the Pioneer Corps. In December 1942, he joined 143 Troop (A) Squadron 55 Training Regt, Royal Armoured Corps at Elles Barracks, Farnborough, where he anglicised his name. He became known as '13046519 Trooper Clive Teddern'. German and Austrian recruits were encouraged to anglicize their names in case of capture. If captured by the Nazis they would have been killed as traitors rather than treated as POWs.

Almost three years passed between Kurt's letter from his aunt telling him that his parents were well and happy and a letter from the War Organisation of the British Red Cross Society and Order of St John of Jerusalem (based at Clarence House, St James SW1) dated 23 Sep. 1943:

Thank you for your letter of the 18th Sep. We think from your parents' message that they expected to be sent to Theresienstadt Ghetto and that no doubt they had been in touch with Mrs Ernst Norden at Qu 715 Theresienstadt, they knew that any messages sent to them care of Mrs Norden would eventually reach them. If you would like to send a message of 25 words to your parents, will you please send this to us together with a 1/- and we shall be glad to have it forwarded for you. We sincerely hope that you will receive good news in reply but must point out that it may be several months before this reply arrives. We regret that at the present time we are unable to send any further messages from you to your parents before 2 months have elapsed from the date of your first message.

Trooper Teddern crossed the channel in the summer of 1944 with the Kings Royal Infantry Hussars as part of the D-Day landings. His Aunt wrote, 'You are quite right in writing that you get satisfaction by paying back the Nazis what they deserve. My opinion is your parents would be proud of you.'

The Story of Ralph Williams
(formerly Ralph Spielmann)

Ralph Gunter Spielmann was born in Munich, the capital of Bavaria, in 1925. His father was an architect and his mother a concert pianist. One day in 1938, Ralph (then aged thirteen) was outside the family apartment in the Prinzenstrasse cleaning his bicycle, when Hitler's Mercedes car drove down the road. The car stopped and a voice ordered Ralph to salute Hitler, when he refused he was arrested and sent to Dachau concentration camp. His uncle, who lived in Switzerland, paid 20,000 Swiss francs for his release.

Ralph attended a Jewish school until November 1938, when the school was burned down during the anti-Jewish riots, known as Kristallnacht (the night of the broken glass). Kristallnacht, the night of 9/10 November, was the start of the anti-Jewish pogrom in Nazi Germany and Austria. During that night hundreds of synagogues were destroyed, thousands of homes and businesses were ransacked, ninety Jews were murdered and 20,000-30,000 Jews were arrested and sent to concentration camps at Dachau, Sachenhausen and Buchenwald. Some were later released after they had agreed to emigrate (their property was confiscated by the State). Many of those imprisoned were killed and hundreds more committed suicide because of the harsh brutality of the guards.

Ralph's father was held in Dachau concentration camp but was released and made an escape to Buenos Aires. After September 1939, very few Jews were allowed out of the expanding borders of the Third Reich. By the end of 1941, the deportation of German Jews to the east had begun.

Following the destruction of Ralph's school in Munich, his mother Edith, placed him with a Roman Catholic tutor, Professor Emendorfer. On Friday 19 June 1939, while the two were taking a walk together, his tutor told Ralph that he would be leaving Germany later that same night and would be taken to England.

Ralph Spielmann, Friday 19 June 1939, the day he was told he would be leaving Germany for England. (*Ralph Williams*)

Ralph Williams (formerly Spielmann), Lingfield 2005, proudly wearing the wings of the Parachute Regiment.

Ralph arrived in England on 21 June 1939 and with sixty-two other boys went to live at the National Children's Home in Clitheroe, Lancashire. Although the children were evacuated by the Kindertransport organisation, their accommodation was arranged by the Society of Friends, as those children whose parents had chosen to leave the faith (Ralph's mother had placed him with a Roman Catholic establishment) were not acknowledged by the Jewish religious community organisation.

In 1941, recruits were urgently needed for Home Defence; Ralph saw it as his opportunity to join the British Merchant Navy at Liverpool. He became a crew member on a tanker and sailed to Egypt. But when the tanker arrived in Egypt, Ralph was arrested as an alien. He was then shipped back to Britain onboard the *Empress of Britain* with German officers captured by the British Army in North Africa.

When the rules regarding the recruitment of enemy aliens were relaxed, recruits were actively recruited into the fighting units. According to Peter Leighton-Langer's research, one in seven German and Austrian refugees who came to England between 1933 and 1939 volunteered for and enlisted in the British forces.

Ralph joined the Royal Artillery at Larkhill Barracks, Salisbury, in 1943. It was then that he changed his name to Ralph Williams; 'Wilhelm' was a family name. He later served with the 50th Parachute Brigade and was parachuted into Burma.

CHAPTER 9

Prisoners of War at Lingfield Racecourse

Britain was reluctant to accept large numbers of German prisoners of war until there was no longer a threat of a German invasion of Britain. The accommodation at Lingfield Racecourse was adapted in 1941 from a secure unit for holding 'Enemy Aliens' to a prison for holding up to six hundred Prisoners of War. Wooden dormitory blocks, or 'cages', were built on the racecourse to house the prisoners. 'Cage' was also official terminology for a Prisoner of War Camp; Lingfield Racecourse became: 'South East Command, 1st Command Cage (Prisoner of War Camp) at Lingfield.'

On 3 May 1941 at 16.30 hours, one officer and two other ranks of the German Air Force were taken to the RAF hospital block, from a crashed plane at Leatherhead. These were the first prisoners of war to be held at Lingfield Cage, four days later they were transferred to other POW camps. Injured German airmen continued to be brought to the RAF hospital block from crash sites in a wide area around Lingfield. They were assessed and received first aid treatment, before transfer to other secure sites throughout the country. While undergoing treatment they were usually interviewed by RAF Intelligence Officers. At least three German airmen died in the hospital unit at Lingfield Cage. Lingfield Parish registers show that three German Prisoners of War were buried in the churchyard: Alphonse Henkel was buried on 21 September 1942; Willie Engel, buried 1 January 1943; and Rudolph Zimmerman, buried on 17 July 1944.

On 1 September 1941, the War Office appointed No. 3 (POW) Field Hospital to this unit; one of the existing cage buildings was adapted to accommodate the new fifty bedded Hospital Block. Three days later construction began on a new cage unit to offset the reduced hospital accommodation; the building was completed on 26 September.

Lingfield Cage Defence Scheme, September 1941

Commanding Officer: Major the Hon. E. G. French D.S.O.

1. Intention: To deny ingress to and use of the P.O.W. Camp and Cage area to the enemy to the last man and the last round.

2. Information:
 - (a) Railway and bridges are manned by the Home Guard as are approaches from Dormansland and Lingfield.
 - (b) There is a Bren Gun Post and an Anti-Tank Gun Post at the top (Southern end) of the mile straight manned by 4th Corps Troops Supply Column.
 - (c) There are 2 machine guns in the Clock Tower.
 - (d) All personnel will operate from within the outer perimeter.
 - (e) Full security measures will operate as regards challenging and admittance to both camp and cage.
 - (f) Dress – Battle Order.

Guard Company: O.C. Lt Ivan D. Margary of Chartham Park, from 11 December 1941.

 Sentry on Camp Gate.

 The active patrolling of the Camp area by day and night.

 2 Guard Huts for perimeter Guard duties.

 Ammunition to full scale of 50 rounds per man will be issued at once.

Water Tanks: capacity 25,000 gallons – are located in both Camp and Cage Areas.

 Lingfield Fire Brigade – Tel. Lingfield 400.

Rations: Direct from Command Supply Depot, Hobbs Barracks. 1,000 reserve rations will be drawn immediately and located at Command Post.

Lighting: If main electricity supply is cut the perimeter can be illuminated by an independent system of car headlamps on 12 volt batteries.

Telephone cables: now all underground. The exchange board, with 3 outside lines operative and 2 spare and 20 extensions, together with admin. HQ moved into the Clock Tower inside the perimeter.

 The Commandant still has an office in Batnors Hall, outside the perimeter, and this will be maintained until 'Action Stations' necessitating only one extension line from within the Cage.

The first Italian POWs arrived on 20 October 1941. Only seventeen Italian sailors arrived that day. By December, a total of eighty-five Italian sailors were held in the camp (all Other Ranks). Early the following year the

eighty-five Italian POWs were transferred to other camps and preparations were made to receive 378 Italian sailors, transferred from South Africa. The prisoners had been captured between October 1940 and June 1941 and held in a POW camp near Pretoria, South Africa. They arrived at Lingfield Cage between 11 January and 28 February 1942.

They were subjected to a rapid preliminary examination for freedom from skin infections. The general health and condition of the entire intake was excellent and only two cases of pediculosis pubis (body lice) were detected; these were immediately transferred to hospital and cleansed.

More detailed examinations began on 28 January. Each one was examined by the Dental Officer. Eight prisoners were found to be in need of urgent treatment and were taken under escort to No. 347 Army Dental Centre at Hobbs Barracks, 'it is anticipated that the Dental Centre in this Hospital will be in operation very shortly'.

Syphilis – out of a total of four prisoners found to have an old history, one case only was discovered to have a positive Kahn reaction. 'He is now undergoing a further course of treatment.'

Gonorrhoea – total number of cases having an old history was twenty-three. Of these seventeen were discharged from surveillance immediately. Prisoners with old histories of VD were all examined by the Command Veneareologist.

A sick parade was held daily at 08.30 hours. The general health of the camp was quite good. 'There would appear to be however a relatively large number of prisoners complaining from time to time of mild dyspepsia.' 354 prisoners were treated at the Medical Inspection Room during the period.

Hospital Admissions: 40 cases were admitted to Hospital during this period:

1 Fractured clavicle, sustained whilst prisoner was sliding on ice
1 case of post operative appendicitis which was admitted on the night of arrival at this cage, having been operated on 15 days prior to disembarkation
1 case of acute appendicitis which occurred during the period. The prisoner was transferred under escort to Redhill County Hospital for operation
1 shrapnel wound of chest. X-rayed at Redhill – no obvious symptoms at present, still under observation
2 Prepatella Bursitis [Housemaid's knee]
1 Sub acute appendicitis – no operation
1 Renal colic, X-rayed Renal Tract at Redhill result negative
1 Whitlow

3 Tonsillitis

2 Otitis Media, 1 admitted to Redhill – not operated on

1 Haemorrhoids

1 Trophic Ulceration of the distal portion of left index finger following a burn (prisoner had old gunshot wound in left shoulder)

1 Abscess – leg

Spectacles were provided where necessary.

Maintenance of Sanitation: all prisoners were bathed once a week by the No. 3 Mobile Bath Unit. The camp was inspected regularly and a sanitary diary maintained. 'The prisoners showed a marked aversion to fresh air and the need for adequate ventilation. Apart from this, general sanitary measures were of a high standard.'

The prisoners were assessed for agricultural work in Italian labour parties. Parties of workers were taken out each morning in lorry convoys and dropped off at farms in a wide area around south-east Surrey. The labour parties were organised by Surrey War Agricultural Committee and allocated according to need. In several cases farmers negotiated with Surrey War Ag and the POW Camp to provide billeting accommodation for the POWs on the farm. Many lasting friendships began at that time between farmers and POWs. Prisoners who were considered to be unsuitable for land work were transferred to other camps.

Preliminary planning started in 1943 on the organisation of POW interrogation which would follow the D-Day invasion of Europe. German prisoners of war captured in Europe were to be evacuated to the UK for interrogation. In June 1944, interrogation of German and Austrian POWs began at Lingfield Cage.

CHAPTER 10

War at Sea

Robert (Bob) Philpott decided he wanted to become a sailor before the age of thirteen. At school he joined the Officer Training Corps. In 1934, at the age of fifteen, he was old enough to join the Royal Navy which his parents reluctantly allowed him to do. After his third OTC camp he went to HMS *Ganges* at Shotley, near Harwich. The following morning with all other new recruits:

> clad in flimsy cotton shorts we were led, or rather marched at the double, to the mast. Our early morning task was to climb the ratlines, out over the devil's gangway, and up to where the Jacob's ladder started the final bit, then down the other side, all in three minutes. The instructors had lengths of tarred hemp with three loose strands which they used with vigour to encourage the faint hearted. Our instructor, a burly petty officer, suggested that perhaps we were missing our mothers "Well I'm your mother now" he bellowed fiercely.
>
> On my 16th birthday I joined HMS Hood, the dream draft for any boy. She was berthed in Portsmouth next to the Royal Yacht 'Victoria & Albert' and I was thrilled to watch King George and Queen Mary make their stately way on board.
>
> The ship carried qualified instructors and our education continued in the normal subjects, but with perhaps more emphasis on naval history and traditions. A short break was announced with the pipe 'stand easy, place spit kids', we soon learned how to chew tobacco and spit with accuracy into the spit kids, then 'out pipes, clean out and stow away spit kids.

Then like a bolt out of the blue, at the age of seventeen, Bob Philpott's parents called him home to consider his future and arranged for him to be

articled to a firm of chartered accountants. In February 1937, he became an articled clerk and stayed with the firm for three years after which he was called up to service with the Royal Naval Reserve.

With joy he learnt that he was to be drafted to his old ship, HMS *Hood*, at Gibraltar. He remembers his action station down in the magazine where the smell of cordite made him feel sick. His wartime memory of action was the dull thud of the guns and feeling sick. There was also the knowledge that should the ship sink there was no hope of getting out.

After the surrender of the French to the Germans on 22 June 1940, Britain stood alone. Most of Europe had been completely overrun and the only thing that prevented the continuation of Germany's expansion into the UK was the English Channel. The terms of the French capitulation were unusual. The Germans allowed the new administration in Vichy, and its leader Marshall Petain, to keep two-fifths of their land. As well as this, they were also allowed to continue to administer their overseas colonies and control their navy. This was a particular worry to the British since they believed with some justification that the neutrality given to the French by the Axis powers could not be relied upon. Consequently they decided to act on their own initiative and to silence the French fleet by any means at their disposal. After the signing of the armistice, many French naval units had fled France to avoid capture. Prime Minister Churchill acted quickly to prevent German seizure of the French fleet on the 3 July 1940.

Operation Catapult was a two part operation. The first part, sub-code Operation Grasp, was to board and impound all French ships in British and Canadian ports. The French crews were promised repatriation. The largest submarine then known was the French submarine *Surcouf*. The submarine had limped across the channel to Portsmouth from Brest where she had been undergoing a refit. When the French ships were boarded by British armed personnel *Surcouf* was the only vessel to resist. One French sailor and one RN rating were killed in the fight on board the submarine and two British officers injured. All other French ships in British waters, principally at Plymouth and Portsmouth were successfully impounded.

The second part of Operation Catapult was to immobilise the French Fleet on the North Coast of Africa. Winston Churchill ordered task force 'H' under Vice-Admiral Somerville, to Mers-El-Kébir, Algeria, where the biggest single concentration of the French fleet was in port. HMS *Hood* was the flagship of Force H.

An ultimatum was sent to Admiral Gensoul, the French commander offering three alternative proposals; to bring out his ships to join the Royal Navy, to take the fleet to a British port with a reduced crew from where they would be repatriated, or to sail the fleet to a French, West Indian, or an American port and decommission the fleet there. Failure to comply

with the ultimatum would result in the use of whatever force might be necessary to prevent French ships from falling into German or Italian hands. Admiral Gensoul rejected the proposals and promised to defend his fleet against any attack from the Royal Navy. The French fleet had already begun a process of decommissioning their ships in accord with the terms of the Armistice agreed with the German government.

In the inglorious British bombardment that followed the exchange of communiqués, 1,200 French sailors were killed and several hundred were injured. The British seized, immobilised, or sunk a large part of the French navy which only two weeks earlier had been their ally. The part taken by the battle cruiser HMS *Hood* in the battle at Mers-El-Kébir continued to worry Bob Philpott for the rest of his life; he said in 2008, 'In wartime one has to do distasteful things.'

Inevitably, many French citizens who had previously supported the British, felt betrayed and alienated. Petain broke off diplomatic relations with Britain and two days later the French captured three British merchant ships in retaliation.

The strong stand taken by the new Prime Minister, Winston Churchill, demonstrated his power and will to Parliament and people. When the action was announced to Parliament there was universal cheering from both sides of the house.

A second British battle force sailed to Alexandria where French ships were in support of the British East Mediterranean fleet. The British commander at Alexandria, Admiral Cunningham, was able to negotiate a successful agreement with Admiral Godfroy, commander of the French vessels. The French ships were immobilised in Alexandria harbour.

Back in Scapa Flow in 1940, Bob Philpott was made bowman in a packet boat. Scapa Flow is an area of eighty square miles of sea enclosed by the Orkney Islands of Mainland, Burray, South Ronaldsway, Flotta and Hoy. The natural harbour was Britain's naval base during both world wars.

In due course Bob Philpott got his commission; he first served as a parade training officer at the shore base HMS *Victory* in May 1941, then completed a gunnery course in HMS *Drake* at Plymouth where a certain sexy 'wren' played havoc with his emotions. His next move was to a Corvette for convoy duty in the Atlantic, then on patrol in the Denmark Straights, in the Arctic Circle.

We had to chip the ice off the guardrails so that the weight of it didn't turn us over. We were then patrolling between the ice and the minefield in case one of the German battleships tried to get into the Atlantic. But we were never quite sure where we were. Our new radar was suspect, our magnetic compasses did not work well so near the pole and there was rarely light

enough for a navigational fix or an horizon for a star sight. Go too far north and we would hit ice, too far south and we would hit the mines. Our job was to sight and report to the fleet in Scapa Flow. We were then disposable. The cruiser had to shadow until the big ships could take over.

A hurricane caused considerable damage to the cruiser which caused her to be sent home for repairs. After a spell of leave the cruiser and crew were sent to the south on escort duty to tankers. The tankers would refuel the escorts as they sailed south then meet the northbound convoy and repeat the process. After several weeks, never going into port, the ship eventually anchored in the fairway in Freetown and received the long overdue supplies and mail. Bob discovered then that the fiancée he had been writing loving letters to had married a Canadian soldier.

The Sinking of HMS *Hood*

Leading Seaman Charles William Allen was one of 1,415 men lost with HMS *Hood* on 24 May 1941. Charles Allen was born in Lingfield in 1904, his parents Charles and May Allen continued to live in the village until their deaths. Charles moved to East Grinstead after his marriage to Edith, their home was at 44, Queen's Road, East Grinstead. Charles Allen served in the Royal Navy for eighteen years.

HMS *Hood* was the pride of England's Royal Navy, the 'Mighty Hood' as she was popularly known. She was the largest warship in the world on commissioning in 1920. Her sinking by the German battleship *Bismarck* caused national shock and horror.

On the outbreak of war *Hood* was based at Scapa Flow with the Home Fleet. On 19 May 1941, *Hood* with the new battleship *Prince of Wales*, under overall command of Admiral Holland onboard the *Hood*, sailed to intercept the German battleship *Bismarck* as it was attempting to break out into the North Atlantic. The *Bismarck* and the heavy cruiser *Prinz Eugen* had sailed from the Baltic port of Gdynia in occupied Poland, to attack Allied convoys in the Atlantic. In the Denmark Strait, between Greenland and Iceland, on the morning of 24 May, Admiral Holland ordered his ships to close the range and shortly before 6 a.m. both sides opened fire. The *Bismarck* hit the *Hood* amidships. The detonation spread to the main magazine resulting in a catastrophic explosion which tore the ship in half. Only three of her 1,418 crew survived and were rescued from the icy waters of the Denmark Strait.

The loss of the navy's flagship and the appalling loss of life were greeted with profound shock in Britain. Prime Minister Winston Churchill famously

signalled to the fleet, 'The Bismarck must be sunk at all costs.' Crippled by Fleet Air Arm aircraft, *Bismarck* was engaged by the battleships *King George V* and *Rodney* on the morning of 27 May before being sunk with torpedoes. The destruction of the 'Mighty Hood' had been avenged after one of the most dramatic chases in naval history.

The Pacific

Another Lingfield sailor, Marine Arthur Leonard Stubbings, served on the battleship HMS *Repulse*. The ship joined the eastern Fleet in October 1941, arriving at Singapore on 2 December. From Singapore, she sailed with the new destroyer HMS *Prince of Wales* and four other destroyers (together known as Force Z) to attack Japanese naval forces in their landing areas around Malaya.

At 7.55 a.m. on Sunday 7 December 1941, the first of two waves of Japanese aircraft began their deadly attack on the US Pacific Fleet moored at Pearl Harbor, on the Pacific island of Oahu. Within two hours 5 battleships had been sunk, another 16 damaged and 188 aircraft destroyed. Fortunately three US aircraft carriers, usually stationed at Pearl Harbour, had been assigned elsewhere on the day and were thus saved. The attacks killed fewer than 100 Japanese but over 2,400 Americans, with another 1,178 injured. The attack came without warning or declaration of war. It was calculated to ensure Japan's dominance in the Pacific. Six Japanese aircraft carriers had secretly sailed within striking distance of Hawaii, under strict radio silence.

Three days later, on the morning of 10 December, Force Z was 200 miles out from Singapore. Eighty Japanese aircraft attacked Force Z that day. Captain Tennant onboard the Battlecruiser *Repulse* reported that he had avoided 19 torpedoes:

> I found dodging the torpedoes quite interesting and entertaining, until in the end they started to come in from all directions and they were too much for me.

Eventually, hit by 5 torpedoes, HMS *Repulse* sank at 12.33 hours on 10 December 1941. Shortly afterwards the destroyer HMS *Prince of Wales* also sank. Marine Arthur Leonard Stubbings was lost with the ship; he was twenty-three years old. The *Repulse* lost twenty-seven officers and 486 men. Captain Tennant survived and was rescued. The *Prince of Wales* lost twenty officers and 307 men. Admiral Phillips and Captain Leach (on the *Prince of Wales*) were drowned.

War in the Air

The pilots who flew with the Royal Air Force came from many countries and many different backgrounds. As well as British pilots, there were many from the colonies and dominions of the British Empire; from Canada, Australia, New Zealand, India and Jamaica. Airmen also came from the occupied countries of Poland, Czechoslovakia, France and Belgium. In 1939 and 1940, the largest group of overseas servicemen based in the British Isles were from the Royal Canadian Air Force (RCAF). Some American pilots joined the RAF in 1940 and 1941, although the United States of America remained neutral until December 1941.

Several young men had been members of their local Air Training Corps and joined the Royal Air Force when the time came for enlistment. Many preferred the RAF of all the services because of the '3 Shs': Shoes (not army boots), Shirts, and Sheets (rather than army blankets). Former Brockley boy and ATC cadet, Dave Mitchell, joined the RAF at the age of 16 ½ (he falsely added a year to his age). Dave enlisted at Lord's Cricket Ground and was posted to Fighter Command, RAF Kenley. His war service took him to South Africa (where he earned his wings), Egypt and Italy.

Sergeant Pilot Stanley Allen Fenemore

Surrey County Constabulary recorded all reported air raids in a series of Day Books. Information included the estimated number of bombs and bomb type, damage to property and roads, crashed aircraft and parachutists. The news often came in a series of messages as information was gathered from various sources:

Incident No 848: 08.25hrs, 15th October 1940: Plane crashed at South Godstone, near Post Office (Postern Gate Farm, South Godstone). P.C.s Hornett and Taylor are attending.

Incident no 861: 12.05 hrs [15th Oct.] Report from Insp. Bishop re plane at Incident 848. It is British but cannot tell maker. Believed single seater. It is buried in the ground, small pieces scattered about the field. No marks visible. Body of pilot believed down with it. I will inform RAF Kenley. Exploded and caught fire on crashing.

Incident no 876: 16.50 hrs [15th Oct.] Plane flying from Kenley, Hurricane, burnt out and buried in Ground. One dead (RAF). Field at Postern Gate Farm.

The body of twenty-year-old Sergeant (Pilot) Stanley Allen Fenemore, 501 Squadron, Royal Air Force Volunteer Reserve was recovered from the wreckage of the Hawker Hurricane fighter aircraft, and identified at 08.20 a.m. on the following day, 16 October 1940. Sgt Fenemore was the son of William Allen and Gertrude Fenemore of Whitewell, Country Antrim, Northern Ireland. The airman had been in action over Redhill.

After the war, a silver cedar tree was planted on the edge of woodland next to the field crash site, alongside is a small memorial plaque recording the fate of Sergeant Fenemore. A short memorial service is held at the site every year when a wreath is laid at the foot of the tree.

Sergeant Alan Andrew Fuller

At 08.45 hours on 1 July 1941, a Bristol Blenheim IV (Bomber) of 139 Squadron took off from Horsham St Faith, Norfolk, the intended target was a Power Station at Oldenburg in northern Germany. The three crew members were Sgt Kenneth Fenton (pilot), Sgt Robert McDonald (W/Op. Air Gunner), and Sgt Alan Fuller (Observer), a Lingfield man.

At 14.00 a.m., the crew reported that they had been hit by enemy fire and were going to ditch in the North Sea north-west of Terschelling Island, about 250 miles west of their intended target. An aircraft overflying the position reported seeing a dinghy with three men in it. This was reported to Air Sea Rescue who dispatched an RAF high speed launch from Gorlestone Harbour (Norfolk) approximately 160 miles from the crash site. At 20.40 p.m., the launch was attacked by two German reconnaissance seaplanes and seriously damaged. During the attack the wireless operator was mortally wounded and subsequently buried at sea. The remaining seven crew members of the Air Sea Rescue Launch and the three crew members of the Blenheim Bomber were taken prisoner.

They were landed at the Dutch seaplane base at Schellingwoude. Sgt McDonald and a member of the RAF Launch crew had been injured in the attack and were taken to Amsterdam Hospital for treatment. The others, including Sgt Alan Fuller, were taken to the Luftwaffe interrogation centre at POW Camp Dulag-Tuft, thirteen km from Frankfurt am Main. They were later transferred to Bad Sulza and then on to the main German POW camp for airmen, Stalag Luft III in Sagan, Poland, where they arrived on 29 April 1942. Sgt Fuller attempted an escape during the move but was recaptured. In late January 1945, the prisoners of Stalag Luft III were forced to march to the west of Germany in advance of the Russian armies.

All ten men survived the war and the so called Long March from Poland to West Germany. They returned home in 1945. Alan Fuller, a former pupil and Head-Boy of Oxted County School, returned to his home in Lingfield. He now lives in Dorset (2009).

Operation Freshman and
Lance Corporal Frederick William (Bill) Bray

Norway had declared its neutrality on the outbreak of war in 1939 but that did not stop the German invasion in April 1940. Norway was strategically important as the gateway to the North Atlantic and the Baltic Sea. A campaign by British forces to liberate Norway in April 1940, failed disastrously.

In June 1942, British secret intelligence was planning the sabotage of the heavy water plant at Vemork near Rjukan in southern Norway, the only large source of production of heavy water in Europe. The operation was known as Operation Freshman. The occupying Germans were known to be increasing output at the plant and it was feared production of atomic bombs would soon begin.

Plans were laid for a British glider attack on the plant, with support from Norwegian agents working with the Special Operations Executive based in London. A reconnaissance party of four agents was parachuted onto a rocky area several miles north of the hydro plant at Vemork on 18 October 1942 (Operation Grouse). They landed several kilometres from their planned landing area. The agents walked and skied to the hydro plant, 1,000 feet above the Vestfjord Valley, in severe weather conditions. They had two objectives: to find a good landing site for two gliders carrying teams of British Commandoes and then to guide the Commandos to the hydro plant at Vemork. After establishing radio contact with HQ in England on 19 November they identified a frozen lake (Mosvatn) as

a suitable landing place for the British team of thirty Royal Engineer Commandos.

On the night of 19/20 November 1942, two Halifax bombers each towing a Horsa glider took off from Skitten, near Wick in Scotland, to fly over 400 miles to the agreed landing site in the mountainous region of Telemark. The mission called Operation Freshman flew in dreadful weather conditions and was a total disaster. One of the Halifax bombers and both gliders crashed in Norway, one bomber managed to return home. A total of twenty-eight soldiers and two officers, volunteers and skilled engineers from 261 Field Park Company (Airborne) Royal Engineers and 9th Field Company (Airborne) RE lost their lives. Eleven survivors from one glider were executed by the Germans and their bodies buried in unmarked graves on the seashore at Sletteboe in the Stavanger area. One of the eleven was a young married man from Lingfield and Edenbridge, Lance Corporal Frederick William (Bill) Bray. The second glider crashed on a mountain side. Eight of the soldiers onboard died in the crash, four were critically injured and subsequently died or were killed by the Germans, five others were taken to Grini Concentration Camp where they were interrogated by the Gestapo, and in January 1943 executed by a firing squad as saboteurs. Their bodies were buried in a forest in unmarked graves. All prisoners taken on sabotage missions were shot by the Germans without trial.

All thirty bodies of the British Commandoes were exhumed by the Norwegians in 1945 and reburied at Eignes Gravland in Stavanger alongside the bodies of the two glider pilots of Army Air Corps and two Australian pilots of Royal Australian Air Force who flew the ill fated Halifax bomber.

Before the war Bill Bray had been a lorry driver employed by Gordon Jenner, the Lingfield Carrier and the son of George and Alice Bray of Stanhope Cottages, Dormansland. Bill and his wife Lily lived at Edenbridge, Kent. At the time of Bill's death, Lily was seven months pregnant; their son, Denis was born in January 1943.

Bill Bray was a life-long friend of Bill Coombes; both were members of the 1st Lingfield and Dormansland Scout Group. Together they used the local rifle range on Racecourse Road, practising with .22 rifles in the run up to the war.

Production of heavy water at Rjukan was eventually stopped in February 1943 by SOE agents. A party of six men were dropped on the frozen surface of Lake Skrykken, in the heart of the Hardangervidda on 16 February. A week later they made contact with the first team to arrive in the area in the previous October, who had survived in the mountains in conditions of bitter cold and semi-starvation. The successful attack on the factory was made on 27/28 February. The saboteurs escaped and all

survived the war. Stores of heavy water were attacked again in November that same year. The Germans finally abandoned heavy water production by February 1944 and attempted to move some 3,600 gallons by steam ferry. One of the team of the successful (1943) saboteurs placed a homemade bomb on board the ferry which sank on 20 February 1944, in 200 fathoms of water.

Sergeant Louis Victor Fossleitner BEM

Born in 1918, Louis Victor was the son of Alois and Edith Daisy Fossleitner of 16 Frith Park (now part of East Grinstead but until county reorganisation in Lingfield Surrey). His father, Alois, had come to England as a refugee from Austria before the First World War. Louis Victor was a pupil of Oxted School between 1929 and 1935. He volunteered to serve in the RAF at the outbreak of the Second World War and was posted to Bomber Command, 149 SQN RAF (East India) Squadron, Royal Air Force Volunteer Reserve, at Mildenhall, Suffolk.

The squadron played a prominent part in the early offensive against Germany, Italy and enemy-occupied territory. Sgt Louis Fossleitner was awarded the British Empire Medal in December 1942 for his part in attempting to save the life of a fellow airman in September 1942. The Citation for the British Empire Medal (Military Division) was published in the London Gazette, 29 December 1942:

> On 19th September 1942 a Stirling BF334 of 149 Squadron, based at Lakenheath in Suffolk, took off for a raid on Munich. The heavy bomber was flown by Flight Sergeant John Philp. The conditions were terrible, with rain, heavy cloud, icing and un-forecast strong winds. Having bombed the target the aircraft set out on the return journey, the Flight Engineer reported that there would only be sufficient spare fuel to operate for 15 minutes, F/S Philp therefore obtained permission to land at a nearer airfield. When nearly to the airfield, however, one of the engines failed and it was necessary to descend on to the sea off the [Margate] coast. Although the aircraft was kept level, it broke in four parts on impact with the water and the five-man crew were all thrown into the sea. Flight Sergeant Philp, who was a strong swimmer, volunteered to swim to shore alone to get help. He abandoned his intention however as it was necessary to help the mid upper gunner, Sgt King, and in company with the front Gunner, Sgt Reardon, they attempted to swim to shore taking the mid-upper Gunner with them. They were picked up by a fishing boat after swimming for 3½ hours, but unfortunately Sgt King had died. In

the meantime, Sgt Fossleitner, although badly shaken had volunteered to remain behind on one of the wings and support the wireless operator, whose spine was fractured. He supported him for 2½ hours, until eventually both were picked up by an Air/Sea Rescue launch.

Flight Sergeant John Philp, Royal Air Force (captain), Sergeant George Kenneth Reardon, Royal Canadian Air Force (front gunner), and Sergeant Louis Victor Fossleitner, Royal Air Force (navigator) were officially recognised for their "courage and fortitude which were of the highest order".

Tragically Sergeant Fossleitner was killed less than two months later, on 10 November 1942, with two other survivors of the bomber crew who had flown with him that day in September. On the night of 10 November 1942, Sgt Fossleitner was a crew member in a Stirling W7582, which took off from Mildenhall on a training flight under the command of Squadron Leader William Cyril Hutchings DFC. A fire broke out in the starboard outer engine and the aircraft crashed just east of Kingsway Road, Mildenhall. The pilot was probably trying to make an emergency landing at RAF Mildenhall. All the crew were killed: Squadron Leader William Cyril Hutchings DFC, Flight Sergeant John Philp BEM, Sergeant George Kenneth Reardon BEM, of the Royal Canadian Air Force and Sergeant Louis Victor Fossleitner BEM. The British Empire Medals were awarded posthumously.

Diana Barnato (later Diana Barnato Walker)

Diana Barnato was the daughter of Woolf Barnato, the millionaire racing driver, financier and Chairman of Bentley Motors. Barnato owned Ardenrun Place, Lingfield, between 1921 and 1933. Diana's mother lived at Kentwyns a farm at Nutfield, her parents having parted when Diana was four. Diana and her sister spent their time between their parents' houses and an apartment in London.

Woolf Barnato and his fellow racers, known as 'The Bentley Boys', were known to race their cars from the drive under the clock at Ardenrun Place, down the front drive to the pond by the farmhouse, over the bridge and down the back drive to Tandridge Lane, turn round and race back again. Pre-war life for Diana and her sister was a seemingly endless social whirl of parties at the Ritz, luxury fast cars, haute couture dresses and expensive foreign travel. Ardenrun Place was destroyed by fire in January 1933 and Woolf Barnato moved to Ridgemead in Englefield Green, Egham, but the family's carefree lifestyle continued much as before. Diana Barnato inherited her father's love of speed and excitement and learned to fly in 1936, at the age of eighteen.

When war broke out, Diana Barnato volunteered for service with the Red Cross and served for a short term as a Voluntary Aid Detachment nurse at Botley's Park, Chertsey; the hospital had been set up to care for the mentally handicapped but was used as a war hospital from 1939. When the Battle of Britain began Diana served with the Red Cross in central London where she drove a green ambulance ferrying bomb casualties from First Aid Posts to hospital.

The establishment of the Air Transport Auxiliary (ATA) in 1939 offered new opportunities but ATA was at first staffed only by men, mostly civilian pilots too old for operations. The ATA pilots delivered fighters, bombers and trainer aircraft direct from the factories or maintenance units to RAF and Fleet Air Arm Squadrons in all weathers, with no radio contact, few navigational aids and no fitted weapons. The serious shortage of pilots and aircraft in 1940 ensured the recruitment of male and female pilots by January 1940. Initially only eight experienced women pilots were recruited all of whom had the minimum requirement of 600 flying hours experience. As more lives were lost and more aircraft were required, more ferry pilots were needed to fly them to the airfields throughout Britain. Diana Barnato applied to join the Air Transport Auxiliary in March 1941 but her recruitment was delayed for six months after a riding accident in Leicestershire left her with serious injuries to her face and jaw, requiring a series of operations and six months of inactivity.

Diana Barnato lost several dear friends during the war, including fellow pilots. She survived many frightening episodes but her 'guardian angel' protected her from disaster. She flew eighty types of aircraft and delivered 260 Spitfires during her ATA war service, between 2 November 1941 and 31 August 1945. She married a decorated fighter pilot, Wing Commander Derek Walker DFC, in May 1944 a month before D-Day. As a late honeymoon they flew wingtip to wingtip in a pair of Spitfires to a newly liberated Brussels. In November 1945, Walker was killed when his aircraft crashed in low visibility while flying to a job interview.

Twenty-eight different nationalities flew with ATA. By the end of the war more than a tenth of ATA's 1,300 pilots were women, the so called ATA-girls.

The Women's Auxiliary Air Force

In 1939, many senior officers of the RAF were sceptical that women had a role in wartime operations. They had just cause for changing their minds as the Battle of Britain brought the front line over head. Women filled vital posts in intelligence, operations rooms, signals rooms and as ground crew servicing aircraft. Women plotted the course of incoming

raiders using the rapidly developing radiolocation system. The WAAF offered more than sixty trades to new recruits including flight mechanics, armament assistants and electricians. They assembled engines, refuelled aircraft, maintained balloon barrages, packed parachutes and worked as photographers, telephonists, teleprinter operators and cooks.

Nineteen former pupils of Oxted County School served in the WAAF in the Second World War. WAAF personnel worked at Biggin Hill, Croydon and Kenley airfields.

Air Training Corp (ATC)

Three of the Brockley schoolboys, of whom Dave Mitchell was one, asked the Lingfield Headteacher, Mr Cecil Paine, to form a Squadron of the Air Training Corp. The ATC has its origins in the Air Defence Cadet Corp (ADCC), which was formed in 1938. A squadron consisted of 100 Cadets, divided into four flights of twenty-five, each with a Flight Sergeant. From the outset squadrons had to be fully self-supporting and controlled by a local civilian committee. Cecil Paine enthusiastically accepted the challenge

Left to right: Squadron Leader, Revd Frederick Wilson Baggallay, Cecil Paine former Squadron Leader 214 Squadron, and past headmaster of Lingfield School who returned from his new post at Hertfordshire to present prizes, and Sergeant David Mitchell, prize-winner. (*Dave Mitchell*)

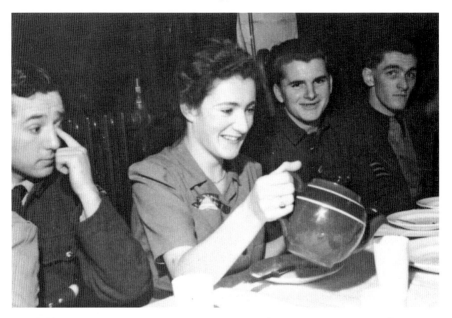

Lingfield Air Training Corps, *c.* 1942 Tea Party. Left to right: Dave Mitchell, Janet Turnbull, Ron Potter and Dennis Shirley.

and made the necessary first steps to organise a civilian committee, he was commissioned by the Air League as Pilot Officer C. F. Paine, RAF Volunteer Reserve, Commanding Officer of 714 Squadron (Lingfield).

Boys from the age of fourteen upwards, from Lingfield and Brockley Schools, were enrolled. Cadets paid 3*d* per week and the Air Ministry promised a capitation fee of 3/6*d* for each proficient cadet. The Ministry's plan was to attract and train young men who had an interest in aviation. They were drilled, disciplined and organised on service lines. Each squadron's aim was to give the cadets as much service and aviation training as possible to prepare them for the RAF. Training included flight experience at Gatwick Aerodrome, Field Exercise with the Canadian Army, and Drill instruction with the Irish Guards at Hobbs Barracks.

The Revd F. W. Baggallay was a veteran of the First World War, ranked Captain in the Army Chaplain's Department. The nephew of Claude Baggallay KC (of The Grange, Felcourt and later Wilderwick, Dormansland) Frederick Baggallay lived at Perry Cottage, West Park. In 1912, he established a fund for the instruction of boys of all classes in principles of discipline, loyalty and good citizenship. On the formation of the Home Guard in 1940, Frederick Baggallay became Corporal in F Company, 21 Platoon, Felbridge. He was appointed Squadron Leader of the Air Training Corps following the departure of Cecil Paine and taught map reading skills to 714 Squadron ATC. He was a local Scoutmaster and

on his death in 1951 the Revd Frederick Baggallay bequeathed his land at Perry Wood, West Park Road, to the Scout Association. It became an International Campsite for the Scouting Organisation.

The first rural Squadron of Air Cadets was Number 19 Squadron; the Burstow-Crawley-Horley Squadron, which was registered on 8 December 1938. Local Headquarters were in Crawley and Horley, and Squadron Headquarters at Burstow School.

Knitting Patterns for Royal Air Force 'Comforts'

Voluntary knitters were recruited by the Royal Air Force Comforts Committee to join knitting parties making mittens, polo-necked pullovers, balaclava type helmets and gumboot stockings, as well as gloves and scarves. They also made pullovers, mittens and scarves for the Women's Auxiliary Air Force. Registered parties could obtain Royal Air Force wool, coupon free at wholesale rates from the RAF Comforts Committee, 20 Berkeley Square, London. One enamel badge was issued free to each Working Party but further badges could be bought for one shilling each.

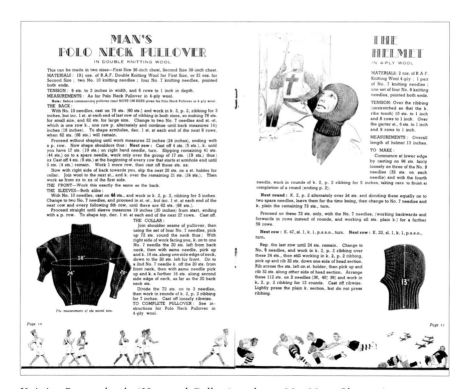

Knitting Pattern book. (*Hayward Collection, donor Mrs Mary Chauncy*)

Front cover of the official booklet of patterns.

Back cover.

War on Land

Napoleon Bonaparte is reputed to have said, 'An army marches on its stomach,' a sentiment with which all soldiers in the British Army would agree. Sapper Edward A. Bryant of Station Road, Lingfield, trained as a cook with the Catering Corps of the Royal Engineers. He noted in his book 'it is essential that every endeavour should be made to ensure that dishes are as attractive in appearance as possible'. Waste was to be avoided in the Army kitchens, as it was in every home kitchen during the war. Clean 'un-fingered' bread left on dining tables was to be used in bread puddings, or as bread crumbs. The recipes were based on quantities necessary to feed 12, 24 or 100 men. Tea for 100 men was made in a tea bucket: twelve and a half gallons of boiling water poured on to twelve ounces of loose tea in the tea bucket. After leaving to brew for at least eight minutes, three pounds of sugar and four pints of milk were added before serving.

Recipe for Irish Stew (Ingredients for 100 men)
37 ½ lbs Mutton
15 lbs Onions
4 oz salt
4 Bay leaves
4 lbs Potatoes for thickening
2 lbs Pearl Barley
50 lbs Potatoes
4 oz Parsley
½ oz Pepper

Fruit Cake for 100 men
Eggless Base: 2 ½ lbs Dripping & 10 oz Baking Powder

9 lbs Flour
4 pts Milk
1 ½ lbs Currants
2 oz Salt
4 lbs Sugar
1 ½ lbs Sultanas

Catering for armies of men in the field required detailed instruction and planning. Sapper Bryant's notebook contains his plan drawings of various ovens for catering in the field of operations. His drawings are of draughtsman-like precision; a Bluff Range to cook for 550 men, a Holdaway Boiler for heating 200 gallons of water for field kitchens, an Aldershot Oven to cater for 250 men, and a mobile improvised stove and oven.

North Africa Campaign 1942-1943

The 11th Honourable Artillery Company Regiment, Royal Horse Artillery, was reformed in England after the debacle of Dunkirk. John Wainwright Hopkins of New Place, Lingfield had been promoted to the rank of Major following his escape from Europe (see Chapter 3). The Royal Horse Artillery received a mobilisation order for service 'somewhere abroad' on 24 August 1941.

All ranks were urged to make wills. Although the soldiers had no idea where they were to be sent they knew it would be hot! The strange tropical shorts with turn-ups almost as long as the legs engulfed many a pair of white, knobbly knees. On 12 September, Major-General the Duke of Gloucester, himself a member of the Hon. Artillery Company, paid a visit to wish the regiment 'God-speed'.

The next day the regiment embarked on board HMT *Samaria*. The course zigzagged as far as the Atlantic. The first two days were bitterly cold and most of the troops were seasick. As the convoy turned south the weather improved. But as the heat increased many of the troop decks became oppressively hot and everybody, almost without exception, slept on deck in the open. When the *Samaria* entered the tropics, milky white English complexions turned to lobster red then to swarthy brown. Everyone passed through the stage of heat blisters and 'gyp-py' tummy. Efforts to relieve monotony included the ceremony of crossing the line (the Equator) and subsequent horseplay, concert parties and boxing tournaments.

Fresh water was soon rationed. Further supplies were acquired at Freetown but troops were not allowed onshore. The three places where the

regiment was allowed to go ashore were Durban, Aden and Port Sudan. Just before entering Aden the regiment paraded to salute HMS *Repulse*, which had accompanied the convoy from Capetown. The regiment heard with particular sorrow the news that after leaving the convoy in October the battleship had been sunk in Far Eastern waters on 10 December 1941. On board that ill-fated ship was Marine Arthur Stubbings of Lingfield. (see the account of HMS *Repulse* in Chapter 10).

The 11th H.A.C. finally disembarked at Port Tewfik on 5 December 1941. It was a great shock to find, not the baking hot stretch of sand that they had imagined of the desert, but icy winds whipping up a fog of brown grit which percolated everywhere, stinging the skin and choking the throat.

On 12 December, the regiment wheeled out of camp and drove through the rain to Mersa Matruh, a distance of 180 miles. Joining with other armoured regiments, they raced forward day after day across the desert to catch up with the offensive which had progressed to Benghazi. Supply lines were over-extended, rations were poor. The basic issue was one tin of bully and one packet of biscuits per man per day, supplemented occasionally by a little jam, very occasionally by bacon, seldom by vegetables. A lively imagination was shown in the combination of bully and biscuits and in serving bully beef fried, boiled or stewed. Water was rationed to half a gallon per man per day for all purposes including the radiator, so it was common to wash, shave and clean one's teeth on half a mug, finally the well used half a mug of murky water was used in the radiator – sometimes even strained through sand or cloth for a second use.

When Benghazi was taken, artillery batteries were able to get supplementary rations by the purchase of tinned food from Italian stocks left behind by the retreating enemy and 'OH JOY' Red Wine. Regular weekly issues of cigarettes, chocolate, etc. had not then been instituted.

On 11 June, it was discovered that the enemy was pushing forward a strong armoured drive towards El Adem and in the evening the group moved towards Bir Lifa to stop this threat. B Battery, led by Captain Wainwright, was on the move at 15.00 hours when they were heavily dive bombed by Junker 87s and 88s. There were heavy casualties and many vehicles were destroyed, the battery withdrew to reorganise after the bombing. B Battery was in action again the following morning. In the early afternoon a powerful enemy tank column was reported bearing down from the west, in exactly the opposite direction from the main battle of the previous two days. The guns were turned round 180 degrees, tanks raced back to ward off this unexpected attack. The enemy tanks closed towards B Battery with their British prisoners walking ahead of the tanks. Suddenly, as though someone had given a

prearranged signal, the prisoners raced away to the flanks and nearly all of them escaped. Fire was maintained until the tanks reined back at about 1,000 yards.

The next morning, B Battery fought a desperate open sight battle; there had not been time to dig in the guns properly. The Command Post was established in a disused vehicle pit. All vehicles moved back about one mile to a shallow depression. The whole battery was covered in successive counter battery concentrations and then the tanks opened up from their firing positions. The tanks methodically picked off each gun as it was betrayed by the flashes; even then the detachments did not leave the guns. No orders to evacuate had been received so everyone sat tight, the tanks were clearly afraid to close in, eventually (orders were received) on 14 June 1942 to organise evacuation on foot, under a smoke screen fired by the battery. As the F Troop gunners came out, Captain Hopkins drove forward to pick them up in his armoured car. Captain John Wainwright Hopkins was killed by anti-personnel shot, which also wounded members of his crew. He has no known grave; his name is recorded on the Alamein Memorial and on the Lingfield War Memorials. (TNA ref: WO 204/8329 – RHA)

The British defeat left the way open for Rommel to lay siege to Tobruk. The ruined city of Tobruk fell to the Germans on 21 June. Hitler promoted Rommel to the rank of Field Marshal. On 6 August, General Auchinleck was relieved of his position as Commander-in-Chief Middle East, and General Officer Commanding 8th Army. His replacement as C-in-C was General Sir Harold Alexander.

General Sir William Gott was appointed GOC 8th Army but was killed the following day when his aeroplane was shot down. His replacement was Lt-Gen. Bernard Montgomery who arrived at El Alamein on 18 August and promptly told General Alexander that all withdrawal plans had been destroyed, 'There will be no more belly-aching and no more retreats' he declared. His determination, and the reinforcements which had been building up since July, were tested two weeks later.

On the night of 30 August, Rommel advanced around the southern end of the British line; he aimed to repeat the approach that had succeeded at Gazala, forcing the British to choose between encirclement and retreat. However, Montgomery had recognised Rommel's superiority in manoeuvre and responded accordingly. East of the line, the tanks of 13th Corps were deployed on and around the Alam El Halfa Ridge, in effect serving as anti tank guns. Rommel's advance was blocked. With fuel supplies running low, he called off the attack on 2 September. No great victory for the British, Alam Halfa was nevertheless a bruising defeat for Rommel and a boost for Montgomery and the 8th Army.

The North Africa Campaign
Seen Through the Eyes of Private Eric Ellis

From the Suez Canal we were sent westward across a desert to the Libyan port of Tobruk to join the Durham Light Infantry. I transferred from the 4th Battalion, Royal Sussex Regiment to the 6th Battalion, Durham Light Infantry.

Gradually we got pushed back [along the North African coast, seeing action at Gazala, Gabr el Fakri, and Mersa Matruh] until we reached El Alamein.

23 October 1942, The Battle of EL ALAMEIN: The 6th Battalion, Durham Light Infantry was then part of the 50th Infantry Division of the 13th Corps of the Eighth Army, under the command of Lt-Gen. B. L. Montgomery.

Night after night we were going on patrol, patrol, patrol, patrol! Anyway, in the end we heard there was going to be an attack. He [Lt-Gen Montgomery] sent one of his big memos round about knocking the Jerries for six – out of Africa. We had to laugh a bit about that.

We were up in the desert and could hear the blinking fighting ... when you're in the desert it's like you're there and you're never going to get out. Because there's nothing. You got a letter about once every six or eight weeks, a paper every six months. We didn't know which month it was. We had no idea how the war was going in Europe. We were up there and we just thought we're all forgotten, we'll never get out of this place.

Anyway at the end of October we were pulled out ... and told that we were going into an attack that night ... I'm not going to tell you much about the attack because it was bloody murder. After we'd attacked we were still under hell of a heavy fire. Then coming up behind us were hundreds and hundreds of our tanks. Oh blimey! The Germans poured all the fire down on them. We were in front of the tanks without any protection.

What we had done, but couldn't see as it was a night attack, we had more or less broken through their forward infantry – but not quite, until the tanks turned up. The tanks crept by us and then came back again, then went up again, then came back and pushed on again. Just after that, all along the front, where we could see, were Jerries with white handkerchiefs, all surrendering. That was the end of the battle. We'd opened up the infantry, the tanks went through, got round the back of their armour and that was the end of the battle of Alamein.

13th Corps insignia.

Rommel was recalled by Hitler, and Hans-Jurgen von Arnim made C-in-C of Afrika Korps. Back home in England the church bells were ringing for the first time since the war began, on Prime Minister Churchill's order. The Allied success at Alamein was taken as the turning point of the war, a tonic to the war-weary and a battle cry for the long haul ahead. Meanwhile the warriors on the front line fought on.

> After the battle we were left behind to mop up for a few days, then we went forward behind the Germans who were on the run. We had a little scrap before Benghazi – not much – then pushed on again to Tripoli. The forward troops then moved on and we had a rest outside Tripoli for a week or so. Eventually we moved on to Medenine (Tunisia) and a few miles further to the Mareth Line, there was the second biggest battle in Africa. It was terrible.

The Mareth Line in eastern Tunisia was a natural defensive position, a front 35 km (22 miles) long which extended from the coast to the mountains inland. On the night of 20 March 1943, Montgomery attacked the line with 30th Corps, while making a flanking attack to the south around the German right flank with New Zealand and Free French troops. The 30th Corps was thrown back, Montgomery then sent back for reinforcements.

> During the day we'd cooked a big rice pudding in a petrol can. They were square tin cans, we used to cut the top off and put it on the fire so it got rid of all the fumes. We only had marmalade to sweeten it. We left the pudding in the can and went off to do this attack but before we got there it was cancelled. We were told to go back and there was our rice pudding! We were always hungry in the desert. At lunch we only had about three or four hard biscuits, a spoonful of jam and a tiny bit of cheese and that was your ration.
>
> The next night we went up to do this attack. We got across this Wadi, I was in a bren-gun carrier, and we attacked the Germans who had taken up positions in the old French defensive forts. While we were doing this Montgomery took the New Zealanders round the back. When we went into battle we had 13 bren-gun carriers and 6 three-inch mortars but we lost every one of them. Apparently there were also about 40 tanks knocked out because that was the place where the Germans first used their Tiger tanks, our Shermans were no match for them. But we survived the frontal assault while the flanking attack got round the Gabes Gap.
>
> Anyway, we came out of it. I've still got the telegram – they let us have a sheet of paper with different words on it: I'm alive and well / I'm something and well and hope you are too, and all my love darling – and this darling – and that darling!
>
> Then it went quiet until we'd been there a couple of days, then at night we saw big flashes in the sky, way to the west, and we knew the Germans were blowing up their ammo dumps. Then they cleared off. So the next day we moved on ... I can't tell you about that because we lost someone ...
>
> We went through a minefield ... a fella was digging one up and got blown up ... The land we went through was littered with guardsmen that had died the week before, or a bit longer. In the heat they were blown right up to twice their size.

The next German fallback position was at Wadi Akarit, north of Mareth ('a whacking great Wadi – a hell of a job'). The Wadi was stormed by 30th Corps on the moonless night of 5 April 1943. Again, German forces made an orderly withdrawal and now fell back to a defensive line covering Tunis.

The final assault on Tunis was led by the 1st Army, heavily reinforced and supplemented by several 8th Army units. The decisive attack began on 6 May with a massive artillery bombardment. Meeting little resistance from an exhausted Armeegruppe Afrika, the British Army entered Tunis on 7 May. Hans-Jurgen von Arnim surrendered on Wednesday, 12 May and was taken prisoner by the British Indian Army. 190,000 German and Italian troops were also taken as prisoners of war. Two years after the first clash between British and Italian forces in Egypt, North Africa had been liberated from the Axis. Europe now lay ahead.

> Then one day they said, 'Right, pack up your gear'. Some lorries were brought up and we got in the backs of the lorries, we went 2,000 miles in those lorries, right back to Suez where we started off.

The news of the victory reached Eric Ellis' home in Lingfield on the following day. After a church service, on Sunday 16 May, Arthur Hayward visited Sir John and Lady Hopkins at New Place, Station Road, Lingfield. Less than one year before, their son Captain John Wainwright Hopkins had been killed in the desert before the Allied defeat at Tobruk. Arthur Hayward invited Sir John and Lady Hopkins to his home at Lingfield Guest House that evening, Sunday 16 May, where he hosted a small sherry party to celebrate the victory in North Africa.

The Invasion of Sicily

The 8th Army next prepared for the invasion of Sicily.

> We did our training on the Great Bitter Lake [a salt water lake between the north and south part of the Suez Canal]. After a week or two training we were taken back to Tripoli where we were put in a camp on the aerodrome – the Castle Benito aerodrome – surrounded by barbed wire fencing – then we were told we were going on the invasion of Sicily.
>
> We sailed all that night [9/10 July 1943] and in the morning we approached Sicily. When we were about 600-700 yards from the coast a blinking searchlight came on us and a machine-gun opened fire. But luckily we had some battleships with us who soon put some fire in and wiped them all out. We landed at Avola.
>
> But I must tell you, the thing I've always said, and I've never forgot it – that when we were approaching the shore of Sicily, the smell, the smell of the trees and the green you could smell it, it was wonderful after all those 18 months or so in the desert.

After we left the beaches we had to go up a bit of a hill fighting but we didn't have too much problem there. There were only Italians there then … they were good at fighting when they got the upper hand but if you got the upper hand they were running away all the time. We made our way inland on the Catania side – we got Stuka'd then, but luckily there were some Spitfires that came on the scene and knocked all 8 of them down … one of them came down very near us … and while we were waiting under a tree, all of a sudden a terrific bang and a blinking bomb went off!

We went on to Lentini and rested for awhile, then got briefed for a battle to take the Primosole Bridge over the River Simeto. From there it was open country over the Catania Plains. Montgomery didn't want to send his blokes into battle across open country. I learned afterwards that he had sent other troops round the other side of Mount Etna (we were on the coast side). (Private Eric Ellis)

The fierce Battle for Primosole Bridge took place on 15 July 1943. German paratroopers forced the withdrawal of the 8th Battalion Durham Light Infantry but the battle allowed Montgomery's diversionary tactic to succeed.

Fusilier James Nicholas Dicker was killed in the battle for Primosole Bridge. James Dicker was fighting with 1st Battalion Royal Irish Fusiliers, he was twenty-one years old and his home was Lingfield. He was buried at

The island of Sicily.

the Sangro River War Cemetery. Two more local men were killed in battles at Syracuse and Catania on the Island of Sicily. Private Edward Thomas Batchelor, 2nd Battalion the Devonshire Regiment died on 13 July. His home was Lingfield; he was buried at Syracuse War Cemetery. Lieutenant John Cecil Horner, 2nd Battalion, the Parachute Regiment, Army Air Corps, Queen's Royal Regiment (West Surrey) was killed on 14 July and was buried at Catania War Cemetery. He was twenty-two years old and his home was Blindley Heath.

CHAPTER 13

1943:
The Bombing of Lingfield
and East Grinstead

The New Year of 1943 began with several enemy aerial attacks on Dormansland, Dormans Park and Lingfield. Police Sergeant Hills' first report in 1943 read as follows:

At 15.00 hrs on Monday 18 Jan 1943, 8 High Explosive bombs fell at Dormansland and Dormans Park. Dormans Park automatic Telephone Exchange was demolished, 16 large houses sustained damage to windows, doors and roofs by the blast. 1 bomb fell on the Telephone Exchange, 1 in a culvert between the Viaduct & Dormans Park Hotel, 1 in a private road near the Hotel, 1 in woodland 75 yards from Dormans House, 3 fell on sewage farm, 1 fell 200 yds from telephone exchange, towards Dormans Station.

Denis Leman wrote:

On 18 January 1943 we had a string of bombs fall right through Dormans Park. The first one fell down by the stream at the bottom of Swissland Hill, the next fell right on the corner outside Shama and demolished the big old oak tree, the third dropped on our little telephone exchange with a direct hit down Pig Lane. The fourth was in the woods at the back of the telephone exchange where indeed you can still see the crater.

Later that same day, at 21.10 hours, Sergeant Hills reported that another exploded bomb had been discovered in Dormansland, making nine bombs in all. The bomb had exploded eighty yards to the rear of The Nobles, Dormansland, causing damage to the windows and tiles of the house. Some windows were broken in Dormans Railway Station. A further report

the following day of an exploded anti-personnel bomb on the tennis court at Dormans House took the total to ten bombs.

At lunchtime on Wednesday 20 January 1943, Lingfield village was attacked by a German aircraft, a note in the *Junior School Log Book* records only the bare facts:

> Air Raid 12.50 pm – 1.20 pm. Machine gunning. The School roof damaged.

The air raid affected attendance in the days following the attack as parents feared for their children's safety.

On Monday 8 February, Lingfield School was closed all day 'due to a leak in the boiler and consequently there was no heating'. The boiler was repaired the same day allowing the school to reopen early on Tuesday 9 February, the day that the school was hit by a high explosive bomb at about 8.30 a.m., with devastating effects.

The Bombing of Lingfield Primary School and the Village Centre

The events of 9 February 1943 in Lingfield were recorded in Surrey Constabulary Day Book:

> Entry no. 86: Report to Godstone Report Centre UXB [unexploded bomb] on lawn of The Medlars, Mount Pleasant Road, Lingfield … 08.30 hrs on top of ground. All visible except fins. Whole bomb exposed.
>
> Entry no. 87: At 08.30 hrs, 10 H.E.[High Explosive] and 1 H.E. unexploded fell on Lingfield in a line from the Central School across the village to Mount Pleasant Road. Direct hit on rear wing of school which was demolished. Adjoining Mission Hall also demolished. Five cottages wrecked, several houses badly damaged and many houses and shops slightly damaged. Road surface of Newchapel Road damaged, gas, water, electricity and telephone system damaged. Three adult female and two female children killed and about 20 male and female adults and children injured. Number of persons evacuated from damaged houses who have been accommodated by friends. Rest Centre open for refreshments.

Newspaper and local eye witness accounts give more details of the tragic events that morning. Local people were making their way to work and schoolchildren were on their way to school when a German 'Dornier 217' bomber flew over the village of Lingfield. Several people saw the bomber

drop its load of bombs as they ran for cover. Seconds later they heard the loud explosions, shouts from all around as people were knocked off their feet, and the crash of falling masonry. Fragments of buildings and brick dust covered the centre of the village. A scene of complete devastation confronted all those who ran to the scene; shopkeepers, villagers, teachers, ARP Wardens, Home Guards, policemen and Canadian soldiers. A well rehearsed procedure was then set up for securing the site and searching for casualties.

One of the high explosive bombs had fallen directly on the village primary school. The rear part of the building, which included the teachers' room and the girls' corridor, was completely demolished. Only three classrooms remained standing. Two teachers were killed; Mrs Heather Lumsden of Vicarage Rd., and Miss Rosamund Joan Hunt; both had been on fire-watching duty on the roof of the school the previous night. Two schoolgirls who were close friends were also killed; Anne Turnbull of the Garage, Felcourt, and Frances Mary (Joan) Maine of the Bungalow, Felcourtlands Farm. The school cleaner, Mrs Jessie Lynn, who lived at Barleystack, Newchapel Rd, was critically injured and died two days later at Redhill County Hospital. Another teacher, Mrs Goodyer, was also

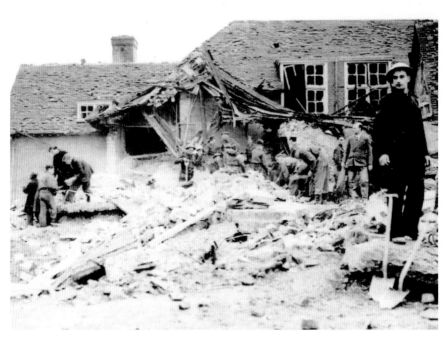

The bombed Lingfield Primary School. (*Hayward Collection*)

injured but made a good recovery. The headmaster Mr Cecil Paine, who had passed the two girls in the corridor only minutes before the explosion, was unharmed. Fifty years later he recalled:

> I had to climb under [the rubble] to identify the bodies. The most difficult thing I remember is talking to the parents and family of the dead children and teachers.

Anne Turnbull and Joan Maine, both aged eleven, had arrived at school earlier than usual. They and Anne's sister Janet, aged sixteen, had taken the bus from their homes at Felcourt to Lingfield High Street, Janet was on her way to work. All three regularly visited the baker's shop before starting their day, but due to the heavy rain Joan and Anne decided to go straight into school.

Witness reports include one from a schoolboy who was on the way to feed his rabbits:

> I saw the plane coming over, just as I looked up, sort of droning, and all of a sudden the bombs coming out. I just dropped the rabbit's food, it was oats I was giving them. I rushed in and said "there's a plane just dropped some bombs" ... everything shook and then the next thing we'd heard, they'd hit the school, just as we were on our way to the school. Of course, we came back ... and they said why are you coming back, and we said "They've bombed the school, there's no school". I knew [the two girls] quite well, Anne Turnbull and Joan Maine and Mrs Goodyer, she got trapped, but she was alright.

The area between Newchapel Road and Mount Pleasant Road was also ruined. The unexploded bomb on the lawn of The Medlars (Police log no. 86) had ploughed through the hedge before coming to rest on the lawn. Mrs Lilian Rose Glover of Noel Villa, Mount Pleasant Road, was killed when a bomb exploded in the neighbouring garden of Callowill. A deep crater was left in the garden of Callowill and Noel Villa was extensively damaged. The explosion also blew in windows and ripped off tiles from most of the houses in Mount Pleasant Road.

Horts Cottages, a row of three terraced cottages in Newchapel Rd were wrecked. The German bomber had fired machine-gun bullets along the Newchapel Road. Misses Daisy and Annie (Nelly) Deacon of Brickyard Farm were injured by the bullets and taken to hospital. The farmhouse and nearby barn were riddled with bullet holes.

Cordons were quickly erected round the two main areas of devastation and guarded by police, wardens and Home Guards. A Bomb Disposal

Squad was called to deal with the unexploded bomb on the lawn of The Medlars. Children who had left their homes in Mount Pleasant Road or Newchapel Road shortly before the bombs dropped were worried about their parents' safety but were not allowed to cross the cordon. Meanwhile anxious parents gathered around the front entrance to the school for news of their children, little of the destruction behind the school could be seen from the cordon as the front elevation of the building remained intact.

Jean Stanford was on her way to school along Lingfield High Street when the bombs were dropped, she took shelter in the nearby fishmongers' shop. Jean thought at the time that the bomb had exploded on land towards the church as there was no visible sign from the front of the school building of the devastation at the rear. The brim of her school hat was covered in glass and debris. The fishmonger checked that she was uninjured, brushed her down and assured Jean that he would get word to her mother that she was safe.

Army medical teams from Hobbs Barracks and Ford Manor worked long and hard to recover the casualties from both areas of the village. Teams of volunteers including Canadian and Irish soldiers cleared the rubble from the village centre. All the surrounding buildings were damaged by falling debris and the effects of the blast, including the Infant School, Lingfield Central School and the Victoria Memorial Institute. The Mission Room at the rear of the Infant School was ruined. The Mission Room and the Memorial Institute had been in daily use as classrooms for evacuees but thankfully none had arrived before the bombs were dropped. Shops and houses in the High Street were also damaged; windows were blown out and glass, brick and tile debris covered the area.

Two days after the raid the Junior School was allowed the use of Lingfield Parish Church for their morning session of lessons. The next day, Friday 12 February, the school was closed throughout the day as the church was required for preparations for the funerals of the air-raid victims.

The joint funeral for the two schoolgirls, Anne Turnbull and Joan Maine, took place on Saturday 13 February. The church of St Peter and St Paul in Lingfield was full for the service. The families of the two girls were joined by the High Sheriff of the County, the Parliamentary Under-Secretary to the Board of Education and many other visiting dignitaries. Assisting the vicar were the archdeacon, the rural dean and clergy from all the neighbouring parishes as well as the Baptist and Methodist ministers. Members of all the Civil Defence services, police officers and special constables formed a guard of honour for the coffins of the two young schoolgirls. The teachers and schoolchildren followed the family mourners to the graveside. After the burial, an estimated total of 500 mourners filed past the two small graves, laid side by side in Lingfield cemetery.

On Monday 15 February the school reopened in the Wesleyan Hall with ninety children present. Class 1 Junior pupils were able to return to their own classroom in the damaged school building the following day, exactly one week after the air raid:

> Tuesday 16 February: One wing of the Junior School where little damage was done has been repaired, and this morning Class 1 children are back in their old room. The remaining Infants and Juniors will continue to work in the [Wesleyan] Hall. 115 children present. (School Log Book)

The pupils of Lingfield Central School had lessons in various large houses as their school building had also been damaged in the raid. Lingfield School pupils who lived in Dormansland village were temporarily accommodated in Dormansland Junior School, to ease Lingfield's accommodation problems.

Mr Maurice Hudspith, Brockley's woodwork teacher, produced a hand carved and decorated oak cross. The cross marks the grave of Joan Paine in Lingfield Cemetery. The next grave of Anne Turnbull is marked with a stone flower vase.

The Mission Room was situated behind the school on land given by Dr Sydney Austin in 1875. A Baptistry was sunk in the floor of the main room in 1901, replacing a large iron tank in the field adjoining the building. Names of a few of those involved in building the baptistry were recorded, all that remains of a generation of faithful worshippers:

The Mission Room, opened on 9 June 1875, was ruined by bomb blast on 9 February 1943. (*Hayward Collection*)

Many of their number were mechanics. Mr Penfold and Tichener laying bricks, Tennant and Huggett holding candles for them. James Tharp in the hole. Willie Payne, Lewis Moore, and Baxter bringing in pails of cement. Mr Terry outside mixing cement, Mr Jones doing carpenter's work and Mr Brooks helping him.

The Whitehall Cinema, East Grinstead, 9 July 1943

Friday 9 July 1943 dawned wet and miserable, just the day to go to the cinema. That afternoon the Whitehall Cinema was packed for a matinee performance of a Hollywood film starring Veronica Lake, *I Married a Witch*, and a supporting western film featuring Hopalong Cassidy, the children's favourite. The audience had seen the main film and newsreels when shortly after 5 p.m. an air-raid warning was flashed on the screen. Several people made for the emergency exits while others remained in their seats, this was a regular occurrence and usually the danger passed over. That day was different as more than one hundred people were killed in the air raid.

Ten enemy aircraft had crossed the coast that afternoon for a bombing mission on London when they were picked up by radar. The RAF had been grounded due to the weather conditions. Nine of the German bombers flew to Croydon while one, who had become separated from the formation, flew south along the railway line towards East Grinstead. At Lingfield, the bomber spotted a train leaving the station for Dormans and began to attack the train with machine-gun fire. The train was packed with schoolchildren returning from Oxted School. Fortunately, there were no reports of injuries to passengers on the train, or at Dormans Station.

The enemy aircraft flew on to East Grinstead where it dropped a string of bombs on the High Street and London Road. One bomb dropped on Bridgelands, the Ironmonger's shop on London Road, which that morning had received a delivery of paraffin. Two bombs fell on the Whitehall Cinema, one a high explosive 500 kg bomb. Fire quickly spread to adjacent buildings along London Road, the flames and thick black smoke could be seen by witnesses several miles from the town.

The cinema was part of the Whitehall Parade and included three shops at ground floor level; over the shops at first floor level were the Rainbow Ballroom, a restaurant and function rooms, additional living quarters were at second floor level. The greatest number of casualties was at the Whitehall Cinema, which 'seemed to collapse like a pack of cards, trapping most of the audience', according to one witness account. People fleeing

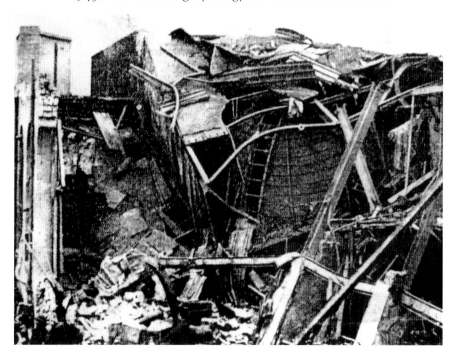

Whitehall Cinema: the collapsed auditorium, 9 July 1943. (*Hayward Collection*)

from the scene were attacked by machine-gun fire from the enemy aircraft as it circled over the town, several were killed or injured. After the attack East Grinstead was a scene of devastation.

Police, firemen, Irish Guards, Canadian soldiers, Home Guards, ARP Wardens and local volunteers worked continuously to rescue the injured, extinguish the fires, and keep the area clear for the coordinated efforts. All the injured had been rescued from the scene before nightfall but work continued through the night to remove the dead. The Citizens Advice Bureau established an emergency incident room to handle all enquiries from the public.

Red Cross and Voluntary Aid nurses worked for many hours in the emergency first aid post in Moat Road. They attached Casualty Cards (MPC46 cards) to the clothing or body of each victim. The cards bore the name and address of the casualty (if known), the nature and the site of all apparent injuries, any treatment given (including time and dosage of administered drugs) and any other relevant notes.

The cinema audience included many schoolchildren who had made their way to the cinema straight from school that wet afternoon. Most were sitting in the cheaper seats at the front of the cinema where the greatest damage was done. Eleven children of sixteen years or under were

pronounced dead on arrival at the Queen Victoria Hospital. The youngest child to die that day was only three and a half years old.

A temporary mortuary was set up at Foster's Garage where bodies were laid out for identification purposes. Estimates of the dead and injured vary. A complete list of the names of the dead and injured was not published at the time or retained on file. Most accounts of the tragedy state that 108 people died and 235 people were injured. The only official records of the event in the public domain are those made by volunteer officers of the Citizens Advice Bureau (CAB), they are now accessible at West Sussex County Record Office in Chichester. Records show that 123 death certificates were issued by Mr Lewis Bennett the Deputy Civil Defence Chief, East Grinstead. 393 injured casualties were officially logged. The Commonwealth War Graves Commission's Register of Casualties omits several known casualties, certified as 'Dead on Arrival' at Queen Victoria Hospital, or who died at hospital in the days following the disaster.

A total of 219 casualties were taken to the Queen Victoria Hospital in a fleet of ambulances, buses, military vehicles and all manner of private vehicles. Many had been referred from the First Aid Post in Moat Road. Seventy-one casualties were fatally injured and were pronounced dead on arrival at the hospital. Twelve more patients were to die at the Q.V.H. in the days following the tragedy.

Additional VAD nurses were in reserve to help existing hospital staff in emergency situations but treatment areas were under extreme pressure. According to the casualty lists thirty-six casualties were treated as out-patients and allowed home after treatment. Sixty-six casualties were admitted at the Q.V.H.; as there were only thirty-six community beds in the original brick building and many of those beds were already occupied, emergency beds in the wooden units, built in 1939/40, must have been used to treat a large number of the casualties. A shortage of beds meant that many casualties were transferred to other hospitals; twenty-five military casualties were immediately transferred to Horton and Smallfield Hospitals. Horton Hospital at Epsom was built as a psychiatric facility but became a military hospital in the First World War and an Emergency Medical Services Hospital in the Second World War, receiving both civilian and military casualties. Nineteen civilians were transferred to Horton Hospital from Queen Victoria Hospital, seven were transferred to Redhill Hospital, two to Tunbridge Wells and one to Leatherhead Hospital.

Fortunately, the Q.V.H. had shortly before taken delivery of supplies of gas cylinders for equipping tank respirators for two polio sufferers; the respirators were better known as Iron Lungs. But for that delivery the hospital would have been unable to cope with the high number of emergency operations on critically injured casualties.

Media attention was drawn to individual stories including the death of Molly Stiller a fourteen-year-old cinema usherette. Molly left the De le Warr School in East Grinstead earlier that year to take up her first post as an usherette on the staff of the Whitehall Cinema. Her older sister Dolly was also employed by the cinema as an usherette, the sisters were on duty together on the afternoon of the bombing. Molly's body was found by her uncle the following day. Dolly escaped injury.

Carol Ann McCollum was the youngest victim, the three-year-old child of Private Edmund McCollum of the Royal Artillery Medical Corps and his wife Vera. The young family left their home in Horley to go to the Whitehall Cinema with Edmund's sister and brother-in-law, Ethel and Herbert Smith. Edmund and Vera McCollum survived, little Carol was dead on arrival at the hospital. Constable Herbert Smith, a member of the Police War Reserve was killed and his wife Ethel died from her injuries five days later.

Margaret Sleight, aged ten, had gone to the Whitehall Cinema with her mother Doris and her father Trooper Jack Sleight of the Royal Tank Regiment. Doris was dead on arrival at hospital, her daughter Margaret died the following day, Trooper Sleight survived. An ARP Warden from the Borough of Holborn was visiting her two evacuee children in East Grinstead. The family were together in the cinema that afternoon. The mother was killed and the two children who were critically injured were first taken to the Q.V.H. then transferred to Horton Hospital, Epsom. The mother's return rail ticket to Holborn was found in the ruins of the cinema.

Isabel Fothergill and her daughters, Erica, Mary, Jessie and Isabelle, their friend Florence Firmin and Isabel's sister-in-law Charlotte Fletcher had gone as a party to the Whitehall Cinema. Isabel and Mary Fothergill and Florence Firmin were killed. Erica died in Dewar Ward, Queen Victoria Hospital on 12 July. Her sisters Jessie and Isabelle were seriously injured. They were transferred to Horton Hospital and eventually recovered. Charlotte Fletcher was also seriously injured and transferred to Horton Hospital where she too recovered. The survivors had lost all their personal belongings including their spectacles, identity cards and ration books. Florence Firmin's gold wrist watch, silver brooch and gold rings were found.

Mrs Mary Elizabeth Greenwood who lovingly cared for the schoolboys of Brockley Central School at her home in Dormans Park was another victim of the Whitehall bombing. Captain and Mrs Greenwood moved to The Shooting Box at Shovelstrode after turning over their home in Dormans Park to Brockley Central School. Mary Greenwood was a fan of the Hollywood star Veronica Lake and had gone to see the film *I Married*

a Witch at the Whitehall Cinema. Her husband telephoned the Citizens Advice Bureau in East Grinstead to explain that his wife was deaf and dumb, so might be unable to give her address to rescuers (CAB volunteers coordinated all enquiries). The next day, Captain Greenwood identified his wife's body in the temporary mortuary. The Commonwealth War Graves record of the death of Mrs Greenwood show her husband's rank as Flt.-Lt Gilbert Frederick Greenwood, RAF. As Gilbert Greenwood's service was with the Royal Flying Corps in the First World War his RFC rank of 'Captain' continued, the equivalent RAF rank is Flight Lieutenant.

Six British soldiers and one service woman were killed instantly. Several truck loads of Canadian soldiers had also gone to the cinema, ten Canadian soldiers are known to have died that day, another twenty-one were to die in Smallfield Hospital from their injuries. Twenty-one-year-old Private Ross, a Canadian from Springhill, Nova Scotia, was taken to the Q.V.H. but the next day transferred to the care of the 5th Canadian Clearing Station at Ford Manor, Dormansland. Signalman Lloyd William Cameron of the Royal Canadian Corps of Signals was passing time at the cinema before visiting his wife Phyllis at the Queen Victoria Hospital. Phyllis was recovering from the birth of their baby son Stephen who tragically died twelve hours after his birth on 7 July. Lloyd Cameron's body was recovered from the wreckage of the cinema.

Several other buildings were destroyed by the stick of bombs that were dropped in the raid. The ironmonger A & C. Bridglands at 33-35 London Road received a direct hit. That morning the store had received a delivery of 500 gallons of paraffin. Mrs Alice Meadmore was the cashier at Bridglands and sat in a glass sided cubicle in the middle of the shop from where she took payments, through a window in the side of the glass cubicle. The late Len Griffiths remembered entering the wrecked building with his mother, a trained VAD nurse.

Len was a sixteen-year-old boy, working in the nearby Cantelupe Road when the tremendous explosions shook the surrounding buildings. He ran to the International Stores to check that his mother was uninjured, as she and his aunt were working in the store; together they entered the ironmonger's shop. Len had a vivid memory of the scene of carnage. Thick black smoke was rapidly entering the back of the building from the burning paraffin store at the rear. Staff and customers were lying everywhere. Alice Meadmore's body was slumped forward in her chair, 'obviously beyond all help'. The CAB record of the identification of her body shows that traces of ink from the date stamp were found on one hand. Alice lived with her husband Joseph and three children, aged twelve, nine and five, at Sackville Gardens, East Grinstead. She was buried at St John's churchyard, Dormansland, on 15 July.

The owners of the Book and Stationery business in the High Street, Mr Edwin Tooth and his wife Kate, were in the garden behind the shop when bombs fell behind the premises, both were critically injured. Mrs Tooth died several hours after the incident, in Queen Victoria Hospital, Mr Tooth died the next day.

The Citizens Advice Bureau dealt with all enquiries about missing loved ones, they remained on-call until 1 a.m. the next day. The CAB received a total of 968 inquiries on the day of the bombing and in the following four days. The Council declared Wednesday 14 July a local day of mourning for the victims. That day twenty-two victims were laid to rest in two communal graves at Mount Noddy Cemetery. The mass burial service was conducted by the Bishop of Chichester.

The majority of victims had private burials arranged by their own families. All of the Canadian military casualties were buried at Brookwood Military Cemetery except Captain Robert Wesley Harcourt of the Royal Canadian Horse Artillery. Captain Harcourt and his young English bride, Ethne Goodbrand Harcourt, were buried together at Chislehurst Cemetery, Kent.

For the first time in this long war the people of Lingfield and East Grinstead had experienced the brutal reality of heavy aerial bombardment: the sound of exploding bombs; the smell of burning buildings, furniture and the memorabilia of a lifetime; the taste of choking brick dust and the horrifying sight of mutilated bodies. It was only then that this rural community fully understood the shocked senses of blitzed Britain and the nightmares of the evacuated children.

CHAPTER 14

Covert Operations in Belgium: The Story of Ides Floor

Great Britain's wartime Secret Service, the Special Operations Executive (SOE), had two main aims: subversion and sabotage in enemy controlled Europe. The organisation was set up by Winston Churchill to 'set Europe ablaze'. SOE's first offices were in Caxton Street near Victoria Street, London, in April 1938. Two years later, in October 1940, the organisation moved to Baker Street taking over the offices of Marks and Spencer. The headquarters steadily expanded to six large buildings in the Baker Street area, under the cover name of Inter-Services Research Bureau. At its peak, some 10,000 men and 3,000 women were working in SOE offices and in missions throughout the world helping an estimated 2-3 million active resistance workers in Europe alone.

The organisation comprised French, Dutch and Belgian nationals, Spanish Republicans, Italian Partisans, Scandinavians and recruits from every country in the Balkans, even Germans and Austrians. There were few places SOE did not cover; missions were set up in distant parts including India, Singapore and Australia. The first requirement for many destinations was fluency in at least one language other than English. Many of those that enlisted held dual or even foreign nationality.

The Special Operations Executive ran training schools in large requisitioned country houses; they also took over deer-stalking lodges in the Western Highlands which were used for paramilitary training.

In France, SOE operated a series of networks known as circuits, usually consisting of an organiser, radio operator and courier (and sometimes a weapons instructor or sabotage specialist). The life expectancy of a circuit was short and many either became penetrated by, or were betrayed to, the Gestapo. At the time of D-Day, special teams of three officers were dropped behind enemy lines in France usually consisting of one American,

one British and one French officer to help train resistance groups, organise arms drops and provide radio links with Allied Command.

On 17 May 1940, the Belgian government moved to the coast at Ostend, after the country had been overrun by the Germans. The King of the Belgians, Leopold III, ordered the surrender of his army on 28 May 1940, against the advice of his ministers. The King was held under house arrest from 1940-44, and a prisoner in Germany between 1944 and 1945. The majority of the Belgian Cabinet sought exile in Britain where they were accepted as the legitimate government of Belgium. The exiled government was in a very sound financial position and paid all expenses incurred by the Belgian Resistance except the pay of agents who belonged to British forces.

Ides Floor and the Special Operations Executive

Ides Floor was the youngest of a family of four sons, born in Bruges, Belgium. He first came to England with his mother and brothers after the outbreak of the First World War. Between the ages of seven and eleven he was educated at Westgate Roman Catholic School in Hampshire where he learned to speak English fluently. The family returned to Belgium after the war.

At the age of sixteen, Ides met his fourteen-year-old second cousin Marguerite (Guiton) Janssen who had also been evacuated to England during the First World War. The two fell in love and married the day after Guiton's twenty-first birthday. Ides had joined a Cavalry Regiment, the 1st Infantry Battalion, Belgian Army, and was promoted to Lieutenant. Their first child Christiane (Minou) was born in Brussels and in 1930 the young family moved to England.

A second daughter, Jacqueline was born in Epsom in December 1932. When the Second World War broke out, Ides was an industrialist making rubber products, his company then turned to making vital war supplies; barrage balloons, gas masks, life jackets and inflatable rubber boats. Ides appointed a Managing Director for his company in 1940, when the Germans invaded Belgium, and rejoined his regiment in Belgium. At the time of Dunkirk, he escaped via the south of France and North Africa where he boarded HMS *Argus*, one of the first Royal Navy aircraft carriers, and sailed for Liverpool.

In the spring of 1939, Ides and Guiton Floor were negotiating to buy 'The Garth' in Newchapel Road, Lingfield from Mr Stanley Hazell, but decided not to proceed with the purchase when war was declared. Guiton and their two daughters first went to live in Scotland but moved to Wales when the Belgian Army moved to Wales in 1940. Ides was posted to

Gibraltar as Belgian liaison officer to Field Marshal Lord Gort, he was probably working in undercover intelligence.

In 1942, Ides and Guiton finally purchased The Garth and moved to Lingfield. Records at The National Archive in Kew show that Ides was by then working with the Belgian 'Surete de L'Etat' (the secret service organisation operating in exile in Britain from November 1940 until September 1944). In October 1942, Lieutenant Ides Floor became head of the department working with SOE on Belgian civilian resistance. He was concerned particularly with the sabotage of German road, rail and canal communication and the preservation intact of certain facilities for the use of the Allies on the liberation of Belgium, especially the port of Antwerp.

Towards the end of March and beginning of April 1944, a critical time in the preparations for D-Day, several civilian resistance workers in Belgium were arrested by the Gestapo and it was known that some had been forced to divulge information. The organiser in the field, whose mission was to pass on all the directives from Supreme Headquarters Allied Expeditionary Force, seemed to have lost control of the situation.

It was evident that urgent and drastic action was necessary and Lt Floor (code-name Agnes) immediately offered to go himself to the field. The offer was not immediately accepted because it was felt that Lt Floor's personality was already known to the German counter espionage services, he having briefed every agent sent to the field since October 1942. A letter from Commander P. L. Johns, RN, Special Force Headquarters to Lt Ides Floor is held on file at the National Archive (Ref: HS 9/521/6):

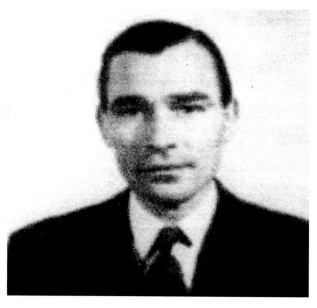

Ides Floor DSO, MBE, 1905-76. (*Mrs C. Wellesley-Wesley*)

Dear Floor, I believe that Hardy Amies had mentioned to you that two of the Belgian Section officers – Capt. Ferry and Capt. Kelly – are expected to leave shortly to join S.F. Staffs in France attached to 21 Army Group.

I am most anxious that you should delegate an officer to join this party, with a view to representing the Surete and being available for consultation on all matters relating to activities of the Civilian Organisations in Belgium. I understand from Hardy that you yourself would like to take on this task, and needless to say, we should all be delighted if you do so, in view of your recent first-hand experience of conditions in the field ... Will you please confirm to me that you will be going yourself, in which case, it will be necessary for you to stand by at 24 hours' notice for departure?

Lieutenant Floor agreed to join the party, with the permission of the Belgian government in exile. The mission required that the team would be dropped by parachute into Belgium. Floor had very little experience of parachuting having only attended a short course three years earlier, but there was no time for him to do a practice jump.

Mission Dardanius: Organised by Lt Ides Floor to Assess the Potential of all Railway Sabotage Groups

Telegraphed Report on the Mission of April to May 1944 (TNA Ref: HS 6/78 SOE Belgium):

DARDANIUS [Floor's new code-name] left with TAMORA and VARRO on the night of 11/12 April 1944.

The team jumped at 2.30 am. The nature of ground made it impossible to bury the parachutes and other material. Varro proceeded to the farm while D & T concealed all the material under shrubbery in a small wood.

Varro and the farmer returned and the team went to the farm. It was agreed that the farmer and T would fetch the material from the dropping point early in the morning and burn it all in his furnace.

D & V planned to travel the same day to Brussels. T was instructed to take the same train the next day when they would all rendezvous in Brussels. Should the meeting not take place T was given the addresse de secours [a safe house].

T was given further instructions to leave sets and all documents at the farm where they would be fetched by an agent later. Strict adherence to these instructions probably saved T's life.

D & V walked to the station, 3 miles from the farm. Raids on Belgium being at that time almost continuous, the train service was delayed by 5½ hours, arriving at Brussels at 5.30 pm. D made contact with Melle Sacre Olin (no 2) and all camouflaged material was put into a safe place.

Only Nicole (no 3) knew of his billet arrangements. During his stay in Belgium D used identity papers issued in London, on his departure from Belgium he had new papers and passport

D was controlled by German police on the 2nd day of his arrival, while travelling by tram. He was searched for arms but otherwise not troubled.

Interviews

D arranged a series of Interviews with agents in Brussels including an interview with (no 12).

In D's opinion (no 12) was one of the active members of the Bureau National, highly intelligent, a great patriot anglophile with strong views on collaboration. He was prepared to use his influence with his group in order to check any possible excess of zeal and in that way keep in hand, under the legal authority, a great number of members of one of the largest Groups of Resistance in Belgium.

Agent No. 12 was Maitre Marcel Gregoire, a member of Bureau National du F.I., he was to travel back to UK with D in order to report fully to the Belgian Government in exile. He was the Catholic Member of the four-man National Committee of the Front de l'Independance et Libération and was subsequently nominated Second-in-Command to General Yvan Gerard, C-in-C Belgian Armed Forces of the Interior.

One of D's first contacts was with agent NELLY (N) whom he found difficult to contact. His instructions were to leave notes via 'Boite Postale', which N was supposed to lift daily, informing him that he was urgently needed by NOLA [another local agent]. Receiving no response from N after one week D found N by constantly going to a small restaurant where N was supposed to lunch very often. A meeting was arranged. D concluded that N's function should be limited to liaison officer with London. N informed D that it was not necessary for him to meet the engineer belonging to Group G, who had drafted 28 points for destruction of railway, as N was meeting the engineer and would pass on the documents.

N never turned up – conclusion – the sooner a younger and more active agent was sent to take over the job of London delegate the better.

N was informed that a replacement would arrive in the field.

V & D met again 2 days after their arrival in Brussels. T had not arrived so an emissaire was sent to the farm to investigate.

Groups of saboteurs now numbered 400 which Petit Henri (Shrew) had formed in Borinage. They now awaited a leader and material from London.

Nola informed D of arrests in Hector II and advised against contacting any of his partners as when Hector II was arrested a list of his appointments for the following fortnight was found on him and Gestapo were forcing Hector II to keep the appointments – to arrest all parties.

Without the loyal co-operation of NOLA, D would have found it practically impossible to fulfil his mission. D had an opportunity to meet No. 7 (Georges Riquer) when a new identity and faked passport was prepared for his journey back through France; made in the name of no 5 (Pierre Van Este), the identity papers supplied by London were burnt. In agreement with Nola, No 7 was asked to busy himself with faked papers and abandon all other activities. No 7 agreed and through him and NOLA all agents were then able to obtain identity papers or passports within 24 hours.

Theo Janssen (no 8) [outlined his plan] to guide agents from Brussels to Paris where he would be the only person to know our contact Socrates – a communist.

Financing

Budget of 15 million Belgian francs per month, 10 million of which for organisation. Remaining 5 million handed to sabotage Group under NOLA.

Transfer of funds via Melle Sacre Olin.

General Information

1. Belgium. Feeling of patriots running high in expectation of D-Day. German personnel met by D had poor aspect. Clothing and general equipment poor. Travelling facilities impeded through allied bombing.

Effect of allied bombing on population very good considering circumstances. Results of bombing very accurate on whole. Food situation better than in 1941 but still inadequate. Black market very active (anything could be got at extremely high prices).

German morale very low.

Underground work becoming more difficult because of increase in German control and vigilance.

Railway rolling stock poor. German road transport material average.

2. France. Results of bombing magnificent on all the marshalling yards seen by D (Autraye, Creil, Juvisky).

Travelling difficult through lack of transport. Trains full to bursting point.

Food position worse than in Belgium.

Effect of bombing on population on the whole bad, more so in Paris.

Return Journey

D whose papers were in name of No 13 (Vincent Flamond) decided to take a reservation in the Paris train in that name but at the same time arranged for a new set of papers in name of Pierre Van Este to be prepared. Reason – as T knew of D's 1st identity and D fearing T's arrest, better that seat reserved in No 13 should be found empty if Gestapo made a control in Paris train.

Contact in Paris satisfactory. Journey back by road via San Roque to Gibraltar.

Lt. Floor was recommended for the award of M.B.E. by the Head of SOE, Major-General Colin Gubbins:

"There is no doubt that by his gallant and spontaneous action, Lt. Floor assisted greatly in implementing plans for the Belgian civilian resistance organisations, which we have been given to understand, have assisted in the safe and speedy creation of the Normandy bridgehead ...

Lt. Floor was able to put into execution certain plans made by the Belgian Government here for financing resistance groups through banking circles in Belgium. This has been of inestimable value, as otherwise resistance groups were dependant on the vagaries of air operations for supplying them with money.

The presence of Maitre Gregoire in this country has been of great value both to S.O.E. and to the Belgian Government, in that he has been able to assist furthering resistance by collaborating in future plans and by making personal broadcasts to Belgium on the B.B.C.

After having completed his mission quickly and efficiently, Lt Floor returned to the U.K. through France, crossing the Pyrenees on foot, and arrived here on 20 May 1944.

In 1944, Lt Floor MBE was promoted to Commandant (Captain) and early in 1945 was also awarded the Distinguished Service Order and Member of the Order of the British Empire for his many gallant actions during his special mission. He retired at the end of the war with the rank of Chevalier (Major). The Belgian government awarded Chevalier Ides Floor, Office de L'Ordre de Léopold avec Palme, Croix de Guerre avec Tour, Croix des Evades. He was also awarded the American Legion of Merit.

CHAPTER 15

D-Day

Troops spent several weeks in marshalling areas in the south of England prior to D-Day. The huge numbers of men and resources that would be needed for the attack, however, could potentially be discovered by enemy reconnaissance aircraft. Tremendous efforts were made to conceal the 2,876,000 Allied troops, armoured vehicles, tanks and lorries, which were amassed in southern England.

Advance SHAEF, The Supreme Headquarters of the Allied Expeditionary Force, was established in the grounds of Southwick House, near Portsmouth. The headquarters of two of the four British corps involved in Operation Overlord were within West Sussex. The 8th Corps used Wakehurst Place at Ardingly, Worth Priory and the Grove at Worth. The 30th Corps used Milton Mount College at Three Bridges. Embarkation camps covered vast areas of Ashdown Forest and the New Forest, hidden under the tree canopy.

Special teams were dropped behind enemy lines in France in preparation for D-Day. The teams were comprised of three officers, usually one American, one British and one French officer. Their task was to help train resistance groups, organise arms drops, and provide radio links with Allied Command.

Operation Overlord

American, British, and Canadian ships made up the largest armada in history. Ships lay in wait off the shores of Plymouth, Southampton and Portsmouth. More than 1,200 planes stood ready to deliver seasoned airborne troops behind enemy lines, to silence German ground resistance

as best they could, and to dominate the skies over the impending battle theatre.

Eric Ellis was once again with the forward troops:

> It was late May 1944 when they shut us in a camp again. Americans were guarding the corners with machine guns and barbed wire so we couldn't get out. We were stuck in that sealed camp for a fortnight. Then we had orders to move down to the coast.
>
> We boarded tank landing crafts; which took a couple or three bren-gun carriers on board. We boarded the morning of 5th June. We guessed we were going to France as they had given us a 5 franc note each the night before. We sailed that night for France. We thought we had now reached the end of the line, we never expected to survive going over the beaches.
>
> We arrived on the morning of the 6 June. Our division, the 50th Division, was the first to land on Gold Beach.

Captain Revd Mark Green, Chaplain, 24th Lancers

Army chaplains found that their non-combatant wartime ministry extended far beyond spiritual need. The Rt. Revd Mark Green, former Bishop of Aston, started his ministry in 1944 as an Army Chaplain attached to the 24th Lancers and took part in the Normandy landings. After his eventual retirement from the Ministry, Bishop Mark lived at the College of St Barnabas in Dormansland, Surrey. There he published a book of his experiences in 2006 entitled, *Before I Go,* in which he tells of his faith, his fears, his mistakes and his successes at that crucial time in his life. His memories are retold from diaries kept at the time; the following account is based on the Chaplain's personal experiences and reproduced with his permission, granted in 2007.

On Thursday 1 June, 1944, troops embarked at Southampton for the Allied invasion of Normandy. An enormous gathering of ships of all sizes pushed out into Southampton Water then lay at anchor over 'what seemed a very long weekend ... all the time there were rumours as to when we might go'. On Sunday, 3 June, the chaplain went round various ships in a motor boat to take impromptu communion services. The troops on board gathered to hear the Captains on each vessel deliver messages from the King, General Eisenhower and General Montgomery. The Chaplain was then asked to deliver a message from the Archbishop of Canterbury (William Temple). The mood was a mixture of excitement, fear, and a relief

that the invasion was, after all the weeks of training, about to begin. The sea had calmed down by Monday afternoon and at 6.30 p.m. that day, 5 June 1944, the ships left Southampton Water.

Not until midday on Tuesday 6 June did the armada of ships have sight of the coast of Normandy. Under the overall command of General Eisenhower, 5,000 ships had crossed the English Channel. During that afternoon some of the tank landing ships opened their huge doors a mile or two offshore to allow the tanks to drive on to 'Rhino Ferries'; the ferries were simply a series of barrels lashed together, propelled by an outboard motor. More than 150,000 men and their vehicles of war; tanks, lorries, jeeps, scout cars and motorcycles were landed on the shores of Normandy during the course of that and the following day. It was late evening on 7 June before all the men and equipment of the first assault party were ashore.

Private Eric Ellis remembers clearly his landing on Gold Beach, Normandy:

The landing was like hell on earth – but we survived it. There was only a short beach where we landed. We were told later that we had landed in the wrong place; we were supposed to have gone in behind the Green Howards, over to the west. A lot of Germans had withdrawn from our area so it could have been a lot worse.

We got out into more open country and had a short break, it was slow going. I remember going through a cornfield, we had to be careful because there was still a bit of sniping and a few shells landing around us. We kept going on and on then stopping to rest. Things didn't seem bad then they hadn't got reinforcements to counter-attack.

That night they said we had got about 8 or 9 miles inland. I was one of a patrol to go ahead and report if we could hear anything. We went forward and I think we got near to the Caen-Bayeux road. We heard Germans there. We also saw a Frenchman with his horse – I don't know what he was doing at that time of night with a horse – must have been midnight. He was surprised when he saw us! He kept looking and didn't know what to say, we couldn't speak French. We just said 'Hello, we're British' and he just said something and off he went. He was quite happy. We went back and reported what we'd heard and seen.

We were up early in the morning because we hadn't reached our objective of 'Jerusalem' [code name for Brouay, 10 kms west of Caen]. About 7 am we were walking down the side of the road and saw some airplanes in the sky but didn't take much notice – then they started machine-gunning us to blazes – they were American Thunderbolts. The bullets were shooting up off the road between our legs. Of course we lost

a few blokes then. Then one of them turned round and dropped a bomb in the middle of the blinking road, at the road junction. We were going to meet some of our other troops coming the other way with armoured cars, and the Americans had knocked a load of them out.

Anyway we took the place eventually; on the outskirts of Jerusalem. We lost quite a few fellows there. They're still there; they wouldn't let the War Graves people take them away. The little graveyard is still there.

We were fighting all around there – Villers Bocage, Tilly, Villers Bocage, to and fro. Even one day fired on our own blokes, I was one of them. It was the Argylls but we thought it was the Germans. It was so close, you didn't know whether you were coming or going. Our blokes had taken Caen [Caen was taken on 9 July]. Then the Germans withdrew – then came the chase. That was happy hunting really. We had one or two little skirmishes but no problems.

Captain Mark Green meanwhile was beginning to learn the difficulties of being padre to armoured units in battle:

no-one seemed to know which was the front or back of the battle, you were likely to get blown to pieces by tank guns firing from all directions, and as likely to be despatched by your own side as by the Nazis.

All through those days I based myself with our medical officer ... at the Regimental Aid Post ... nothing more than a bit of space in an orchard on the top of this literally blasted hill. [The MO] was operating in appallingly difficult conditions; e.g., doing what he could for a man who had lost both legs, working in the dark by the dimmed light of a torch, with a gas-cape rigged up between the branches as shelter from the rain ... I soon saw that my most useful role would be to do what I could to speed up the evacuation of our casualties, for in many cases their hope of survival depended on surgery that could not possibly be done in the middle of an orchard, in the dark and the rain ...

I took a jeep ... and drove across the fields and farm tracks to find the Advanced Dressing Station between us and the beaches. God knows how I found it, because normally my sense of direction is so bad that I would get lost trying to find Trafalgar Square at the end of Whitehall ... I poured out my soul to the CO of the ADS ... I must have seemed desperate and genuine because he gave orders that every available vehicle be rounded up. He told me to lead this convoy of ambulances and stretcher-bearing jeeps back to Point 103 ...

Then shortly before midnight ... I went in a 3-tonner to locate 'C' Squadron who were installed in St Pierre ... having put in an attack with the 8th Durham Light Infantry ... they were very pleased to see that we

had brought them food and fuel, though I could feel them thinking that
if it needed the regimental chaplain to bring these things, the situation
must be even more desperate than they feared ...

The damaged farmhouse serving as their Regimental Aid Post was
crammed with Durham Light Infantry casualties ... when dawn broke
I acquired a 3-ton lorry into which we loaded as many as we could of
those who looked as though they might survive the journey. So back we
went toward the Advanced Dressing Station, via Point 103, where the
battle was still going on ... we got through safely and unshipped our
pathetic human cargo at the ADS. One had died on the way.

There were some lighter moments in those terrible days. Driver 'Ginger'
Smith was a stickler for hygiene until one day after putting the dixie on
for tea he went off to relieve himself, came back and tested the water
with his finger. The others yelled at him, but it still made a lovely mug of
tea. The next morning the crew got all the hammers from the tool kit and
the large supply of biscuits they hadn't eaten, and hammered them to
powder on the top of the tank tracks, which were clean and shiny after
running on wet grass. Ginger got his vest – he swore it was clean – and
mixed the powdered biscuit with water to make a soggy mass, spread it
out on his vest, and topped it with jam, he then rolled it up and boiled it
in a dixie ... it made an excellent roly-poly.

Captain Mark Green's training as a priest did nothing to prepare him
for his service in the battlefields of Normandy, using for an altar an
ammunition box, a packing case, the tailboard of a lorry, or the bonnet of
a jeep. Even less was he prepared for 'scraping bodies out of tanks, driving
ambulances, making tea for wounded ... getting hold of soap, toothpaste
and writing paper for soldiers ... digging graves or acting as a messenger
boy'.

The Falaise Pocket and the Gap

After the Normandy landings the Americans made advances to the south
into Brittany. The British and Canadian forces successfully took Caen on
9 July. In August 1944, the Allied force of American, British, Canadian,
Polish and Free French troops planned to encircle and destroy the remnants
of the German Army, including Panzer divisions, in the Falaise Pocket. The
area was to the south of Caen between the four cities of Trun, Argentan,
Vimoutiers and Chambois, near Falaise. The Allied offensive began on 12
August and the Germans fought hard to open gaps in the encirclement.
Several thousand German troops successfully escaped but by 21 August

the Falaise Pocket was finally closed. The bodies of over 10,000 German soldiers were found in the trapped area. 150,000 Germans were taken as prisoners, many were wounded. The road through the pocket was made impassable by wrecked vehicles and bodies.

Eric Ellis witnessed the scene: 'We got to Argetan at the same time as the Americans. The Americans thought we were Germans and nearly fired on us. Falaise one side and Argetan the other. You've never seen such carnage, acres and acres and miles and miles of it.'

One of the German officers captured in the Falaise Pocket between 20-22 August 1944, was later interrogated in the Hospital Block of Lingfield Racecourse; Oberstleutnant (Lieutenant-Colonel) Karl Muelch, Officer I/C 11 Para Corps, see Chapter 17 below.

CHAPTER 16

The 'Doodle-Bugs', the Diver Campaign and the End of the Home Guard

The first intelligence report concerning the building of launching equipment for pilotless aircraft was received in England at the end of 1943. Several launch sites were identified in a line between Calais and St Valery; their various targets were London, Portsmouth, Southampton and the area around Bristol. The threat of attack by pilotless aircraft was believed by the British War Cabinet to be very real and it was considered that the attacks were likely to begin about the middle of January 1944. On Christmas Eve 1943, the RAF began to bomb the launching sites in France and the results of continuous bombing were apparently so successful that German plans for the use of the sites were delayed. Attempts were made to repair sites where only minor damage had occurred and by 21 April, thirty-five sites appeared to be near completion. These sites were put on the priority list for bombing but aerial bombing was reduced partly due to weather conditions and partly due to other priority sites being identified. Renewed attacks by the RAF and USAAF in May reduced the number of sites to eighteen. A few days later reconnaissance revealed seven entirely new sites.

The War Cabinet was prepared to accept a reduction in existing anti-aircraft defences in other parts of the country in order to provide the necessary defence against pilotless aircraft in identified areas. Plans were made for a belt of heavy anti-aircraft (HAA) guns, 10 miles deep, from East Grinstead to Faversham and a thinner group on the coast for early engagement. Additional searchlights were provided along the line of defence and a 40 mm gun was to be deployed on each HAA and searchlight site. The new defensive operation was known as The Diver Campaign.

Royal Observer Corps Posts were set about 10 miles apart and were linked by telephone line to the various Operational Centres. Their task was

to identify enemy aircraft including rockets, to note their exact position, height and type, then report the situation to the various operational centres. There the 'bandits' were plotted across a grid map table. Coloured counters representing the aircraft were moved across the table to track their route.

Four Anti-Aircraft Sectors were established by the Royal Signals at the beginning of 1944, at Lingfield, Tonbridge, Maidstone and Norton, each controlled a sector of the Gun Belt. They were controlled by the Sector Operations Room at Biggin Hill.

The Operations Room at Lingfield was at the Drill Hall on Racecourse Road, east of the railway line. The Drill Hall had formerly been manned by the 27th Anti-Aircraft Brigade – Home Counties Area, Eastern Command Brigade (part of the 6th AA Division of the 34th (Queen's Own Royal West Kent) Searchlight Regiment Royal Artillery). The 27th Anti-Aircraft Brigade was raised on 15 December 1935 at Kenley. From the 4 March 1944, Lingfield Operations Post, the Western Sector of the Kentish Gun Belt Area, was manned by No. 162 Mobile Anti-Aircraft unit under the command of 101 AA Brigade. In April/May 1944, a decision had been made not to deploy guns in the Western Sector but that decision was reversed on 16 June when it was realised that the Rouen launching sites were in fact being used and ranged against the Western Sector.

The Lingfield Operation Post was manned by four officers of the Royal Artillery, one NCO and six other ranks who were drawn from the Auxiliary Territorial Service and Royal Signals. Dormitory accommodation was provided on site, above the main Drill Hall.

The Anti-Aircraft Operation Rooms used two sources of early warning information; RAF information from the defence teleprinter network at Biggin Hill and the Coastal Radar Stations (C.R.S.) at Brighton and Beachy Head. Several lookouts had to be provided at each site to obtain aural and visual warning of the approach of flying bombs and to watch for intercepting friendly fighters. They also had to give warning if a flying bomb was likely to crash on the site.

It was not always possible for aircraft travelling at high speeds to keep clear of the gun belt, especially when the visibility was bad. Officers reported 'considerable anxiety among the gunners lest an intercepting friendly fighter be hit'; the results of the shooting were indifferent.

The word radar was an American term, not then used in Britain where it was always referred to as Radio Direction Finding or more commonly shortened to RDF. An extract from an unidentified HAA troop commander's diary illustrates the general attitude towards the new HAA equipment:

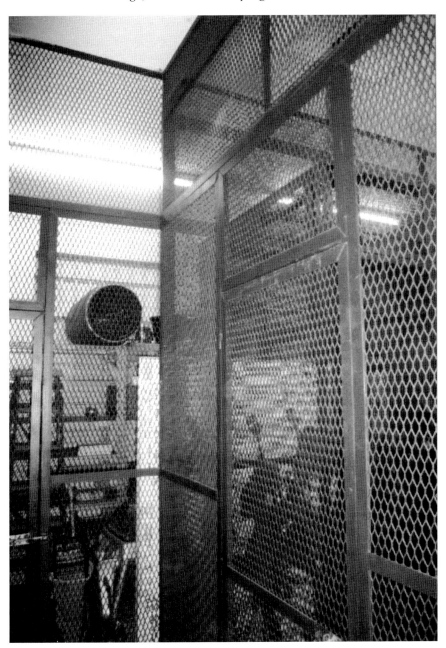

Interior of the Second World War Munitions Room, Lingfield Operations Post, the Drill Hall. (*With the consent of Sergeant Instructor Forward, O/C Army Cadet Force, Lingfield*)

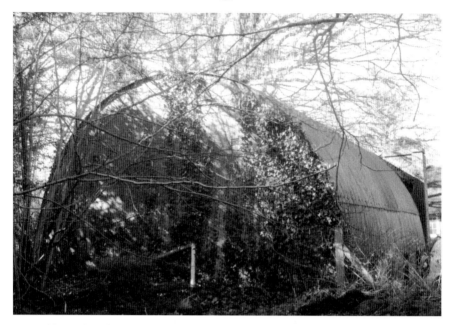

A Nissen hut hidden under the trees at the Drill Hall.

The new Radar equipment arrived at 1700 hours one evening, all nicely waterproofed. It took the OFC (Operational Fire Controller) close on 2 hours to unwaterproof it, and then ironically but not at all surprisingly it started to rain in torrents. It would! The generator came in a lorry and it had to be got off because naturally enough the driver wanted to get back. The REME officer was very busy but stayed long enough to explain to us how to get it off using 2 tractors. He assured us it was simple enough – he had done scores of them! After about 3 hours it was still raining and the generator was poised halfway between the lorry and the ground at an angle of 50 degrees and not looking at all safe. It came to earth eventually however, to the accompaniment of sighs of relief from 2 officers who had not thought it possible at first. Then it wouldn't go. It was going by midnight.

The rest of the equipment was eventually working by 0700 hours the next morning and everybody was thoroughly wet. A relief detachment came on in the morning fresh and dry, and the long process of testing and adjusting started. There were many teething problems and after a day or two of hard work one OFC was heard to voice one opinion which all of us tended to hold; "This new stuff would be bloody good if only it worked!" This is typical of the soldier's inherent suspicion of new equipment and his disinclinations to change from the old familiar stand-bys. (TNA: WO 199/2985)

The first flying bomb crossed the English coast in the area of Dymchurch/ Hythe at 04.07 hours on 13 June (seven days after the Normandy landings). Fourteen were plotted in the attack, they were engaged by anti- aircraft guns but none were claimed destroyed, one crashed in the London area. No more were launched until the night of 15 /16 June when activity began in earnest and 122 flying bombs were plotted, twenty-four were claimed as destroyed by anti-aircraft fire. One fell close to Horne Airfield. The V-1 rocket, or flying bomb, was a pilot-less aircraft which made a buzzing sound and could be clearly heard approaching above, then sudden silence as the engine died and the warhead, packed with a ton of deadly explosive, plummeted towards its target below. They became known as buzz bombs or 'Doodle-bugs'.

Horne Airfield

Horne Airfield straddled farmland at Bones Lane (O.S.345430). The airfield was one of several temporary airfields built in the south and east of the country to support the Normandy landings. On 30 April 1944, three Squadrons of Supermarine Spitfires arrived at Horne. The airmen were of English, Canadian, Polish, Australian and New Zealand nationalities, who together formed No. 142 Fighter Wing. Horne Airfield was operational for only fifty days in 1944; crews flew on various missions in preparation for D-Day. The airfield became operational in May 1944 and closed on 19 June 1944.

In his book on *RAF Horne's D-Day Spitfires*, Brian Buss wrote:

> Late in the evening of Thursday 15 June searchlights close to the [Horne] airfield coned an aircraft making a most peculiar noise and it looked as if it was on fire. It sounded as one pilot described it, like a bunch of unevenly exploding fire crackers going off in a barrel, or a large slow revving motorcycle without a silencer. Shortly after this the engine stopped and there followed a tremendous explosion which shook the entire airfield and everything on it ... Because the number of V I s passing over the airfield were continuing to increase by the day, Group HQ ... decided ... on Sunday 18 June that the airfield would disperse the following day.

The London balloon barrage was extended to the south-west in 1944. Horne airfield and many farm fields in a semicircle from Crawley, around Horne, Blindley Heath, Lingfield, Dormansland, Oxted and Limpsfield were scattered with barrage balloons. The balloons were erected and maintained by the RAF and were designed to protect targets from low-

flying aircraft and enemy attack. They were tethered to the ground by steel wire cables.

The Observer Corps warned approaching allied aeroplanes of balloon barrage positions by shooting up red flares at night, and flares attached to parachutes in daylight which descended slowly from a considerable height.

At 7.30 a.m. on 12 July 1944, a flying bomb fell on the rubble of the Whitehall Cinema, East Grinstead, which had been destroyed in a raid the previous year. Over four hundred houses, shops and offices were damaged in the vicinity. Three people were killed and thirty-eight injured. The King and Queen visited the scene.

Mrs Diana Mary Lambert, wife of Uvedale Lambert, was killed on 21 July 1944 when a flying bomb fell on South Park Farm, Bletchingley. The family house was destroyed and Mrs Lambert was found dead in the ruins. Major and Mrs Lambert's two children were found safe and unharmed in the air-raid shelter. South Park House was extensively damaged, as was St Mark's Church and the surrounding farm buildings. Major Uvedale Lambert was away on war service in Africa with his regiment, The Kings Royal Rifle Corps. Diana Lambert was buried at the church of St Mary the Virgin in Blechingley.

Smoke from a Doodle-bug flying bomb that fell near Dormans Station. The bomb hit a tree opposite the main gate of 'Nobles', leaves from the tree showered over a wide area including The Platt. View from the back garden of No. 12 Jeddere Cottages.

A flying bomb caused many casualties in the girls' homes of the Lingfield Epileptic Colony, fortunately none were serious. Three homes at the colony were declared uninhabitable and most other buildings had some minor damage. Within a few days, all of the children with relevant staff were evacuated to a Miner's Hostel at Mansfield where they stayed until the end of February 1945, by which time 90 per cent of the bomb damage had been repaired.

The additional threat to children posed by pilotless aircraft led to a new evacuation programme. The Reception Area in south-east Surrey was now under the flight path of V-1 and later V-2 rockets aimed at London and the Home Counties. Schoolchildren from London who had been sent to the relative safety of the Surrey countryside were evacuated again, to South Wales. Local children were also to undergo the trauma of separation from their families, as the London children had in 1939. As in 1939, the new evacuation was recommended but not compulsory. Several parents rejected the offer of evacuation, having witnessed the trauma of separation on the London children they wanted to spare their own children that experience.

Evacuation Forms were distributed to every schoolchild in the county on 14 July, that same day the schools were closed for Midsummer. Schoolchildren packed their bags, exactly as the London children had done in 1939, and set out with their teachers to go to South Wales.

Lingfield children set out for Bridgend during the summer holiday from school. Miss Carpenter had first arrived at Lingfield School in October 1940 with eighteen children from Mitcham School. In November 1944, she took up evacuation duty at Bridgend with Mitcham and Lingfield schoolchildren, taking supplies of books and equipment from Lingfield School. A few evacuees returned to Lingfield before Christmas, Miss Carpenter and the remaining evacuees moved further west to Carmarthen.

Mr Vine, the headmaster of Dormansland School took charge of 250 children travelling to Neath, in Glamorgan, while Mrs Wilson accompanied some of the younger children to Cardigan, 69 miles from Neath across the Pembroke peninsular. Mr Vine's duty with the Home Guard ceased on 6 September 1944, when the Home Guard was ordered to stand down as a fighting force. Miss Lansley remained at Dormansland School with forty local children whose parents had rejected the offer of evacuation. She was joined by a teacher from Baldwins Hill School.

Blindley Heath schoolchildren evacuated to Abercrave, while the younger children (under five) went with their mothers to Brecon.

The Brockley boys were re-evacuated to Maesteg in Wales, where they found the food was more plentiful than in Lingfield. The Headmaster, Mr Green, went with the school. The girls of Brockley School went from

Oxted to Newton Abbot in Devon and the boys of Haberdashers' Aske's School travelled to the nearby coastal resort of Teignmouth.

Children from Notre Dame School were evacuated to Hinckley in Leicestershire. I am grateful to a former pupil of Notre Dame School who volunteered this information. She was evacuated to Hinckley with other pupils where they joined a school with a similar foundation.

According to Home Guard records, ninety-five Doodle-bugs were brought down in the Godstone Rural District. Despite the successes of the RAF in flipping over many rockets, and the efforts of the AA units throughout the area, many V-1 rockets got through to London. Although Radar Direction Finding equipment was efficient at tracking aircraft over the sea (for a distance of up to 100 miles), irregularities in the terrain made aircraft identification over land more difficult.

The Observer Corps were considered by some to be the most efficient trackers over land. The Observer Corps Post was simply a sandbagged hole in the ground, with two or three volunteer civilian spotters with binoculars, charts, altitude measuring equipment and a telephone. The volunteers came from all walks of life, and were responsible for monitoring the skies around the clock, spotting and tracking aircraft by sight or sound and reporting by telephone to control centres. The centres then collated the information which was plotted on map tables and passed on to Fighter Command. Their work during the Battle of Britain led to the grant of the 'Royal' title to the Corps in April 1941. Post observers also guided lost friendly aircraft to safety.

On 13 July 1944, the whole line of anti-aircraft guns was moved down to the coast, between Cuckmere Haven and St Margaret's Bay. No. 40 AA Brigade, including the unit at Lingfield Drill Hall, was moved to Newhaven sector operating from Eastbourne. The movement of the RDF units was highly successful; the enemy aircraft were plotted on their approach to the coast and were destroyed by the AA guns as they came within range. At that time the AA guns were shooting down about 60 per cent of the flying bombs. Fighter aircraft intercepted another 30 per cent.

That September, an order was passed to GHQ Home Forces: 'There is now no longer any requirement for Defence Works to be maintained for anti-invasion or anti-raid purposes and these will be removed.' More than sixty years later most pillboxes remain in the rural landscape. They have proved to be both difficult and costly to remove.

The End of the Home Guard

On 6 September 1944, with the threat of invasion passed, the order was given for the Home Guard to stand down; the final ceremony took place on 3 December that year. The 9th Surrey (Oxted) Battalion met for only the second time as a unit on that day. The battalion marched from East Hill Road with Major R. Toynbee at the head, preceded by the Drum and Fife Band of the Training Battalion of the Irish Guards. The salute was taken first by Colonel Sir Leslie Burnett CBE at Oxted Railway Station and secondly by the Battalion Commander, Lt-Col. Ian Anderson MC opposite the Hoskins Arms. As soon as the battalion was drawn up in Master Park Lt-Col. Anderson made his farewell address.

Lt-Col. Anderson's farewell address was published in 1946 by W. A. D. Englefield (*Limpsfield Home Guard*):

> If invasion had been attempted in the early days, as was imminently expected, there would have been a great deal of bloodshed in this country, and a large number of Home Guards would have been killed. There would have been bitter and bloody fighting, and whether we should have been able to repel the invasion, in view of what we now know of our own unpreparedness, is very doubtful, but one of the important factors which prevented that problem ever being put to the test was the

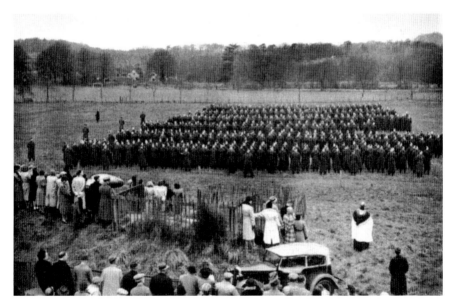

The 9th Surrey (Oxted) Battalion Home Guard, Stand Down Parade at Master Park, Oxted 1944.

existence of a civilian army of nearly two million men ready to do their utmost to prevent the Germans landing here. That is why today we can celebrate with thankfulness a victory as real as any won in battle. Our long, monotonous and tiring turns of duty at the end of a full day's work throughout these four years give us cause for the noblest form of pride. As long as England's history is told we shall be remembered as the men of the Home Guard who, by standing firm and ready, helped to save the last stronghold of civilisation from annihilation. These are big words, but we have done big things in a simple way and it will be very good for us to remember it.

The proceedings closed with the National Anthem.

Several awards for exceptional service were made following the Home Guard stand down. Major Ralph Victor Toynbee of Starborough Castle, joined the Home Guard at its inception and, although not physically strong had given exceptional service. He was promoted to the rank of Captain on 7 April 1941 and promoted to the rank of Major, and appointed Officer Commanding 'F' Company on 7 March 1942. The citation read:

During the Winter of 1940 Major Toynbee spent night after night in terrible weather on the Stop Line, the manning of which was then the

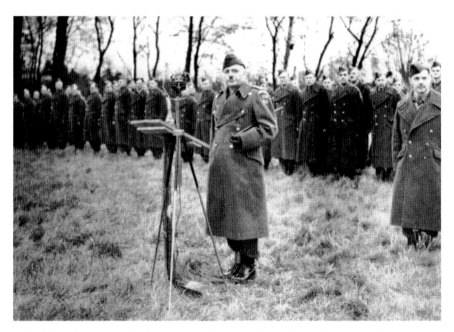

Lt-Col. Ian Anderson dismisses the 9th Surrey (Oxted) Battalion, Home Guard, 3 December 1944, Master Park, Oxted.

duty of his Platoon. Major Toynbee was awarded the Commander-in-Chief's Certificate.

The Llewelyn Palmer Memorial Fire Station building which had been used by the Home Guard during the war was eventually converted to a private dwelling, with the stipulation that the front aspect of the building must remain the same. The dedication stone can clearly be seen above the former garage of the fire tender. The name of Llewelyn Palmer lives on in the twenty-first century as the 'Llewelyn Palmer Hall' in the Lingfield and Dormansland Community Centre.

The End of the Auxiliary Units

The secret organisation known as the Auxiliary Units, officially part of the Home Guard, was disbanded in November 1944. The Special Duties Zero Station at Wakehurst Place was closed in September 1944 and stripped of furniture and equipment. The women of the Auxiliary Territorial Service were transferred to other mundane but necessary tasks.

Forgotten How to Smile: The Interrogation of Prisoners of War

Interrogators were often able to pass on vital information to British Intelligence, including developments in weapon technology, details of concentration camps in Europe, statements concerning war crimes and the names of war criminals, the location of military installations and fuel and vehicle parks.

Some of the prisoners of war at Lingfield were civilians captured with fighting units. Karl Pincas and Rudolf Habersack were half-Jews conscripted into forced labour at Boulogne where they worked under SS guards of Flemish, French and Italian nationality. In 1944, they were taken prisoner by British forces and subsequently brought to England and interrogated at Lingfield; their information was considered very reliable. Both men were intelligent and co-operative and testified to cruelties perpetrated by SS guards to the Jews.

One POW gave evidence concerning SS Untersturmfuhrer Franz Fiala who was responsible for a great number of atrocities against the Jews and other anti-Nazis. Fiala used two confiscated private houses belonging to a Jewish banker in Vienna as a torture chamber for his unfortunate victims. Another young POW was a former student of law at Halle University between 1941 and 1943. He gave evidence of prominent personalities in Osnabrück, including Oberarzt Dr Kramer head of hospitals in Osnabrück, a rabid Nazi who was responsible for the detention of anti-Nazis in public lunatic asylums by declaring them insane, they were eventually sent to concentration camps or handed over to the Gestapo.

Civilian, Max Nemitz

Nemitz was captured by British forces on 12 Aug 1944 at Le Blanc, France. Extracts from the interrogator's report:

> POW is a Communist who shot his wife in 1931 because she had an affair with a Nazi. He was sentenced by an ordinary German Court to 10 years 6 months hard labour which he served in full. After the Nazis came to power he was transferred to various Reichsjusticzstrafgefange nedlager which were run by the S.A. on concentration lines. In August 1942 when POW had completed his sentence he was sent to Berlin. He was interviewed by Wolf-Heinrich von Helldorf and told that he would now be re-educated on Nazi lines. For that purpose he was sent to Sachsenhausen/Oranienburg concentration camp. POW is a poor type and not considered truthful and reliable. The information in this report is on the whole confined to the description of personalities.
>
> In Oct 1942 there were roughly 1,000 prisoners (political as well as criminals) at Sachsenhausen/Oranienburg. The prisoners were divided into two groups, each of 500 prisoners, to remove bomb-debris in Dusseldorf and Duisburg respectively for five months. They were then sent to the Channel Island of Alderney, to Lager Sylt, to build pillboxes … Their treatment during their stay on Alderney was particularly severe and of the 1,000 prisoners who were sent there in 1943 only 550 returned to France in June 1944. The others were either shot or beaten to death.

The occupying German force turned Alderney into a fortress island. They brought forced labour from Europe to construct the island defences, including pillboxes, a network of bunkers, and a string of fortified structures on the coast of the small island. By January 1942, four camps, or Lager, had been built: Helgoland, Nordeney, Borkum and Sylt. Each camp held about 1,500 inmates: German political prisoners, Russian prisoners of war, and forced labour mainly from Eastern Europe. Lager Nordeney and Lager Sylt (where Max Nemitz was held) were in reality concentration camps handed over to the SS Construction brigade, 'Organisation Todt'. Organisation Todt used the forced labour as slaves; they were beaten with whips, overworked and underfed. Considerable numbers died from malnutrition, dysentery, septicaemia and pneumonia. The island was freed on 16 May 1945 when the German garrison surrendered, more than a week after Jersey and Guernsey were freed.

Oberleutnant (First Lieutenant) Karl Muelch

Officer in Charge 11 Para Corps, captured in the Falaise pocket on 20 or 22 August 1944:

> A highly intelligent, educated and pleasant man who through his political, social and military contacts has a wide and thorough knowledge of German affairs. He is not a Nazi and can be considered a great admirer of the British way of life ... He is very badly wounded and had to be interrogated in hospital ... There is no doubt that with sufficient time and patience a great deal of interesting information could be obtained from him ... It can be added that PW, in spite of his high intelligence, is quite susceptible to flattery.
>
> P.W. heard from Gen. Meindl about ten days prior to his capture that 1st Para Army HQ in Nancy had been bombed and many high staff officers had been killed. Main Para HQ was to be transferred to Germany at any time. Meindl told PW in early August that 1 Para Corps had suffered badly in Italy.

Grenadier (Private) Peter Schloder

Peter Schloder was a farmer who worked with his parents in Philipsheim until 1937. A member of the Communist Party since 1930 he was arrested in May 1937 for distributing Communist literature and making noises during a Hitler broadcast by revving his motorbike. He was sentenced to three months imprisonment and sent to Buchenwald Concentration Camp which was then in the first stages of building. Although only given a short sentence he was not released until January 1944 when he was at once conscripted to the Wehrmacht. Schloder was captured by British forces at Lisieux on 24 August 1944.

Schloder was interrogated on 4 October 1944. He gave interrogators detailed evidence of the location, construction and layout of the buildings in Buchenwald as well as the camp personnel and the conditions suffered by the prisoners. Although his educational standard was considered to be poor, he made all his statements with thoughtfulness and seriousness and his evidence was considered to be completely reliable. The interrogator added: 'As is already well-known conditions at Buchenwald were appallingly inhuman and PW opined that not only did few Germans know about them but that they would not have believed it if they had been told.'

Construction of the camp began in early 1937 when hundreds of prisoners arrived daily and were set up to work felling trees, levelling and

digging the ground, erecting huts and wire fences. During the building the Jews and Catholic priests were given all the filthiest jobs.

Extracts from the interrogators report 4 October 1944:

Profession: Farmer. Present whereabouts of his wife unknown.

Hobbies: Riding, boxing, motorcycling, swimming

Military history: Taken from Concentration Camp in January 1944, to serve in the Wehrmacht, trained as a gunner. Posted eventually to Boulogne, and shortly afterwards to Normandy. In action there he deserted and spent 2 days in a Farm, after which he gave himself up to British authorities 3 km from Liseaux on 24 August 1944.

POW is 37 years old and is married. He told me, he was 7 years in the Concentration Camp at Buchenwald. He showed me a bad scar where his head had been bashed in with a brick (top of the skull) when in the Concentration Camp. In September 1942 the prisoner was transferred temporarily to Cologne with about 800 other men from Buchenwald ... where they were chiefly employed on the building of ARP shelters, demolition work and extraction of bodies from debris, burials, and removal of unexploded bombs. It was strictly forbidden to talk to civilians. On several occasions prisoners were employed unloading goods that had been confiscated from the Jews, – furniture, clothing, jewellery etc. These were stored in Messehalle for redistribution to the bombed out.

On 9 November every year at Buchenwald a number of prisoners were selected at random, taken out and shot in celebration of Parteitag (NSDAP Nationalsozialistische Deutche Arbeiterpartei – Nazi Party convention).

The clear up of Cologne followed the first 1,000 bomber raid on Cologne by the Royal Air Force which took place on the night of 30/31 May 1942.

The interrogator included detailed drawings showing the layout of Buchenwald Concentration Camp; based on information supplied by the POW. One drawing showed the external camp which was set in woodland and had barrack accommodation for the SS guards, a radio station, and separate houses for the commandant and officers. The second drawing showed a map of the Prisoners' Camp with single-storey wooden huts, laboratory, brothel, and a stone-built injection room. Nearby was a crematorium designed as a pleasant little villa with flowers in window boxes and a cellar below. Access to the cellar was from an adjoining courtyard. Corpses were thrown down a chute into the cellar crematorium. A gibbet also stood in the courtyard.

The camp doctor, Sturmfuhrer Dr. Hofen, was described in detail:

Age 35; height 1.75 m. [5ft 8ins]; Figure smart; Face: round, pale and clean shaven; Eyes: short sighted, wears horn rimmed spectacles; hair dark, brushed back; voice: medium refined; gait: smart. Dr Hofen administered experimental typhoid injections. In the notorious Block 46 he injected about 1,000 victims, causing the death of about 90 per cent. Sick prisoners were also given injections to cause their death; they usually died about one hour afterwards. False reports of victims' deaths were sent to prisoners' relatives, in return for five deutschmarks the ashes would be sent on. Sometimes a shovelful of anonymous ashes, of which there was plenty, was put into a box and sent off. P. W. Schloder had seen lamp shades in Dr Hofen's laboratory made from human skin.

Two escapees were caught and given 40 lashes on their behind in front of 20,000 inmates, machine guns were posted in order to prevent a revolt. Although the two men were not killed on the spot they were never seen again. Another escapee was thrown into a cage with about 25 dogs which tore him to pieces.

Schloder estimated that about 25,000 prisoners perished while he was at Buchenwald. He attributed his own survival to his physical condition built up as a farmer. The interrogator made a note that 'the mental effect of his experiences was evident in the fact that he appeared to have forgotten how to smile'.

The interrogators at Lingfield Cage decided that Peter Schloder would make a good saboteur and recommended training as an agent, code name BONZO 15, his training to commence on 25 October 1944. The training officer concluded:

The only word to describe this man is "thug". He is just a big bullet-headed bruiser with great physical strength and no other attributes. He has an idea that he wants to be revenged on those who have done him down, but that is all. He is so independent as to be useless to a leader as he will always go his own way. By himself he is equally useless as he has no brain. He does however get on well with POW Guss and if there were one particularly physically tough job to be done these two might do it.

Schloder and Guss were sent overseas on 10 February 1945 and took part in Operation Carew, tactical sabotage on targets behind enemy lines. They returned from the mission on 2 June and were given the status of sergeant. An interesting note is attached to Schloder's file:

Schloder and Guss applied for compassionate leave in Germany 26 May 1945 but wereinstructed that there is no such thing as compassionate leave in Germany ... if they behave themselves they will soon be allowed to return to Germany.

Obergefreiter (Corporal) Otto Frohlich

Otto Frohlich was captured at Brussels on 11 September 1944, he was then forty-three.

The type of German who prides himself on always being perfectly dressed and being a man of the world. He has excellent manners, a good appearance and is an excellent conversationalist. The type of man who always knows someone who can – and will – pull strings for him. Reasonably honest and straightforward – but knows how to swim.

Defection of a German Airman

At 18.57 hours on 15 May 1944, an unarmed German Messerschmitt 109 aircraft crash landed at Herringfleet, north-west of Lowestoft. The machine was said to have crossed the coast over Hopton at a very low altitude, there was no air-raid warning and the 'plane apparently came in unobserved'. The pilot, the only occupant, was Stabfeldwebel (Warrant Officer) Karl Wimberger, aged twenty-five, who sustained a broken leg in the crash landing. Wimberger was taken by police car to Lowestoft Hospital.

The police reported that upon landing he asked where he was and, when told this country, said, 'Good'. He was dressed in a light flying helmet and overalls, under which was a German Air Force uniform equivalent of a Warrant Officer. His documents showed he was a member of the German Air Force stationed at Zerest, near Innsbruck.

During the night, two officers of RAF intelligence interrogated the prisoner. They reported that he had arrived as an escapee, that he wished to be of assistance to the British authorities, and that he travelled the 400 miles in just under two hours.

The following afternoon WO Karl Wimberger was removed to the RAF Hospital at Lingfield Racecourse by 146 Ambulance Brigade, Lowestoft, with military escort.

CHAPTER 18

The Liberation of Europe

Allied intelligence was fully aware of the brutality, starvation and mass murder in the Nazi concentration camps well before the liberation of prisoners in 1945. The vast populace of the Allied powers had no prior knowledge of the concentration camps, the death camps or the extermination camps which were a feature of Nazi occupation and rule in Europe. Shock and revulsion at the news of those camps and the images of piles of dead bodies and emaciated survivors was universal. The dead included citizens from the Soviet Union, Poland, France, Belgium, Holland, Czechoslovakia, Yugoslavia, Hungary, Italy and Greece.

Major Ides Floor and his colleagues of the Special Operations Executive progressively searched the Concentration Camps for surviving resistance workers and agents in an effort to get medical help for them as quickly as possible.

Meanwhile British POWs held in Poland, Holland and Germany were waiting for their release. Captain Colin Daintry Anderson of Old Surrey Hall, Dormansland, who was with his regiment, 25th Dragoons, Royal Armoured Corps set out to pick up his brother Captain John Murray Anderson MC from a German prisoner of war camp in Holland. The jeep crashed and all the occupants including Captain Colin Anderson were killed on 7 April 1945. The brothers were sons of Lt-Col. Ian Forrest Anderson, former Commander of 9th Surrey (Oxted) Battalion Home Guard, and his wife Mona. Colin Anderson was buried in the Groesbeck Canadian War Cemetery, approximately 10 kms south-east of the city of Nijmegen, on the Netherlands/German border.

Private Albert L. Strudwick

Private Albert L. Strudwick of the Royal West Kent Regiment was captured at Dunkirk in 1940 and subsequently taken to Stalag 344 (formerly known as Stalag VIII-B) in Lamsdorf, Poland (now Lambinowice in Silesia). On 23 January 1945, with the Russian forces closing in on Stalag VIII-B and the German Army on the retreat, the POWs were marched out of the camp. They walked westwards towards Germany on a gruelling walk now known as the Lamsdorf Death March, covering about 20 miles each day. The prisoners slept wherever they could find shelter; often in pig-sties and barns, in sub-zero temperatures. Many had blisters on their feet that froze. Their clothes were not changed during the long journey. Many fell ill with dysentery, dehydration or exhaustion. Those who were too weak to walk were left where they fell; some were shot by their guards. The survivors reached Göttingen on 18 March 1945.

POW No. 47933 'Bert' Strudwick survived the walk. When he was examined by an American doctor at Hadamar his weight had dropped

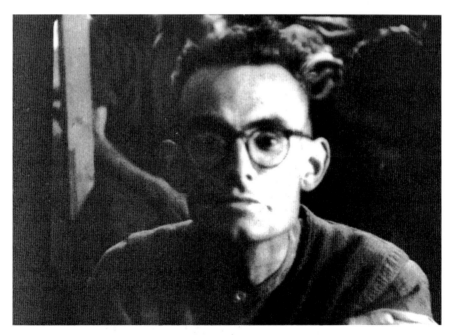

Private Albert Strudwick of Station Road, Lingfield, a POW from 1940-45, he survived the forced march from Lamsdorf to Göttingen. The survivors were examined by American doctors in the State Hospital for the mentally ill at Hadamar on 8 April 1945. Frame isolated from film, 'Hadamar Survivors'. (*Imperial War Museum, catalogue No. A70 514-15*)

from one hundred and forty pounds to eighty pounds in his five years of imprisonment.

Bert's brother, Private Thomas F. Strudwick (Tom), was also taken prisoner in 1940 while serving with Queen's Own Royal West Kent Regiment. Tom, POW No. 11305, was eventually taken to Stalag XX-A at Torun, Poland. In 1945, prisoners in Stalag XX-A were also force marched westward on the 'Long Walk' across Poland and Czechoslovakia to reach Germany. Bert and Tom Strudwick eventually came home to Lingfield in 1945.

VE Day and VJ Day

It was clear to the Allies at the beginning of 1945 that victory in Europe was imminent. At the end of April events gained momentum. News of food shortages and images of the hungry and ill-clad people in the liberated countries filled the British newspapers. In April 1945, an appeal was made by the Women's Voluntary Service Depot for discarded blackout material to make pinafores for French schoolchildren. The Women's Institutes responded with their customary enthusiasm. They also responded to an appeal in February 1946 from the Help Holland Council asking for Home Guard uniforms.

The Italian dictator Benito Mussolini was captured by Italian Partisans on 27 April and executed the following day. On 30 April, the German dictator Adolf Hitler committed suicide in his Berlin bunker. German forces in Italy surrendered on 1 May and German forces in Berlin surrendered on 2 May 1945. Over the course of the next four days all German forces in Europe surrendered to the advancing Allies. The final document of unconditional surrender was signed at General Dwight Eisenhower's headquarters in Reims on 7 May.

After the final surrender of all German forces Field-Marshal B. L. Montgomery, Commander-in-Chief of the 21 Army Group, issued a personal message to be read out to all troops. His message concluded: 'And so let us embark on what lies ahead full of joy and optimism. We have won the German war. Let us now win the peace. Good luck to you all, wherever you may be.'

All schools were closed on 8 and 9 May as a, 'Thanksgiving on account of Victory in Europe.' Two months later, on 2 July, Miss Carpenter returned to Lingfield School from her duties with the evacuees at Carmarthen. The strain of the war years had affected her health; she was forced to resign her teaching post in October 1945.

John Jones was eleven when news of the Victory in Europe was declared:

I was living at Hurst Green in Surrey and heard over the radio that the war in Europe was over ... On the morning of V.E. day ... it was decided that our street would have a street party. My brothers and sisters and I had to perform one task that we regularly had to throughout the war. After saving the top of the milk over several days it was all poured into a large Kilner jar and we kids took it in turns to shake and roll the jar until, after about half an hour, the top of the milk turned to butter. This was used to supplement the butter ration. On this occasion it was used for the street party.

All that morning the women of the street were busy making sandwiches and baking cakes and other goodies. With rationing being so tight, they performed a miracle getting all the baking ingredients. We also had soft drinks supplemented by home made lemonade from crystals.

In the afternoon tables and chairs were brought from many houses and joined together along the street. Our street was a cul-de-sac with a large circle at the end and a grass area in the centre. Flags and bunting lined the street. The kids got very excited and played games. Later everyone joined in singing and dancing in the street. In the evening with no more black-out to worry about a large bonfire was lit on the grass circle and everyone sang and danced around the bonfire. It was tempered by the knowledge that most of the husbands and fathers from the street were away in the services.

As I recall about 10 pm that night, with yours truly too excited to go the sleep I looked out of my bedroom window and saw all the searchlights suddenly light up the sky, their beams criss-crossing over the night sky for about fifteen minutes. On reflection this was probably the last time searchlights lit up the skies over Britain. So came to an end a day that remains in the memory for the rest of our lives.

Betty Sargent was nineteen in 1945. She lived in one of the new 'prefabs' in Common Road and remembers a street party all along Common Road on VE Day.

Ian Gibbs was stationed on an RAF Airfield in Yorkshire, working as a RADAR mechanic and maintaining the equipment used on Halifax bombers. Early in May 1945, he applied for seven days home leave. On the eve of VE Day he was travelling south on a train towards his home in Felbridge. The talk all around him was of the news that had just broken announcing the end of the war in Europe.

When he arrived home he found a telegram awaiting his return. Eagerly he opened the telegram expecting to see how much his leave was to be extended. To his dismay he discovered that it was an immediate recall to his Station! All attention was on the Far East and he was told to prepare

for embarkation to Australia or India. Although many in his Section were sent to India, Ian Gibbs stayed in England until his demob in May 1947.

Joan Reichardt went to a dance at the Castle Barn in Richmond on 7 May, the dance was arranged to raise funds for returning POWs.

It turned into a huge celebration as soon as word got out that 8 May had been declared V.E. day. I went to the dance with my girl friends, somehow I won a bottle of gin and gave it to a sailor to hold – did I mention that I was young and stupid? Never saw either again. My Canadian husband to be showed up at some point and we cheered and sang and danced ourselves hoarse – it was wonderful, a once in a lifetime, never to be forgotten event. We eventually started to wend our way home and got dragged into a street party. All these people, mostly women calling to my tall red haired escort "Get over here, Canada". Soon there he was doing Knees up Mother Brown with a little old lady who was about 4'10" – he was 6'6". I have never forgotten that sight. A couple of years ago I

Joan and John Reichardt in 1945. (*Joan Reichardt*)

took my three granddaughters to the spot and told them the story. V.E. day itself was a mixture of joy and relief with still the concern for family members and friends still in the Far East I remember total strangers coming up to us and thanking my Canadian companion.

By V.J. day I was married and my husband was back in Canada on the Pacific draft. I do not remember that same great surge of jubilation; I do remember being horrified by the unbelievable destruction of the atom bombs. I still have the red, white and blue ribbon I wore in my hair on both occasions.

In May 2009, Joan Reichardt came to visit England with her daughter and son-in-law. She brought her red, white and blue hair ribbon with her; clean, bright and newly ironed a souvenir of her courtship and a precious reminder of her late husband.

Many British service men were overseas on VE Day. Private Eric Ellis was in hospital in Belgium recovering from wounds. He remained in the hospital for another month. His long spell of good luck had run out, 'You can't keep going out in the rain and dodging all the raindrops.'

Flight Sergeant Ron Granger remembers being glued to the forces radio network, the general excitement and the many thoughts of home. Parties followed and a formal celebration dinner given by the commanding officer. The wine and beer flowed freely, 'few could recall what was said ... but I do remember the very special loyal toast proposed by the CO and the great tribute he gave to Mr Churchill'. Ron's unit was in the port of Haifa. 'The place was alive with mosquitoes, bugs and fleas ... What was great was the food and in particular the fruit – those large Jaffa oranges with quarter inch skins, lashings of bananas, sultana, grapes, figs, etc – stuff we had not seen at home for a long time.'

Victory events continued throughout the summer of 1945. A 'Red Cross Victory Garden Sale' was held at Rosslyn House, Dormansland, on 30 May.

Lingfield Women's Institute had a 'very special treat' in June 1945, their first meeting since VE Day. The meeting took place at the Guest House, the home of Arthur Hayward. The programme of activities included a talk by Mr Hayward on the founding of Lingfield College by Sir Reginald Cobham in 1431, followed by two members acting a scene from Shakespeare's *Twelfth Night* in the sixteenth-century panelled room. The local schoolchildren led by Miss Cowling sang 'Olde English Songs' and finally members all sat down to tea and an iced cake, decorated with 'Victory in Europe'.

The WI Knitting Party transferred their efforts to knitting coats for Europe. The group had made 711 garments during the war years which

PONY RIDES

from 3 p.m. to 6 p.m.

Tickets to be obtained from the Ticket Table.

STALLS.

BOOK STALL.

SURPRISE STALL.

"KNOW ALL ABOUT YOURSELVES"

FROM

MADAME X.

Take your places at the tent.

MUSIC

BY

T. D. W. COLLINS and his electrical equipment.

7 p.m. to 10 p.m.

DANCING

TO

LEW LAKE AND HIS BAND.

Charge 6d.

Tickets obtainable at Entrance to Dancing Enclosure.

GOD SAVE THE KING.

Blindley Heath School held Victory Sports on the school playing field in July. It was hoped that Ice Cream would be available for children ('subject to being procurable'). (*Mr Geoff Post*)

were sent to British troops, and urgent aid to Russia; they had also darned socks, mended pants and blouses and collected money to buy wool for distribution to relatives of local serving men.

On August Bank Holiday 1945, a VE Fete and Gala was held on Blindley Heath Cricket Ground. Thirty-eight traditional races were held for all children, from the ages of five years to eleven plus. Games included the cat crawl, wheelbarrow race, three-legged race and a slow bicycle race. There were also races for the mothers and for the fathers. The afternoon finished with a Punch and Judy show.

CHAPTER 19

The Jewish Children, Survivors of the Holocaust

On 27 January 1945, Auschwitz Concentration Camp was liberated by the Russian Army. Three months later, at about 5 p.m. on 15 April 1945, combined British and Canadian troops liberated Bergen-Belsen Concentration Camp, near Hanover. Richard Dimbleby, a BBC reporter, was with the Allied forces and broadcast his impressions of the scene: 'this day at Belsen was the most horrible of my life'. Anguished reporters struggled to control their own emotions and to find adequate words to describe the scene of lice-infested, emaciated people meandering aimlessly behind the barbed wire, their once bright, vital eyes now vacant and expressionless, no longer able to comprehend what was happening around them. Human beings had become dehumanised by months or years of brutality. There were images too of corpses lying all around the camp in various stages of decomposition some piled high in ditches and pits, some bodies, not quite dead, were twitching convulsively in the pile of bodies around them.

Anita Lasker-Wallfisch, a survivor of Auschwitz and Belsen, has written a book of her experiences (*Inherit the Truth, 1939-1945*, Giles de la Mare Publishers, 1996). The following paragraph is an extract from the book:

After years of living for the moment and perhaps ... for the next day, all at once there was space in front of us ... I was nineteen years old and felt like ninety ... We had lived surrounded by filth and death for so long that we scarcely noticed it. The mountains of corpses in their varying degrees of decay were part of the landscape and we had got used to the dreadful stench. It would be wrong to assume that everything was instantly transformed the moment the first tank entered Belsen. What the

British Army found was far removed from anything it had ever had to deal with ... They were totally shattered by what they saw, and in their desire to help us as much as possible, they produced lots of food ... many people died after this sudden intake of food.

It is estimated there were over 60,000 prisoners in Belsen by April 1945 and that approximately 35,000 prisoners died of typhus, malnutrition and starvation in the first few months of 1945. A typhus epidemic was out of control and threatened the liberating armies. The arrest of the Camp Commandant Josef Kramer was received with relief. There was a general revulsion for the Nazi ideology represented by Kramer; he would be called to account.

Unfortunately, in many British minds all German people were held responsible for the atrocities exacted by the Nazis. In May 1945, Miss Sophie Dann, a Jewish refugee from Augsburg who had fled Germany in April 1939, had to go to hospital for major surgery. She found herself to be the only German in the hospital ward. News of the liberation of Bergen-Belsen had just been announced and everybody in the ward turned against her. The fact that she was a victimised Jew and had experienced discrimination and ill-treatment at the hands of her fellow countrymen was of no relevance.

Shortly before her illness Sophie had met and befriended Mrs Rebekah Clarke at a series of lectures on child care in London. Mrs Clarke had furnished some of her empty cottages in the neighbourhood of West Hoathly in 1939 to accommodate children and their mothers from Mitcham, London. In gratitude for this generous gift, she was invited to attend the series of lectures by Miss Anna Freud, a child therapist and youngest daughter of Sigmund Freud. The Freud family had fled Vienna in June 1938 following the Nazi takeover in March and the subsequent ransacking of their home. The family had settled in London but Sigmund Freud, who had been suffering from cancer for several years, died on 23 September 1939.

Mrs Clarke invited Sophie Dann and her sister Gertrud to stay for a few weeks convalescence with her and her family at Hoathly Hill, West Hoathly. As Sophie was still very weak Mrs Clarke arranged transport from London by taxi for Sophie and Gertrud. Rebekah Clarke was the wife of Colonel Ralph Stephenson Clarke, Member of Parliament for East Grinstead from 1936 to 1955.

The images of Bergen-Belsen were the visual and undeniable proof of Nazi atrocities. In Britain, in 1945, the word 'Belsen' became synonymous with 'concentration camps'. Mrs Rebekah Clarke referred to the child survivors of Theresienstadt Concentration Camp as 'the Belsen children'

in her correspondence with Jewish aid organisations at the time. Her correspondence has been preserved at the Wiener Institute in London.

Theresienstadt Concentration Camp was liberated by the Russian Army in early May 1945. Whereas elsewhere May 1945 was the time for rejoicing over the Allied Victory in Europe, the prevailing mood in Theresienstadt, and all other Nazi concentration camps, was shock and bewilderment. The camp was approximately 56 km north of Prague and close to the Czech border with Germany. The Czech town of Terezin was built in 1780 as a fortress and named after Empress Maria Theresa, the Nazis renamed it Theresienstadt. Its former use as a military camp, with barrack accommodation, watch towers and barbed wire, made an easy conversion to a concentration camp. Nearly 141,000 Jews were deported to Theresienstadt, including 15,000 children; one in four of all Jews there died of starvation, overwork, disease and execution. Hundreds more were deported from Theresienstadt to Auschwitz where they were murdered.

The International Red Cross immediately isolated the camp in May 1945 because of the appalling death rate from typhus, tuberculosis, polio, scarlet fever and hepatitis. A de-lousing policy was already in operation in the camp but shortly before their defeat the Germans herded about 25,000 more prisoners into the camp ahead of the advancing Russian army and their de-lousing programme was unable to cope with the vast numbers. Lice carried the bacterium responsible for typhus.

The orphaned children who were not sick or infectious were moved to a castle in Olesovice, one of four nearby 'castles' or large country houses, near Prague. Attempts were made to trace their homes and possible surviving relatives but repatriation was extremely difficult with thousands of displaced people, bombed and destroyed towns and cities, and disorder in government departments. The temporary hostels in Olesovice were set up by Premysl Pitter, a Christian and a pacifist, and Olga Fierz as a sanctuary for children at the end of the war.

In August 1945, the British government gave permission for up to 1,000 child survivors to come to the UK on temporary visas under the Children from the Concentration Camp Scheme. A total of 732 children were airlifted to Crosby on Eden Airfield in Westmorland (now part of Cumbria); 308 of them were from the Theresienstadt camp. Large crowds of cheering people and the press met the children who were loaded into a convoy of army lorries and taken to a former war workers' camp at Troutbeck Bridge.

On arrival in Westmorland, the children were taken to Calgarth housing estate at Troutbeck Bridge, on the shores of Lake Windermere. The estate had been built during the war to house the employees of a nearby

aircraft factory. Their welfare and support was taken over by the Jewish organisation, the Children's Refugee Movement.

Forewarned of the typhus outbreak at Theresienstadt, doctors in Westmorland had made preparations for the medical examination of all children on their arrival. The children were stripped and carefully inspected for cleanliness and vermin by a staff of nurses, and passed on for a final check by the doctor. Finally they were given fresh clothing and sent to bed.

Dr J. F. Don who wrote an account of his experience of the Troutbeck Bridge evacuation noted that:

> This cursory inspection was sufficient to reveal that their general state of cleanliness was excellent and not a single case of vermin was found … the younger children were unspeakably pathetic and very tired, and all of them were most thankful to get to bed … It was possible to recognise the post typhus condition almost immediately the child entered the room. He would have a sallow complexion, an anxious expression, slight jaundice of the eyes … and thin hair.
>
> There was a delay before food was organised … it was explained to them that people here were rationed … this caused them considerable surprise as they were under the impression that England was a land of plenty.

The children were divided in groups according to age. Great care was taken to keep friends and those of similar interests together; brothers and sisters were never parted. Over the next few months the various groups were dispersed to one of twenty-eight hostels situated throughout the country. For the bewildered and traumatised children it was yet another journey to an unknown destination, more adult strangers, more strange food. The young Jewish children had known nothing other than deception, hunger and fear in their short lives. They were cautious about accepting food or any other kind of handouts. They had no confidence in adult assurances, they only had each other and their bond with each other was very close.

Colonel Ralph and Mrs Clarke visited the six youngest children in the group at Troutbeck Bridge to see for themselves the obvious psychological damage to those young minds. Mrs Rebekah Clark was then in the process of buying a house in Sharpthorne intended for the use of Anna Freud and the Hampstead Nursery, as a facility for the after care of refugees from the bombed areas of London. Instead the house called Bulldogs Bank at Sharpthorne, 4 miles south-west of East Grinstead, was used to accommodate six very young orphans, aged three to four, who had been liberated from Theresienstadt Concentration Camp. The venture was

supported by the American Foster Parents Plan for War Children, the organisation arranged homes for many children from the Concentration Camps. Five children arrived at Bulldogs Bank on 15 October 1945, the sixth child arrived a few weeks later.

Bulldogs Bank 'Hostel' was run by the two sisters, Sophie and Gertrud Dann. Sophie had been a social worker in the Jewish community in Augsburg, Bavaria. Gertrud was a fully qualified Kindergarten Nurse. Sophie Dann became the Superintendant of Bulldogs Bank and her sister Gertrud the teacher, local staff were recruited for domestic duties. The six children were described by Gertrud Dann as 'a very disturbed and aggressive group'.

Sophie Dann described the children's behaviour several years later:

> The beautifully equipped home did not make the slightest impression on them. Most of the toys and part of the furniture were broken wilfully in the first days after their arrival. As to the adults, the children had nothing but distrust and hostility for them. They hit us, spat and shouted at us. Initially this was their main way of showing awareness of our presence at all. Time and again we had to admit that they ignored us completely. But their aggression was not directed exclusively against the few people who took care of them, workmen and visitors did not fare any better, passers-by were hailed with shouts of abuse. Only very gradually did the children begin to trust us; their hostility decreased together with their restlessness. They started to listen to us and to show interest in what we did. The more they felt protected the easier it became for them to acquire the language spoken in these new surroundings. No effort was spared to understand them and to gain their confidence.

The children stayed at Bulldogs Bank until September 1946. They had learned to speak English, how to eat with a knife and fork, and how to behave with adults. They learned also to love and trust their carers, making birthday cards for Mrs Clarke and writing to thank her for various kindnesses such as tea parties. Thanks to their gradual introduction to Mrs Clarke's pet dogs they learned that dogs and other animals should not be feared. Considered by their carers to be able to integrate into a family atmosphere, the children were taken to join the older children at the newly organised Hostel at Weir Courtney, Blackberry Lane, Lingfield.

Mrs Clarke provided alternative accommodation for the two Dann sisters at 1, Highcroft Cottages, Station Road, Sharpthorne, where their parents were to join them in 1948. Gertrud Dann went to work at Weir Courtney, visiting her sister and parents at weekends.

Weir Courtney

One of the trained staff who helped to set up the rehabilitation centre in Troutbeck Bridge was a very remarkable woman, Alice Goldberger. Alice dedicated her adult life to the care of orphaned children and those children who had been separated by war from one or both parents. Miss Alice Goldberger was herself a refugee from Germany. Born in Berlin in 1897, she trained as a youth work instructor and eventually became the head of the 'Obdach', a state-funded shelter for disadvantaged children and their families. The post was eventually taken from her by the Nazi administration. Alice fled Germany in 1939 and came to England where as a registered Alien, she was interned on the Isle of Man. There she set about organising a nursery school for the children of internees. The success of that venture was reported in a national newspaper and the account came to the notice of Anna Freud. Through Anna Freud's intervention Alice was released from internment.

During the rest of the war, Alice worked with Anna Freud as superintendent of one of her War Nurseries in a country house called 'New Barn' near Chelmsford in Essex. There she cared for thirty children aged between three and six years. The nurseries were established to help all children who suffered as the result of war conditions, irrespective of nationality, race or religion. Some of the children were from the blitzed area of the East End of London. At the end of the war, Alice Goldberger went to the Lake District where she first made contact with the children rescued from the concentration camps. Some of the youngest children who arrived in Troutbeck Bridge in 1945 were to become her family and shaped her life from then until her death in 1986.

Alice was appointed Matron of the newly organised hostel at Weir Courtney, Blackberry Lane, Lingfield in 1945. The house was the country home of Sir Benjamin and Lady Drage – Sir Benjamin Drage was the owner of a large furniture store in High Holborn, London. Weir Courtney was leased rent-free to the Jewish Refugee Committee on the understanding that the J.R.C. would pay the rates and taxes and maintain the fabric of the building. The cost of maintaining the children and of equipping and staffing the hostel was borne by the West London Synagogue. Sir Benjamin Drage was a warden of the West London Synagogue between 1931 and 1933. The synagogue diverted funds previously reserved for building redecoration, to the support of Weir Courtney Hostel. They also held an Annual Bazaar to raise additional funds.

The children arrived at Weir Courtney from Cumbria on 5 December 1945. With love and patient understanding the children settled to their new life. They began to learn the English language so that they could mix

with local schoolchildren and teachers in the surrounding community. In the New Year of 1946, several of the children were registered at Lingfield Junior School. Four girls, including Zdenka Husserl, were registered on 8 January 1946, three boys followed one week later. A total of nineteen children from Weir Courtney were registered at Lingfield School over the course of the next few weeks. According to the Lingfield School Logbook, two Home Office Inspectors arrived at the school on 20 March to report on 'the children from the Belsen Camp'. The same day all of the schoolchildren received a quota of milk chocolate from Canada, which was delivered by the WVS.

A reporter representing the magazine *John Bull* was granted an interview with Alice Goldberger in 1948. Alice spoke of the night the first children arrived in 1945:

They were full of hostility, fear and distrust. When they caught sight of food they rushed to it, snatching bits from each other's plates and stuffing their pockets with uneaten pieces. These they later hid under their pillows fearing that they would get no more. When the staff tried to undress them for bed, pandemonium broke out. They had decided that this fairyland was a trick; as soon as the lights were turned out the SS

Alice Goldberger.
(*Zdenka Husserl*)

men would come and kill them in their beds. Some of the children were difficult to understand because they spoke a mixture of several languages picked up in the various camps through which they passed.

<div align="right">(John Bull, 9 October 1948)</div>

The upkeep of Weir Courtney Hostel continued to be borne by the members of the West London Synagogue. Additional funding from other sources was difficult to find, although contributions were made by individuals in Britain and America. In response to an appeal from Mr Leonard Montefiore, Mrs Meyer Sassoon promised a donation of £1,000 which she wished to have earmarked for the Lingfield Hostel. After some argument with the Committee for the Care of Children from the Camps, when it was explained that funds could not be earmarked for particular schemes, £500 of Mrs Sassoon's donation was made available to Weir Courtney.

Parcels containing toys and luxury foods came from supporters. Fifteen parcels arrived from Hollywood in July 1946. The American Foster Parents Plan for War Children regularly contributed to funds. Some of the children were eventually found homes and foster families in America.

After three years living in quiet security at Weir Courtney, the C.B.F. considered that 'the family' of Jewish children would gain benefit from moving to a busy city environment to develop their confidence and self-

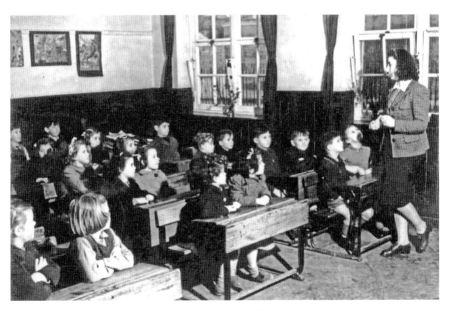

The classroom at Lingfield School, the Jewish children are seated in the middle row; second row, on the left is Zdenka Husserl.

The Jewish children playing happily in the playground, Lingfield School, 1946. Zdenka Husserl is in the centre of the front row.

reliance and in December 1948 they moved to their new home at 42 The Grove, Isleworth, London; which they named Lingfield House.

In 1951, the American Foster Parents Plan for War Children decided to celebrate its fifteenth anniversary by inviting one child from France, Italy and England to visit America. Hanka, one of the children who had attended Lingfield School and Dormansland School, was chosen to represent England. She was feted everywhere and entertained at a luncheon held by Mr and Mrs Tyrone Power, when she was called upon to give a speech. Hanka returned from America laden with presents.

Not all the children were able to recover from their experiences; one was mentally scarred for life and entered an institution for the mentally ill.

Personal Stories of Three Weir Courtney Children

Zdenka Husserl was born in Prague in February 1939. Shortly after her birth Zdenka's father, Pavel, sent baby Zdenka and her mother, Helena, to live with her grandparents in the village of Zdikov in the South Bohemian Region of Czechoslovakia for their safety.

Zdenka with her mother Helena in 1942, at the nearby town of Strakonice in South Bohemia. Zdenka's mother Helena is wearing the mandatory Star of David on her left shoulder. The dictate that all Jews must wear the yellow, six-pointed star with the word 'Jude' printed on it, had been introduced shortly after the German forces occupied Czechoslovakia in March 1939.

In November 1942, the same year that this photograph was taken, mother and daughter were arrested by the Nazis. Zdenka, then three years old, was sent to Theresienstadt Concentration Camp close to the Czech border with Germany. She remembers having her hair shaved, and receiving a burn on top of her right hand. No other memories have been recorded by Zdenka of that dreadful time between November 1942 and May 1945.

She learned later that her mother, Helena, was transported to Auschwitz concentration camp in Poland, where she was murdered. Zdenka's father Pavel had been transported to the Lodz Ghetto in Poland, he was never seen again.

Three months after the liberation of Theresienstadt, six-year-old Zdenka was one of the group of 308 orphaned children who were selected to be airlifted to England. The group was assembled under the leadership of George and Edith Lauer who were also Jews and had been imprisoned in Theresienstadt. Edith Lauer had been put to work with the children in the camp. After liberation she was left in charge of child welfare. George helped to organise the air transport to carry the children to England and he and Edith accompanied the children on their journey to England; both were able to translate the several languages spoken by the children.

The children were walked to the train station in Olesovice where they boarded a long, slow train to Prague. Bad weather delayed the arrival of the planes at Prague airfield which was under joint military control; the French, the British and the Russians each having planes on a corner of the field. Nine heavy bombers arrived at the airfield to evacuate the children. The planes were not equipped for passenger transport having no seats other than wooden benches on the side of the craft, the numerous apertures so recently used for bombing raids were an obvious risk for the children. Crews supervised the older children in the first eight planes. The youngest children travelled with George and Edith Lauer in the last plane. There were no seats; all sat on the floor or on orange boxes, the youngest sat on the knees of adults, Zdenka sat on Edith Lauer's knee. George and Edith Lauer became dear friends of Zdenka, who at the time mistakenly thought that Edith was her mother as she demonstrated her love and spoke her language.

Zdenka can remember the first rehabilitation centre in the former settlement of aircraft workers in Troutbeck Bridge. The children were met by a team of social workers, headed by Alice Goldberger; all had been trained by Anna Freud. Plans were soon made to house the children in smaller groups of similar ages. All the children were then dispersed to hostels around the country. The very youngest, a group of six infants were taken to Bulldogs Bank, Sharpthorne, and a slightly older group, including Zdenka, were taken to Weir Courtney Hostel, Lingfield.

Zdenka Husserl, six years old, 1945.

Thursday 29 November 1945 coincided with the first night of the Festival of Chanukah in the Jewish calendar; the Jewish children arrived at Weir Courtney on 5 December, the seventh day of Chanukah. The Festival commemorates the Syrian suppression of the Jews when very many Jews were killed for their religious beliefs. The Syrian King, Antiochus, ordered the desecration of the temple at Jerusalem and forbade observance of the Sabbath. The Syrian armies were eventually defeated by the Jews in 168 BC. The Jews then found only sufficient consecrated olive oil in the temple to fuel the eternal flame for one day; miraculously the oil burned for eight days. The Chanukah Festival (or the Festival of Lights) symbolically lasts for eight days. Traditionally presents are given and special food is cooked, generally in a party atmosphere.

The Allied victory over Nazi tyranny in 1945 was poignantly significant for the Jewish survivors of the Nazi holocaust. Zdenka Husserl cannot now remember the exact course of events at that first Chanukah in England but, every year since then has experienced a profound sadness on lighting the first candle on the Menorah. On the tenth anniversary of the Jewish children's arrival at Weir Courtney Alice Goldberger made a scrapbook for each one of her remaining 'family', who were by then living at Lingfield House, Isleworth.

The Chanukah Menorah: eight side branches plus a central ninth branch, the 'Shamash' or servant light, which is used to start the other lights.

You do remember, Zdenka, the arrival at Weir Courtney, the open door, the lovely warm house with everything prepared for you all and the shining Chanukah-candles in the nursery! And another evening, when you arrived at Lingfield House, and again the Chanukah-candles were lit. And to-day, after ten years in your young lives, the eight candles are burning again, for all of us!

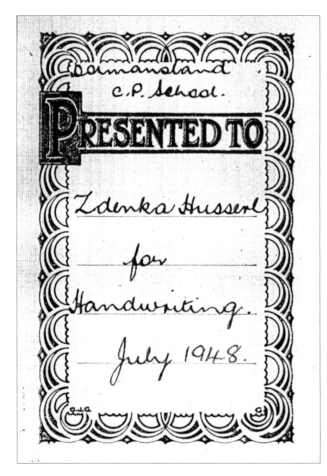

Above: One page of Zdenka's book was inscribed by Alice.

Left: At the end of her first school year at Dormansland, in July 1948, Zdenka received a school prize book for 'Neat Handwriting'.

In 1947, Lingfield School was becoming more and more overcrowded; facilities were stretched to the limit. The thirteen remaining Weir Courtney children were transferred to Dormansland Primary School at the beginning of the autumn term 1947 (six of the children had been reunited with relatives here or abroad, or had been adopted by Jewish families). The children were admitted to Dormansland School on 2 September 1947, they were aged between six and ten years old. Alice Goldberger told *John Bull*'s reporter that 'they hold their own very well in and out of the classroom'.

Jona Spiegel was born in Vienna in December 1941; three weeks later he was placed in an orphanage. His mother was deported in June 1942 and sent to her death in Maly Trostenets, near Minsk. Baby Jona was subsequently deported to Theresienstadt. It would be another forty years before 'Jackie' was able to learn more than those basic facts of his birth and deportation to the concentration camp in Czechoslovakia.

After liberation from the concentration camp Jackie came to England 'on a bomber' on 14 August 1945. His first temporary home in England was the reception camp in Troutbeck Bridge near Windermere. Then on 15 October 1945, Jackie went to live at Bulldogs Bank, the special home in Sussex provided by Mrs Rebekah Clarke for the six very young refugees. Almost a year later, in September 1946, Jackie was taken to Weir Courtney with the five other young children. He was registered at Lingfield School on 24 February 1947.

Jackie Spiegel was adopted later that year and moved to London with his adoptive parents. They changed his family name to theirs (Yanofsky) and kept secret from him all details of his birth, imprisonment in the concentration camp and eventual liberation and transport to the UK. His new parents doted on him; they considered that it was in his best interests to shield him from the horrors of the first five years of his life. Then, when he was ten years old, a fellow schoolboy told him that he was adopted (Jackie's memories of his earlier life and adoption had by then faded). He had vague memories of playing with lots of boys and girls and that sometimes adults would come to take one or other of them for a car ride out through the countryside. Some of those old feelings would keep nagging at his memory but he could never recall the exact events of the time. He saw that his questions about his family history and early life upset his adoptive parents, causing them pain and frequent tears. He soon realised there was a great secret surrounding his early life and became increasingly frustrated that he was never able to discover his dark past.

SURREY EDUCATION COMMITTEE

FROM THE HEAD TEACHER

_____SCHOOL

_____25 JUL 1947____194

Jackie Spiegal

Is very intelligent and could do better work if he concentrated.

A Coleman

Jackie has not yet settled down although he is improving.

E. F. Browne

Jackie has one of his school reports, dated July 1947; the head teacher wrote: 'Jackie has not yet settled down although he is improving.'

He had recurring dreams, including one of a big house backing onto a racecourse with lots of tall pointed trees.

When Jackie was thirteen his name was changed by deed poll to Jack Morris Young, the reason given for the change was that Yanofsky was too long a name. His life within the local Jewish community in London continued normally until one day his grandmother let slip a closely guarded secret that he had been born in Austria. The questions began again but it was not until he was nineteen and had met and fallen in love with Lita that he was to discover the secrets surrounding his birth and early childhood.

Jackie was at the time of his engagement to Lita learning by heart the streets and the buildings of London, the training known as the Knowledge, essential to becoming a London taxi driver. With a career and prospects of being able to support a wife and family, Jackie and Lita approached the Jewish Board of Deputies to seek permission to marry in their synagogue. It was then that papers in support of his birth, the name of his natural mother and his eventual adoption were retrieved by his adoptive mother from a safe deposit box. Slowly details of his mother Elsa Spiegel, his own birth in Vienna, his imprisonment in Theresienstadt Concentration Camp, his mother's presumed death at the hands of the Nazis at the age of thirty-two, his liberation and transfer to England and his adoption from a house in Lingfield, were all revealed to the highly distressed Jackie.

Reluctantly his adoptive parents told him the facts they knew but they were unable to give him all the details of his personal history; the details that Jackie longed to know. In 1962, Jackie and Lita visited Lingfield and with the help of the Lingfield Police found the house that had featured in Jacky's dreams; Weir Courtney, a big house backing onto a racecourse with lots of tall pointed trees. The owners kindly invited them in and made them welcome with cups of tea.

Gradually with the help of Jewish agencies Jackie learned that his mother, Elsa Spiegel, had been a milliner and that she was deported to Minsk from where she never returned. He eventually learned the names and subsequent fate of several relatives. Sadly he is the only known member of the family to survive.

The infamous SS-Hauptsturmfuhrer Alois Brunner handled the extermination of Viennese Jews on his own, according to evidence gathered by Simon Wiesenthal. By the end of November 1941, he had established regular cattle truck transports of Jews to Poland, Riga and Minsk. The transports were taken straight to the Rumbula Woods near Riga for execution; pits had already been dug for the bodies. Brunner made a tour of inspection of Theresienstadt Concentration Camp, early in 1945, to speed up the rate of deportations of Jews from the camp to Auschwitz. By the time the Third Reich collapsed Alois Brunner was living

as an inconspicuous German civilian. He travelled to West Germany, under the assumed name of Alois Schmaldienst and there made his living as a truck driver for the American Army in Munich. After several moves he eventually made his way to Syria where he continued to live under Syrian protection despite extradition requests from several nations, including Austria and Germany.

＊＊＊

Bela Rosenthal was born to Siegfried and Else Rosenthal in Berlin in 1942. Else's mother, August Schallmach, lived with the family until September that year when she was arrested by Nazi officials, then deported to Theresienstadt with other elderly Jews considered by the Nazi regime to be too old to work. Bela learned later that her grandmother was subsequently transported by cattle truck to Auschwitz where like a great many others she was gassed. Her father, Siegfried, suffered the same fate at Auschwitz in March 1943.

Else and Bela continued to live in Berlin until they too were forcibly ejected from their flat in June 1943 and taken to a temporary holding camp in a Jewish Hospital before their deportation to Theresienstadt. On their arrival at the camp, mother and daughter were separated. Else was made to work and saw little of her baby daughter. She died of tuberculosis a few months later. Bela was held in a separate unit with other very young children at Theresienstadt.

> Women from the camp brought us a little food and, as each one in turn was deported to Auschwitz, another woman took her place. The International Red Cross heard rumours about the conditions in Theresienstadt and came to visit. When the Nazis were informed that they were coming, they got people to quickly paint the buildings, clean up the streets, print some money, build shower blocks, open coffee bars, they even built a cemetery! The Nazis reasoned that in a real town people died so they put up grave stones with names on, but there were no bodies in the graves and the names bore no relation to anyone who died there ... ashes that had accumulated in the crematorium were thrown in the river so that they did not have to account for them. My mother's ashes were thrown into the river along with the others at that time ... All the preparations to influence the Red Cross were successful in diverting attention away from the atrocities that were happening there. As soon as the Red Cross left, everything went back to the way it was before, and none of the new facilities was ever used.
>
> (Taken from Bela Rosenthal's personal testimony)

Bela caught scarlet fever and hepatitis. When the camp was liberated in May 1945, she was too ill to move and remained in the camp for another month until she had made a full recovery. She then joined the other orphaned children at Olesovice, near Prague, in the Přemysl Pitter Children's Rehabilitation Centre situated in a castle of Baron von Ringhoffer. The children stayed for a couple of months while attempts were made to trace their homes and any surviving relatives and then were airlifted from Prague to Crosby on Eden in Westmorland. Bela was one of the six very young children taken to Bulldogs Bank in Sharpthorne in the autumn of 1945 and a year later transferred to Weir Courtney.

Bela was soon adopted by 'an older Jewish couple' in London and became their only child. Her name was immediately changed to Joanna. She can remember the car journey to London with her adoptive parents, and their discussion about the new name. Why, she wondered, did she need a new name, she already had a name, she had always been known as Bela? But her new parents considered her name to be too German. Gradually the little tomboy with the cheeky manner changed, she became a quiet little girl with pretty ribbons in her hair. In line with common opinion and in an attempt to blend Joanna into the local community her new parents taught her to keep secret the history of her birth and adoption. In post war Britain a lot of anti-German attitudes prevailed, anti-Semitism too existed. Joanna's psychological pain continued and an increasing frustration about her inability to change anything about her life, or the attitudes of those around her until her adult years.

CHAPTER 20

A Time for Peace

Slowly life assumed a new reality after the excitement of the victory celebrations. Destroyed buildings could be rebuilt, not so a dead loved one. It was a hollow victory for the bereaved. Many families had lost their main breadwinner; some families had been deprived of several members. The war left permanent scars on human relationships; many of the bereaved were unable to move on, to do so would leave their lost loved ones behind amid the tangle of horrific memory. The enormity of coping with everyday existence after the loss of a close relative or friend always seems an insurmountable hurdle and yet somehow the sun keeps on shining and the birds continue to sing.

Husbands and wives had to get to know each other afresh after years apart. There were broken marriages and failed relationships that did not survive the enforced separation of the war years. Young babies had become school children during their father's absence, they had no memory of the father who left home to fight in a far away land, 'Daddy' was a stranger. Some men were unable to settle for a quiet life after six years of living by the notion 'kill or be killed', now the commandment 'thou shall not kill' prevailed.

War veterans were damaged mentally and physically and would need years of care and understanding to come to terms with their afflictions. Many former soldiers, sailors and airmen had permanent disfigurement; scarred faces and bodies, shattered and mutilated limbs. Prisoners of war suffered from dietary complaints after years in the camps. Most veterans suffered the mental trauma of their lost youth, and had to learn to live with the nightmares year after year.

Villages throughout the country were preparing celebrations to welcome home the returning troops. On Saturday 1 June 1946, Lingfield Park

 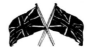

LINGFIELD
Welcome Home
to Members of
His Majesty's Forces &
Merchant Navy (1939-
1945)

LINGFIELD PARK RACECOURSE
Saturday, 1st June, 1946

**Souvenir
Programme
of Dinner**

A Memory of the Fallen

MENU

Kidney Soup

—

Roast Chicken Bread Sauce
Potatoes
Spring Cabbage

—

Apricots and Cream

—

Cheese

—

*Letheby & Christopher Ltd.,
Caterers.*

TOASTS

THE KING

—

OUR GUESTS

THE VERSATILE VARIETY SHOW

1 MARGUERITE AND HER ACCORDION
 The Community Singing Specialist

2 LESLIE STANTON Comedian Female Impersonator

3 MARGERY GOODWIN Soprano

4 REX REYNOLDS *(Guest Artist)* B.B.C., of CLARKE & REYNOLDS
 Navy Mixture Workers' Playtime Music Hall etc.

5 DOREEN HARTLEY Tap Dancer

6 JOHN ELLIOTT Tenor

7 FRED CROUCH (CAROL LEVIS' Discovery and Broadcasting
 Musical Railwayman)

8 FRED ROBERTS Entertainer

The Souvenir Programme of the dinner. (*Eric Ellis*)

Women's Voluntary Services
~~for Civil Defence~~

W·V·S CIVIL DEFENCE

Tun. Wells 1104.

Our Reference AW/AO

Your Reference

Regional Office,
5, Church Road,
Tunbridge Wells.

3rd November, 1945.

Dear Mr.Haywood,

 We are so very grateful to you for allowing the W.V.S. to use your garden Room as an office all these years and for your unfailing help, and kindness.

 I know how enormously your kindness has been appreciated.

 Yours sincerely,

 Regional Administrator.

A.B.Haywood, Esq.,
Guest House,
Lingfield.

Letter of thanks to Arthur Haywood from the WVS.

Racecourse hosted a Welcome Home Dinner and Entertainment for the returning Forces, funded by local efforts.

The racecourse was restored by the local building firm of Head's. Schoolboy evacuee, Geoff Post, was an apprentice builder with the firm and clearly remembers the restoration of the stable blocks. Communication doors had been inserted between all the stalls to make a corridor through for staff, these were all taken out. The first race meeting after the war was held on 26 and 27 April 1946.

Requisitioned property was returned to the owner, although many buildings had suffered. Arthur Hayward recorded in his diary of 22 September 1945, 'Miss Dunstan hands me back the Garden Room after 6 years occupation by the W.V.S.' He received letters of thanks from the local organisers, as well as from the Regional Administrator, (Lady) Alexandra Worsley.

The end of rationing began in 1948 but continued on many items until 1954. Between 1939 and 1954, all of the following items were rationed at some time: petrol, bacon, butter, sugar, meat, tea, margarine, jam, cheese, clothing, eggs, coal, rice and dried food, soap, tinned tomatoes and peas, gas and electricity, sweets and chocolate, biscuits, sausages and flour.

The Aftermath of War

A large number of Auxiliary Firemen were killed in action on the Home Front. A kneeler in St John's Church, Dormansland is dedicated to the memory of Percy Charles Aitchison, aged twenty-seven, who joined the Auxiliary Fire Service at West Wickham in the London Borough of Bromley. He was transferred to Beckenham AFS, to a temporary fire station set up in the Old Palace L.C.C. School in St Leonard's Street, Poplar. In the early hours of 20 April 1941, the building was hit by an enemy bomb during a raid on the London Dockland. Thirty-two firemen and two firewomen were killed; the largest loss of fire brigade personnel in the history of the fire service in Britain.

The Women's Land Army

Mary Card received her release papers from the Women's Land Army on 1 January 1946, although the WLA was not finally disbanded until 1950. She was awarded the Defence Medal in August 1946 for her voluntary ARP service with Toc H canteen. Mary met her husband to be, Guy Chauncy, at the wedding of a WLA friend (one of her gang of six). Guy

had served with the RAF Military Police and after the war was seconded to the Federation of Malaya Police which was formed in 1948. Mary and Guy were married in Singapore Cathedral in August 1952 after Mary had sailed alone from Southampton to Singapore for the wedding. Their first two years of marriage was spent at a bungalow home in the jungle of Malay Peninsula. Most of their married life was spent in Canada.

The friendship between Josephine Steel and Dick Osborne blossomed at the end of the war. Dick had left his post with Surrey War Ag and moved to Tanhouse Farm in Four Elms. Jo, as a recently qualified WLA dairy girl, started to work at Chellows Farm, Crowhurst, where she worked twelve hours every day, milking, bottling, and delivering milk in the surrounding area. Dick and Jo married on 26 June 1948. As suits and dresses were expensive and clothing was still rationed they borrowed their wedding clothes, as hundreds of other couples did at that time. The following day they set out on Dick's motorbike for their honeymoon in Penzance, Cornwall. They were met by their disapproving host who reproached Dick for bringing 'that poor girl all those miles on the back of that thing'.

The post-war years saw a further drift of farm workers away from the countryside to the cities and even abroad. Service men returned from the war and were tempted by the promise of a better life elsewhere. In 1947/48, several Crowhurst families chose to emigrate and left for Rhodesia. Local farms remained in crisis. In 1921, a row of six houses had been built in Crowhurst by the RDC called St George's Cottages, they were reserved for Crowhurst brick workers. An additional four cottages were built on the row in 1948 which were allocated to farm workers. Numbers 7 to 10 St George's Cottages were allocated to Mansion House Farm, Stocks Farm, Gatlands Farm and Old House Farm.

Dick Osborne transferred to Stocks Farm, Crowhurst in September 1948 and was allocated No. 8 St George's Cottages, the cottage reserved for Stocks Farm. Dick loved the small, quiet, rural community but was surprised to see, three years after the end of the war, a government information poster, 'How to Spot a German Paratrooper.' The poster was still displayed on the stable wall at Church Farm, the home of by Mr A. W. Robbins, District Councillor and Crowhurst Head Warden, known affectionately as 'Cock Robin'.

The County War Ag Committee maintained their powers of control over food production for several years after the war. Ted Hook's father purchased the lease of Windyridge Farm hoping to manage a herd of cattle on the farm, but was forced out by the committee in 1951 in favour of crop production at Windyridge Farm.

Now widowed, Mary Chauncy lives in East Grinstead. She continues to suffer from back pain, a legacy of her years with the Women's Land Army.

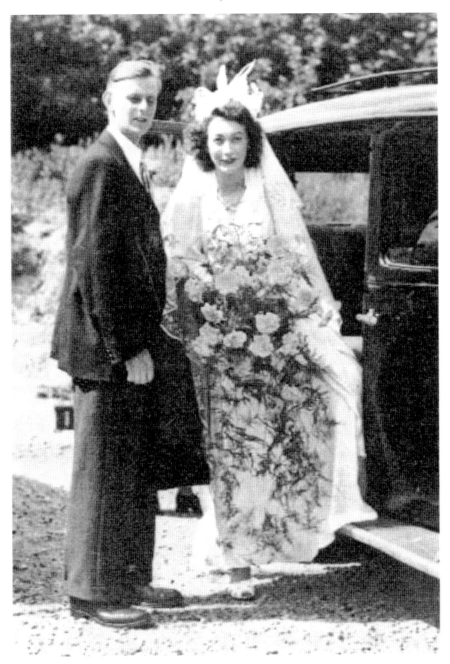

Dick and Jo Osborne on their Wedding Day, 26 June 1948.

Both Mary Chauncy and Jo Osborne received a letter of gratitude from the British government in 2008, and a Women's Land Army/Women's Timber Corps Medal of Service. In 2009, Mary attended a reception to honour the Berkshire Women of the Land Army and the Timber Corps.

Hundreds of former WLA girls have died in the interim since completing their war service; they received no recognition during their lifetime. The Women's Land Army/Women's Timber Corps Medal was designed by the Garter King of Arms and bears the Royal Crown. It shows a gold wheat sheaf motif on a white background surrounded by a circlet of pine branches and pine cones to indicate the work of both the WLA and the WTC. The WTC, affectionately called 'the Lumberjills', worked on timber producing estates throughout the country but mainly in Scotland.

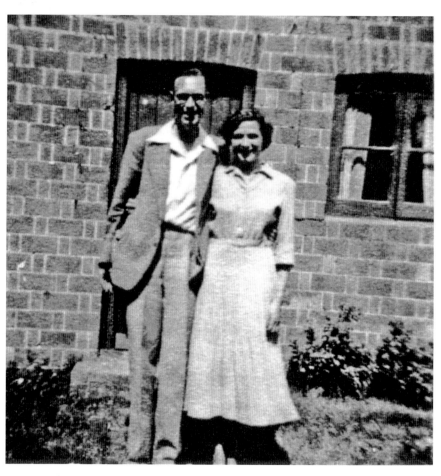

Former Brockley evacuee, Philip Huggill eventually married Brenda, 'the girl next door', in 1952. Brenda and Philip are pictured outside No. 2 Cherry Cottages, The Platt, in 1949, the Huggill family home until 1962.

The first Reunion of the Old Brockenians, held at Lingfield in 2000.

The Evacuees

Brockley Central School returned to Ranworth from Maesteg in December 1944 and stayed until the end of the war. Mr Green, the Headmaster, retired at the end of the war and the Ranworth estate was sold. A campaign to encourage the London County Council to buy the house as a holiday home for London schoolchildren was unsuccessful. The former owner of Ranworth, Captain Gilbert Frederick Greenwood, who lost his wife Mary Elizabeth in the Whitehall Cinema tragedy, married Lady Barbara Huddleston Abney-Hastings, 13th Countess of Loudoun, in November 1945. They had two children, a daughter and a son. Captain Greenwood died in 1951.

Several evacuees remained in the area; some had lost their homes in the blitz of London.

Recalling the Battle of Britain

Many Operational Bases for Auxiliary Units and Zero Stations were destroyed at the end of the war. Evidence of some of the bases was recorded for the Council for British Archaeology Defence of Britain Project. The Department of National Heritage and the Council for British Archaeology launched the Defence of Britain Project in April 1995. An

army of volunteers recorded the remains of the Second World War military constructions, including pillboxes, anti-tank obstacles, bombing decoys, radar stations and airfields between 1995 and 2001.

A total of one hundred pillboxes were recorded on the GHQ Stop Line between Burstow in the west, to the eastern boundary of Lingfield. Evidence was found too, of the gun emplacements surrounding the Nodal Points at Limpsfield, Godstone and Newchapel. One anti-tank block, a section of anti-tank ditch and an anti-tank obstacle remain in the Stop Line. Evidence of military occupation can be seen in Staffhurst Wood, north-east of Crowhurst. Staffhurst Wood was used in the First and Second World Wars as an ammunition dump.

Bob Pucknell, a former pupil of Brockley Central School who won a scholarship to Haberdashers' Aske's Boy School in 1944, returned from evacuation to Devon in 1945 and armed with a pre-war road atlas set off for his first post-war trip to London.

On the first occasion I walked the length of the Rotherhithe Tunnel, I could have taken a bus but decided the novelty would be to walk it. On emerging, I turned westwards towards the City and here it was that I had my first shock. I had seen newsreels and newspaper reports of the Blitz on East London but was still unprepared for the devastation that I beheld.

The chairman of the publishing company Benn Brothers Ltd likened East London to the Roman ruins of Pompeii or Timgad. There were fearsome gaps between properties, 'The City of London had no such experience since 1666.'

Queen Victoria Hospital

Archibald McIndoe was awarded a CBE in 1944 and was knighted in 1947 for his remarkable work. He became a member of a council of the Royal College of Surgeons in 1946 and its president in 1958. McIndoe, with two of his former pupils, Michael Wood and Tom Rees, founded the Flying Doctors Service of East Africa in 1956. He died in 1960, one month before his sixtieth birthday. In 1961, The Blond McIndoe Centre at the Queen Victoria Hospital was named in his honour and opened by the Minister of Health. All the temporary wooden buildings that were built to house Archibald McIndoe's Emergency Unit are still in use in 2009; Ward III is now 'The Spitfire Restaurant'.

Group Captain A. Ross Tilley, a.k.a. 'Wing Co', and his Chief Assistant, Marjorie 'Marge' Jackson. The presentation of the air-raid siren from Whitehall at the Farewell Dance held in the refurbished Rainbow Ballroom, Whitehall, 5 September 1945. (*Q.V.H. Museum*)

The Canadian Wing of Queen Victoria Hospital was handed over to the people of Britain in 1945 as a token of thanks and friendship. It is a fitting memorial to the bravery and dedication of the boys who defended our countries during the Second World War. The official Handing-Over Ceremony occurred on Wednesday, 5 September 1945, when a formal Farewell Dance was held in the refurbished Rainbow Ballroom in East Grinstead. Dr Ross Tilley had his living quarters at the Whitehall. His chief problem was the air-raid siren, 'It was only 22 ft from my pillow. I know because I measured it.' The siren sat on the roof of the building, directly over his room. He always swore that when the war was over he 'would take the darn thing back to Canada'. Dr Tilley did take the siren back to Toronto. In the 1970s, it was in use as a fire alarm in the village of Rousseau, 140 miles north of Toronto.

Marjorie Jackson became an RCAF nursing sister in 1942, after graduating from Brandon General Hospital of Nursing. In August 1942, she was posted to the Burns and Plastic Surgery Unit, East Grinstead. Nurse Jackson was part of the transition into the newly built Canadian Wing where she became head nurse. She remained at East Grinstead until the end of 1945. After the war, she took courses in hospital administration at McGill University in Montreal.

The British War Relief Society of the United States of America provided funding for a new wing at the Queen Victoria Hospital, as a permanent tribute to the British people and dedicated to Anglo-American goodwill. The American Wing, complete with all necessary equipment, parquet flooring and a tall exterior clock tower, was funded entirely by American efforts. The building was opened by Queen Elizabeth on 25 July 1946. Miss Cowling, teacher at Lingfield School, was absent from school that day so as to join the Guard of Honour at East Grinstead Hospital. Lingfield School Records show that the whole of the school lined up outside the building, on Lingfield High Street, to see the Queen pass by on her way to Dormansland. The Queens's youngest brother, the Hon. David Bowes-Lyon married Rachel Pauline, younger daughter of the late Lt-Col. Spender-Clay of Ford Manor, the King and Queen were frequent visitors at Ford Manor.

Mr Alfred Wagg

Mr Alfred Wagg, who had contributed so much time and effort towards the building of Wards III and IV at the Queen Victoria Hospital in 1939, purchased the grounds of East Court in 1946 to be laid out as a permanent memorial to those who had lost their lives in the war. A plan for the layout

of the estate was drawn up by the architect, Mr Louis Osman. Louis Osman had made his own contribution to the defence of the nation; he was a Major in Intelligence involved in Combined Operations and the Special Air Service. His plan for the grounds of East Court was a more lavish version of the boy's summer camp built by Mr Wagg at the Isle of Thorns in Ashdown Forest. The new scheme included community housing, a school, community centre, memorial garden, open air theatre, and a large sports complex including full-size cricket and football pitches and a swimming pool. The site was to be linked to the Queen Victoria Hospital via two footbridges across the main road. An appeal for building funds was launched in 1947 but very little of the project was built. Only the garden of remembrance and the war memorial of the original project were completed and dedicated on 4 June 1950. The main house became the town's administrative centre.

Alfred Wagg died in 1969, his former home (The Hermitage) was demolished in 1972.

The Guinea Pigs

The Guinea Pigs continued to support each other in every way, except pity. The President and Maestro, Archibald McIndoe, told members in 1944: 'We are the trustees of each other. We do well to remember that the privilege of dying for one's country is not equal to the privilege of living for it.'

The camaraderie of the club survived peace-time. Regular reunions and the publication of their own magazine continue to provide a lifeline to Guinea Pigs all over the world. They share a common history of survival against all odds. Sixty years later William Foxley and several other survivors continue to receive treatment for their war injuries. They live with obvious permanent disfigurement and hidden but permanent mental scars.

At the end of the war, there was a total of 649 members of the Guinea Pig Club; 62 per cent were British, 20 per cent Canadians, 6 per cent Australians, 6 per cent New Zealanders and 6 per cent from other countries.

Jackie Mann was a member of the illustrious Guinea Pig Club, a sergeant pilot in the Battle of Britain he was shot down several times, on the last occasion being seriously burned. In 1946, he joined Middle East Airlines and eventually became chief pilot. He married an air hostess and together they made their home in the Lebanon. The couple lived there for over forty years until Jackie was kidnapped in Beirut by the Hezbollah, pro-Iranian

Shiite Muslim militants, on 13 May 1989. He was eventually released on 24 September 1991. The RAF arranged for a Spitfire to fly overhead as Jackie Mann emerged from the plane which brought him from Princess Mary Hospital, Akrotiri, to RAF Lyneham for a period of convalescence. He died 12 November 1995 in Nicosia, Cyprus, aged eighty-one.

The East Grinstead U.D.C. began a programme of house building after the war. The Stone Quarry Estate was started in 1948, a planned community of houses, shops, a church and a public house. The Guinea Pig pub was built on the corner of Quarry Rise and Holtye Avenue and opened in 1957. The name was inspired by the Guinea Pig Club and the official opening ceremony was performed by Sir Archibald McIndoe in the presence of many members of the world famous club. The decor included many drawings and photographs of Spitfires, Hurricanes and other Second World War images. When the pub finally closed in 2009 most of the Second World War memorabilia was taken over by The Guinea Pig Club and is now part of their archives. Several of the photographs decorate the walls of the Queen Victoria Hospital.

The Prefabs

Before the end of the war, in 1944, Winston Churchill announced the 'Temporary Housing Programme'. The aim was to provide large numbers of houses quickly and economically. The temporary houses were primarily for families whose homes had been destroyed by enemy bombing, or to provide houses for key workers who would be needed to help the country recover after the war.

Local authorities played a major role in providing temporary buildings. Godstone Rural District Council built prefabricated temporary buildings in most district villages. The single-storey units known as 'prefabs' were built in factories that had shortly before manufactured aircraft and armaments. Made of steel, aluminium, asbestos or timber, the homes were designed to last for a maximum of twenty-five years but sixty years later several remain in the villages (mostly timber construction). Now privately owned, improved and extended, they continue to provide comfortable accommodation for small families. The prefabricated sections were transported from factory to building site and rapidly assembled. Each house had two bedrooms, a living room, hallway, bathroom and toilet, and a kitchen equipped with hot and cold running water, cooker (gas or electric) and a built-in refrigerator. The accommodation was comparatively luxurious as most low cost pre-war houses had no running water and the only toilet was a privy in an outhouse.

Thousands of larger two-storey family houses designed and developed by Sir Edwin Airey and called 'Airey Homes' were also built in towns and villages throughout the country. The houses were mass-produced and constructed from light reinforced concrete posts positioned on a concrete foundation slab. The walls were faced externally with precast concrete slabs fixed in ship-lap style to the concrete columns, and lined internally with insulating fabric and an appropriate wall lining. Large estates of Airey homes were built near to centres of employment. In rural areas, small groups of six to eight semi-detached Airey homes were built near to farms to house agricultural employees and their families.

Canadian War Brides

The term 'war bride' refers to the estimated 48,000 young women who met and married Canadian servicemen during the Second World War. Most were British but a few thousand were from other areas of Europe: the Netherlands, Belgium, France, Italy and Germany. Canadian servicemen and women had to seek permission to marry from senior officers, usually the chaplain. Senior officers were instructed not to grant permission unless they were satisfied that the soldier realised his financial responsibilities and that the bride was of good moral character.

The brides and their 22,000 children were given free passage to Canada by the Canadian government between 1942 and 1947. A few Canadian servicewomen married British men who were also eligible to travel to Canada and had to put up with a bit of good-humoured teasing about being male war brides. The majority of brides sailed to Canada in 1946 after their husbands had returned home; those who chose to travel during the war years were in real danger from enemy U-boats in the North Atlantic.

Before travel the brides had to undergo a medical examination to ensure they were free of venereal disease, much to the dismay of the girls and their families. Tests for tuberculosis and vaccinations for smallpox followed. Their children also had to undergo medical examinations.

Kathleen (Kay) Garside sailed to Canada from Liverpool on the Cunard liner RMS *Samaria* in June 1945. Fred and Kay had had been married for only two weeks when Fred was posted to Italy in February 1944. Their first home in Canada was with Fred's family on the farm in Colfax, Saskatchewan. A few months later they moved to Regina, approximately 80 kilometres from Colfax.

I wouldn't say adjustment to my new life was easy. I had worked in London most of my life and went to live on a farm in Colfax ... We

then moved to a small town where I was much happier. My in-laws were very kind to me, so I had no problem there ... They were originally from England and knew how I would be feeling.

Fred Garside died in 1989, Kay still lives in Regina.

It was the turn of the British war brides to confront culture shock in Canada. Most experienced some seasickness on the long crossing of the North Atlantic. Many then went on to cross the vast continent of North America, experiencing extreme weather conditions. It had been impossible to imagine the reality of extremely cold winters back in England. They crossed seven time zones, and put four to five thousands miles between them and their families in Britain. They saw mile upon mile of grain-growing prairies as the trains passed through Saskatchewan, the bald-headed mountains of the Rockies towering over the plains of Alberta and British Columbia, and finally meeting for the first time a family of inquisitive in-laws. Over 27 per cent of the Canadian population spoke French as their native language, mainly in the area of Quebec.

On board ship the brides were sorted alphabetically. Joan Reichardt shared a cabin on the Lady Rodney with Bette Read, a former member of the Dagenham Girls Pipe Band. Bette piped the ship in to Pier 21, Halifax, Nova Scotia on 24 May 1946. They were met there by Red Cross and Salvation Army volunteers, who offered the new Canadians a warm welcome and gifts of food and clothes for the children. Then began a five-day, two thousand mile train journey across Canada, to Saskatoon, where Joan was met by her husband, dressed in his new demob suit and tie.

My husband had tried to explain to me how cold it was in Saskatchewan but it is hard to put into words what 50 below feels like. Of course the train was not like the little English trains we were used to. Despite having been warned of possible 'scams' with people trying to take advantage of our ignorance, we were not long out of Halifax when we stopped (possibly to let someone off) and little tubs of ice-cream were being peddled through the windows. Those who purchased found themselves with nice little tubs of sand! As we travelled through the Maritimes, I was impressed with the scenery, the large tracts of unspoiled countryside, and the lack of towns and cities.

As our journey continued I was amazed at the wild and rugged country we travelled through, with the occasional stop to let a bride or two off. We would all peer out of the windows to have a look at the 'meeters'. Seeing the men in civvies was quite a shock as they looked quite different from their uniformed selves ... On we went to Saskatoon, and there he

was, my husband, looking most respectable in his new demob suit and complete with tie!

All these crazy cars and busses driving at top speed on the WRONG side of the road was a highlight. For years we had seen very few 'civilian' vehicles, our buses moved at a very sedate speed and most of the traffic was military convoys, so this wild and uninhibited mass of vehicles was unbelievable. There never was a journey to equal that amazing 5 day odyssey of exploration across Canada, to a new life.

Joan Reichardt went to a place 'with no history, no theatre, no museums and no music, to a new country populated almost entirely by first generation immigrants'. Despite their difficulties Joan and John Reichardt's happy marriage lasted for over fifty years until John's death. They had five children.

Eunice Theed married her Canadian soldier, Sgt Reginald Partington on 4 March 1945. Their wedding had originally been planned for August 1944 but was postponed when the bridegroom's leave was cancelled prior to the D-Day landings in Normandy. Sgt Partington was fighting in France on what should have been his wedding day. Eunice sailed to Canada on

Joan Reichardt, daughter Janet and son-in-law George on holiday in Brighton, 7 May 2009.

RMS *Aquitania* in March 1946 'and was sick all the way'. Her new life was on a farm miles from anywhere. Fortunately, Eunice loved the life on the farm where she learned to milk cows, churn butter and preserve almost everything, above all she learned to save and re-use every drop of water.

Margaret Houghton followed her husband to Canada, 'sailing on the *Queen Mary*, which was very comfortable'. She arrived in Moose Jaw on 16 August 1946, her new sister-in-law's birthday. 'Mum Houghton greeted me with open arms, being from St Helens they liked the idea I was from England.' Arthur and Margaret were allocated a 'Wartime House' in Moose Jaw. The houses were built by the Canadian government for returning servicemen and their families.

Margaret and Arthur have four children, fourteen grandchildren and five great grandchildren. They have made several visits to Margaret's large family in England; Margaret was the eldest of ten children. Four of her sisters and two brothers live in the Leatherhead area. In May 2009, one of Margaret and Arthur's daughters accompanied them to England to visit Margaret's family.

The Cunard White Star luxury liner *Queen Mary* was launched by Her Majesty Queen Mary on 26 September 1934. The liner held the Blue Riband trophy for the fastest Atlantic crossing at 31.6 knots, from 1937 to 1952. In 1940, she was refitted as a troop ship and in 1943 held the record for the greatest number of people ever carried on a ship; that record still stands at 16,683. In the Second World War, Hitler offered the Iron Cross and a big reward to any German U-boat that sank the *Queen Mary*.

Inevitably not all Canadian war brides made happy marriages. The dream of a happy marriage on the other side of the Atlantic was very different to the reality of leaving family, friends and familiar surroundings in England. Several brides arrived in Canada to find that their husband already had a wife and their bigamous marriage in England was a complete surprise to their Canadian family! The Canadian government had financed their crossing in 1945/46 but the return fare would have to be paid by the bride. Wives who were unable to afford the passage to Britain sought help from the Canadian Red Cross who had earlier organised the welcome parties at Halifax, Nova Scotia, and continued to provide support and advice where necessary. In the event of family breakdown, the Red Cross and the Salvation Army gave such support as funds allowed to help the War Brides. There are no accessible statistics on failed marriages.

The Canadians planted an avenue of maple trees leading to the main entrance to Smallfield Hospital. In 1948, the National Health Service took over the hospital, which eventually closed when the new East Surrey Hospital was built. The site of the hospital was redeveloped as a housing

Margaret and Arthur Houghton, Effingham, Surrey, 13 May 2009.

estate but the Canadian connection has been preserved in the names of the roads which are Canadian cities.

Canada Avenue to the north of the present East Surrey Hospital owes its name to the use of the site as a camp for No. 13 Squadron, RCAF. In its army co-operation role the squadron took part in the Dieppe raid of August 1942.

The Aliens

Clive Teddern (formerly Kurt Tebrich) ended his service in uniform as an interpreter with the Control Commission Legal Division in Germany, working at war crimes courts in Luebeck and Hamburg, before returning to civilian life in England.

He had left the great port of Hamburg in 1939 as a child of fifteen. He returned to the city, the second largest in Germany, in May 1945 and saw Hamburg as a great mass of rubble, destroyed by Allied bombing. Nearly one million residents of the city were homeless. One soldier recollected, 'wherever we went we could smell death'. Clive's letters to his Aunt Margot in England have been lost but her letters to him have been preserved. It is clear from her letters that Clive began an emotional search for his parents, his home, and his friends. Aunt Margot wrote:

Oxford, 8 Juli [1945]. My dear Kurtl ... I am so glad that you could go again to Hamburg ... How wonderful that you could speak so many Jewish people ... I can understand how excited you have been to talk with people from Theresienstadt and to hear about your mother. It was not much news for me because I knew that your mother has not been in Th. [Theresienstadt] since September 1944. A friend of us ... who was lucky to be released from Th. some months ago to Switzerland, wrote me that your mother has been sent away with the last transport, September 1944, destination unknown. And later I heard on the wireless that people who left Th. at that time were sent to Auschwitz ... I did not tell you about this here because I did not want to spoil your leave ... Now I am waiting if some day we will still get some good news from your mother. It is my prayer every day and night ... Nothing positive is known about your father. May be you will have an opportunity to speak with people who have been together with your parents in Th. and can tell you more ... all my love and many kisses.

After the war Ralph Williams (formerly Spielmann) joined the Cecil Gee organisation and became General Manager from 1958 until 1962 when

he left the company to found his own gent's wear shop. Ralph, with his wife and daughter, moved from their home in Sanderstead to Ladbroke Hurst, Dormansland, in 1967.

Ralph visited his father in Buenos Aires several times and learned from him the fate of several members of his family. His mother, Edith, her sister and his father's sister had all been deported to the Latvian capital, Riga, where they were all murdered. He now knows that his mother was shot on 30 November 1941.

The Prisoners of War

The German POWs in Britain became displaced persons at the end of the war. Several had no wish to return to the Russian zone in post-war Germany. Those who had been trusted to work on farms were often encouraged to stay as skilled farm labourers; their contribution to the local economy was highly valued. One POW stayed on at Mansion House Farm in Crowhurst until 1949/50. His home was a substantial brick building with a chimney and a room above, some 200 yards away from the main farm in the middle of a field. The building remained unoccupied after his departure and was largely destroyed by fire in recent years. The ruin remains in the field clearly visible from the road, between the Church and St George's Cottages.

A German POW in America
and his Post-War Years in Lingfield

Heinz Schmidt was born in Berlin in 1919. At the age of nineteen he joined the Luftwaffe and became a ground gunner manning an anti-aircraft gun. He spent some time at the Mohne Dam but moved away about a week before the Allied 'Dambuster' raid, the night of 16/17 May 1943. Later that same year he was hit by an incendiary bomb and received injuries to his back, he then spent a few months in hospital.

In 1944, Heinz was switched to the German Army because of the shortage of soldiers and was made an NCO in charge of an anti-tank gun on the German/Polish border. His unit was suddenly ordered to move out after only two or three weeks on the Polish border and was transported by truck and train to eastern France.

Arriving at St Avold their new orders were to defend Metz against the advancing Americans and were to fight to the last drop of blood. The drive to the west was through thick snow. There they were ordered to unload the

gun on the top of a hill, between the two villages of Destry and Marthile in the Moselle district. Their lorry was parked under a tree which, as it was winter, gave neither shelter nor camouflage. Almost immediately range finding shells began to fall around them. The gun crew took cover in a ditch filled with snow and freezing water and watched as their gun, lorry and all ammunition was destroyed by shell fire.

An American tank approached from the nearby trees and circled around their position. They were taken prisoners by the American crew, given dry clothes, food and overnight shelter in a barn. They were moved progressively across France to Liege where Heinz Schmidt had a fall which aggravated his back injury and he was hospitalised again.

Eventually Heinz was shipped across the Atlantic to New York. He spent eighteen months in a POW Camp in Colorado where he was put to work cultivating and harvesting sugar beet. After his release he was shipped back home stopping on the way at Liverpool (1945). He never returned to live in Pomerania as the town had become part of Poland and was under Russian control.

A year after arriving in England, Heinz moved with other stateless persons to South Godstone where they lived in Nissen huts on land belonging to Norbryght House. The same huts had been occupied by Princess Patricia's Canadian Light Infantry during the war. Each day the former POWs were taken to various farms in the area. Heinz worked mainly at Beeches Farm at Dry Hill, Dormansland. The farm was owned by Mr Ken Faire who arranged permanent accommodation for Heinz at the farm; he stayed there for two years until the farm was sold.

Heinz then moved to Blackgrove Farm, working for Mr Young. It was there that he met his wife, an Austrian who came to England before the war but returned home briefly and moved back again to learn English, working as an au pair at Blackgrove Farm. The couple were married in 1953 and moved to Waterside Cottages, Haxted Road. Heinz continued to work for Mr Young until 1963 when he decided to take work as a painter and decorator which he continued until his retirement.

The Sailors

In 1960, Bob Philpott was instrumental in forming an East Grinstead branch of The Nautical Training Corps; the Nautical Training Ship Resolution in premises at Chequer Mead School. There the cadets learned the skills of boating, sailing and knot-tying as well as a range of sporting activities. They also had their own band. Wearing his other hat as a professional accountant Bob wrote to one of his former clients, the

Maharajah of Jaipur, who until 1959 lived at Saint Hill Manor, to ask if he could supply a tiger skin for the NTC band drummer. The Maharajah replied from his home in India that he had disposed of all of his tiger skins, the last one had recently been donated to the Royal Marine Band. Perhaps the Royal Marine Band might pass that on to East Grinstead Nautical Training Corps if approached? In due course a tiger skin arrived from the Royal Marine Band.

In the mid-1960s when the Army moved out of Hobbs Barracks they found in some undergrowth a wooden boat. The boat was offered to the Nautical Training Corps for training purposes. Bob Philpott accepted the boat which although not in good condition still had the 'required pointed and blunt ends'.

The Airmen and Women

RAF Biggin Hill is the most famous of all of the Battle of Britain fighter stations. To commemorate the 454 Allied airmen killed during the Second World War a chapel was erected in 1951 to replace the first station church which was destroyed by fire. Today some 12,000 people a year enter St George's Chapel to pay their respects to 'The Few'. The gates to the chapel are flanked by full scale replicas of a Spitfire and Hurricane.

In 1964, the bodies of the three German airmen found at Hoopers Farm on 11 September 1940 were exhumed from St John's Churchyard and taken to the Cannock Chase German Military Cemetery in Staffordshire. Similarly the three German airmen who died in the hospital unit at Lingfield Racecourse Cage between 1942 and 1944 were exhumed from Lingfield Cemetery and reburied at the Cannock Chase German Military Cemetery. The German Military Cemetery was made at Cannock Chase following an agreement between the governments of the UK and the Federal Republic of Germany that the graves of German nationals which were not situated in cemeteries maintained by the Commonwealth War Graves Commission would be transferred to the new cemetery. German servicemen buried in British Military Cemeteries and in war grave plots in civilian cemeteries were not moved.

The British Empire Medal and other war medals in a group of five which were awarded posthumously to Sergeant Victor Louis Fossleitner, of No. 149 Squadron, Royal Air Force have twice been sold in auction.

Diana Barnato Walker continued flying after the war and became the first British woman to fly a Spitfire across the Channel and the first British woman to break the sound barrier (flying a RAF Lightning T4). She was awarded the MBE in 1965 and about that time moved to Horne Grange

where she farmed sheep. Her love of riding and foxhunting continued; she became Master of the Old Surrey and Burstow Foxhounds. Diana Barnato Walker died at the age of ninety in 2008.

The phrase 'a bomber's moon' continues to be used. The phrase may be a mystery for the children of the twenty-first century but their grandparents remember the advantage to enemy bombers of a clear moonlit night when lakes and rivers are illuminated by the moon, visible from a pilot's cockpit as if drawn in relief on a map of the British Isles.

The Soldiers

Bill Coombes, lifelong friend of Lance Corporal Frederick William (Bill) Bray, visited the memorial to the casualties of Operation Freshman in 2008. Bill Coombes wore the beret of the Scout Association in honour of his friend's long association with the Scout movement. Bill Bray's widow, Lily, and Doris Jenner, daughter of Bill's employer Gordon Jenner also made a pilgrimage to his grave. Bill's son, Denis, who was born two months after his father's death has also visited the site.

In 1965, a film was made of Operation Grouse, the ill-fated Operation Freshman, and the eventual destruction of the heavy water plant at

Bill Coombes at the memorial to the casualties of Operation Freshman in 2008.

Doris Jenner at the Commando Memorial at Spean Bridge, north of Fort William. The memorial was erected in 1952 to commemorate the elite commando units who trained in the surrounding area during the Second World War. (*Courtesy of Miss Doris Jenner*)

Vermork by Norwegian resistance fighters. The film called *The Heroes of Telemark* starred Kirk Douglas, Richard Harris and Michael Redgrave.

Eric Ellis and his wife Theresa made pilgrimages to Dunkirk, to North Africa, to Sicily and to Caen in the decades after the war. The last Thames Estuary Paddler the *Medway Queen*, that rescued hundreds of men including Eric Ellis from Dunkirk, continued to work as a pleasure steamer on the Rivers Thames and Medway until she was decommissioned in 1963. To celebrate the 70th Anniversary of the Dunkirk 'Miracle of Delivery' the *Medway Queen* is undergoing a programme of restoration in 2010.

Former Captain Mark Green, Chaplain to the 24th Lancers throughout the Normandy campaign of 1944, was consecrated Bishop of Aston, Birmingham, in 1972. He returned to the Second World War battlefields on several occasions but one fond memory was of leading a group of young cadets of the Eastbourne branch, Royal British Legion to Caen in 2003. Caen, where as a young Chaplain he had helped injured, dead and dying soldiers from the Regimental Aid Post on the front line, to the Advanced Dressing Station a few miles back. Caen now has a Museum of Peace 'Le Mémorial de Caen'. The story of the sacrifice of so many is a living *'Histoire Pour Comprendre Le Monde'* helping the young to understand the world they have inherited. In 2006, the Right Reverend Dr Mark Green MC retired to the relative peace and calm of the College of St Barnabas, a community of retired clergy in Dormansland, Surrey. He died at the College in August 2009. He had hoped that he might live to see the publication of this work, sadly that was not to be.

A Postscript to the Lingfield Bombs

The Police Incident report on the air raid in 1943 only mentioned one unexploded bomb in Mount Pleasant Road but another 50 kilogram unexploded bomb remained undetected in a garden in Mount Pleasant Road for almost sixty years. It was discovered accidentally on 7 January 2002 by builders. The bomb was highly unstable and could have exploded at any time. More than 400 dwellings in the immediate vicinity were evacuated. The coordinated effort of an army of local volunteers, Police, Ambulance and Social Services assumed Second World War proportions.

The residents were first taken to either Lingfield Community Centre or the nearby Day Centre. Many residents spent the night at Lingfield Racecourse where they received first class hospitality.

The Royal Engineers Bomb Disposal Squad under the command of Lt Ness carefully stabilised the bomb before moving it to open fields at Pond Farm where it was detonated. The highly skilled operation took fifteen hours to complete.

A new house has been built on the site of the ruined Horts Cottages in Newchapel Road. The old pollarded tree-arch which once marked the entrance to Horts Cottages now marks the entrance to the new house which is called 'Arch Trees'.

Major Ides Marie Joseph Michel Antoine Alphonse Gerard Vincent Corneille Floor

Major Floor was decorated by the Belgian, British, and American governments. In 1947, the Floor family removed from The Garth to Lullenden Manor, Hollow Lane, Dormansland. Ides Floor died at Middlesex Hospital on 28 July 1976 aged seventy. His death announcement was published in *The Times*, Friday 30 July 1976:

> On Wednesday, 28th July 1976, peacefully in London, Major Chevalier Ides Floor, Office de L'Ordre de Leopold avec Palme, Croix de Guerre avec Tour, Croix des Evades, D.S.O., M.B.E. adored husband of Guiton and much loved father of Minou and Jacqueline. Requiem Mass, St Bernard's Catholic Church, Lingfield, on Monday 2nd August at 11.45 am. Memorial service in Brussels later.

His body was buried in St John's graveyard, Dormansland, later that day. The Memorial Service was held at the Church of the Abbaye de la Cambre at Ixelles, Brussels on Saturday 9 October 1976. Major Floor's widow, Marguerite (Guiton) Marie Mathilde died in December 1991 and was buried with her husband.

As part of the Centenary celebrations for St John's Church, Dormansland in 1984, hand embroidered kneelers were made, each one included a personal motif. One of the kneelers was sponsored and made by Mrs Christiane (Minou) Wellesley Wesley, in memory of her father. Mrs Wellesley Wesley is the elder daughter of Major and Madame Ides Floor. The kneeler has the motif of a parachute with wings to symbolise the heroic deeds of her father while serving in the Special Operations Executive during the war.

Child Survivors of the Holocaust

The Lingfield House Report for 1950 gives some idea of the children's improvement after five years:

... in 1945 our aim was to provide a home for some of the Jewish children from the concentration camps. It seemed too much to hope that these children could reach maturity unscathed by the horrors they had witnessed and suffered ... although they still require the greatest understanding and patience, most of them are now indistinguishable from normal children. Only one child, a girl now 15, proved to be a hopeless case and had to be transferred to a mental home where she is regularly visited by the matron.

Several children were adopted, including Jacky Spiegel and Bela Rosenthal, a few fortunate survivors had been re-united with a parent or relative (some in Israel), one child died.

Alice Goldberger remained a mother figure for all her 'family' of refugee children. At the end of 1957, the house at Isleworth was closed and a flat in West Hampstead was purchased as a home for the remaining four children. The flat was home and a refuge, where all the children could return when they needed help and advice. Zdenka Husserl was one of that large family, she appeared in a BBC television tribute to Alice Goldberger, 'This is Your Life: Alice Goldberger' which was broadcast on 25 October 1978. Alice Goldberger died on 22 February 1986.

Sophie and Gertrud Dann were joined in Sharpthorne by their parents Albert and Fanny Dann. Albert had been president of the Jewish synagogue in Augsburg. When the synagogue was burned down in November 1938, Albert was arrested but freed after a few days. Albert and Fanny left their family home the day before their 40th wedding anniversary, March 1939. They fled via Italy, to the home of their youngest daughter Lotte, then to Palestine where they joined another daughter Elizabeth. They eventually left Palestine to live with their two unmarried daughters in Sharpthorne, arriving on a banana boat in March 1948.

Albert, Fanny, Sophie and Gertrud Dann continued to live at 1 Highcroft Cottages, Sharpthorne for the rest of their lives. Lady Clarke refused any rent for the property until Albert Dann had received his first restitution money from Germany. The local villagers called Albert 'Rabbi Dann', he died in 1960. One tribute given at his funeral at West Hoathly on 3 October 1960 acknowledged 'his and his family's good fortune to find shelter, friends, good neighbours and a new home. He learnt to love this country'. Sophie and Gertrud Dann too enjoyed living in the village of West Hoathly. An article in the *West Hoathly Chronicle*, October 1984, praised their work for the Red Cross over many years, 'they must surely be two of that institution's most diligent collectors'.

Colonel Ralph and Mrs Clarke moved to the Clarke family home of Borde Hill in 1949 following the death of the Colonel's father in the

previous year. When hearing that some German Prisoners of War had decided to stay on in England, Rebekah Clarke furnished some of the cottages for their use. Then in 1956 during the revolution in Hungary she admitted thirty-two refugees into the family house, Borde Hill. She also prepared cottages for refugee families, even hanging a welcome wreath on the door. Lady Rebekah Mary Clarke died on 24 July 1985.

In 1947, the newly created Czechoslovakian government opened the National Suffering Memorial on the site of the Theresienstadt Concentration Camp. It was later renamed Terezin Memorial.

Zdenka Husserl did not see a photograph of her mother until 1989, two years after her first trip back to her birthplace. Distant family and friends had spent two years trying to track down a photograph, which is now her only image of her mother. In 1994, Zdenka made contact with Vera Hajkova, a woman from Prague who had taken the young Zdenka under her wing at the camp. The pair visited the Terezin Memorial in 1995 – the 50th anniversary of their liberation from the camp.

Jackie Young (formerly Jona Spiegel) eventually visited his mother's last home address in Vienna, a large block of flats with one central door. He then bought a big Russian-type fur hat, possibly a subconscious link with his mother's profession as a milliner. Jackie, his wife Lita and their two daughters visited Sophie and Gertrud Dann at their home in Sharpthorne and were taken by them to see the old house at Bulldogs Bank where he and the five other children had lived in 1945/46. Sophie and Gertrud gave him several photographs of that time at Bulldogs Bank.

In 1981, Jackie went to a World Reunion of Holocaust Survivors in Israel in the hope of locating a long lost relative. His one vain hope was that one person among the thousands present might recognise the name of Elsa Spiegel from Vienna but that was not to be. The following day he did find a registration card of his own transport from Vienna on 24 September 1942: transport No. 1236. He saw too his own name in a very large book of those transported to Theresienstadt, there were several with his family name of Spiegel. Back home in London he received a copy of his own birth certificate from Vienna. He was born at Rothschild-Spital in Vienna on 18 December 1941 at 11.45 a.m. The certificate bears his mother's own signature and is annotated in the corner 'unmarried'. Jackie also received a copy of his mother's birth certificate with the names of both of his maternal grandparents, small precious fragments of new information.

The Rothschild-Spital was known as one of the most modern hospitals in Vienna, and was the only one of its kind permitted to treat Jewish patients during the war. In 1942, the temporary haven that the Rothschild hospital had for so long provided to Jews was brought to an abrupt end. The hospital was stripped of its license to serve a Jewish clientele. It was

taken over by the Nazis and for the rest of the war functioned as an SS military hospital.

Jackie has visited The Terezin Memorial in Czechoslovakia, and Maly Trostenets in Russia where his mother's body is buried. He is always grateful for the love and support he has received from his adoptive family. Jackie's particular blessings are his wife, children and grandchildren, of whom his natural mother would undoubtedly have been proud.

Joanna was married but is now widowed. She has three children all of whom are married and has several grandchildren. Joanna told her children about her own story when they were teenagers. Happily she has recently made contact with cousins in America, the family of her mother's older sister who immigrated to America in the 1920s. The family have preserved photographs of Joanna's mother as a child and as a young woman, now Joanna has copies of those photographs and has learned more of her mother's childhood. She continues to search for new information and is delighted to know that she has accounted for all of her parents' generation.

For several years Joanna has visited Notre Dame School in Lingfield to speak to the children of her own experiences as a Holocaust survivor. She travels all over England, Scotland and America, visiting schools, colleges and universities to talk of her experiences of the Holocaust. She also works

Left to right: Zdenka Husserl, Jackie Young (formerly Jona Jakob Spiegel) and Joanna Millan (formerly Bela Rosenthal), Lingfield 2005.

tirelessly for the Association of Jewish Refugees. Joanna considers that the most lasting effect of her experiences is a lack of trust in people and a determination to be as self-sufficient as possible.

> The reason why I talk to people about my experiences and those of my family is to help prevent any repetition of these awful events. It is so important to stress that each one of us can make a difference and that to say or do nothing is not an option if we wish to make our world a better place. (Joanna Millan 2003)

Coming to Terms with the New Peace

A variety of memorials were erected throughout the area to those who had lost their life during the course of the war. Before the war, The Oak Fitment Company of Blindley Heath had specialised in the restoration of old timber framed buildings and highly skilled oak panelling for houses and churches. During the Second World War, most of their time was spent on government contract work; making alterations to requisitioned properties and emergency repairs to bomb damaged buildings. In the post war years, the Oak Fitment Company made several carved wood memorials, including the war memorial in St John's Church, Blindley Heath, made in 1949. The company also made a memorial shield to hang in Lingfield Primary School recording the names of the staff and pupils who died when the school was bombed on 9 February 1943.

Churches of all denominations erected memorials to their dead of the Second World War. Cowden Church and Blindley Heath Church added stained glass windows to record their thanks to God for their safe deliverance from the perils of war. Bereaved families presented memorial gifts of stained glass, church furniture and furnishings.

On 22 November 1948, Lt-Col. Ian Anderson MC presented a parcel of land to the Rural District Council for the benefit of the villagers of Dormansland and in memory of his son Colin Daintry Anderson. The Colin Anderson Memorial Playing Field, Wildcrwick Road, is now the home of the Dormansland Rockets Football Club.

Ian Anderson's own wartime contribution was enormous. His land and farm buildings were a refuge for young Jewish men from pre-war Nazi Germany. His home, Old Surrey Hall, became a Maternity Hospital, where mothers could give birth in the relative peace of the countryside, away from war-ravaged London. The courtyard buildings housed not only his own family and household but also the home of a Canadian General and his family. The swimming pool and games room were a convalescent

facility for airmen with 'dermatomes and pedicles, glass eyes, false teeth and wigs'. Ian Anderson's role as Commanding Officer of the 9th Surrey (Oxted) Battalion Home Guard was a demanding office to which he dedicated his time and energy in the same way that he served his country in the First World War and earned him the award of the Military Cross.

In the rural communities of south-east England the old class divisions survived the war but were somewhat blurred at the edges. The gaps between the social classes lessened with the arrival of the Welfare State. Nothing would ever be quite the same again.

Appendix of Those Who Died

Blindley Heath Memorial

Gunner Joseph **APPS,** Royal Navy, HMS *Excellent*. Died 10 March 1941, age 49 (a veteran of the First World War). Son of William and Phoebe Apps of Hastings, husband of Sarah Apps of Hastings.

Driver William Joseph **BATES,** Royal Army Service Corps. Died 17 January 1941, age 31. Son of William Robert and Annie Bates, husband of Dorothy Evelyn Bates of Blindley Heath. Buried Ismailia War Cemetery, Egypt.

Flying Officer (Pilot) Adrian **BEARE,** Royal Air Force Volunteer Reserve. Died 7 July 1943, age unknown. The Pilot of a Wellington Mk X of Bomber Command that took off from RAF Hixon, Staffordshire, at 23.40 hrs on 6 July 1943 for a 'bullseye' night mission; bullseye was an evasion technique for avoiding search lights and night fighters. Three hours later the bomber emerged from cloud, in a steep dive, and failed to pull out before hitting the ground at 03.44 hrs on 7 July, at Hanging Wicket, in the area of Abbots Bromley, Staffs. All of the six-man crew were killed. Buried Stafford Cemetery.

Lieutenant Robert Morris Liddell **CARRUTHERS,** 6th Btn. The Royal Inniskilling Fusiliers. Died 4 January 1943, age 22. Son of Lt-Cmdr. Robert Jardine Carruthers, RNVR, and Georgina Rose Carruthers of Blindley Heath, husband of Doris Joan of Katesbridge, Co. Donegal. Buried Dely Ibrahim War Cemetery, Egypt.

J. **DAVEY** (unable to identify).

Private Ronald H. **DIGGINS**, The Queen's Royal Regt (West Surrey). Died 29 February 1944, age 21. Son of Charles Edgar and Rachel Louise Diggins of Godstone, Surrey. During the early months of 1944, Cassino saw some of the fiercest fighting of the Italian campaign, the town itself and the dominating Monastery Hill proving the most stubborn obstacles encountered in the advance towards Rome. Private Diggins has no known grave, his name is recorded on the Cassino Memorial, Italy.

Sergeant (Flt Engineer) Robert Cooper Mills **DOUGLAS**, Royal Air Force, 77 Sqdn. Bomber Command. Died 21 April 1943, age unknown. The Halifax II aircraft took off at 21:21 from RAF Elvington, East Yorkshire, engaged in Operation Stettin. Homeward bound the Halifax was attacked by a German night fighter and crashed at 03:21 hours into the sea 5 kilometres north-west of Mandø island on 21 April 1943. The crew of seven perished and were laid to rest in Forvfelt cemetery in Esbjerg on 30 April 1943. Flt. Engr. Sgt Douglas's body had been found at Ribe and brought to Esbjerg for burial.

First Officer Gilbert Christopher **GOULD**, Air Transport Auxiliary, Royal Air Force Volunteer Reserve. (Formerly: Flying Officer). Died 8 February 1945, age 38. Son of Gilbert and Grace M. Gould, husband of Esme Maude Gould of Felbridge. A schoolmaster.
Additional memorial : a metal plaque hangs in St John's Church inscribed to F/O Gilbert C. Gould.

2nd Lieutenant Denys Hallen **HANCOCK**, 6th Royal Tank Regiment, Royal Armoured Corps. Died 20 November 1941, age 21. Son of Clarence Henry Ralph and Hilda Muriel Hancock of Chelsea. Buried Knightsbridge War Cemetery, Acroma, Libya, about 25 kilometres west of Tobruk.

Lieutenant John Cecil **HORNER**, 2nd Btn The Parachute Regiment, Army Air Corps, Queen's Royal Reg. (West Surrey). Died 14 July 1943, age 22. Son of Harold Wallington Horner and Norah Horner of South Godstone. Buried Catania War Cemetery, Sicily.

Ordinary Seaman James **IVORY**, Royal Navy, HMS *Pembroke* (shore-based at Chatham). Died 22 Nov. 1941, age 32. Husband of Hope Ernestine Ivory, of Lingfield. Buried St John's Churchyard, Blindley Heath.

Petty Officer Arthur F. L. **LOWE**, Royal Navy, HMS *Vernon* (Torpedo and anti submarine training establishment). Died 1 January 1940, age 43.

Pilot Officer Geoffrey C. **POLGLASE**, Royal Air Force Volunteer Reserve. Died 3 May 1940, age 32. Son of Alan G. W. Polglase and Nellie Polglase of South Godstone. Buried St John's Churchyard, Blindley Heath.

Sergeant (W. Op/Air Gunner) John **SHORT**, Royal Air Force 608 Sqdn. Coastal Command. Died 23 November 1941, age unknown. The Hudson V aircraft took off at 10.30 hrs from RAF Thornaby, North Yorkshire. During the patrol the aircraft flew over cross country and followed the railroad from Tarm towards Skjern, Denmark. South of Skjern it dropped two bombs which fell between the railroad track and the main road without exploding. Apparently the aircraft struck a telephone pole at 14.41 hours and crashed into the ground. Sgt John Short and Sgt Francis G. Simmonds were taken to Skjern hospital, both badly wounded. Short perished soon after arrival at hospital, Simmonds died at 09.00 hours the following day. The whole crew were laid to rest in Frederikshavn cemetery on 28 November 1941.

Private Ronald George **WHITTAKER**, 1st Battalion. The Royal Sussex Regiment. Died 22 November 1941, age 26. Son of Edwin Charles and Elizabeth Hannah Whittaker, husband of Elizabeth Helena Ella Whittaker of Blindley Heath. Buried Halfaya Sollum War Cemetery, Egypt.

Crowhurst Memorial

Sergeant John Anthony Martin **BELL**, Royal Air Force Volunteer Reserve, 44 Squadron (Rhodesia Sqdn). Died 9 January 1943, age 19. A former pupil of Oxted County School. The Lancaster I aircraft took off from Waddington, Lincolnshire at 17.54 hrs for a mining sortie (Operation Gardening) dropping sea mines in the 'Daffodils area'. The aircraft was lost without trace. The crew are commemorated on the Runnymede Memorial.

2nd Lieutenant James Samuel **PINGREE**, Royal Engineers, 997 Docks Operating Coy. Died 20 Sept 1941, age 36. Son of William & Fanny Pingree, husband of Aileen Bartram Pingree of Branksome, Dorset. Buried at St George's Churchyard, Crowhurst.

Sergeant (Herbert) Arthur **ROBERTS**, Royal Air Force Volunteer Reserve, 115 (Bomber) Sqdn. Killed on Operations 14 Sept 1942, age unknown. Son of Herbert John and Dorothy Mabel Roberts of Crowhurst. A former pupil of Oxted County School. The crew are commemorated on the Runnymede Memorial.

Private Derek Vivian **WINTER**, 2nd Battalion. Somerset Light Infantry (Prince Albert's). Died 3 November 1944, age 20. Son of Ronald & Alma Winter of Tandridge. Buried Coriano Ridge War Cemetery, Italy.

Dormansland Memorial

Captain Colin Daintry **ANDERSON**, 25 Dragoons, Royal Armoured Corps. Died 7 April 1945. Son of Lt-Col. Ian F. Anderson and Mrs Mona Anderson. He was a passenger in a jeep, travelling to pick up his brother John Anderson from a POW camp when the vehicle crashed causing his death. Buried Groesbeek Canadian War Cemetery, Netherlands (see Chapter 18).

Lance Corporal Maurice Leslie **ATKINS**, Royal Army Medical Corps. Died 5 October 1944, aged 30, during the Battle for Arnhem. Buried at Woensel General Cemetery, Eindhoven.

Able Seaman Albert Edward **BOWEN**, Royal Navy, HMS *Hecla*. Died Thursday 12 November 1942, aged 43. Husband of Dorothy Bowen of Dormansland. The adopted son of Mr & Mrs James Spillman. During the Allied landings in North Africa, the destroyer HMS *Hecla* was torpedoed by U-boat U-515 and sunk west of Gibraltar; 279 of the crew went down with the ship, 568 men were rescued. His name is inscribed on the Portsmouth Naval Memorial.

Lance Corporal Frederick William (Bill) **BRAY**, 261 (Airborne) Field Park Company, Royal Engineers. Died 19/20 November 1942 aged 29 (see Chapter 11).

2nd Lieutenant Alastair Glanville **FORSYTH**, Royal Engineers. Died 1 October 1942, aged 20. Son of Major and Mrs Alexander Forsyth of Hollow Lane, Dormansland. Buried St John's Church, Dormansland. The carved oak pews in the South Aisle of St John's Church were the gift of the family to his memory.

Private Bertie **HODGE**, 1st Battalion, Royal Sussex Regiment. Died Saturday 22 November 1941. Fought and died with Pte Whittaker of Blindley Heath (they served in same Reg. and were killed the same day). Buried Halfaya Sollum War Cemetery, Egypt. A kneeler in Dormansland Church was given to his memory by his brothers and sisters.

Corporal Ian Mackay **PURDY**, 2nd Battalion, The London Scottish, Gordon Highlanders Regiment. Died 29 March 1945, aged 27. Son of Reginald John and Catherine McDonald Purdy of Westminster. Buried Harrow (Pinner) New Cemetery.

Civil Defence Memorial South Nave Wall of St John's Church

Erica Fothergill, Mary Fothergill, Florence Firmin and Alice Meadmore (see Chapter 13).

Lingfield

Leading Seaman Charles William **ALLEN**, Royal Navy, HMS *Hood*. Died 24 May 1941, age 36. The son of Charles and May Allen, husband of Edith Nora Emily Allen. One of 1,415 men lost with HMS *Hood* during combat with the German battleship *Bismarck*, in the Denman Strait on 24 May 1941 (see Chapter 10).

Private Charles Reuben **BATCHELOR**, 1st Btn. Royal Sussex Regiment. Died 9 January 1943, age 26. Son of William and Sarah Batchelor of East Grinstead. Buried Tripoli War Cem.

Private Edward Thomas **BATCHELOR**, 2nd Btn. The Devonshire Regiment. Died 13 July 1943, age unknown. Buried Syracuse War Cemetery, Sicily.

Pilot Officer Brian Bertram Horace **BEST**, Royal Air Force, 153 Squadron. Died 13 November 1941, age unknown. stationed at RAF Ballyhalbert, Northern Ireland, 24 Oct. 1941. Buried Lytham St Anne's (Park) Cemetery.

Private John Alfred **BOORER**, The Royal Sussex Regiment. Died 28 May 1940, age 21. Buried Caestre Communal Cemetery, Northern France.

Lieutenant Robert Morris Liddell **CARRUTHERS**, 6th Btn. The Royal Inniskilling Fusiliers. Died 4 January 1943, age 22. Also recorded on the Blindley Heath Memorial (see above).

Guardsman Stanley William **CLARK**, 1st Btn. Grenadier Guards. Died 22 July 1944, age 24. Son of Edwin and Lily Clark of Lingfield. Buried Banneville-la-Campagne War Cemetery, Calvados, France.

Gunner L. L. **COOPER**, (unable to identify).

Fusilier James Nicholas **DICKER**, 1st Batt. Royal Irish Fusiliers Died 6 October 1943, age 21. Killed in the Battle for Primosole Bridge, Sicily. Buried Sangro River War Cemetery, Sicily (see Chapter 12).

Sergeant Pilot Robert Moffatt **FORSTER**, RAF Volunteer Reserve. Killed 20 September 1941, age 25. Son of John Moffatt Forster and Annie Forster. No known grave. Runnymede Memorial.

Sergeant Louis Victor **FOSSLEITNER** BEM. 149 Sqdn. RAF Volunteer Reserve. Killed in Action, 10 November 1942. Son of Alois and Edith Daisy Fossleitner of East Grinstead. Buried East Grinstead (Mount Noddy) Cemetery (see Chapter 11).

Lance Corporal Douglas William (Bill) **GORRINGE**, 5th Btn. Highland Light Infantry (City of Glasgow Reg.). Died 28 October 1944, age 25. Son of David and Violet Gorringe of Lingfield, husband of Hettie Gorringe of Pengam, Glamorgan. Buried Bergen-op-Zoom War Cemetery. A former gardener at Crowhurst Place.

Sergeant Arthur Ernest **GUNN**, 181st Field Regiment, Royal Artillery. Killed on 25 June, 1944 in Normandy, aged 38. His wife, Kathleen, and parents William and Emily Gunn lived in Lingfield. Buried Brouay War Cemetery, code named 'Jerusalem' (See Chapter 12).

Petty Officer Stoker Charles **HEASMAN**, Royal Navy, HMS *Imogen*. Died on 16 July 1940, age 39. Son of Charles and Lilian Ethel Heasman of Lingfield. On arrival at Scapa Flow the area was fog bound, the Admiral decided to carry out fog exercises. During this exercise HMS *Imogen*, a destroyer, was rammed by a cruiser and eventually sank with several of her crew including Petty Officer Charles Heasman.

Captain John Wainwright **HOPKINS** MC, 11th (Hon. Artillery Co.) Regiment, Royal Horse Artillery. Son of Sir John Wells Wainwright Hopkins and Lady Hopkins of New Place, Lingfield. Killed 14 June 1942, age 31. Name inscribed on Alamein Memorial (see Chapter 12).

Private Eric D'Oyley **HUTCHINS**, 4th Btn. The Buffs (Royal East Kent Reg.) Died 23/24 October 1943, age 34. Athens Memorial.

Trooper Raymond (Ray) Alfred **JEFFREY**, 40th (7th Btn. The Kings Regt (Liverpool)), Royal Tank Regiment Royal Armoured Corps. Died 23 July 1942, age 30. Son of Arthur Sidney & Ellen Jeffrey, Bakers Lane; husband of Bessie Jeffrey of Lingfield. Buried El Alamein War Cemetery.

Major Denis Vincent **KELLY**, Civilian. Died at sea 7 December 1942, age 38. Husband of K. Kelly, of Orchard Cottage, Wadlands Lane, East Grinstead, Sussex. A civilian aboard the MV '*HENRY STANLEY*', sailing from Liverpool to Freetown and Lagos. The ship left Liverpool on 26 November. At 23.59 hours on 6 Dec, 1942, the *Henry Stanley* dispersed from the convoy (under attack from at least three U-boats) and was hit in the foreship by one torpedo from U-103 about 580 miles north-west of the Azores. The survivors abandoned ship and were questioned by the Germans from the surfaced U-boat. The master of the ship was taken prisoner. He was landed at Lorient on 29 December and taken to the POW camp Milag Nord. At 01.40 hours, the abandoned ship was again hit aft of the bridge, there was an explosion and the ship disintegrated. The lifeboats were never seen again: forty-four crew members, eight gunners and eleven passengers were lost. The 4,000 tons of general cargo, included explosives and 2,000 bags of mail.

Sergeant (Obs) Leonard **LOBB**, Royal Air Force Volunteer Reserve, Died 1 August 1942, age 29. Son of Albert & Annie Lobb of St Austell, Cornwall. Schoolteacher. Buried Tilburg (Gilzerbaan) Cem.

Able Seaman Albert **MADGWICK**, Royal Navy, HMS *Mohawk*. Died 16 April 1941, age 36. Son of George and Amelia Madgwick, husband of Eliza Madgwick. Portsmouth Naval Memorial. HMS *Mohawk* was struck by two torpedoes fired by the Italian destroyer '*Tarigo*' as she attacked an Italian convoy. HMS *Mohawk* sank in the Mediterranean, off Kerkennah Island on 16 April. Forty-one of the ship's company lost their lives, 168 were rescued.

Lieutenant James Seymour **PEARS**, Royal Scots Greys (2nd Dragoons) Royal Armoured Corps. Died of wounds 20 October 1943, age 28. Son of Mr and Mrs Harry William Kilby Pears of Newchapel House, Lingfield. Brother of Joan and Nora. Buried at Minturno War Cemetery, Italy. (*Times* Memorial, October 1944)

Warrant Officer (Nav.) John Reginald **PROCKTER**, 428 (RCAF.) Sqdn. Royal Air Force Volunteer Reserve. Died 1 September 1943, age 28. Son of Henry James Prockter and Elizabeth Mary Prockter, of Lingfield, Surrey; husband of Gladys Ellen Prockter, of West Byfleet, Surrey. Buried Berlin 1939-1945 War Cemetery.

Flight Sergeant (Air Gunner) John Paul **RICHES**, Royal Air Force Volunteer Reserve 617 Sqdn. (The Dambuster's Sqdn.) Died 13 February 1944, age 22. Son of John Harvey & Alice May Riches of Lingfield. Husband of Lily Riches. The Lancaster I aircraft took off from RAF Ford, West Sussex, at 08.20 hrs, (where it had landed following an operation to the Antheor Viaduct on the vital coastal rail link between Italy and the south of France). The aircraft crashed ten minutes after take off, on high ground at Waltham Down, 10 miles north-east of Chichester. Buried Lingfield Churchyard Extension

Sergeant (WO/Air Gun.) Arthur John (Jack) **SELBY**, Royal Air Force Volunteer Reserve Died 26 June 1942, age 28. Son of Charles and Florence Selby of 11 Vicarage Road, Lingfield. Husband of Olive Rhoda Selby of Brechin, Angus. Sage War Cemetery, Northern Germany (NOT ON VILLAGE MEM.).

Private Cyril James **SIMMONS**, The East Surrey Regiment. Died 12 May 1944, age unknown. Son of Alfred and Jessie Harriet Simmons, of East Grinstead, Sussex. Buried Cassino War Cemetery.

Private Ronald George **SMITH**, 5th Btn. Essex Regiment. Died 7 November 1943, age 21. Son of George and Mabel E. Smith of Lingfield. Buried Bari War Cem., Italy.

Rifleman Robert Frank **SNELLGROVE**, 9th Btn. Cameronians (Scottish Rifles). Died 26 June 1944, age 20. Son of Mr and Mrs J. F. Snellgrove, of Lingfield, Surrey. He has no known grave, Bayeux Memorial.

Marine Arthur Leonard **STUBBINGS**, Royal Marines, HMS *Repulse*. Died 10 December 1941, age 23. HMS *Repulse* operated off Norway in 1940, and on Convoy duty until the summer of 1941. *Repulse* joined the eastern Fleet in October 1941, arriving at Singapore on the 2nd of December, she sailed with HMS *Prince of Wales* and four destroyers to attack Japanese naval forces in their landing areas around Malaya. On the 10 December both the *Repulse* and *Prince of Wales* were attacked by eighty Japanese aircraft and were sunk, HMS *Repulse* being hit by a Torpedo and sunk at 12.33 hours, after being hit a further four times (see Chapter s 10 & 12).

Flight Officer Donald George **TURNER**, 49 Squadron, Royal Air Force Volunteer Reserve. Died 22 March 1944, age 28. The son of George and Victoria Turner, husband of Marjorie Abbott Turner of Bell Fields, Guildford. Buried Reichswald Forest War Cemetery, Germany.

Steward Joseph (Joe) A. **WHITE**, Merchant Navy MV *Kars* (London). Died 22 February 1942, age 18. The son of William and Margaret White. Tower Hill Memorial.

Corporal George William **WOOLLER**, Royal Corps of Signals, 49th Div. Signals. Died 3 July 1944, age 24. The son of George Albert and Emily Beatrice Wooler, husband of Lucy Margaret Wooller of East Grinstead. Buried Tilly-sur-Seulles, Calvados, France.

Flight Engineer Edward (Ted) S. **YORK**, (known as 'Yorkie') Unable to identify.

South Godstone

Sgt/pilot Stanley Allen **FENEMORE**, RAF. Died 15 October 1940, age 20. A cedar tree was planted to his memory on the south edge of woodland opposite Postern Gate Farm (see Chapter 11).

Canadian Casualties, East Grinstead Bombing 9 July 1943

About one third of the casualties from the bombing of the Whitehall Cinema 9 July 1943 were Canadian servicemen. No complete list of the Canadian dead and injured has been traced. Twenty-one deaths have been traced through the Commonwealth War Graves Commission. Another ten were traced at the Brookwood Military Cemetery (where all Canadian casualties were buried).

Brookwood Military Cemetery near Woking contains 2,405 Canadian Second World War burials. Those who died in the UK of injuries received in the Dieppe Raid were buried in Plot 38. Canadian soldiers who died in the Whitehall Cinema on 9 July 1943 were buried in Plot 40, Row A. Those who subsequently died of injuries received on 9 July were buried in Plot 45, Rows A-C.

A Canadian beaver carved by an engineer over the entrance to the Canadian Records building at Brookwood Military Cemetery.

Royal Canadian Corps of Signals

Signalman John Daniels BROWN, died 18 July, age 20, of Humber Bay, Ontario. Buried Block 45, Row A.

Signalman Lloyd William CAMERON, died 9 July, age unknown, of Inchkeith, Saskatchewan. Buried Block 40, Row J.

Signalman Augustus Herbert Leroy CRANDELL, died 9 July, age unknown. Buried Block 40, Row J.

Signalman Alfred (Fred) Eric GOODALL, died 9 July, age unknown, of Toronto, Ontario. Buried Block 40, Row J.

Signalman Arthur Findlay IRONSIDE, died 9 July age unknown. Buried Block 40, Row J.

Signalman Clifford Walter TRUAX, died 9 July, age 20, of Waverley, Ontario. Buried Block 40, Row J.

Royal Canadian Army Service Corps

Private James Franklyn CAMPBELL, died 9 July, age 27, of Toronto, Ontario. Buried Block 45, Row A.

Private Gordon Thomas CARMICHAEL, died 9 July, age 21, of Toronto, Ontario. Buried Block 45, Row A.

Lt. James Alexander Crozier CARRICK, died 19 July, age 34, of Toronto,

Ontario. Buried Block 45, Row B.

Private John Joseph Francis DUNN, died 21 July, age unknown. Buried Block 45, Row C.

Private Emrys George JONES, died 1 August, age 38, of Carno, Montgomeryshire. Buried Block 45, Row C.

Private Ronald Freeman MACADAMS died 22 July, age 24, of Port Joli, Nova Scotia. Buried Block 45, Row B.

Private Ivan William McILROY, died 1 August, age 22, of Hamilton, Ontario. Buried Block 45, Row C.

Private Melvin SORENSON, died 16 July, age 22, of Paddockwood, Saskatchewan. Buried Block 45, Row A.

Private Victor SWEET, died 12 July, age unknown. Buried Block 45, Row A.

Private Gordon Lewis WILKINSON, died 22 July, age 23, of Chilliwack, British Columbia. Buried Block 45, Row B.

Royal Canadian Engineers Corps

Sapper Weldon Archibald CARNEGIE died 5 August, age 20, of Pembroke, Ontario. Buried Block 45, Row C.

Sergeant John Henry Arthur CORNWALL, died 29 July, age 21, of Toronto, Ontario. Buried Block 45, Row C.

Sapper/Sapeur Clifford Eugene COUTURE, died 9 July, age 33, of Timmins, Ontario. Buried Block 40, Row J.

Sapper Edward Lewis HILL, died 17 July, age unknown. Buried Block 45, Row B.

Sergeant George Victor HUMPHRIES, died 13 July, age unknown, of Toronto, Ontario. Block 45, Row A.

Sapper Donald Lloyd McRAE, died 18 July, age 33, of Alexandria, Ontario. Buried Block 45, Row A.

Royal Canadian Artillery

Gunner/Artilleur Rolland Joseph COTE (7th Anti-Tank Reg.), died 22 July, age 22, of Montreal, Quebec. Buried Block 45, Row B.

Captain Robert Wesley HARCOURT, Royal Canadian Horse Artillery died 9 July, age 29. (Captain Harcourt's wife, Ethne Goodbrand Harcourt aged 20, was also killed in the Whitehall Cinema tragedy on 9 July, they were buried together at Chislehurst Cemetery, Kent.)

Royal Canadian Infantry Corps

Private Alexander CHAMPAGNE (Les Fusiliers Mont-Royal) died 20 July, age unknown. Buried Block 45, Row B.

Private Murray William DALE, (Royal Hamilton Light Infantry) died 21 July, age unknown. Buried Block 45, Row B.

Royal Canadian Armoured Corps
Sergeant John Ritzema COATSWORTH (41 Gen Transport Coy), died 22 July, age 29, of Consort, Alberta. Buried Block 45, Row B.
Trooper Donald Frederick FITZGERALD (Halifax Rifles), died 31 July, age 21, of New Glasgow, Nova Scotia. Buried Block 45, Row C.
Lance Corporal Garret HOFSTEE, 8th Princess Louise's (New Brunswick) Hussars, died 16 July, age 23, of Monarch, Alberta. Buried Block 45, Row A.
Corporal William MACDONALD, died 9 July, age 22, of Inverness Co., Nova Scotia. Buried Block 40, Row J.

Canadian Provost Corps
Corporal George Dale BURGESS, died 14 July, age unknown Block 45, Row A.

Godstone Rural District, Civilian Casualties

BRICE, ARTHUR JAMES Age: 35, Date of Death: 10/11/1940, of Egdon, Peter Avenue, Oxted. Son of Arthur William and Helena Blanche Brice. Died at Egdon, Peter Avenue. Air raid casualty.

BRICE, HELENA MARY Age: 31, Date of Death: 10/11/1940, of Egdon, Peter Avenue, Oxted. Daughter of Arthur William and Helena Blanche Brice. Died at Egdon, Peter Avenue. Air raid casualty.

BROWNING, RICHARD POWER Age: 54, Date of Death: 22/01/1944. Air Raid Warden. Son of Jeffrey Browning, of Kilgrogan, Adare, Co. Limerick, Irish Republic; husband of Margaret Theresa Browning, of The Red Barn, Blindley Heath. Died at The Red Barn, victim of a flying bomb incident.

DOHRN, JOACHIM SEBASTIAN ('Serge') Nationality: United Kingdom. Born in Dresden, Germany. Age: 29, Date of Death: 09/07/1943 at Whitehall Cinema, of Invermay, Vicarage Road, Lingfield. (Miss Churchill made enquiries on behalf of his partner Jane Parr and their son, on the evening of 9 July, Citizens' Advice Bureau Casualty Station) Identified by Police Sergeant Harry Hills, Lingfield Police Station. Buried at Lingfield Cemetery.

DUNCAN, DOREEN Age: unknown. Date of Death: 24/07/1943, Firewoman. Daughter of Mrs I. P. Todd, of 107 Hillbury Road, Warlingham. Died at Godstone.

EDMONDS, SYBELLA Age: 60. Date of Death: 09/07/1943, Wife of George Marcus Edmonds, of Rose Walk, Mill Lane, Felbridge, Godstone. Died at London Road, East Grinstead.

FIRMIN, FLORENCE MARY ELIZABETH Age: 32. Date of Death: 09/07/1943, of 82A Kingwood Road, Fulham, London. Daughter of C. M. and F. M. Barrett, of 87 Hatton Garden, Holborn, London; widow of Edward Firmin (formerly of Dormansland). Died at Whitehall Cinema (see Chapter 13).

FOTHERGILL, ERICA Age: 49. Date of Death: 12/07/1943, of The Beacon, Dormansland, Lingfield. Daughter of George Algernon Fothergill, of 40 Copse Close, and of Isabel Fothergill. Injured 9 July 1943, at London Road, died at Queen Victoria Cottage Hospital. Buried Dormansland (see Chapter 13).

FOTHERGILL, ISABEL Age: 73. Date of Death: 09/07/1943. Wife of George Algernon Fothergill, of 40 Copse Close. Died at London Road (see Chapter 13).

FOTHERGILL, MARY Age: 46. Date of Death: 09/07/1943, of The Beacon, Dormansland, Lingfield. Daughter of George Algernon Fothergill, of 40 Copse Close, and of Isabel Fothergill. Died at London Road (see Chapter 13).

FRANCE, ELLEN Age: 68. Date of Death: 09/07/1943, of Merxies, Copthorne Road, Felbridge, Godstone, Surrey. (St John's Felbridge Burial Register gives her address as Green Platt, Copthorne Road). Widow of Arthur France. Died at Whitehall Cinema. Buried 15 July 1943, St John's, Felbridge.

GLOVER, LILIAN ROSE Age: 59. Date of Death: 09/02/1943, of Noel Villa, Mount Pleasant Road, Lingfield. Daughter of the late William and Rose Isabel Gadd, of Cavendish House, Lingfield; widow of Harry Glover. Died at Noel Villa, Mount Pleasant Road (see Chapter 13).

GOODWIN, SAMUEL Age: unknown. Date of Death: 29/10/1942. Killed in aircraft accident at Godstone.

GREENWOOD, MARY ELIZABETH Age: 37. Date of Death: 09/07/1943, of The Shooting Box, Shovelstrode. Daughter of the late Major and Mrs

G. Botham, of Kensington, London; wife of Flt./Lt Gilbert Frederick Greenwood, RAF Died at London Road, East Grinstead (see Chapters 2 &13).

HOLMDEN, DENIS RICHARD CHARLES Age: 39, Date of Death: 13/02/1947, Fireman, of 8 Knights Hill Cottages, Hurst Green, Oxted. Son of Mr and Mrs A. Holmden, of 11 Red Lane Cottages, Limpsfield; husband of E. A. Corke (formerly Holmden). Died at 8 Knights Hill Cottages.

HUNT, ROSAMOND JOAN Age: 23. Date of Death: 09/02/1943, Primary School Teacher and Firewatcher. Daughter of Mrs R. Backlock (formerly Hunt), of Shardeloes, Alma Road, Reigate, and of the late Barrett Hunt. Died at Lingfield School (see Chapter 13).

KEATES, ALFRED NELSON Age: 82. Date of Death: 24/09/1940, of West View, Barfields, Bletchingley. Husband of Fanny Keates. Died at West View, Barfields.

LAMBERT, M. A., DIANA MARY Age: 34. Date of Death: 21/07/1944, of South Park, Bletchingley. Daughter of A. Grey, of East End House, Ditchling, Sussex, and of the late Col. Arthur Grey CIE; wife of Major Uvedale Lambert, The King's Royal Rifle Corps. Died at South Park (see Chapter 16).

LUMSDEN, HEATHER MARY Initials: H. M. Nationality: United Kingdom Rank: Civilian Regiment/Service: Civilian War Dead Age: 28. Date of Death: 09/02/1943 Additional information: Firewatcher. Daughter of Mr and Mrs L. H. Dymond, of Elm Grove, Victoria Road, Dartmouth, Devonshire; wife of John T. Lumsden, of Berwyn, Vicarage Road, Lingfield. Died at Lingfield Central School (see Chapter 13).

LUXFORD, FLORENCE ELIZABETH Age: 44. Date of Death: 09/07/1943. Daughter of William and Ellen Luxford, of Elmhurst, Hurst Green, Oxted, Surrey. Died at London Road, East Grinstead.

LYNN, Jessie Age: 36. Of Barley Stack, Newchapel Road, Lingfield. Daughter of the late Thomas Edward and Mary Ann Lynn. Injured 09/02/43 at Lingfield School. Died at Redhill County Hospital 11/02/43 (see Chapter 13).

MAINE, FRANCES MARY JOAN Age: 11. Date of Death: 09/02/1943. Daughter of Mrs Fitzell (formerly Maine), of The Bungalow, Felcourtlands

Farm, Felcourt, East Grinstead, Sussex, and of the late William Edward Maine. Died at Lingfield School (see Chapter 13).

MAMMATT, JOAN EULALIE MARY Age: 40. Date of Death: 10/11/1940, of Rhyl, Peter Avenue, Oxted. Daughter of the late Arthur William and Chrystabel Smallwood, of St Nicholas, Oxted; wife of J. T. Mammatt. Died at Rhyl, Peter Avenue. Casualty Type: Civilian War Dead.

MAMMATT, PHYLLIS MARY Age: 11. Date of Death: 10/11/1940, of Rhyl, Peter Avenue, Oxted. Daughter of J. T. Mammatt, and of Joan Eulalie Mary Mammatt. Died at Rhyl, Peter Avenue.

MAMMATT, WINIFRED MARY Age: 69. Date of Death: 10/11/1940, of Rhyl, Peter Avenue, Oxted. Daughter of the late John Edward and Isabella Mammatt. Died at Rhyl, Peter Avenue.

MEADMORE, ALICE MAUD Age: 43. Date of Death: 09/07/1943. Wife of Joseph Lewis Meadmore, of 9 Sackville Gardens. Died at London Road, East Grinstead. Buried Dormansland (see Chapter 13).

MITCHELL, CLARA LOUISA Age: 60. Date of Death: 09/07/1943, of Hollycroft, Rowplatt Lane, Felbridge, Godstone, Surrey. Widow of John Mitchell. Died at Whitehall Cinema.

TURNBULL, ANNE Age: 11. Date of Death: 09/02/1943. Daughter of Peter and Helen Turnbull, of The Garage, Felcourt, East Grinstead, Sussex. Died at Lingfield School (see Chapter 13).

Glossary

AA Guns	Anti-Aircraft Guns (sometimes: ack-ack guns)
ADS	Advanced Dressing Station
AFS	Auxiliary Fire Service
ARP	Air Raid Precautions
ATA	Air Transport Auxiliary
ATC	Air Training Corps
ATS	Auxiliary Territorial Service
BBC	British Broadcasting Corporation
B.C.S.	Brockley Central School
BEF	British Expeditionary Force
CAB	Citizen's Advice Bureau
C.B.A.	Council for British Archaeology
C.B.F.	Central British Fund for German Jewry
CO	Commanding Officer
FANY	First Aid Nursing Yeomanry
GHQ	General Headquarters
GOC	General Officer Commanding
HAA Guns	Heavy Anti-Aircraft Guns
J.R.C.	Jewish Refugee Committee
LCA	Landing Craft Assault
L.C.C.	London County Council
L.D.V.	Local Defence Volunteers (later known as the Home Guard)
MI9	Military Intelligence, British escape service
MI(R)	Military Intelligence (Research) Unit
MO	Medical Officer

NAAFI	Navy, Army and Air Force Institutes (HM Forces official trading organisation)
NCO	Non-commissioned Officer
OB	Operational Bases
OTC	Officer Training Camp
P.C.C.	Parochial Church Council
POW	Prisoner of War
RADAR	Radio Detection And Ranging
RAF	Royal Air Force
RAFVR	Royal Air Force Volunteer Reserve
RCA	Royal Canadian Artillery
RCAF	Royal Canadian Air Force
RCAMC	Royal Canadian Army Medical Corps
RCE	Royal Canadian Engineers
RDF	Radio Direction Finding
RDC	Rural District Council
SHAEF	Supreme Headquarters Allied Expeditionary Force
SOE	Special Operations Executive
TA	Territorial Army
U.D.C.	Urban District Council
USAAF	United States Army Air Forces
V-1	Vergeltungswaffz 1, German retaliation flying bomb (popularly known as the Doodle-bug)
V-2	Vergeltungswaffz 2, Long range rockets, carried 2,200 lbs (1,000 kg) of high explosive
VAD	Voluntary Aid Detachment
VD	Venereal Disease
VE Day	Victory in Europe Day, 8 May 1945
VJ Day	Victory in Japan Day, 15 August 1945
W/Op.	Wireless Operator
War Ag.	County War Agricultural Committee
WAAF	Women's Auxiliary Air Force
WI	Women's Institute
WLA	Women's Land Army
WRNS	Women's Royal Naval Service (the 'Wrens')
WTC	Women's Timber Corps
WVS	Women's Voluntary Service

Bibliography and Primary Source Material

A Note on Sources

In the preparation of this book material from as wide a field as possible has been sought from national and local archives and personal and previously unpublished recollections. Sadly several contributors are no longer with us.

From the appointment of Adolf Hitler as Chancellor of Germany on 30 January 1933, until the self-conscious celebration of the Festival of Britain in 1951 the nation commonly re-ordered their lives. Although official government records of those years are now being released into the public domain there is a paucity of primary source material on the activities of the heroes, and villains, of the Home Front. The names and experiences of most of the men and women who served in the Auxiliary Units remain secret.

Key Texts

A Short History of Blindley Heath, East Surrey: compiled on the occasion of the 150th Anniversary of the Church of St John the Evangelist, Blindley Heath, 20 June 1992.

Bailey, Roderick, *Forgotten Voices of the Secret War: An Inside History of Special Operations during the Second World War*, 2008.

Binney, Marcus, *Secret War Heroes: Men of the Special Operations Executive*, 2005.

Brown, Mike, *Evacuees: Evacuation in Wartime Britain, 1939-1945*, 2000.

Chorley, W. R., *Operational Training Units 1940-1947*, Vol. 7.

Chorley, W. R., *Royal Air Force Bomber Command Losses of the Second World War*, 1942, 1943, & 1944.

Coombes, Bill, *Pals from the Past* (unpublished paper).

Coombes, Bill, *Those Were the Days: As I remembered Life and Leisure in Lingfield in the Twentieth Century*.

Davies, Vincent, *A History of Dormans Park*, 1993.

Dighton, Barry and Liz, *The History of the Grange and its Occupants*, 1997.

Don, J. F. and M. A. Brown, 'Evacuation to Westmorland: from Home and Europe, 1939-1945', *Westmorland Gazette*, 1946.

Donovan, Rita, *As for the Canadians; the remarkable story of the RCAF's 'Guinea Pigs' of World War II*.

Edmunds, H., *A Brief History of Greathed Manor (formerly Ford Manor)* (unpublished manuscript).

Englefield, W. A. D., *Limpsfield Home Guard 1940-1941*.

Flensted, Søren C., *Airwar over Denmark*.

Foxley, William, Newsletter of The Blond McIndoe Research Foundation, Spring 2009, pp. 4-5: 'William's Story.'

Friedman, Manna, *Bulletin of the Anna Freud Centre* V. 9: pp 313-314: 'Alice Goldberger', 1986.

Friedrichs, Jonathan, 'The Rothschild Hospital in Vienna,' The Vancouver Holocaust Education Centre, Newsletter, June 2004.

Front Line 1940-41: The Official Story of the Civil Defence of Britain. Issued for the Ministry of Home Security by the Ministry of Information, 1942.

Fuller, Charles M., *Halliloo Farm, Woldingham*, Local History Records, Vol. XVI, 1977. Bourne Society.

Green, Mark, *Before I Go*, 2005.

Hatswell, Dorothy, *East Grinstead: A History and Celebration of the Town*, 2004.

Hassan, Judith, *The Missing Years: Experiences of Children Who Went through the Holocaust* inc. *Journal of Holocaust Education*. Vol. 4, No. 2.

Hobbs Barracks, The Felbridge & District History Group.

Home Guard Manual 1941.

Johnston, J. and Nick Carter, *Strong by Night: History and Memories of No. 149 (East India) Squadron Royal Air Force 1918/19 – 1937/56*.

Kee, Robert, *The World We Left Behind: a Chronicle of the Year 1939*.

Kushner, Tony, *Holocaust Survivors in Britain: An Overview and Research Agenda* (inc. *Journal of Holocaust Education* Vol. 4, no. 2).

Lampe, David, *The Last Ditch: Britain's Secret Resistance and the Nazi Invasion Plan*, 1968.

Lasker-Wallfisch, Anita, *Inherit the Truth 1939-1945*, 1996.

Lauer, George, G., *The Story of my Life and Times*, 1993-4 (limited publication).

Leighton-Langer, Peter, *The King's Own Loyal Enemy Aliens 1939-45: German and Austrian Refugees in Britain*.

Leppard, M. J., *A History of East Grinstead*, 2001.

Leppard, M. J., *100 Buildings of East Grinstead*, 2006.

Letters from a War Child: Ernest Dieter Ball's correspondence, 1939-41, 1999.

Levine, Joshua, Forgotten Voices of the Blitz and the Battle for Britain.

Lewes Evening Argus.

Longstaff-Tyrrell, Peter, *That Peace in Our Time: the artefacts of World War Two in Sussex*, 1993.

Mayhew, E. R., *The Reconstruction of Warriors: Archibald McIndoe, the Royal Air Force and the Guinea Pig Club.*

Mackenzie, William J. M., *The Secret History of SOE: the Special Operations Executive, 1940-1945*, 2000. With a foreword and notes by M. R. D. Foot.

McEleran, Brock, *V-Bombs and Weather Maps: Reminiscences of World War II*, 1995.

McNeill, Ross, *Royal Air Force Coastal Command Losses of the Second World War*, Vol. 1.

Mobsby, Angus J., *A History of the Homes and School for the Medical Treatment and Education of Children with Epilepsy (1894-1972).*

Money, Bruce E., *Bletchingley in the World War 1939-1945.*

Ogley, Bob, *Surrey at War 1939-1945.*

Peters, T. P., *Reminiscences of 1938-1945 by a Head Warden.*

Pitchfork, Graham, 'The Sea Shall Not Have Them,' in *Flypast*, December 2006.

Ramsey, Winston G. (ed.) , The Blitz Then and Now, Vol. 3, 1990.

Robbins, Gordon *Fleet Street Blitzkrieg Diary*, Chairman of Benn Brothers Ltd. 1944.

Saunders, Hilary St George, *The Red Cross and the White: A Short History of the Joint War Organization of the British Red Cross Society and the Order of St. John of Jerusalem 1939-1945*, 1949.

Snowman, Daniel, *The Hitler Emigres: the Cultural Impact on Britain of Refugees from Nazism*, 2002.

St Bartholomew's Church Burstow, Parish Magazine.

Stacey, C. P. and Barbara M. Wilson, *The Half Million: The Canadians in Britain, 1939-1946.*

The Brockenian: Brockley Central Old Scholars Magazines.

The Work of the Lord in a Surrey Village: A Testimony Carried on in Lingfield, with a Short Biographical Sketch of Dr Sydney Charles Austin. Author unknown. Published *c.* 1920 by Pickering & Inglis, London.

Thompson, Julian, *The Imperial War Museum book of the War at Sea: the Royal Navy in the Second World War,* 1996.

Walker, Diana Barnato, *Spreading My Wings,* 1994.

Whitworth, Wendy (ed.), *Survival: Holocaust Survivors Tell Their Story,* 2003.

Wiesenthal, Simon, *Justice not Vengeance,* 1989.

Who Was Who, Vol. III, 1929-1940.

Wicks, Ben, *The Day They Took the Children,* 1989.

Wicks, Ben, *No Time to Wave Good-bye,* 1988.

Primary Source Material

BBC/ WW2 People's War Project:
Freddy Gomshaw (Article ID A3332611)
Ben Cumming (Article ID A3740104)
Francis Wallace (Article ID A8993604)

Commonwealth War Graves Commission: Casualty Reports

Council for British Archaeology, Defence of Britain Project

Imperial War Museum:
Photograph of a member of Women's Land Army: Image Ref.: D 4741
The private papers of Clive Teddern (formerly Kurt Tebrich) Ref. 15482 07/35/4: Clive "Teddy" Teddern/Kurt Tebrich)
Chaim Raphael, Interview Ref. 4289
Photograph of Private Albert Strudwick, survivor of the forced march from Lamsdorf to Göttingen. (film: Imperial War Museum (Catalogue No. A70 514-15)

Library and Archives Canada: Dept. of National Defence
Photographic Images:
1. Troopers of the Ontario Regiment taking part in Exercise Tiger, East Grinstead, May 1942. Photo: Lieut. C. E. Nye, PA – 14577. *Item 759-13,* Item (Acc.) 1967- 052 NPC.
2. Officers of the Cameron Highlanders of Ottawa (M.G.) with a Vickers Heavy Machine Gun, Lingfield, England, 8 April 1942. Photo: Capt. Frank Royal, PA – 138338 Item (Acc.) 1967-052 NPC.

3. The Canadian (Regiment de Maisonneuve). Personnel of a Casualty Clearing Station of RCA Medical Corps, [Ford Manor, Dormansland]. Evacuating 'casualties' during training exercise with Home Guard, Lingfield, 16 June 1942. Photo: Lieut. C. E. Nye, PA – 151132 *Item:* 772-3 Item (Acc.) 1967-052 NPC.

4. Private H. Roach, a simulated casualty, receives treatment in the operating theatre of No.5 Casualty Clearing Station, Royal Canadian Army Medical Corps (RCMAC), Lingfield, England, June 1942. [Ford Manor, Dormansland, Lingfield, Surrey]. (L-R): Major P. J. Maloney, Nursing Sister Evelyn Pepper, Private H. Munro, Major S. W. Houston, Private B. Grayson, Nursing Sister E. Galbraith. Photo: Unknown, PA – 151138. Item (Acc.) 1967-052 NPC.

London Metropolitan Archive, (Prefix Ref L.C.C.):
Evacuation of L.C.C. Schoolchildren: ARP Circular No 16/1939; EO/PS/9/2; CH/M/6/1
PH/WAR/01/019; PH/WAR/01/020; AR/CB/2/64
Statistical analysis of children in reception areas: PH/WAR/01/021
Emergency Hospital Scheme: PH/WAR/01/012; PH/WAR/01/016
Records of the Central British Fund for World Jewish Relief: ACC/2793
Correspondence files – Weir Courtney: ACC/2793/01/06/09
Lingfield House Report: ACC/2793/01/06/10
Children's Movements: ACC/2793/03/04/4-12
Lingfield Epileptic Colony: GLC/AR/BR/34/002674

Surrey History Centre References:
Lingfield District Fire Brigade: 2184/3, 2184/13, 2184/16
9th Surrey (Oxted) Bn. Home Guard: 477/3/2; Certificates for Gallantry and Good Service: 477/6/1; 477/6/3; 455/6/1; 477/24/1
Lingfield Internment Camp: Queen's Regimental Museum, ESR/6/12/4 Anti Tank Reg. RA Scrapbook
Leonard Sandall's Log Book: 6661/4
Dormansland Primary School, Register, 1939-1947
Parish Marriage Registers: 2399/1/20 (Lingfield); 3804/1/4 (Blindley Heath); 6141/1/6 (Dormansland)
Parish Records of St Peter & St Paul, Lingfield. P.C.C. Minutes
Surrey Constabulary Wartime: CC98/8/1; Nodal Points: CC 98/8/10
Surrey Constabulary Day Book: CC 98/8/12; CC98/8/13; CC98/8/16
Surrey Constabulary Reports: CC98/8/20; CC98/22/10

The National Archives References:
Evacuation: ARP Circular No 16/1939

Emergency Hospital Scheme: PH/WAR/01/012; PH/WAR/01/016; PH/WAR/01/020; PH/WAR/01/021

Auxiliary Units: WO 199/1955; WO 199/2151; WO/199/3391; HQ Special Duties: WO 260/9

Southern Command, Home Defence: Pillbox design WO 199/1779; GHQ. Zones WO 199/1800

ATS Recruitment: LAB 6/180

Lingfield Aliens Camp WO 215/470

Enlistment of Alien Internees to Pioneer Corps and ATS: HO 213/1742

Lingfield Prisoner of War Camp: WO 166/5976; WO 166/10300; Hospital Block: WO 222/71 (Z-64)

Employment of Italian POWs: CAB 114/25; CAB 114/26; MAF 99/711

Canadian troops: WO 199/576, WO 199/577, CAB 65/2/52, CAB 66/19/1 & CAB 68/5/18

Strength of Canadian Forces in UK: DO 35/1207

Exercise Tiger: WO 199/222

Operation Diver: WO 199/2985,

11th (Hon. Artillery Company) Reg.: WO 204/8329; Escape of Hopkins and Rae: WO 373/60

SOE Belgium, Mission Dardanius: HS 6/78; Ides Floor: HS 9/521/6; WO 373/184

SOE personal file Peter Schloder HS 9/1325/2

S.E.COMMAND 1 COMMAND CAGE POW: WO 166/5976, WO 166/10300

Interrogation Reports, Lingfield: WO 208/3630 & WO 208/3634 (LF 137-204); WO 208/3639

(LF 732 – 788);

Stalag VIIIB, Lamsdorf, Poland: WO 309/1831

The Wiener Library Institute of Contemporary History:

Lingfield Internment Camp postcard: Ref 899

Nicholas Winton MBE, Scrapbook, 'Saving the Children' Ref: 5192

Dann family papers – 1070/1/2; 1070/1/6; 1070/1/21; 1070/3/9;

Bulldogs Bank – 1070/5/2; 1070/5/3

West Sussex County Record Office:

Ref: Dann family papers – Add Mss, 36776, 36777, 36780, 36782, 36783 and 36784

Bombing of Whitehall Cinema, Newspaper cuttings (*East Grinstead Observer and East Sussex Courier*)

MP 4386

Citizens' Advice Bureau, Records of East Grinstead bombing, July 1943: Add Ms 47871 – 47881

(Including Queen Victoria Hospital Casualty Lists, 9 July 1943)

Local Archives

Dormansland Women's Institute: Reports and Minutes 1938-1946

Hayward Memorial Local History Centre, Lingfield Guest House
 Library:
Diaries of Arthur Baldwin Hayward 1938-1945
Note and Recipe Book of Sapper Bryant, E. R, Royal Engineers, 4 Oct
 1941–July 1942
(E. Bryant Collection.)
Lingfield Women's Institute, Records and Minutes 1938-1946 (W.I.
 Lingfield Collection)

Lingfield Primary School, Registers and Log Book, 1939-1946

Queen Victoria Hospital, East Grinstead. Museum Collections:
Guinea Pig Archives

RH7 History Group, Oral History Project: 'The Memory Bank'.
Personal memories of Beryl Brown, Eric Ellis, David Gorringe, Ron
 Grainger, Violet Kinnibrugh, Betty Snow, and others who wish to remain
 anonymous.

Index